BEYOND BRUCE LEE

GW00683845

PAUL BOWMAN

BEYOND BRUCE LEE
Chasing the Dragon through Film, Philosophy and Popular Culture

WALLFLOWER PRESS
LONDON & NEW YORK

A Wallflower Press Book
Published by
Columbia University Press
Publishers Since 1893
New York • Chichester, West Sussex
cup.columbia.edu

Copyright © Paul Bowman 2013
All rights reserved.
Wallflower Press® is a registered trademark of Columbia University Press

A complete CIP record is available from the Library of Congress

ISBN 978-0-231-16528-0 (cloth : alk. paper)
ISBN 978-0-231-16529-7 (pbk. : alk. paper)
ISBN 978-0-231-85036-0 (e-book)

Book design by Elsa Mathern

Columbia University Press books are printed on permanent
and durable acid-free paper.
This book is printed on paper with recycled content.
Printed in the United States of America

c 10 9 8 7 6 5 4 3 2 1
p 10 9 8 7 6 5 4 3 2

CONTENTS

PREFACE

This book is closely related to my earlier work, *Theorizing Bruce Lee* (Bowman 2010). It is both younger and yet more mature. At times it picks up, unpicks and reworks some of the loose threads of that earlier book, at others it takes off in completely different directions. Some sections reiterate, restage and rework earlier debates. Many others are completely different. All try to move *beyond* Bruce Lee: beyond a narrow conception of what is meant by Bruce Lee – whether that be merely as celebrity, icon, choreographer, martial arts innovator, pop psychologist, philosopher or film star – and into the wider waters of the questions of his cultural emergence and popular cultural intervention; the significance of the East/West dynamics that are played out in and around the texts that are Bruce Lee; questions of the status of 'his' philosophy; the significance of the effects his films have had on cultures East and West; the ways in which Bruce Lee has been articulated with other cultural realms and registers or translated into and out of cultural and political discourses; as well as the enduring questions of ethnicity and identity politics that arise *vis-à-vis* Bruce Lee.

Rather than simply being a contribution to any one academic discipline or field, I offer this work as a supplement to film studies, a footnote to debates in contemporary Continental philosophy, a post-mortem of that old chestnut called postmodernism, and a contribution to postcolonialist cultural studies, insofar as I use elements of all of these discourses to unpick and analyse the texts of Bruce

Lee – whether that be texts that bear the name or texts bearing the (hall)marks and traces of Bruce Lee.

I could not analyse all such texts. I could almost certainly not even find them all, even to list them in the most fleeting manner. Part of my point is that Bruce Lee's influence is incalculably expansive and diverse. Bruce Lee has had a massive intertextual impact that knows no borders. Any cultural study of 'Bruce Lee' ineluctably becomes the study of a complex field of intertextuality, one which demands an interdisciplinary approach. However, as if to compound matters, by focusing in multiple ways on several textual senses and scenes of Bruce Lee, such an approach will produce a text that may not be easily recognisable or categorisable as this or that sort of 'proper' academic work. Both such productivity and impropriety are unavoidable. As one of the first theorisers of 'the text', and of its emergence, Roland Barthes pointed out several decades ago:

> It is indeed as though the *interdisciplinarity* which is today held up as a prime value in research cannot be accomplished by the simple confrontation of specialist branches of knowledge. Interdisciplinarity is not the calm of an easy security; it begins *effectively* (as opposed to the mere expression of a pious wish) when the solidarity of the old disciplines breaks down – perhaps even violently, via the jolts of fashion – in the interests of a new object and a new language neither of which has a place in the field of the sciences that were to be brought peacefully together, this unease of classification being precisely the point from which it is possible to diagnose a certain mutation. (1977: 154; emphasis in original)

As Barthes predicted all those years ago, innovative interdisciplinary work is never going to be uncontroversial, nor will it necessarily even be recognisable as a 'proper' study of this or that 'proper' thing.

I preface this book with an introductory account of this important point of poststructuralist theory for two reasons. The first is to provide readers with a taster – to give them a taste of the flavour of the kind of orientation they can expect in the following pages. The second is to offer an explanation of why the expectations of some readers may not be met by this kind of interdisciplinary work. It will hopefully show clearly that this work is an academic study of Bruce Lee rather than a biography, filmography, hagiography or history. It is not a general survey. The work focuses on some often unlikely aspects of the texts of Bruce Lee: his intervention in relation to thinking about cultural politics, pedagogy and emancipation, cultural translation, postmodern and postcolonial ethnicity, and even post-humanist approaches to this 'thing' or 'field' that bears the proper name of a human but that is not simply the name of a human.

Several people have directly helped me to complete this book. Firstly, the book would not have been written at all were it not for the wise counsel of my friend Claire Munro and the generosity of Yoram Allon, Commissioning Editor at Wallflower Press. The School of Journalism, Media and Cultural Studies at Cardiff University has provided me with an exceptionally healthy, heartening and conducive working environment. And thanks to the wonders of the internet and specifically the cultstud-l email discussion list, I was given, first, the wonderful screen grabs from *Toy Story III* of Mrs Potato Head wielding *nunchakus*, from Steve Jones, and second, generous advice about Cantonese to English translations from several people, including Fan Yang. Others who helped with important linguistic and filmic facts were Keiko Nitta, Ye Weihua and Vanessa Wingman Chan. Thanks are also due to Colette Balmain and Spencer Murphy who invited me to Coventry University several times, to engage with subjects that I may not have otherwise tackled but that have directly enriched this book. In addition to these people, I also owe thanks and gratitude to many people with whom I have discussed diverse matters relating to Bruce Lee, film and martial arts that have fed into this book, and whose knowledge or approach has inspired me, including, primarily but not exclusively, Rey Chow, Leon Hunt, Gina Marchetti, Meaghan Morris, Jane Park, Richard Stamp, my martial arts instructor Graham Barlow and my 'Hong Kong connection' and classical Chinese martial arts expert Phil Duffy. But, as always, in the first and last analysis, none of this would ever have been possible were it not for Alice.

BEYOND BRUCE LEE

KUNG FU CONNECTIONS

To make sense of Bruce Lee we need to look beyond Bruce Lee. We need to look beyond the individual, the figure, the films and the other texts, and into the historical contexts of the emergence and influence of these different elements. In this sense, the 'beyond' of my title aims to refer both to the *before* as much as to the *after* of Bruce Lee, to what feeds into and what comes out of the emergence, the moment, the event, or intervention of Bruce Lee. It also signals that we will be concerned with more than just Bruce Lee fandom or the analysis of Bruce Lee in isolation, and that we will be connecting such discussions and analyses with other realms – film, philosophy, popular culture and cultural politics, in terms of questions of cultural translation, communication, practices and encounters.

Of course, what is most known about Bruce Lee is undoubtedly his films. More specifically, it is the cinematic representation of kung fu as it appears within his films. These representations have had a massive and ongoing impact upon what was 'known' (or rather, believed) about kung fu and Oriental martial arts across the world. While working on this text, the Disney Pixar animation *Toy Story III* (2010) was released in the UK, the opening scene of which features Mrs Potato Head twirling a set of nunchakus, the martial arts weapon first popularised by Bruce Lee, and screaming in what is nowadays taken to be the martial arts

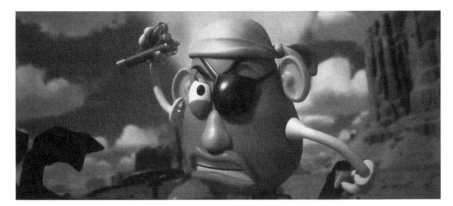

Figure 1: Mrs Potato Head, opening scene of *Toy Story III*

manner. This manner of making catcalls and elongated screams whilst fighting was effectively nonexistent before Bruce Lee incorporated it as a novel idea in his second adult film, *Fist of Fury* (1972). Few, if any, serious martial arts actors or performers (and certainly far fewer martial arts practitioners) have followed Bruce Lee's lead in using this device. And yet it remains *the* hallmark, *the* metonymic device, *the* shorthand, signature and symbol of and for martial arts. If Bruce Lee has apparently receded from view, his influence has not.

So let us first explore some key dimensions of the cinematic contexts that have a bearing on the dissemination of 'knowledge' about Bruce Lee and his influence. This will not be a comprehensive martial arts film history. There are already some excellent such histories (see for example Hunt 2003; Teo 2009). A brief consideration of cinematic contexts will be, rather, a way of opening and connecting Bruce Lee film to other cultural contexts. For instance, the cinematic element

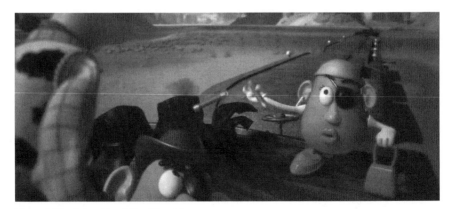

Figure 2: Mrs Potato Head, *Toy Story III*

cannot be disentangled from wider technological and economic processes of globalisation. As such, cinematic developments should not be disentangled from developments in other discourses and practices, including global trade, various nationalisms and practices of martial arts. So, rather than dwelling solely in and on film, this book seeks to attempt to reconnect approaches to understanding Bruce Lee with historical, cultural and economic contexts and processes, as well as emphasising the ways that Bruce Lee can be taken to illustrate some far wider theoretical, ethical and conceptual problematics.

CONTEXTUALISING BRUCE LEE

If we were to pick a date, and to treat that as 'the beginning' in a consideration of the conditions enabling the emergence of Bruce Lee, 1966 would be a good candidate. That was when Mao Zedong announced what came to be universally referred to as the Cultural Revolution, of course. That same year, the Hong Kong film industry set itself the task of breaking the Western market within five years. This goal was achieved with the Shaw Brothers film *King Boxer/Tianxia Diyi Quan* slightly belatedly in 1972. However, along the way, 'between 1971 and 1973, approximately three hundred kung fu films were made for the international market, some of them never released in Hong Kong itself' (Hunt 2003: 3). This, of course, is the story of a major *marketing* campaign, first and foremost. But its cultural effects were immense and continue to be felt.

This may seem to be hyperbole; yet consider this. In 1966, in the West, Bruce Lee was trying to make a name for himself in Hollywood. He succeeded in gaining a supporting role in the TV series *The Green Hornet* (1966–67) plus guest appearances on several other TV shows. His screen presence and physical grace, impact and abilities were widely recognised, and many Hollywood stars, writers and producers clamoured for private kung fu tuition from him. He also gained work as a fight choreographer on several films. But the Hollywood industry itself was entirely resistant to the idea of an Asian leading actor. This is reputedly why David Carradine was given the role of the wandering Shaolin Monk Kwai-Chang Caine in the TV series *Kung Fu* (1972–75), even though Bruce Lee auditioned for the role and even though Carradine was neither a martial artist nor ethnic Chinese, but a white non-martial artist (Chuck Norris once reputedly said, 'he is about as good a martial artist as I am an actor'! (*Telegraph* 2009)).

However, in breaking the American market, the Hong Kong kung fu film industry also opened the floodgates for what became something of an immense Western popular cultural transformation. Keen to cash in on the increasing success

Figure 3: The white David Carradine Orientalised for the role of the half-Chinese character Caine in *Kung Fu*

of Hong Kong kung fu films – Bruce Lee's in particular – Hollywood eventually ventured into what the original movie posters called 'the first American produced martial arts spectacular', *Enter the Dragon* (1973). This US and Hong Kong co-production had significant box office success, and – more importantly – arguably almost single-handedly revolutionised the American perception of the Chinese. Furthermore, as has been widely acknowledged by cultural critics, Bruce Lee's

heroic persona regenerated a sense of pride for ethnic Chinese everywhere. At the very least, after Bruce Lee, Asians in the West were no longer automatically represented through entirely negative stereotypes. Of course, what Bruce Lee offered was also a stereotype. But, as stereotypes go, being tarred with the image of the invincible, disciplined, ethical hero who champions China and fights for justice is perhaps not too bad a deal.

Of course, the growing Western interest in all things Oriental around this time did not begin or end with martial arts film. Rather, as Alan Watts (1957) suggested, such an interest was already emerging as one of the few positive consequences of World War II. Similarly, the Western countercultural movements, fuelled by frustration with Western traditions and institutions, combined with anti-Vietnam War sentiments to produce a massive interest in Asian culture and philosophy as an 'alternative'. This notion of Asia as 'the alternative' has led to many clichés – the meditating, yin-yang-necklace-wearing, peace-loving hippy being perhaps the main one. But Bruce Lee, entering at the height of the popularity of the counterculture in Western popular culture, offered something more: a complete transformation in the image of the male hero. No longer dependent on a gun or a car or the messy brawling or any of the trappings of John Wayne or Clint Eastwood, Bruce Lee offered an image of perfectly self-reliant grace, and turned the heads, hearts and minds of millions of Westerners eastwards. The martial arts explosion, the 'kung fu craze', and a massive new wave of Westerners exploring Eastern philosophy and culture commenced.

In *Bruce Lee and Me: A Martial Arts Adventure* (2007), Brian Preston interprets Tarantino's two *Kill Bill* films as amounting to Bruce Lee finally getting a kind of symbolic revenge on Carradine. In these films, Uma Thurman plays a character who rides a motorbike to the theme music from *The Green Hornet*, wearing an updated version of the yellow outfit Bruce Lee wore in his unfinished *Game of Death* (1973/1978). She seeks to exact revenge on 'Bill', who is played by David Carradine, and – just to make sure we get the references – Bill even plays the long wooden flute his character carried in *Kung Fu*. But Preston also notes that 'in the choreography of *Kill Bill* we can also see the triumph of Bruce Lee in a wider sense. It's a triumph owed to Bruce Lee', he asserts: 'the triumph of Asian sensibilities in world culture, specifically in the world's number one universally appreciated art form, the action movie' (2007: 75).

Both Preston and Davis Miller (2000) list many major recent films (*Kill Bill: Vol. 1* (2003), *Kill Bill: Vol. 2* (2004), *The Matrix* (1999), *The Matrix Reloaded* (2003), *The Matrix Revolutions* (2003), *Crouching Tiger, Hidden Dragon* (2000) and *Unleashed/ Danny the Dog* (2005)) and point out that what all of these films have in common is the fact that they were all choreographed by Hong Kong-based Yuen Wo-Ping;

the man who also choreographed the films that made Jackie Chan into a star, *Drunken Master* and *Snake in the Eagle's Shadow* (both 1978). Added to this is an important point, made by George Tan:

> Almost all stunt co-ordinators who came after Bruce [Lee] were influenced. Any movie or TV show with fights in it – *Raiders of the Lost Ark*, *Star Wars*, *Buffy the Vampire Slayer*, animated fights in *The Lion King* – it doesn't matter what. If you know what you're looking at, you'll catch camera angles and martial arts techniques from Bruce's scenes, stuff Bruce invented. He contributed so much to the industry that has never been recognized. (Quoted in Miller 2000: 156)

To this we might add many other films, such as the *Bourne* trilogy (2002, 2004, 2007) (choreographed by Jeff Imada, whose connections with Bruce Lee will be discussed further in chapter seven) and indeed the entire global phenomenon of 'mixed martial arts'.

The important point to note here is that all of this filmic transformation is not just a contribution to an *industry*. It is also a massive contribution to popular *culture*, and not just in the West. For instance, one might ask: without Bruce Lee and kung fu films generally, would the Shaolin Temple have reopened as a popular tourist destination in China? It seems unlikely. Before Bruce Lee and the Hong Kong films of the 1970s, the Shaolin Temple was scarcely known outside of the most obscure circles. Its myth had been largely created in two books: a popular novel called *Travels of Lao Can*, written between 1904 and 1907, and an anonymous and apocryphal book written around 1915 called *Secrets of Shaolin Temple Boxing* – a spurious training manual that had instantly been debunked by the respected martial arts historians Tang Hao and Xu Je Dong, but whose appeal nevertheless caught on. Now, thanks to kung fu films, the myth of the Shaolin Temple is firmly enthroned in global consciousness, and with it comes an abiding fascination with Chinese culture, history, beliefs and practices – an interest which has markedly transformed global popular culture.

As such, it is possible to see that the popularity of Bruce Lee and of martial arts *per se* are both clearly inextricably linked with the processes and effects of internationalisation or globalisation of and within cinema. Furthermore, such cinematic globalisation clearly has effects on other realms and contexts – social, cultural, economic. Unfortunately, however, terms like 'globalisation' are complex and open to a variety of different understandings. In this respect, they are similar to the term 'martial arts' itself, which (despite its familiarity) is actually very slippery, complex and difficult to define. Stephen Chan illustrates this by pointing out that a study on the martial arts of the world commissioned by UNESCO with

which he was involved had to be disbanded before it even began because its team of researchers and authors could not agree on a working definition or organising concept of 'martial art' (2000: 69). Similarly, 'globalisation' can be understood in many different (often antithetical) ways, and whilst many of these perspectives are justified in one way or another, a coherent consensus about what globalisation is still cannot be reached. However, some of the salient preconditions for and coordinates of globalisation include: the expansion of increasingly instantaneous telecommunication networks; the opening of ever more contexts to market mechanisms owing to the internationalisation of finance systems; and the deregulation of those finance systems, the effect of which has been to undermine the traditional power of nation-states to control their own economies and societies. 'Commodities', including films, of course, 'flow' across borders and around the world.

Indeed, the deregulation of global finance markets since the 1970s had the effect of outflanking any government's ability to be able to intervene significantly into its own economy, because attempting to do so by monetary or fiscal policy or legislation – say, by raising taxation or minimum wages beyond a level deemed acceptable (or efficient) to capital – simply results in capital investment being moved to more 'favourable' markets. Certain thinkers have described globalisation's radical transformation of global power relations through this analogy: formerly, nation-states could be compared to receptacles *containing* water (and having the ability to control its flow through fixed conduits to other nation-state contexts). However, globalisation turns the tables on nation-states, so that they find themselves emptied of 'water', and instead find that they now are now receptacles floating in water, bobbing about, sinking or swimming, on the ebbs and flows of the seas of finance (see Castells 2000). Along with the impact of these processes on many aspects of culture and society the world over, the new context of forces and relations attendant to globalisation have had an ineluctable impact on the forms, practices, institutions, orientations and indeed the very definitions of martial arts. The cinematic and media impact of Bruce Lee can be regarded as a very significant moment here.

In this context, the most relevant aspect of – or way to approach – 'globalisation' is in terms of the internationalisation of media. The development of global media is particularly relevant because, historically, the spread of martial arts could formerly be strongly correlated with *military*, *margins* and *migration*. The effects of media have exponentially increased martial arts' dissemination. Bruce Lee rode the crest of the first wave of this mediation. That is to say, if, historically, martial arts have developed around zones and sites of conflict and antagonism, and their spread or dissemination was linked to the cultural and social diasporas that

spread out from these historical sites, since the 1970s, the availability of media and multimedia images, representations, accounts and even manuals has taken control of the ability of martial arts styles to spread and transform. Television, film, media and multimedia have increasingly freed knowledge or awareness of martial arts styles from specific cultural contexts. Hence, martial arts have become increasingly *deracinated* and *commodified*. 'Traditional' martial arts have been uprooted from their historical locations; new hybrid forms have emerged; and the places, roles and functions of martial arts in different social situations have changed considerably.

For instance, former traditional military and self-defence forms have become increasingly sport and fitness orientated. The development by Billy Blanks of 'tae-bo' is a good case in point: tae-bo has taken moves from Western boxing, Muay Thai and taekwondo, combined them together with music, and become a new form of aerobics. As such, martial arts are hybridised (grafted together), deracinated (severed from their roots and traditions), commodified (tae-bo was from the outset mass marketed through globalised media and finance networks), and reconfigured: the clear lines of demarcation between aerobic exercise and combat training are utterly blurred. Deracination and commodification, then, are now arguably the dominant forces acting on martial arts. This can even be seen in the case of putatively ancient and authentic practices and locations, such as the Shaolin kung fu of the Shaolin Temple in Hunan Province in China. The reopening of this temple by the Chinese government in the 1980s was effectively no different from the opening of a theme park or gift shop: a novel or niche demand (a market) was perceived; a supply was provided. An entrepreneurial government capitalised on (movie-mediated) fantasies about the 'authenticity' and austere, mystical, almost magical 'ancient history' of such locations and practices, and exploited it as a marketing opportunity. The Shaolin Monk character played by Bruce Lee in *Enter the Dragon* doubtless played no small role here.

Of course, this is only one aspect of the productivity and inventiveness of the connections between *mediatisation* (the increasing role of film and TV representations) and commodification that are part and parcel of globalisation. In the wake of the unprecedented global success of Bruce Lee's films (1971–73) and the *Kung Fu* TV series (1972–75) – which effectively introduced 'kung fu' to the Western popular culture consciousness – myriad 'kung fu' and 'karate' schools appeared out of the woodwork (see Inosanto 1980; Thompson 1993a: 19; Miller 2000). These often made various kinds of claim to 'authenticity' defined through some form of relation to an 'authentic' ethnic East Asian lineage. Over time, the perceived necessity of claiming a direct and authentic connection to Asia has diminished in many modern martial arts, but it has certainly not disappeared.

The desire for (and *tradability* of) 'authenticity' is tenacious, but the point is that there is arguably a strong difference between martial art development and dissemination in the cultural epochs and contexts of war, colonialism, imperialism (ie the internal and external peripheries or margins of cultures and societies), on the one hand, and, on the other, those developed in the context of martial arts films, magazines and businesses in the context of peacetime. What is called 'Westernisation' has always been bound up in both processes, but in rather different ways.

Historically, the major impetus to develop martial arts has arguably always been overwhelmingly related to cultural exigencies and necessities: defence, security, conquest, domination, survival, and so on (see Brown 1997; Kennedy and Guo 2005). Martial arts developed on the margins: margins of territory, of empire and colony; economic and cultural margins, sites of struggle and antagonism between the disenfranchised and the state, and a whole range of borders, whether political, geographical or cultural. Thus, there are the martial arts of the powerful and the martial arts of the relatively powerless; there are those of the military and security apparatus and those of the antagonists of power, whether by default (the enslaved, the poor, disenfranchised, occupied, or colonised and so on) or by design (guerrillas, paramilitaries and so on). There are martial arts that are extremely codified, whose roles and functions are predominantly ceremonial, often nationalistic, dynastic or even nostalgic. Then there are martial arts that are entirely pragmatic. And of course, there are martial arts which combine these and add yet other dimensions, too – such as health, philosophy or spirituality.

In addition, in the contemporary globalised world, there has been a proliferation of knowledge, information and discourse about martial arts themselves. Specifically, there has been an increase in knowledge about the myriad number of martial arts of the world. This has arguably transformed the nature of the 'borders' on which martial arts now develop. For, as opposed to martial arts developing on sites and lines of conflict and warfare (as they did in premodern and modern times), in the contemporary technology- and information-saturated context, innovation in martial arts – especially hand-to-hand combat – today takes place knowingly and self-consciously on the 'borders' between styles and approaches. This kind of development is self-reflexive and deliberately informed by research into different styles, rather than springing from the urgencies and exigencies of a particular conflict. Such innovation often takes place for sporting (cross-training) or for marketing reasons. It is a type of development that is therefore technically *postmodern*. Bruce Lee's 'Jeet Kune Do', which we will consider in more depth in due course, is a good example of this sort of 'interdisciplinary' and 'postmodern' martial art development.

There are strong reasons for the 'postmodern' proliferation of this type of martial art. On the one hand, military and paramilitary 'arts' are increasingly technologised, dehumanised and virtualised today, with the (literal and metaphorical) distances between combatants often expanding, such that lines between warfare and computer game-play are increasingly blurred (see Hables Gray 1997). Today conflict is more and more premised on digital, surveillance and technological action at a distance. Indeed, even non-military hand-to-hand or face-to-face conflicts increasingly involve firearms, sprays or 'tasers'. Unarmed or armed hand-to-hand conflict is becoming more of a minor supplement to martial arts, at least wherever the dominant technologies are high-powered guns. With guns entering ever more contexts, the necessity of skill in unarmed combat declines. It does not become obsolete, but its field of applicability becomes more circumscribed. Thus, wherever their practice survives, other elements, rather than the 'martial' are accentuated: health, sport, discipline, self-actualisation and fun become more significant in more contexts.

Historically, martial arts have overwhelmingly developed in contexts where a colonising power has been resisted. 'Classic' examples of this include the following: the development of karate-do in the ever-contested and ever-occupied area of the Ryukyu islands of Okinawa (see Funakoshi 1975; Krug 2001); the development of Filipino kali and eskrima in the Philippines; and the development of capoeira, first among slaves and then among the Brazilian underclass in Brazil (see Downey 2002). These arts have all been subsequently globalised in various ways, ways that are inextricably linked to the media. But their initial development was linked to the military, and their older forms of dissemination and spread were linked to migration. All of these factors and more combine in what is perhaps the most famous example of martial arts: karate. Although this, like other arts, was spread communally at first, by practitioners often associated with clan, military or paramilitary training, it first entered into a global circuit of representation and discourse with 'mythologised' media representations. That is, the world 'learned' of karate through amazing tales, fantastic legends, and entrancing fantasies, popularised first in travel literature and then in film and TV (Krug 2001: 398). These tales often reflected what are called 'Orientalist' fantasies (see Said 1978), and such fantasies perhaps spoke more about the daydreams (and prejudices) of Westerners, rather than relating simply to reality. Nevertheless, first travel literature and subsequently media representations – no matter how apocryphal – played a large role in promoting interest around the world. But the reason why it was karate and judo that first gained such global fame relates to the post-World War II military occupation of Japan by that military and cultural superpower, the United States of America. The fact that the cultural and martial experiences of

US military servicemen could come to infect and reorientate the imagination of Hollywood, and that this in turn could impact on the cultural literacy of the rest of the world (in terms of 'knowing about' karate, judo, ninjas and so on) indicates the global reach of American film and media.

According to Gary J. Krug, martial arts first appeared in cinema in films of the 1930s, and became much more common after the 1960s (2001: 399). The reason for this subsequent proliferation relates strongly to military and global geopolitical events and processes. The cinematic proliferation marks the advent of martial arts becoming in their own right a recently familiar form of knowledge in the West, as more and more American soldiers who had experienced karate and judo in Japan and Asia returned to the USA and opened dojos (2001: 401). However, Krug argues that what took hold in America was by and large sport-orientated. This was derived from the revised orientation of karate set in motion by Gichin Funakoshi, who had successfully institutionalised 'Okinawan' karate within Japanese culture, by having it accepted and taught in Japanese schools and universities (2001: 401–2). Indeed, the process of standardisation and insti-tutionalisation that Funakoshi initiated vis-à-vis karate-do is a model for the way martial arts have been institutionalised and disseminated more broadly.

This institutionalisation chiefly took the form of standardised uniforms, for-mal lesson structures, fixed syllabi and the coloured belt ranking system. This version of karate had also been sanitised, with lethal moves either removed or redefined as 'block' or 'punch'. It was this that American servicemen encoun-tered: an almost Fordist mass-production-line approach to martial arts, whose rhythmic, repetitive straight line drills and nuts and bolts approach were already akin to military basic training. Thus, what first emerged on a large scale in the United States, the United Kingdom, Australia, and in other Western cultures was substantially different from pre-Funakoshi Okinawan karate. Indeed, according to some commentators, the status of karate was effectively transformed in its entry first into Japanese social institutions and then into a larger, more Westernised global circuit. What was originally a local practice that was stitched through the fabric of Okinawan culture became disconnected and rewired very differently into a different set of social and cultural relations. Thus, karate in the West became connected with the discourses of sport, of health, and of various ideas (beliefs and fantasies) about Oriental mysticism and spiritualism.

The form of the integration of karate and other martial practices into Anglo-American culture was always going to be conditioned by the environment of its reception. The cultural textures of nineteenth-century Okinawa, early twentieth-century Japan and then mid-to-late twentieth-century America are all drastically different. As such, the 'karate' of these places and periods is very different in

each case. According to Krug, from the 1960s and 1970s and until the present day, martial arts have been increasingly stitched into a relationship not only with sport generally but also with bodybuilding in particular (2001: 402). The effects of the influence of discourses of sport and body image on the practices of martial arts are significant and noticeable. Bruce Lee, it should be noted, was a trailblazer in using 'Western' bodybuilding methods for martial arts training purposes. Lee was also instrumental in the development of what has become the expected physique of the archetypal (or stereotypical) muscled and striated martial artist: after Bruce Lee, the assumption has always been that a martial artist must look like an Olympic athlete (unless they are old, in which case they must look like a rotund Buddha or wiry Pei Mei).

Spectacular film representations of improbable and impossible feats of ath-leticism (cinematic wushu or 'wire fu') and ultra-athletic bodies feed these preconceptions and beliefs about martial arts. But, as well as the rapid growth in participation in the most spectacular of styles (such as taekwondo and capoeira) there have also been equally strong reactions away from spectacular and showy styles. Many commentators have noted the relatively new phenomenon of various versions of ultimate fighter and no-holds-barred Mixed Martial Arts competitions on television (normally on pay-per-view and subscription channels). This commodified and 'mediatised' development has had a pronounced impact on the character of many martial arts practices. Firstly, it has in many ways problematised the very idea of adhering to a martial art '*style*' at all. As Royce Gracie, the winner of many of the first televised Ultimate Fighting Competitions, once put it: 'At first it was style versus style, now it's athlete versus athlete, because everyone cross-trains… And now with time limits built into the fights, not always the best wins, sometimes it's just the most aggressive' (quoted in Preston 2007: 64). In other words, this trans-formation, from martial bouts being style against style to athlete against athlete, 'because everyone cross-trains', has an irreducible connection to the imposition of (Western) sportive and televisual conventions: rules, time-limits, and the banning of potentially lethal techniques and so on. In this way, a *mediatised form* becomes imposed upon such martial arts – ironically this is so even though the standardised, commodified media form claims to be 'authentic', 'real', 'no-holds-barred' or 'ulti-mate'. In other words, and despite appearances, it is possible to argue that a media form has silently, invisibly hegemonised the structure, orientation and appearance of such martial arts. 'Authenticity', that is, has its vicissitudes.

Traditionally, martial arts always required the presence of the authentic mas-ter, whether 'authentically' ethnically East Asian or, more recently, authentically ex-military. However, over time the internationalisation of martial arts has gradu-ally loosened the belief in the importance of an 'authentic' master as a guarantee

of a style's legitimacy. That is to say, for a long time throughout the twentieth century, authenticity and legitimacy were largely associated with ethnicity and masters were associated with migrant communities, ethnic lineages and geographical regions. But, over time, martial practices have been severed from former historical locations. Authenticity and direct lineage are often discarded as old yardsticks of legitimacy in favour of newer procedures of verification: trophies, titles, stringent examinations and other measures. Indeed, more recently, entire new martial systems have been devised and/or popularised around movie action choreography, with stuntmen replacing special forces veterans as innovators, and celebrities replacing 'authentic natives' or 'inheritors' as martial arts conduits.

Institutions have increasingly replaced or supplanted patrilineal structures. As such, 'standards', examinations, trophies, titles and other forms of verification and demonstration have replaced unconditional deference to a hierarchy. This is not to say that such hierarchies and codes of behaviour have vanished, but rather to say that martial arts are also ensnared in other networks of circulation. It is certainly still the case that many will wish for what they believe to be an 'authentic' or 'ancient' martial art, and so will seek out a traditional 'master'. But the point is that this choice is a consumption choice, and the status of the notion of being a master is now indelibly associated with branding and marketing, even when those involved do not want this to be the case (see Krug 2001: 403–4).

None of this should be taken to mean that the globalisation of martial arts is a process of levelling or homogenisation. Indeed, in some respects, perhaps the older notion of *internationalisation* is more useful than *globalisation*. Many things are international; few are ubiquitous. Vast differences in styles remain evident regionally, nationally and internationally. Indeed, these are much more visible now thanks to such technologies as the internet and such web resources as YouTube and other video file sharing platforms.

Globalisation does not simply mean the making ubiquitous of everything. It refers to the proliferation of communication technologies and networks, firstly, particularly within the context of the increasing deregulation of aspects of social and cultural life, with their transformation into markets. But this proliferation does not imply homogeneity. It also implies fragmentation – or indeed, as one cultural theorist has proposed to call it, '*globalkanization*' (Froment-Meurice 2001: 60). And these two forces certainly do seem to operate simultaneously, pulling in opposite directions: the spread or hegemony (dominance) of certain forms that become common as a result of their mass mediation in film, TV, the internet, at the same time as the fragmentation, splintering, and proliferation of diversity.

So, on the one hand, certain martial arts styles have become hegemonic and ubiquitous, for various reasons: first, judo and karate (owing to the American

occupation of Japan), then kung fu (largely thanks to Bruce Lee), then taekwondo (because of its relative similarity to the already-familiar shotokan karate but supplemented with even more spectacular kicks than karate or kung fu, something which both satisfied an enduring Western fantasy about the spectacular character of martial arts and which by the same token enabled taekwondo to become a recognisable 'point scoring' Olympic sport), and more recently, of course, capoeira (which is even more spectacular and novel than kung fu and taekwondo, plus it has an immediate subcultural and countercultural cachet because of its connections with slaves and outlaws in Brazil (see Downey 2002)), as well as the inevitable reactions away from such spectacular forms, in innovations like mixed martial arts, no-holds-barred martial arts, and so-called 'reality' martial arts in all of their various manifestations.

Globalisation leads to globalkanization in the sense of fragmentation, splitting and the production of difference. In other words, *hybrids* arise. Development takes the form of combinations and recombinations of often-unexpected elements, different styles from different societies and cultural traditions. Moreover, these hybrids do not remain confined within the circumscribable sphere of martial arts: martial arts shade into combat sports. Novelty in martial arts influences cinematographic choreography which feeds back into martial arts fashions and influences (such as the Keysi fighting system which was popularised in *Batman Begins*, 2005)). T'ai chi is combined with yoga and pilates. Thai boxing, boxing and taekwondo techniques are combined with music into aerobics ('tae-bo'). And so on.

Of course, all martial styles are arguably always demonstrably hybrid, multi-disciplinary and 'multicultural'. The Japanese characters for *karate-do* were changed by Gichin Funakoshi from those which meant 'China-hand' to those meaning 'empty-hand', for instance, for reasons that were essentially nationalistic (see Funakoshi 1975). Taekwondo is a combination of shotokan karate obfuscated with the names and values of older Korean (and vociferously non-Japanese) arts such as taekyon and tangsoodo; and so on. But the intensification and acceleration of the development of martial arts in the contemporary world is overwhelmingly related to the saturation of media and communication networks as well as franchises and marketing associated with globalisation. An index of this can be seen in the expansion of martial arts into contexts that far exceed the confines of martial arts contexts 'proper'. The baseline for all movie fight and action choreography has been utterly transformed by martial arts since Bruce Lee's Hollywood success with *Enter the Dragon* in 1973 – a transformation in film which itself has further knock-on effects in other cultural realms, practices and contexts. It is not just that many major recent films have been choreographed by Yuen Wo-Ping; it is also that virtually any movie or TV show with fights in it is indebted to martial

arts generally and Bruce Lee's trailblazing filmic success in particular (see Miller 2000; Preston 2007).

The filmic globalisation of the sort of spectacular choreography that is – no matter how putatively 'realist' – ultimately informed by the style of Hong Kong wushu (or wire-fu) is not merely a contribution to the film industry. It is also a massive contribution to popular culture, and not just in the West. As mentioned earlier, without the global success of kung fu films, it seems unlikely that the Shaolin Temple would have reopened as a popular tourist destination in the 1980s. Before the Hong Kong martial arts movies of the 1970s, the Shaolin Temple was scarcely known outside of the most obscure circles and myths about it had been largely created in apocryphal books (see Anon. 1971; Kennedy and Guo 2005: 70–1; Lui 2005). But now, thanks to kung fu films, it is firmly enthroned in global consciousness. With it came an enduring fascination with Chinese culture, history, beliefs and practices – an interest which arguably transformed global popular culture in the 1970s, in ways which continue to be felt and in transformations that are ongoing. Indeed, as we can see in this and other similar examples, the globalisation of martial arts has had effects not just on martial arts, but on many aspects of cultures and economies more widely. Into this context we can insert Bruce Lee's best known contribution to martial arts: the system, style or set of principles he devised, which he called 'Jeet Kune Do'.

BRUCE LEE'S MARTIAL ARTS

Jeet Kune Do is both a martial art and a set of principles that came into existence through Lee's critique of existing martial arts styles (as he saw them in the US context) and a process of interdisciplinary research, experimentation and innovation. Jeet Kune Do has been credited as a key precursor of, first, 'American' Freestyle Karate and, subsequently, of 'no-holds-barred', 'Ultimate Fighting' and 'Mixed Martial Arts'. There are a huge number of texts written about Jeet Kune Do. These are of widely (and indeed wildly) differing degrees of reliability, verifiability and accuracy. Reasonably reliable texts on the history, development, philosophy, training and fighting strategies of Jeet Kune Do include the books and articles written by Lee's first-generation students Dan Inosanto, Ted Wong and Taky Kimura. Unfortunately, other equally well-informed works, such as the many edited collections and books authored by John Little, tend to shade into hagiography and hero-worship. But we should be concerned primarily with the theory behind Jeet Kune Do. This is because the theory of how to develop pragmatically useful and efficient fight training was always Lee's avowed primary concern. For

Lee, the outward forms, practices and execution of Jeet Kune Do would differ from person to person and place to place, but what always mattered was the set of theoretical principles that one applied to the training and combat strategies.

The term 'Jeet Kune Do' first appears in Bruce Lee's notebooks in 1967 (see Little 1996: 96), but Lee's friend and student, Dan Inosanto, claims that the definite decision to use the term to refer to the style of martial arts that they were practicing came in 1968 (1980: 66). According to Inosanto, the idea for the name reputedly took its inspiration from European fencing's stop-hit technique, which Lee regarded as 'the highest and most economical of all the counters'. Lee regarded the stop-hit so highly because it accomplishes blocking, interception/ neutralisation (*jeet*) and attacking (*kune*) in one economical movement. According to Inosanto, a 'stop-hit is when you do not parry and then counter, it's all done in one step' (ibid.). Thus, in the face of an attack, the attack is intercepted not with a block, but with a block that is also a strike: the move is 'designed to score a hit in the midst of the attacker's action' (ibid.). According to Inosanto, Lee translated this 'stop' and 'hit' into the Chinese martial terms *jeet* and *kune* and added the conventional or obligatory (Japanese-sounding) suffix -*do* to refer to martial art way or style (when spoken, '*do*' follows the Japanese sound, as opposed to the Chinese *dào* or *dou*). Thus, the literal meaning of Jeet Kune Do is 'stop-hit-way' or 'intercept/interrupt-hit-way' (ibid.).

Before this baptism (that is, taking the name of an idealised technique to designate both the principle and the name of the 'art' – which might be better termed 'research programme'), Lee had practiced and taught a bricolage of techniques that he called Jun Fan Gung Fu. Jun Fan was not derived from or founded on any one complete system; instead, it took the form of techniques appropriated from a wide range of styles. Inosanto lists Northern Praying Mantis, Southern Praying Mantis, Choy Li Fut, Eagle Claw, Hung Gar, Thai boxing, Western boxing, freestyle wrestling, judo, jujutsu, along with 'several Northern Gung-Fu styles' as sources for Jun Fan Gung Fu. Yet, Inosanto admits, it is 'obvious' that Wing Chun was the 'nucleus' and that the other methods evolved around this core (1980: 67).

Jun Fan and then Jeet Kune Do took from Wing Chun such principles as the centreline theory, the privileging of direct linear attacking, simultaneous attack and defense, vertical punches, forward pressure and 'sticking hands' (Cantonese *chi sau*, Pinyin *chishou*) sensitivity training. However, Lee modified Wing Chun postures and movements (which are often compact and close range) in light of his aim of establishing complete fluidity and economy of movement and motion at any range. To this end, Lee experimented with principles, stances and footwork from European fencing – in which the practitioner literally puts their best foot (and hand) forwards – in conjunction with those of Western boxing. Thus, Lee would

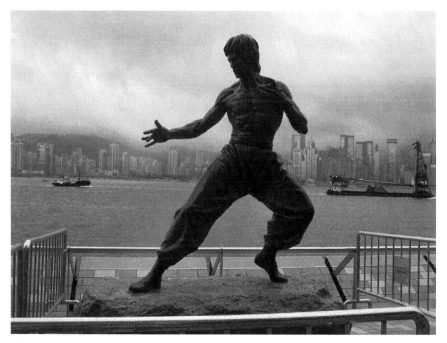

Figure 4: Bruce Lee 'jeet kune do stance' Statue on Avenue of the Stars, Kowloon Waterfront, Hong Kong

come to propose that the lead (jabbing) hand of a right-handed fighter should not be the left hand (as it would be in traditional boxing), but rather it should be the strongest weapon: the right hand. In other words, the right-handed fighter should hold the right hand forward, so that the lead jab – or, more precisely, the straight right – could realistically aspire to be a knockout punch. Similarly, Lee's dissatisfaction with the idea that any fighting sequence should take more than one move to complete caused him to develop a stance from which any kick could be delivered by the front leg without any preparatory stance adjustment. Hence, the characteristic Bruce Lee stance since immortalised in countless images, including the statue on the Avenue of Stars in Hong Kong: most of his weight is in the rear supporting leg, its heel slightly raised, the front leg is ready to deliver any kick; the rear hand is primarily in a defensive position, held high and relatively close to the face and head, while the lead hand is loose and low, and ready to flick out a wide range of potential strikes – most characteristically a direct finger jab to the eyes.

If Jeet Kune Do came to have this definitive stance and a characteristic 'look', then we encounter a paradox, namely Lee's frequently repeated claim to have 'no-style'. For if, in implementing a dynamic principle rather than a fixed form, a

characteristic set of postures, movements and responses is developed, is this not in fact the institution of a style – the very thing that Lee regarded as limited and limiting, and sought to critique and dispense with or indeed 'transcend' (Lee 1971: 24)? Indeed, Lee was adamant that he had 'not invented a "new style", composite, modified or otherwise that is set within distinct form as apart from "this" method or "that" method. On the contrary, I hope to free my followers from clinging to styles, patterns or molds' (ibid.).

In later years, Inosanto notes, Lee 'became sorry that he ever coined the term Jeet Kune Do because he felt that it, too, was limiting, and according to Bruce, "There is no such thing as a style if you totally understand the roots of combat"' (1980: 66–7). Inosanto, who Lee certified as the most senior instructor of Jeet Kune Do, goes on to handle the paradox by adding to the term Jeet Kune Do a supplementary suffix: the word 'concept'. Hence, Inosanto almost always says or writes 'Jeet Kune Do concept'. His point is that, in contradistinction to the names of martial arts styles – with their fixed syllabi of traditional forms, patterns or kata and so on – the term Jeet Kune Do was initially intended to refer to a guiding principle, rather than a fixed form. In taking this stance of maintaining fidelity to the concept but allowing the appearance and syllabus to develop, Inosanto (along with Richard Bustillo and Larry Hartsell) differs from other students of Bruce Lee (such as Taky Kimura, James Lee, Jerry Poteet and Ted Wong), who all tried instead to preserve the 'original form' of Jeet Kune Do. Thus, 'Jeet Kune Do concept' practitioners proceed in a spirit of innovation while 'original form' practitioners stick to doing things the way Bruce Lee did them.

In any interpretation, what Bruce Lee popularised was something like the 'scientific' or pragmatic search for efficiency in martial arts. His procedure involved exposing an existing form to the scrutiny of a guiding idea – in other words, questioning the current institutional form of a martial art by way of the ideals implied by the guiding idea of efficiency and effectiveness. This 'science' involved a four-step methodology: '1. Research your own experience; 2. Absorb what is useful; 3. Reject what is useless; 4. Add what is specifically your own' (Lee, quoted in Bolelli 2003: 175). Lee's rhetoric sounds very slick. Yet these words – like several other of Lee's 'striking thoughts' and 'wise words' – merely repeat aphorisms attributed to Chinese leader Mao Zedong (1893–1976). Indeed, even when Lee is not directly reiterating one or another of Mao's formulations, he often sounds very close. Consider, for instance: 'There are two different attitudes toward learning from others. One is the dogmatic attitude of transplanting everything, whether or not it is suited to our conditions. This is no good. The other attitude is to use our heads and learn those things that suit our conditions, that is, to absorb whatever experience is useful to us' (Mao 1957: 75). It is unfortunate that, since his death,

Lee's name has become attached to the wholesale and indiscriminate posthumous publication of selections from his notebooks, college essays, journals and jotters, and that these often include many unattributed but readily traceable quotations from other thinkers. For all of this ultimately makes Bruce Lee seem to be a barefaced plagiarist. But it is not as if he himself made the decision to publish 'his' words in that form, after he died. The packaging of 'Bruce Lee Wisdom' is something that happened after his death (see Bishop 2004).

One 'pragmatico-theoretical' question arising is whether it really is possible to know with certainty what might be useful and what might be useless in a martial art system without having studied that system for enough time to have mastered it and hence be qualified to judge its usefulness. Indeed, the esteemed martial arts researcher and writer Robert W. Smith suggested that it was precisely because Bruce Lee did not have enough experience in any one martial art (Lee never completed any formal syllabus nor officially mastered any system in any martial art) that he could even think that existing martial arts styles needed to be significantly improved or even eradicated (1999: 346). To put all of this slightly differently: how could one know in advance what will be needed to survive a fight or win a contest, and what will not? As Lee put it, 'Research your own experience'. But is your experience necessarily enough?

It is clear, then, that aspects of Jeet Kune Do are controversial. Such characteristics of Jeet Kune Do include: its critique of styles and its championing of pragmatic experimentation; the fact that this critique came from someone who had no recognised or recognisable qualifications and hence 'authority'; and – overall, perhaps – the fact that it became well-known solely because its originator was, first, a Hollywood fight choreographer and, subsequently, a world famous movie star.

Nonetheless, there is something uniquely interesting – indeed exemplary and instructive – about Jeet Kune Do. First, it developed during an epoch of great upheaval: in 1968, the critique of established institutions was proliferating in many realms, and the advocacy of interdisciplinary approaches was growing in any number of fields and contexts. As such, Jeet Kune Do might be regarded as a trailblazing part of a wider cultural transformation that later came to be called 'postmodern'. Thus, in part, Jeet Kune Do remains controversial simply because it exemplifies many of the cutting-edge transformations, debates and issues in modern martial arts, such as controversies about the place and role of tradition, the place of innovation vis-à-vis established forms, how to verify effectiveness or reality, and the reasons why one does what one does.

Jeet Kune Do is also controversial because its success is so directly related to celebrity. Because of the massive success of Lee's films, coupled with the

cultural capital (and kudos) of the countercultural 'radical chic' attached to all things 'Oriental' and anti-institutional in late 1960s and early 1970s Hollywood, Bruce Lee was instrumental in the popularisation of Asian martial arts, both in the West and in Asia. The impact of Lee's films on the global awareness of East Asian martial arts cannot be overstated. It is as a function of this celebrity that Jeet Kune Do itself came to be mythologised and popularised as an innovative, revolutionary or superlative 'Westernised' (yet still supposedly 'Oriental') martial art. Indeed, the rhetoric associated with Jeet Kune Do proceeds in two directions at once. On the one hand, Bruce Lee used broadly Taoist ideas (about flow, flexibility, spontaneous nature, vitality and so on), while on the other hand insisting upon the need for scientific research, rationality and logic in one's training. These two approaches became synthesised into a deliberate anti-institutional pragmatism.

In other words, whether justified or not, Lee translated into the martial arts some putatively 'Oriental' (but arguably deeply Westernised) countercultural ideas about the stultifying effects of the institution on the individual. Bolelli calls Jeet Kune Do the 'archetypal martial art of the 1960s' (2003: 181). And it is true that one can discern a very 1960s (vitalist, individualist, humanist) philosophy or ideology in Lee's belief in the possibility of a 'return' (paradoxically via pragmatic 'scientific method') to a kind of spontaneous state of nature, somehow unfettered or unconstrained by culture's 'arbitrary' conventions (see Lee 1971; Lee 1975). Despite the significant cultural limitations of this utopian individualist idealism, 'what this translated to in practical terms', argues Bolelli, 'was a radical departure from the methodology normally used by martial arts schools' (2003: 171). For, 'rather than following the standard curriculum of an established style, Lee began advocating a form of cross-training aimed at picking the best from different martial arts styles' (ibid.). Inevitably, then, 'Lee moved away from the Wing Chun style that he had learned in Hong Kong from Yip Man and established his own "non-style" of Jeet Kune Do' (2003: 171–2). Nonetheless, the principles which guided the decision-making and selection processes of identifying and 'picking the best' arguably remained firmly rooted in the paradigm of Wing Chun (or Lee's understanding thereof). The 'move away' from the Wing Chun appearance was governed by interdisciplinary cross-training that was (consciously or otherwise) driven by Lee's understandings of the Wing Chun principles of efficiency and economy of motion.

If the guiding principle is indeed 'jeet', then this was not in itself new or unique, even if the way Lee tried to implement it was. As a concept, 'jeet' is explicitly found in existing Chinese martial arts such as hsingi. And, as Inosanto's account of the decision to call their style 'Jeet Kune Do' makes plain, jeet can

also be seen in aspects of other combat or contact sports, such as fencing. But jeet need not necessarily be actualised in the same way as a fencing-like stop-hit. Jeet can also take the form of an interruption of the other's rhythm that is not premised on intercepting or parrying their attack.

The aim of being able to respond instantaneously and decisively to an attack from any angle is regarded by some as profound and somehow revolutionary (see Little 1996). However, others have called this original principle naïve (see, for example, Miller 2000), because such an aim presumes the opponent will not be able to anticipate or interrupt your stop-hit or that your own direct linear attack will not be – no matter how fast – equally predictable and hence subject to counter by the opponent's stop-hit. Indeed, the search for an ideal technique or superlative principle might be counter-posed with the proposition that when it comes to styles, tactics and strategies, martial arts are ultimately rather like the game of scissors/paper/stone: one may take the other by surprise, but there will always be something that trumps your manner of attack or defence, especially if the opponent learns to predict what kind of thing is likely to be coming.

Thus, the problem with Bruce Lee's proposition that 'there is no such thing as a style if you totally understand the roots of combat' is that no one totally understands the roots of combat. There *are* such things as styles and they *have* been used in combat. There are also luck, chance, contingency and personal preferences. Consequently, the question of what a non-style should, will or 'must' look like or how a principle should be actualised is a difficult one to answer.

Lee also referred to Jeet Kune Do as broken rhythm and – perhaps surprisingly – translated this idea into one about free-flow. The most famous illustration of Lee's ideal of broken rhythm is reputedly seen in *Way of the Dragon* (also known as *Return of the Dragon*, 1972), during Lee's fight with Chuck Norris in the Coliseum in Rome. In this fight, Lee is at first formal and predictable; hence his equally formal opponent (the karateka 'Colt', played by Norris) is able to fare well against him. Upon realising this limitation, Lee's character switches to a more anarchic, fluid and unpredictable style, one which Miller argues was heavily indebted to Lee's attempts to emulate the movements of boxer Muhammad Ali (2000: 105). Lee's new style then breaks through his opponent's formal movements and rhythms, and Lee emerges victorious. This scene is widely held to constitute a Jeet Kune Do lesson which illustrates the need to 'be like water' and to use 'broken rhythm'. Yet, as Meaghan Morris points out, the dramatic logic of this scene is also that of the common movie cliché: flexibility and adaptability overcome rigidity and fixity (2001: 170).

A more literal illustration of broken rhythm is shown in the fight footage for *Game of Death*, a film that remained incomplete and unfinished at the time of

Lee's death. In this footage, Lee plays an unorthodox and unconventional martial artist. His lack of orthodoxy is signalled by his wearing a bright yellow tracksuit rather than anything that might associate him with any recognisable martial arts style. At one stage he faces an opponent (played by Dan Inosanto) who is dressed as and performing according to the conventions of Filipino kali/eskrima. Thus, Inosanto ceremonially beats out traditional rhythms with his eskrima sticks. In response, Lee confidently brandishes a length of flexible bamboo and tells his opponent that his fixed forms will be no use against his own broken rhythm. Lee proceeds to break through his opponent's predictable patterns and rhythms by delivering quick, unpredictable whipping and stinging blows. With this 'lesson', Lee believed he was demonstrating a superior martial principle – a 'free-flowing' vitality (and vitalism) that he was convinced was lacking in existing martial arts styles.

THE BRUCE LEE EFFECT: LEE'S SEMIOTIC ECONOMY OF STILLNESS AND MOVEMENT

Whatever the status of the martial arts 'represented' or simulated in Bruce Lee films, the impact that they had on audiences is well documented. Lee's films certainly thrilled, captivated, enthralled and excited audiences, who would often carry that excitement out of the movie theatre and into the streets, trying to emulate the moves and cat-calls of Bruce Lee. One of the most powerful yet concise accounts of this 'Bruce Lee Effect' is given by Davis Miller. In his autobiography – an autobiography that is equally a biography of Bruce Lee – Miller recounts his first experience of seeing Lee:

> The picture that night was *Enter the Dragon*. The house lights dimmed, flickered, went out. The red Warner Brothers logo flashed.
>
> And there he stood.
>
> There was a silence around him. The air crackled as the camera moved towards him and he grew in the centre of the screen, luminous.
>
> This man. My man. The Dragon.
>
> One minute into the movie, Bruce Lee threw his first punch. With it, a power came rolling up from Lee's belly, affecting itself in blistering waves not only upon his onscreen opponent, but on the cinema audience.
>
> A wind blew through me. My hands shook; I quivered electrically from head to toe. And then Bruce Lee launched the first real kick I had ever seen. My jaw fell open like the business end of a refuse lorry. This man could fly. Not like Superman – better – his hands and his feet flew whistling through the sky. Yes, better: this

wasn't simply a movie, a shadow-box fantasy; there was a seed of reality in Lee's
every movement. Yet the experience of watching him felt just like a dream.
 Bruce Lee was unlike anyone I (or any of us) had seen. (2000: 4)

Miller eloquently conveys an experience – *his* experience – singular, intimate,
personal. But it is also an experience that has been shared by innumerable people
in many different situations, all alone, all sharing something in common. We can
see this same process, this same experience, in many accounts, in the most
diverse places: all over popular culture; in many forms of literature from many
countries; and even in all sorts of academic work. All of these accounts describe
this same thing: once, I was one way; then I saw Bruce Lee; and that was the
day everything changed.

 One of the strong interests within the book you are currently reading is the
nature of this change: how it works, who is changed, why certain people are
touched (whilst others remain unmoved). There are lots of ways to enter into this.
But at this point I would propose to introduce it in terms of what might be called a
historicisable restricted economy of motion. I use the term 'restricted economy'
in a sense informed by Derrida. What I mean by this is that in order to account
for the appeal of Bruce Lee I want to do so by focusing on a *deliberately limited*
number of factors – one binary and one supplement – in full knowledge of the
limiting bias of this gesture. One binary and one supplement is very limited, given
the general field of textuality or discursivity – or, in other words, all of the other
things I could possibly have focused on as well or instead, which would surely
transform the nature of the discussion. But it is also enabling: it enables us to
see in a clear way the nature of the effect. Furthermore, my choice of this limited
economy of motion can be justified by historicisation. Many have proposed that
the reasons for the immense global impact of Bruce Lee make sense only when
historicised. The moment of the entrance of Bruce Lee (basically, 1972–73) can
be drawn as a historical conjuncture characterised as overwhelmingly organised
by two interrelated forces. The first is America's grieving attempts to come to
terms with the traumas of Vietnam (see Brown 1997: 24–48). In Hollywood film,
China, Okinawa, Japan, Korea and the 'yellow' East in general are often used as
codes for 'Vietnam' throughout the 1970s, 1980s and even into the 1990s (see
Nitta 2010). The second is the familiarisation and normalisation – the hegemonic
incorporation or appropriation; the wholesale commodification and domestica-
tion – of countercultural motifs (the exotic, the other) that had characterised
1960s radicalism. This expansion and normalisation is indexed by the installation
of these motifs right at the heart of mainstream popular culture. There is perhaps
no better example of this than Bruce Lee's global box office hit, *Enter the Dragon*,

which – it is always important to remember – the movie posters proudly declared to be 'the first American produced martial arts spectacular'.

The key point here is this: in the context of that particular historical conjuncture, something in the 'logic' of the spectrum or range of Bruce Lee's *movement* enabled (or precipitated) a profound transformation in Western discourses and in Western bodies. Specifically, this boils down to the fundamental binary of movement/stillness, stillness/movement that constitutes Bruce Lee's 'range'. This is so even though the semiotic effects (or affects) of this restricted economy vary across his films. In his early Hong Kong-produced *Fist of Fury*, for instance, Lee's stillness is always the stillness of the brooding, seething, barely controlled rage of the colonised subject in the face of horrific injustice inflicted on the Chinese community by the Japanese colonisers of the Shanghai International Settlement. By the time of his final film, the incomplete and posthumously cobbled-together film *Game of Death*, Lee's stillness has become the cocky nonchalance of someone who is supposedly self-consciously, 'postmodernly' 'free' of all allegedly 'limiting' 'cultural' and institutional 'constraints'. But in *Enter the Dragon* – his most global and 'American produced' film – it is a movement from esoteric disciplined calm to superlative physical violence back to supreme meditative calm that is reiterated

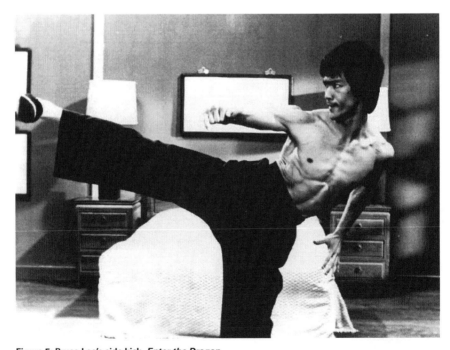

Figure 5: Bruce Lee's side kick, *Enter the Dragon*

regularly. Repeatedly, Bruce Lee fights, wins, stops; is utterly calm. He bests hordes of opponents; then sits down in the lotus position. He kills a man, waits; walks away. Amidst the mayhem of a mass battle, he sees his enemy, stops, ignores all else, walks towards him.

In terms of the binary of stillness and movement, it is the stillnesses – punctuated by very small gestures – that are semiotically 'full'. In other words, without the stillness, refracted through tiny gestures, the famous fight choreography 'means' very little – almost nothing. Yet, what is most known of Lee, what most remains familiar and known, is the fighting and pre-fighting movements: the fast furious kicks, the courting-cat-calls, the thumbing of the nose, the settling into the signature stances, front-hand forward, rear-hand held like he's holding a telephone, close to his face, and so on. These are what most remain. But, as we will see more fully in a later chapter, these gestures have become over time rather more like punctuation marks abstracted from the speech they once punctuated; in other words, now, *relics*, *tokens*, *fetishes*. Undoubtedly, the stillnesses and miniscule gestures therefore deserve more consideration. For it is these gestures that are, in a quasi-Heideggerian sense, the most 'gigantic'. Pinnacles include Lee's ultra-clenched fist, trembling lip and grinding jaw in the face of the insulting Japanese at his master's funeral in *Fist of Fury*; or, in *Enter the Dragon*, Lee sitting, glistening with sweat, in the lotus position after a mass battle, or – when rudely interrupted during his morning workout by the evil O'Hara – turning slowly, mid-movement, on one leg, to aim his flawlessly perfect sidekick towards the intrusive O'Hara, as if inexorably fixing his target in the deadly sights of the barrel of a gun; or finally, in *Game of Death*, Lee's many cocky, casual, almost-yawning 'seen it all before' appraisals of his various opponents.

These three sorts of gesture in three sorts of film – the ethnonationalist *Fist of Fury*, the Orientalist/asiaphobic/asiaphiliac *Enter the Dragon*, and the postmodern/post-nationalist *Game of Death* – suggests that the 'event' of Bruce Lee was not 'one', but rather at least three.

THE THREE BRUCE LEES

The proposition that there is more than one Bruce Lee is not unusual. Stephen Teo, for instance, argues that there are *two* 'Bruce Lees': the ethnonationalist 'Eastern' Bruce Lee, of and for ethnic Chinese everywhere; versus the more postmodern multicultural 'Western' Bruce Lee for everyone else (2008: 110–20). Teo leaves out a third Bruce Lee – the Bruce Lee of the postcolonial imaginary, of decolonising struggles, civil rights movements, anti-racist movements – the

Lee whose currency comes from what Bill Brown has called his 'generic ethnicity' (1997: 33), who could function for many as a fertile source of identification, fantasy and desire because of the simple fact that he was a non-white character besting often-white characters in a white-dominated world. However, what seems shared in common by all of Lee's different films, in different ways, and across their different receptions in different contexts, is the extent to which, in different ways and for different people, they amounted to *interventions* – transformations; public, private, discursive, psychological, corporeal – in transnational popular culture. Indeed, to isolate the word that the philosopher Alain Badiou has made his own: with seeing Bruce Lee we are dealing with seeing an *event* (2001: 41–7, 51, 68, 72).

Badiou argues: events are *encounters*. Moreover, they cannot be communicated as such – at least not in any conventional sense of the term communication. Rather, in his view:

Communication is suited only to opinions [...]. In all that concerns truths, there must be an *encounter*. The Immortal that I am capable of being cannot be spurred in me by the effects of communicative sociality, it must be *directly* seized by fidelity. That is to say: broken ... with or without knowing it, by the eventual supplement. To enter into the composition of a subject of truth can only be something that *happens to you*. (2001: 51; emphasis in original)

In its simplest form, the event of Bruce Lee boils down to this: in viewing Bruce Lee, something happened to many people. This took place overwhelmingly at a certain historical moment, and in certain places (although it is not limited to that time or those places). And the effects of this cinematic encounter had effects whose resonances can be felt widely throughout transnational popular culture. This is the case *even though* the entrance of the dragon was primarily a cinematic event of the order of what postmodernists called the 'simulacrum', namely, of the fake or entirely constructed representation; or what psychoanalytical cultural theory calls fantasy (or 'phantasy'). For, fantasy and physical reality cannot really be divorced. Instead, explains John Mowitt, even 'in what makes reality seem original to us, fantasy is at work' (2002: 143). In other words, fantasy ought to be understood in a way that frustrates the possibility of a simple or sharp distinction between objective and subjective, and indeed between the inside and the outside of the subject.

But what was it that happened? And how? If there is a 'change' as a result of an encounter with the cinematic text, then, in the words of Rey Chow, what is clear is 'the visual encounter and the change, but not *how* the visual encounter caused

the change'; thus, Chow suggests: 'The central question in all visual encounters boils down to this simple *how*... how do we go about explaining the changes it causes in us?' (1995: 7; emphasis in original). What happened to Miller and to the many others who report a profound change in light of the encounter with the celluloid Bruce Lee might perhaps be understood in terms of the Althusserian paradigm of *interpellation*, which is, after all, a theory about the mechanism of how we become (again and again) certain sorts of subjects.

Yet, in Althusser, subjects are interpellated or recruited by a social institution: the policeman calls to us and we 'realise' that we are subject to their authority; hence we 'find ourselves' by virtue of being posited and positioned by a social institution. The same can be said for the teacher interpellating students, parents interpellating children, and so on. The theory of interpellation suggests that we are called into a position, called into a place. Yet, with a Bruce Lee film, or any other, the question is: who or what is or was doing the interpellating, or the making of subjects of and for what power or institution? For someone like Žižek (who, as we will consider more fully below, mentions Bruce Lee in his afterword to Rancière's book *The Politics of Aesthetics* (2006)) it is the case that the emergence of the image was once a pole of *subjectivating identification*, but that the future of the image is ideological phantasy. Žižek's point is that images, moments, events, subjects, become so to speak *co-opted* – ideologically recuperated: domesticated, channelled: moved into a place. (Many others have made similar arguments before Žižek, of course. One example, one that we will also be looking at in some depth is Bill Brown (1997). Brown himself refers us back to Stuart Hall's trailblazing analysis of co-optation or ideological rearticulation, but we will focus on Brown because his work applies directly to martial arts culture. Brown's analysis of 'co-optation' is also, it deserves to be noted, considerably more nuanced and sophisticated than most others.)

However, as Rancière himself proposes, there are also processes of *subjectivisation*, which operate in complete opposition to 'interpellation'. So, where Žižek (in a way that is not all that different from Althusser, who first theorised interpellation as a primary aspect of ideology) would see imaginary and symbolic identification as *placing* us in a *pre-given ideological* 'place', Rancière prompts us to see *subjectivisation as a disidentification that displaces us into a political 'place'*. This is a place of what Rancière calls 'the aesthetic dimension of the reconfiguration of the relationships between doing, seeing and saying that circumscribe the being-in-common'; this 'aesthetic dimension', he continues 'is inherent to every political or social movement' (2000: 17).

Is this to say that the entrance of the dragon is the birth of a political or social movement? This is the question we explore more fully in the following chapter.

In one sense the answer is obvious: not in any necessarily conscious or real-ist sense of 'political'. But what about when it comes to what Rancière calls the discursive 'reconfiguration of the relationships between doing, seeing and saying that circumscribe the being-in-common' (2000: 17)? This aesthetic event is embodied in a restricted economy of stillness and movement punctuated by signature gestures in which – to use the words of Jacques Derrida – 'what is transmitted or communicated, are not just phenomena of meaning or significa-tion [for] we are dealing neither with a semantic or conceptual content, nor with a semiotic operation, and even less with a linguistic exchange' (1982: 309). In other words, Bruce Lee, as a cultural and aesthetic text, 'communicates' far more than mere words alone; and the basic point is that what is communicated in Bruce Lee are not simply messages with or having or about 'meaning'.

The concept-metaphors often used to think about 'culture' ought perhaps themselves to shift from conceiving of it as a fixed or essential *thing* towards thinking of it as an *event*, a *process*, or – as is common nowadays – as *communi-cation*. But what is communication? And how is 'it' communicated? As Jacques Derrida once asked: what does the word *communication* communicate? We tend to 'anticipate the meaning of the word *communication* [and to] predetermine communication as the vehicle, transport, or site of passage of a meaning, and of a meaning that is one' (ibid.). But, he observes,

> To the semantic field of the word *communication* belongs the fact that it also designates nonsemantic movements […] one may, for example, *communicate a movement*, or […] a tremor, a shock, a displacement of *force* can be communi-cated – that is, propagated, transmitted. […] What happens in this case, what is transmitted or communicated, are not just phenomena of meaning or signification. In these cases we are dealing neither with a semantic or conceptual content, nor with a semiotic operation, and even less with a linguistic exchange. (Ibid.; emphasis in original)

Such is the communication of the fantasy offered by Bruce Lee: it cannot be reduced to a hermeneutical or logocentric communication of meaning, nor even the direct transmission of a 'real' tradition. It is always the performative reiteration of 'material' from heterogeneous realms or registers: myths, spectres, symbols and simulacra being as operative in – and as organising of – bodily practice as any positive or empirically specifiable 'real'. Of course, such communications, events, exchanges or encounters can be placed in historical contexts, and can be historicised. But they should not be regarded as 'therefore' being simple epiphe-nomenal 'expressions' of larger (or 'more real') historical processes. Rather, such

events as 'Bruce Lee' are equally *productive* of their historical contexts. Such events are rearticulations which 'rewire' and transform discourses, ideologies, fantasies and bodies.

Indeed, the entrance of Bruce Lee into global popular culture constituted for many an event of the order of what Badiou (1997) makes of St. Paul's encounter on the road to Damascus – an event producing a range of performative fidelity-procedures. Of course, over time, the gestures that most remain 'known' of Bruce Lee – the signatures – gestures which once punctuated and defined a discourse – have (to borrow a phrase from Ernesto Laclau), today become fetishes, dispossessed of any precise meaning. We will examine the significance of what Gina Marchetti (2006) refers to as the waning of the affect of Bruce Lee-inspired martial arts characters and narratives in chapter five, and reassess the nostalgic character of these fetishes.

CHANGING BRUCE LEE

Given the palpable ossification of Bruce Lee's status, and the widespread familiarity and normality (or 'everydayness') of martial arts, what more might there be to say about Bruce Lee? Can we – do we need to – think about Bruce Lee, differently? Or might we be better off thinking not simply about Bruce Lee, but about his cultural legacies – up to and including our own various different investments in him, about the significance and effects of the enduring obsessions with Bruce Lee?

To some people, even many working in film or cultural studies, such questions will seem hardly worth asking, let alone answering. Why would we even want to bother with Bruce Lee? Why should anyone care? There are many possible answers to this question. Most of them exist on a fan-like spectrum which ranges from 'because Lee was the greatest' to 'because Lee was the worst'. Yet, aside from the value judgements, what all positions seem to agree on is this: that Bruce Lee *changed things*. They may disagree on what these things are and whether this change was for the better or for the worse. To some, Lee is the hero; to others, the villain. But what everyone agrees on here is that Bruce Lee changed things. Bruce Lee made things different. The things that Bruce Lee changed, for better or for worse, are multiple. A list of some of them would have to include the following: Bruce Lee changed film fight choreography forever; Bruce Lee changed Western popular cultural representations of Asian men; he introduced uncountable swathes of people the world over to the very idea of Oriental martial arts; Lee, then, changed something significant in what we might

call the Western – but also Eastern – indeed, global or transnational, popular cultural imaginary. By 'popular cultural imaginary' I mean simply this: before Bruce Lee, adolescents had been able to imagine being an athlete, soldier or spy, and so on; after Lee an entirely new – and, crucially, an apparently entirely real and realisable – possibility became available: the martial artist, the invincible product of self-discipline and diligent training. He furthermore changed the paradigms of martial arts training; Lee even changed the paradigm or the notion of the ultimate male body. And so on.

In Foucauldian terms, or those of Laclau and Mouffe or Stuart Hall, Bruce Lee transformed a discourse (or two, or three, or more discourses). In Jacques Rancière's terms, Bruce Lee was instrumental in an aesthetic redistribution of the sensible or of the partition of the perceptible. There are, then, numerous possible ways of assessing Bruce Lee, differently, in numerous registers. Again, in all of these, Bruce Lee may be hero or villain or pawn. What I mean by this is the possibility that, for instance, when we consider the fact that Bruce Lee was the first Asian male lead in 'the first *American produced* martial arts spectacular' in 1973; or if we think about the fact that Bruce Lee was the first Asian male to (co)star on American TV in the 1960s, first in *The Green Hornet* in 1966 and then in episodes of *Longstreet*, the question is how do we assess the significance of these 'firsts'?

One (common) way is to paint Lee as a hero, as someone instrumental in broaching the white hegemony of Hollywood and in 'bridging cultures'. The diametrically opposite approach is to regard Lee as something of a villain: as self-Orientalising, as playing the stereotype of the Asian man as Confucius or Lao Tzu, in order to profit personally but in a way which has regressive cultural consequences. In this way, then, Bruce Lee can be regarded as something of a player being played – a hapless dupe of larger historical-ideological processes – profiting from a kind of cultural neo-colonialism which changes the meaning of the phrase 'enter the dragon'. We tend to think of the phrase 'enter the dragon' in the title of the film as referring to the active entrance upon the global scene of the Chinese dragon. But it might equally well refer to the dragon being entered, opened up, as a colony, a market, a conquest and a brand.

Slavoj Žižek has made much of this sort of ideological analysis. Of course, Žižek has rarely mentioned Bruce Lee directly or Bruce Lee as such – although, as already noted, he has done at least once, and quite conspicuously, in his afterword to Rancière's *The Politics of Aesthetics*. In this text, Žižek argues that the initial popularity of Bruce Lee in the West in the 1970s was an example of what he calls an 'authentic working-class ideology': that is, martial arts, as a new possibility for Westerners, appealed specifically to working-class youth, because, as

Žižek formulates it, richer people have more things, more options, but those who have nothing have only their bodies, only their discipline. So, in this respect, for Žižek, martial arts as popularised by Bruce Lee films, can be regarded as ideological in the sense given to the term by Marxists in the tradition of Max Weber, ie in the sense of a lived coping mechanism, like religion or wine or beer.

But, Žižek argues, over time the ideological status of martial arts became much more problematic. This is because, he proposes, it shaded into an obsession with the self, with one's own body, with one's own propensities and one's abilities 'to become'. Thus, like yoga, like feng shui, like tai chi, qigong, acupuncture and so many other erstwhile or putatively 'Eastern' practices, in Žižek's line of reasoning, such things become packaged and commodified and reconstituted in a completely different discursive context: the context of middle-class Western consumerist individualism.

For Žižek, this is of course about much more than Bruce Lee or martial arts. Bruce Lee is just a barely considered example, in Žižek's text, a name mentioned to illustrate something more profound. The wider issue that Žižek seeks to broach with this and other similar examples boils down a paradox: namely, what he calls the 'victory' of so-called 'Western' technology and economics at the level of the 'base' – in other words, a domination moving from West to East – which is matched by its reciprocal or inverted reverse: namely, a kind of 'victory' at the ideological or superstructural level for a strange kind of Buddhism and Taoism – a Westernised Buddhism and Westernised Taoism. What Žižek means by *Western* Buddhism and *Western* Taoism is a certain kind of commodified, deracinated, fetishistic relation to the world. So, all things ostensibly 'Eastern' become, to Žižek, an ideological coping mechanism the world over for all who must learn to survive in a world of deregulated flows and unpredictable and unmanageable upheavals. The mantra of this attitude would be something like 'Don't cling. Go with the restructuring flow.' This, argues Žižek, is the ideological status of the Tao.

However, Žižek's own works are normally all about clarifying some things that he believes in: namely, some supposedly universal formal structures of human perception, ontology, ideology, and, indeed, human nature. Žižek just reconceives of the supposed binary between nature and culture and implicitly argues that culture is nature and vice versa. So, his work is not really *about* Bruce Lee, as such. But, at the same time, I would suggest, Žižek's '*mere*' example, Bruce Lee, must actually be regarded as the *exemplary* example of his entire argument. That is, if we are being Žižekian, then Bruce Lee is the sublime object of ideology.

However, as will become increasingly important throughout this book, we cannot overlook the fact that Žižek's mention of Bruce Lee occurs in his afterword to Rancière's *The Politics of Aesthetics*. It is significant because this kind of

argument is very different to *anything* Rancière has ever argued. Indeed, in that book and elsewhere, nothing in Rancière's argument about anything at all would suggest that Rancière himself would regard Bruce Lee as an example of '*ideology*'. Quite the contrary: if Rancière would regard Bruce Lee as anything at all (and there is no guarantee that he would – there is certainly no mention of Bruce Lee in his *Film Fables* (2006a)) it would most likely involve reconceiving of Bruce Lee in terms of his aesthetic reconstitution of what Rancière calls the partition of the perceptible – in terms, that is, of a redistribution of perceptions, values, possibilities, and ways and modes of living and doing and being – which would strike me as a much more productive way of approaching someone or something like Bruce Lee.

The productivity of Rancière's aesthetic approach, with its Foucauldian attention to what Rancière calls 'the partition of the perceptible' and the 'distribution of the sensible', is deepened by combining it with an approach offered by Rancière's primary sparring partner, Alain Badiou. As is well known, one of Badiou's principal interests lies in theorising the effects of 'events' in producing subjects. Now, to reiterate: all of the narratives about encountering Bruce Lee that I know share the following structure: once upon a time I was one way; then I encountered Bruce Lee; and that was the day that everything changed – that was the day that *I* changed. So I think it is both easily empirically verifiable and quite theoretically reasonable to propose that many people's encounters with Bruce Lee can be approached in terms of Badiou's theory of the event.

Obviously, though, one need not follow Badiou's theory of the event to think about Bruce Lee as a life-changer. One might instead recall for instance the apparatus opened up by Lacan in such texts as 'The Mirror Stage' (Lacan 1989) for example, to find a compelling account of how imaginary and symbolic identifications work to produce subjects. Then there is the old but irrepressible Althusserian theory of interpellation to which we will return more than once. Yet what is interesting in Badiou's approach is his focus on the ways in which the event results in what he calls procedures – truth procedures, fidelity procedures – namely, the ways in which people act or be or become, according to their interpretations of what Badiou calls the 'evental supplement' (2001: 41, 51).

In its simplest terms, of course, this means: people moved by Bruce Lee try to 'follow' or 'emulate' or 'be' or 'do' or 'have' Bruce Lee in different ways in different times and places. They try to be faithful to something. But to what? And how? As we have already seen, even Bruce Lee's own personal martial arts students very quickly split right down the middle, into two camps, so that following Bruce Lee quickly came to mean one of two directly opposing things: one branch of students established what they called 'original' jeet kune do, ie they maintain fidelity

to Bruce Lee by trying to do things exactly the way he was doing them when he last taught them; then there is the jeet kune do 'concepts' branch – these are the students who constantly try to experiment and innovate, according to Bruce Lee's guiding (wing chun-based) concepts of efficiency of movement, maintaining the centre-line, and directness.

Both schools attempt to institute fidelity, to be faithful to a truth, but in utterly opposite ways. Both *do* Bruce Lee differently. As does everyone else. And this is my point. There is no one, fixed, final, immutable signified for 'Bruce Lee'. The dissemination of the celluloid Bruce Lee had untold consequences. Many saw Bruce Lee's nominally Chinese kung fu and ran off to do all sorts of things – including nominally Japanese karate or judo or Korean taekwondo. This was not necessarily out of the Orientalist ignorance which conflates and collapses different styles and different nations, although that was certainly present. It was mostly out of chance, contingency or convenience: you see Bruce Lee; you go to whatever martial arts club you can find. In the 1970s, in the US and the UK, at least, you could mainly find boxing, wrestling, judo or karate. Many other people, however, saw Bruce Lee and ran *away* from these selfsame things, on the basis of Bruce Lee's critique of what he saw as stultifyingly formal, rule-bound institutions like boxing, wrestling, judo or karate. Such people ran towards a dream of freedom and into what soon became known as 'freestyle' and then 'mixed' martial arts. (These, of course, quickly became stultifyingly rule-bound institutions.)

More broadly, Bruce Lee has been credited as an influence on professional boxers and other athletes, jazz musicians, lifestyle and management self-help gurus, rap and hip hop artists, movie directors, cinematographers and (especially, perhaps) choreographers, dancers, the first Parisian *parkour* free-runners, and even cultural and political thinkers: a Bruce Lee statue was erected in Mostar, Bosnia's UNESCO town, in an attempt to unite the divided communities. Bruce Lee has been theorised as offering a new model of masculinity, and Bruce Lee has of course been instrumental in the performative elaboration of new modes not just of masculinity but also femininity, from Cynthia Rothrock to Buffy to Beatrix Kiddo in *Kill Bill* to Trinity in *The Matrix* to Princess Fiona in *Shrek* (2001) to – as mentioned earlier – the character Mrs Potato Head is playing in the child's imaginary game at the opening of *Toy Story III*. Bruce Lee has functioned in many different ways as a fantasy, muse, teacher, pedagogue, inspiration, spectre, allusion, ideal, superego, founding text, dangerous supplement, a figure in the carpet or in a collage, or bricolage, in opening credits or gestures or bedroom wall posters or bathroom mirror images or schizophrenic alter-egos.

If all of this is, as Žižek would have it, 'ideology', then perhaps this means that ideology is not the dirty word it once was. Were we so inclined, then, maybe we

could 'reclaim' ideology. But, maybe we need not bother. Because if *everything* is ideology, then *nothing* is. So maybe we should move on and approach all of this (or any of this) not in terms of the kind of neat and tidy ideology critique that Žižek proffers as a supposed advance on the discourse theory and discourse analysis and cultural studies that preceded him, but rather in terms precisely of messiness and complexity.

CHANGING APPROACHES

This might perhaps best be demonstrated not by further enumeration of the different appropriations of Bruce Lee throughout culture, but rather by a consideration of the extent to which Bruce Lee differs across divergent academic paradigms. For instance, Bruce Lee exemplifies Žižek's arguments about the relay and routing of East/West 'encounters'. Bruce Lee is also an excellent example of Rancière's arguments about partitions and redistributions of the perceptible, as we will continue to see. We will also see that Bruce Lee offers an exemplary example of a Badiouian event, offering something no different in structure from what Badiou argues about St. Paul's vision of Christ on the Road to Damascus. Moreover, Bruce Lee has also evidently functioned in ways that make sense in terms of theories of imaginary and symbolic identifications in subject constitution. Bruce Lee's image offers a superlative interpellative 'hailing'. (As Robert Walser argued of music, so we can argue of Bruce Lee: he 'hail[s] the body directly' (Gilbert and Pearson 1999: 46)). Bruce Lee illustrates arguments and approaches which focus on Orientalism and the Orientalist appropriation of eastern cultural practices and phenomena by Western discourses. He can also be regarded as a Foucauldian 'founder of discursivity'. He also illustrates postmodernism, in many registers. Similarly, Bruce Lee is centrally present in several studies of postcolonial cultural struggles. ... And so on.

What does this difference signify? These various paradigms are often taken to be in conflict, contradiction or disagreement: Žižek is not Rancière is not Badiou is not Lacan is not Foucault is not Althusser is not Laclau, and so on and so on – and woe-betide anyone rash enough to suggest that these thinkers are not forever locked in deep and fundamental disagreements. But, over and above nominal academic disputes, the point is that there are some serious questions here: what is the significance of the fact that Bruce Lee can be regarded as an *active agent* or *agency* in one paradigm and a *passive expression* or *symptom* or *dupe* in the next? Of course, when Bruce Lee is explored through one, then another, then another of such paradigms, the differences between them seem to shift their

status somewhat. Bruce Lee 'works' through all of the approaches. He works differently, of course. Sometimes, the supposed differences between the paradigms become much less palpable; sometimes more pronounced. Sometimes it can clearly be seen that the different paradigms produce a different object as such – a different Bruce Lee per paradigm: a Žižekian Bruce Lee of ideology; a postcolonial or Rancièrean Bruce Lee of 'aesthetic dissensus'; a queer Bruce Lee of cultural and subjective torsion; and so on.

In approaching Bruce Lee *through* these differences, in terms of these differences, and the kind of impossibilities and aporias that they signify, we can glean something of the constructive – actually, *constitutive* – character of the (academic) approach *to* the (object) approached. Indeed, like any good 1960s radical, Bruce Lee too knew this well. As he wrote:

> Each man belongs to a style which claims to possess truth to the exclusion of all other styles. These styles become institutes with their explanations of the 'Way', dissecting and isolating the harmony of firmness and gentleness, establishing rhythmic forms as the particular state of their techniques. (1975: 14)

When faced with the proposition of the organising and orientating effects of approaches and institutions and paradigms, with their guiding ideas and rules and rituals and procedures, Bruce Lee's own conclusion was that there was a need to reject all institutions. This heroic anti-institutional radicalism is seductive, even if it is, unfortunately, utopian, idealistic and romantic. But nevertheless, anti-institutionalism, anti-disciplinary interdisciplinarity, and so on, were the very hallmarks of 1960s and 1970s radical thinking. And they formed the basis not only of Bruce Lee's cultural legacies but also of much more besides, up to and including the vexed fields of cultural studies as such – fields that we still inhabit, with rather messy histories. In other words, the complexity, the tangles and the complex texture of the relations within which Bruce Lee exists and operates cannot be divorced even from academic approaches.

To take just one example, we might note that in its formation, cultural studies (along with feminism, postmodernism, postcolonialism and poststructuralism) shared a wider interest in the anti-institutional, the anti-disciplinary, the inter-disciplinary, the other, alterity, difference, the different, the excluded and so on. And what has been the exemplary instance of many of these things in many different ways? A one-word answer comes to mind: China. This is because, as Rey Chow has pointed out, first, the Chinese 'other' played a constitutive (haunting) role in the deconstructive critique of logocentrism and phonocentrism, in ways that far exceed the general 'turn East' (in the search for alternatives) characteristic of

'French' theory and much more besides of the 1960s and 1970s. Second, the feminism of the 1960s and 1970s actively admired and championed the Chinese encouragement of women to 'speak bitterness' against patriarchy. And third, the enduring interest in the 'subaltern' among politicised projects in the West has always found an exemplary example in the case of the Chinese peasantry. Indeed, says Chow, in these ways and more, '"modern China" is, whether we know it or not, the foundation of contemporary cultural studies' (1993: 18). I would add that, given this discursive, theoretical and cultural complexity and complicity, Bruce Lee may also be regarded as an exemplary object or example of cultural studies. But this object or example is more than the mere object or example of a fixed and immutable field and approach. It is, rather, an object or example which, when fully engaged, *changes* things, up to and including the approach of the field which attempts to take it as an object.

READING BRUCE LEE

I attempt to read Bruce Lee in this way throughout this book. That is, instead of thinking of Lee as just a 1970s chop-socky Hollywood figure, I begin from the proposition that quite a lot happens when we check his status in terms of some of the dominant problematics of cultural and political theory. For, with Bruce Lee, on the table here we have, at least, the themes of ethnicity, especially in terms of cross-ethnic representation, especially in a context of white hegemony; cultural hybridity, postcoloniality, interdisciplinarity, globality (if not globalisation), as well as multiculturalism and postmodernism. Furthermore, questions of both racism and Orientalism are not far away, either, as well as their obverse: asiaphiliac fetishisation, and questions of commodification and exploitation. There are also some rather knotty questions about cultural translation, or intercultural encounters or exchanges, which we will be dealing with throughout this book.

These need not necessarily be thought simply in terms of 'East' meeting 'West'. If we recall Miller's experience or encounter, for instance, we should note: this encounter – *with a film* – changes Miller's life. In his account of this moment, Miller conveys *his* singular, intimate, personal experience. But, it must be emphasised, it is also an experience that shared by innumerable people in innumerable situations. We can see this same process, this same experience, in many accounts, in the most diverse places: all over popular culture; in many forms of literature from many countries; and even in all sorts of academic work.

This work does not try to enumerate, organise, marshal or even take stock of the full range(s) of Bruce Lee's significance(s) and intervention(s). Rather, it

engages with Bruce Lee-related topics, in terms of his intervention into some selected cultural contexts. The next chapter assesses a range of positions in the discourses on Bruce Lee that can be found in politically-inflected fields concerned with cultural politics, such as cultural studies, media studies, film studies and ethnic identity studies. In these fields, Bruce Lee ought to be regarded as culturally-politically significant, particularly in terms of his contributions to Asian-American identity politics, diasporic Chinese cultural identity, the deconstruction of white Eurocentric hegemony in Hollywood film and notions of masculinity, his kinetic, symbolic and affective associations with civil rights movements and decolonisation struggles, and so on. The chapter clarifies the ways in which all of these assessments of Lee's contribution, intervention or significance imply one or another relation between *culture*, *media* and *politics*, with film in particular playing a constitutive articulating role. It also indicates the extent to which many such studies of Bruce Lee's significance for cultural politics offer celebratory narratives which are slightly problematic in being utopian. However, the chapter also draws on a reiterated argument of Slavoj Žižek's, about the 'strange exchange' between 'Asia and Europe' – an exchange which is arguably exemplified in the case of Bruce Lee. Žižek, of course, has often critiqued the many narratives and arguments about the inherent goodness and progressive character of postcolonial, multicultural and politically correct cultural politics, so the chapter explores the Žižekian critique of the kinds of protests, aims, objects, and achievements implied by those who champion Bruce Lee. Put differently, the chapter assesses Žižek's critique of what he regards as the dominant notions of cultural protest and cultural politics.

Chapter three engages with the question of Bruce Lee as a pedagogue – and moreover, a 'radical' 1960s pedagogue at that. This is significant because central to much 'radical', 'politicised' scholarship (such as that associated with the formation of cultural studies, gender studies, queer studies, and so on) is a critique focused on the cultural power of institutions – pedagogical institutions in particular. There are lots of different versions of this critique of educational and other institutions. But this chapter relates Jacques Rancière's exemplary critique of educational institutions to this wider 'radical political' impulse, and relates this impulse itself to the 1960s counterculture. It reads Bruce Lee through Rancière, but also asks why Rancière's critique stops *before* his own historical moment, a moment that can be tied to the 1960s; and it attempts to establish the discursive status of Rancièrean *and* radical approaches such as queer theory by picking up where Rancière leaves off: the countercultural critique of pedagogical institutions, which spread through many realms of society, including martial arts. The key figure throughout is the anti-institutional and countercultural Bruce Lee. So,

the chapter explores Bruce Lee's iconoclastic, inter- and antidisciplinary approach to 'learning' in relation to Rancière's 'queer' pedagogy in order to deepen our thinking about an 'emancipatory relation'.

Chapter four translates this thinking about 'queering' (and) institutions into a different direction: that of using Bruce Lee to think about 'cultural translation'. It proceeds by considering some peculiarities of *Fist of Fury*. The opening of that film depicts the funeral of a Chinese martial arts master, in a Chinese school in the Japanese-dominated area of the Shanghai International Settlement, circa 1908. This is already a fraught moment of cultural transmission: indeed the eulogists at the funeral expend most of their energy emphasising to the assembled Chinese martial arts students that they know the correct way to preserve their master's lineage and their tradition. But the funeral is rudely interrupted by the arrival of belligerent representatives of a Japanese martial arts school, who contemptuously present the Chinese with a large framed piece of calligraphic writing, which reads 'Sick Man of Asia'. The Japanese issue a challenge, via their translator, the creepy (and culturally and sexually ambiguous character) Hu En. The senior Chinese elders prevent any of the Chinese students from answering the challenge, in order to preserve decorum. At one key point a senior Chinese teacher addresses the translator. In the dubbed English version, the Chinese senior asks Hu, 'Look here, just what is the point of this?' In the English subtitles, however, this exchange is rendered as, 'One question, are you Chinese?' These are significantly different renderings. Hu's answer in the subtitled version is that whilst he is Chinese he shares a different destiny to them. In the dubbed version, however, Hu shortly proceeds to speak of the superiority of 'we Japanese'. Accordingly, the chapter focuses on this disjunction in order to explore several interconnected issues of translation. Firstly, various theories of translation and their imbrication in various models of culture and tradition; and secondly, Benjaminian arguments about the text as construct. *Fist of Fury* is clearly a complex (and internally contradictory) construct, with all sound added post-production and hence lacking any 'original' as such. Hence the chapter addresses the complexity of such putatively 'simple' popular cultural texts as *Fist of Fury* when approached as the 'arcades' of 'cultural translation'. In order to delimit and organise this massive set of problematics, the chapter focuses specifically on the two key dimensions of this opening scene: first, the fact that the funeral of the founder is already a fraught scene of rupture/tradition, transfer/loss, continuity/disjunction – indeed, of cultural translation – here supplemented; secondly, by the double, duplicitous (*cultural*) status of the (*literal/linguistic*) translator, Mr Hu. The reading of this scene is organised by Chow's contribution to theories of translation in her chapter, 'Film as Ethnography; or, Translation Between Cultures in the Postcolonial World' (1995: 176–202), which

itself begins from a consideration of the Italian expression '*Traduttore, traditore*' – 'Translator, traitor'.

Chapter five returns to the well-worn theme of masculinity, revisiting the topic of the significance of Lee's intervention into a racialised and sexualised semiotic economy. It undertakes an exploration of his significance through postcolonial-ist, semiotic and psychoanalytic readings of various martial arts masculinities, connecting these with Chow's (2002) formulation of the connections between ethnicity and 'protest'. In this chapter and the following two – concluding – chap-ters, the transformations of Lee's significance and 'work' over time is addressed. Chapter six considers the various 'spectres' of Bruce Lee that circulate today. It is increasingly acknowledged that Bruce Lee still haunts not only martial arts cinema but also action film fight choreography and indeed a lot of transnational popular culture beyond film. That chapter begins by clarifying the ways that the impact of his interventions on action film fight choreography the world over are still being felt, in myriad international and multimedia contexts. It sets out the ways in which key scholars have traced the contour lines and shock waves of Lee's cinematic interventions, as well as illuminating many of the social, cul-tural, ethnic and ideological resonances that have been carried by Bruce Lee and his many clones, imitators and metonyms (including his movements, postures, gestures, sounds, camera angles and so on). It then considers one of the most recent – and perhaps significant – returns of one of the spectres of Bruce Lee, as it has elaborated itself recently within Hong Kong cinema.

In this resurgence, the figure of Bruce Lee can be found structuring such major recent films as the *Ip Man* (2008, 2010, 2010) trilogy, *Legend of the Fist: The Return of Chen Zhen* (2010) and *Champions* (2008), among others. In these recent (highly successful) films, a certain spirit of Bruce Lee is conjured. The chapter shows how and asks why: why this return of the dragon, at this time, in this way? In order to construct an answer, it revisits the scholarship that has tackled the question of Lee's influence and the various ways in which Bruce Lee imagery has functioned in different historical and cultural contexts at different times; whether that be within certain film genres (Eastern and Western martial arts films, action cinema, comedy, parody and pastiche) or within different sorts of ideological discourse (such as around ethnic Chinese identity and identifica-tions, Chinese diaspora, romantic Chinese nationalism within pre-1997 Hong Kong film, countercultural and Orientalist discourses of East and West, anti-racist and multiculturalist discourse and so on). The chapter links the recent resurgence of the ethnonationalist spectre of Bruce Lee in particular to other recent films in which 'China' emerges as a deliberate and prominent construct within films – particularly those films which have been shot partly or entirely within China itself;

films that are often part or entirely funded by Chinese sources. These films have taken the form of both nominally Eastern and nominally Western productions, and the chapter argues that what they all share is a certain refiguring or reworking of the very idea of 'China'.

Of course, Bruce Lee films, images and ideas could be said to function quite differently to such films as *Crouching Tiger, Hidden Dragon* (2000), *Hero* (2002), *House of Flying Daggers* (2004), or even the more recent remake of *The Karate Kid* (2010). But the chapter argues that the spectre of Bruce Lee that is currently in the ascendant constitutes a symbolic renationalisation. It proposes that, since 1997, the figure of Bruce Lee has been particularly ripe for exploitation and for ethnonationalist deployment, insofar as such a globally successful US/Hong Kong icon as Lee can function so easily as a metonym for Hong Kong itself: conduit of East and West, economic success story, site of economic and inter-nationalist antagonism and conflict, and so on. This process can be seen in such devices and displacements (or degrees of removal from the obvious) as the *Ip Man* films' palpable retroactive/nostalgic phantasy 'reclamation'/construction of Bruce Lee's teacher, Ip Man, as a mythic national hero and a virtual national treasure. As the first film states, Ip Man was a Chinese mainlander who was forced to flee to Hong Kong because of his heroic struggles against the Japanese, and whose style of kung fu (wing chun) became internationally successful in the wake of the popularisation of the knowledge that wing chun was Bruce Lee's first main style.

Like the other films that the chapter analyses, *Ip Man* begins, ends and is structured throughout by visual quotations from Bruce Lee films. So, the chapter itself is structured by identifying, elaborating and elucidating the main types of visual, cinematic and dramatic quotations of Bruce Lee that make his spectre live within so many films. Replays of the famous dojo fight scenes of *Fist of Fury* will be one of the main points of focus. Analysing these, the chapter will argue that it is through reiterations of the affects of the dojo scenes that the spectres of Bruce Lee are primarily conjured. But it will pause to consider the significance of the fact that one cannot merely conjure up 'one' Bruce Lee: Bruce Lee will always be both ethno-nationalist and trans- or inter-nationalist, because there can be no exorcising of the global/'Westernised' Lee of *Enter the Dragon* or the cosmopolitan/anti-nationalist Lee of *Game of Death*.

Finally, chapter seven reads the 'beyond' of Bruce Lee in terms of the emergence of 'Oriental style' in Hollywood, which Jane Chi Hyun Park (2010) couches as an exemplary case of what Rey Chow calls 'cultural translation'. So, the chapter explores the intimate yet paradoxical relationship between 'Oriental' martial arts and the drive for 'authenticity' in both film choreography and martial arts

practices; plotting the trajectories of key martial arts crossovers since Bruce Lee. It argues that, post-Bruce Lee, Western film fight choreography first moved into and then moved away from overtly Chinese, Japanese, Hong Kong or indeed obvious 'Oriental style'; a move that many have regarded as a deracination or Westernisation of fight choreography. However, a closer look reveals that this apparent deracination is actually the unacknowledged rise of Filipino martial arts within Hollywood. The significance of making this point, and the point of making this kind of argument overall boils down to the insight it can give us into how 'cultures' and texts are constructed, and also into our own reading practices and the roles they play, sometimes in perpetuating certain problematic ethno-nationalist discourses.

chapter two

chapter two
BRUCE LEE BETWEEN POPULAR CULTURE AND CULTURAL POLITICS

MOVIE POSTERS AND MUSCLE POSES:
GENERIC ETHNICITY AND POPULAR CULTURAL GENRES

To suggest that seeing Bruce Lee could perhaps have some relation to politics or to the political may seem preposterous. However, there are several ways to verify this claim. The most obvious is empirical: the sheer volume of the occurrence and even prominence of the figure of Bruce Lee in political or politicised discourses. Bruce Lee often features as a countercultural motif, in much the same way as (and sometimes even alongside) the likes of Che Guevara and Jimi Hendrix. As testified by innumerable autobiographical accounts, filmic allusions and popular cultural juxtapositions and combinations, Lee functions in diverse popular narratives of *struggle*. And his appeal was not confined to particular ethnic or cultural groups. As Keiko Nitta observes, 'if Lee's ethnic representations have marked so strongly his impact, this is enabled by their equivocality that allows a translation of ethnicity to social alienation or a marginalized experience of struggle in general' (2010: 380). She points out that 'contemporary cinema has repeatedly reproduced Lee as the idol of not merely Asian men, supposedly confined in an emasculated stereotype, but also men socially vulnerable for disparate reasons' (ibid.), and gives the example of the Bruce Lee poster which features in a famous early scene in *Saturday Night Fever* (1977), which

uses an impressive cross-cut of Lee's naked torso in a poster on the wall and flesh of Tony Manero (John Travolta), an unskilled paint-shop clerk without any prom-ised future. First imitating the poster at his bedside in a primary scene, Tony then dresses up flamboyantly in pink silk-satin, transforming himself to the weekend disco king. (Ibid.)

Twenty years later, *Boogie Nights* (1997) was still evoking the strength of this early popular cultural connection in its depiction of what Nitta calls the 'popular cultural landscape of the 1970s'; the film utilises 'Lee's figure and kung fu moves to represent the ideal self-image of Eddie Adams ['Dirk Diggler'] (Mark Wahlberg), an underachieving high-school student who has no particular redeeming features other than oversized genitalia' (ibid.).

Perhaps the first cinematic instance of this connection is to be found in the use of a Bruce Lee poster in Horace Ové's social realist classic about life in West London, *Pressure* (1975): we see a long shot of a Bruce Lee poster, which is the only apparent decoration in a room, before panning down to see the teenage hero sobbing on his bed after a nasty brush with the reality of racism – the inscru-table Lee staring out impassively like the protecting/judging super-ego.

In various ways, each of these examples can be said to provide grounds for Slavoj Žižek's claim that the first kung fu craze of the early 1970s testified to 'a genuine working-class ideology of youngsters whose only means of success was the disciplinary training of their only possession, their bodies' (2004: 78–9). (We will look further into Žižek's argument in due course.) Of course, the Bruce Lee poster features in very many teen identity conflict/struggle flicks, from *No Retreat, No Surrender* (1986) (which actually stars the resurrected 'spirit' of Lee as the teen hero's teacher) to *Forbidden Kingdom* (2008). But, if the use of Bruce Lee posters in the opening scenes of films like these testify to the power of Bruce Lee as a *generic* muse, inspiration and pedagogue, it is the use of the poster in *Pressure* that precisely pinpoints the initial significance of Bruce Lee for a significant constituency of viewers: his ethnicity.

Bill Brown argues that what he calls Bruce Lee's 'generic ethnicity' was evidently of immense importance to the first clearly defined Western viewing constituency of Eastern martial arts films: blacks and hispanics in American cities. Hollywood's awareness of this constituency – this market – was signalled first by its tentative allocation of starring roles to both the Asian Bruce Lee and the black Jim Kelly in *Enter the Dragon* – a film which divided the starring role three ways, rather than entrusting it to Lee alone. Both Lee and Kelly 'star' alongside the white John Saxon. Lee is given no discernible personality (remaining, of course, 'inscrutable'), while the black Kelly is characterised as appropriately politicised

(on seeing the squalor of the harbour in Hong Kong he declares 'ghettos are the same everywhere: they stink'). Kelly is also drawn along ethnic stereotypes, as someone who is 'street', hip, promiscuous and – predictably – destined to be killed off. Saxon, meanwhile, functions as an ersatz James Bond character, but one who has been reduced to a suave swagger, a gambling habit and a certain kind of formulaic attractiveness. Hollywood's awareness of 'the black connection' was signalled secondly by the subsequent film, *Black Belt Jones* (1974), a film 'in which black martial arts students battle white gangsters' and which was the 'first U.S.-lensed martial arts actioner' (Brown 1997: 33).

In addition to class and ethnicity, an equation was quickly established between martial arts prowess and physical power and hence possible female empower-ment (aka feminism) – as exemplified by numerous female martial arts stars in Hong Kong film, and then a legacy from Cynthia Rothrock to *Buffy the Vampire Slayer* (1997–2003) and the Western reception of *Crouching Tiger, Hidden Dragon* in the West. But whether approached in terms of class, age, ethnicity or gender, what is crystal clear is that Bruce Lee always functioned within what Meaghan Morris calls 'a "popular" cultural genre'. She writes:

> A 'popular' cultural genre is one in which people take up aesthetic materials from the media and elaborate them in other aspects of their lives, whether in dreams and fantasies, in ethical formulations of values and ideals, or in social and some-times political activities. (2005: 1)

What, then, are some of the 'sometimes political activities' with which Bruce Lee might be linked?

BRUCE LEE AND THE BLACK CONNECTION

In a wide-ranging and detailed study organised by an argument about 'the revolu-tionary significance of popular culture' (Kato 2007: 8), M. T. Kato focuses on what is referred to as 'the kung fu cultural revolution'. The key argument in Kato's book, *From Kung Fu to Hip Hop*, is about 'Bruce Lee's kine-aesthetic of liberation and [its] reverberation with the decolonization struggles in Asia' (2007: 6). Kato connects 1960s decolonisation struggles in Asia with the Western counterculture, which he construes as epitomised by Jimi Hendrix, driven by the cultural responses to the American war in Vietnam, and traces all the way to the American hip hop cul-ture of the 1990s. Kato characterises all of this as 'revolutionary' – a claim which demands some clarification.

Popular culture is revolutionary, Kato claims, despite the fact that the 'circulation of the popular cultural revolution, such as ... kung fu films and hip hop culture ... takes place primarily in the global commodity market as a deviant by-product of the mass consumer culture'; furthermore 'popular cultural revolution arises from the historical context in which the commodity culture constitutes the infrastructure of communication among the masses' (2007: 2). He continues:

> Accordingly, the mass's appropriation of the progressive aesthetics of popular cultural revolution can render the commodity to 'speak' for itself against the grain of its commodity identity, similar to how Luce Irigaray demonstrates that women's autonomy undermines its imposed identity as a commodity: 'For such actions turn out to be totally subversive to the economy of exchange among subjects'. (2007: 3)

Kato turns to Jameson to note the problem of the 'penetration and colonization' of 'the unconscious' that occurs with the 'rise of media and the advertisement' (ibid.), and then turns to the work of Guattari to support his claim that 'affects' can nevertheless arise at certain times and in certain places which *supplement* bare commodity relations, and engender a subversive form of affective communication or communion (2007: 5). Thus, the 'colonization of the unconscious' is drawn as a cultural-political problem connected to 'the cinematic mode of colonization' (2007: 8). In Kato's text, this is illustrated by the example of African-born viewers and spectators who would not only cheer for (the white) Tarzan but who, 'whenever Africans sneaked up behind him ... would scream ... trying to warn him that "they" were coming' (Haile Gerima, quoted in ibid.). In response to this, Kato suggests that, given the problem of 'the colonization and decolonization of the "mental universe" [associated with] cinematic colonization, the decolonization in the cinematic mode necessitates reconstruction of a vernacular imagery, narrative, and mode of reception, which can transcend the colonial imagery imposed upon the colonized' (ibid.). Kato finds precisely such a decolonising vernacular in the work of Bruce Lee.

Similarly, Vijay Prashad writes: 'There was something extraordinary about Bruce Lee' (2001: 126). This related to his screen presence, of course, but also to the fact that Bruce Lee was clearly a trailblazer. In Prashad's words, 'The anti-racism of Bruce was not matched by the world in which he lived' (2001: 127). Indeed, Prashad refers us to the fact that Lee lived in an era in which Asians, whilst gradually gaining some legal, social and civil advances within US society, were highly marginalised and ongoing victims of historical prejudices and stereotypes. It is in this context that Bruce Lee emerges – a context in which ingrained 'cultural stereotypes enabled the mockery of a people by suggesting that they could never

be part of the republic, since they had too much alien culture' (ibid.):

> This was to change somewhat in the 1960s, as social movements against racism
> and state management of these movements helped produce what we know today
> as multiculturalism. US television, with *The Green Hornet*, 1966–67, embraced
> Bruce Lee to play the Asian, just as the state acknowledged the role of Asians in
> the creation of a cold war United States. The passage of the 1965 Immigration Act
> signaled a shift in US racism from outright contempt for Asians, as evinced in the
> 1924 Immigration Act, to one of bemused admiration for their technical and profes-
> sional capacity. In the throes of the cold war, and burdened by the lack of scientific
> personnel, the US state and privileged social forces concertedly worked to wel-
> come a new crop of Asians whose technical labor was to be their crucial passport
> to this New World. That is not to say that Asians found life easy… (2001: 127–8)

Prashad is keen to number Bruce Lee as part of what in Raymond Williams'
(1977) terms one could call an emergent and progressive political formation (for
which 'multiculturalism' is only one possible name: multiculturalism refers us to
only one sociological dimension of a far wider array of overlapping emancipatory
and egalitarian struggles). This is why the final words of Prashad's book are: 'To
remember Bruce as I do, staring at a poster of him ca. 1974, is not to wane into
nostalgia for the past. My Bruce is alive, and like the men and women before him,
still in the fight' (2001: 149). This 'fight' – if it is indeed *one* fight – is represented
as a very widely proliferating series of skirmishes, and as taking many forms
across the globe. Prashad himself focuses on the significance of 'Afro-Asian
Connections and the Myth of Cultural Purity' in the fight against racism and the
movement towards an egalitarian multiculturalism. In such accounts, then, Bruce
Lee is shown to be part of a counter-hegemonic movement, *versus* hegemony.

However, as is the case with other similar accounts, a certain question also
emerges and remains unanswered. This is the question of *articulation*. Specifically:
precisely how is Lee articulated with this (or that) emerging discourse? As we
have already seen, Bruce Lee could quite easily be lined up alongside all sorts of
things and said to be 'like' this or that, 'part of' this or that, or an 'example' of this
or that. But *which* claimed articulation or linkage is valid and which is not? *Which*
interpretation has the greatest claim to veracity, and on what grounds? This boils
down to the question of articulation.

By 'articulation' I mean specifically the following. A thing may be said to be
articulated to, with or by another thing in a number of different ways. It may be
linked to it (as in the case of an articulating joint, hinge or chain). It may be some-
thing *spoken* by another thing or *expressed through* another thing (as when a

sentiment is articulated by someone). It may be a situation or relation in which one thing *determines* the character, behaviour, status, meaning or form of another thing. Or, vice versa, one thing may be *determined by* another. One thing in the relation may have *produced* the other thing or been produced *by* it. Or it may be said to be 'affiliated' with another thing, 'expressing' or 'an expression of' another thing, and so on.

Some relations are literal, mechanical or unequivocal. However, there is a sense in which in the realm of culture – in which relationships are neither straightforward nor predictable nor perhaps even knowable – they all have a figural element to them. And this is where difficulties enter. For being *affiliated* with, *expressing* or being an *expression* of, and so on, all beg the question of the precise nature, 'mechanism' or 'logic' of the relation. What is the nature of the articulation? What do figurative expressions like affiliated, expressing, attuned with and so on, *mean*? Is the 'expression' active or passive, productive or produced, determined or determining? In any case, how and why? In other words: *Where does the agency lie?* Where does the articulating action take place? This question is often elided, in many different kinds of (cultural) study – and certainly not just in accounts of Bruce Lee which attempt to deal with 'Bruce Lee *and...*' or 'Bruce Lee *as...*'. Rather than offering an analytical account of the relation of articulation that specifies where agency lies, such accounts offer descriptive or synthetic accounts that claim associations without fully specifying the nature of the association.

The work of Kato is an exemplary case in point. Throughout *From Kung Fu to Hip Hop* he asserts and reasserts a 'connection' between Bruce Lee and lots of other things. But the nature of these connections more often than not boils down to rhetorical sleights of hand on the part of the author, rather than being straight-forwardly demonstrable. Kato repeatedly equates things that are 'like' each other, or translates distinct realms, practices or phenomena 'into' each other by way of a third term – very often the idea of 'the beat' or 'the groove' – the jeet kune do 'beat' and the hip hop 'beat', and so on.

It is possible to open the book at virtually any page in order to see various unanalysed rhetorical devices structuring the work. For instance, Kato writes:

> In both *Jeet Kune Do* and hip hop culture, creativity arises from the autonomy of self-expression. Accordingly, the quality of a work of art is gauged by the unique-ness of individual expressions that transcend the institutional boundaries. Hip hop comes from funk, rock and r&b, or reggae, but it's free from any genre boundaries. So is *Jeet Kune Do*: it incorporates different styles into an open-ended system that is not institutionalized by any styles. However, both hip hop and *Jeet Kune Do* are

> not a postmodern bricolage of cultural multiplicity with weak or no foundation. The
> flourishing individual expressions in hip hop and *Jeet Kune Do* are well embedded
> in the cultural foundations and historical legacies: the African culture for hip hop and
> the Chinese culture for *Jeet Kune Do*. (2007: 177)

The range and interplay of internal contradictions and essentialisms within this paragraph is noteworthy (although, in the context of the book as a whole, this paragraph is not unique). Hip hop is essentially African, we are told, while jeet kune do is essentially Chinese. One may pause for thought about this. Both value the individual's creativity when faced with a range of material from a multiplicity of styles and practices, and this creativity means that neither are institutionalised nor limited by styles. And yet, this creativity is not 'postmodern' – because it is anchored in essential traditions, African for the hip hop individuals, Chinese for jeet kune do individuals. Yet these two cultures, 'both *Jeet Kune Do* and hip hop culture', can be singled out and compared or drawn into supposed equivalence or identity because within them both 'creativity arises from the autonomy of self-expression'. Implicitly, that is, these 'two' are 'the same' in a way that is *different* from any other possible thing that either might be put into a comparison with. But is this necessarily so? Is it not possible to compare either of these two not with each other but with, say, artistic practice, business practice, school work, and find that 'creativity' arises in much the same way? The rhetorical trick here involves proposing a state of exceptionality for these two valued 'cultures', drawing them into equivalence and then conflating that equivalence into a state of effective identity.

Kato immediately proceeds to quote a passage by Jeff Yang which performs much the same operation:

> In inventing Jeet Kune Do, [Lee] took the lean and lethal kung fu style known as
> Wing Chun and stripped it down to the primal beats. ... Because the art of Jeet
> Kune Do was motivated by practicality, it evolved like hip hop: It began in the old
> school – spare, freestyle, with nothing separating the master from the rhythm. And
> then, only after locking down the basics, did Lee start sampling the best of what
> other disciplines had to offer, biting on world flavours like Muay Thai, Jiu Jitsu, and
> Tae Kwon Do. Even toward the end of his days, Lee was still remixing. (Quoted in
> Kato 2007: 177–8)

Although more apparent in Yang's passage here, the constructive/inventive processes are effectively the same as those used by Kato: the valued terms are represented through attractive images and analogies and presented as unique.

But let me be clear. To say that the connections between a and b are neither clear nor certain is *not* to say that there is *not* a link between, say, Bruce Lee and international anti-racist movements (Prashad) or even between Bruce Lee and 'popular cultural revolution' (Kato), or indeed between Bruce Lee and anything else at all, for that matter. It is simply to ask for further specification of the relation. What we mostly see in this regard is exemplified in the passage from Prashad given in the quotation above. In it, Bruce Lee is lined up with other historically, geographically, temporally or otherwise potentially 'associated' material, and a relation is assumed, implied or fabricated, but without being fully clarified. If we reread the following sentence from Prashad, for instance, we can see this occurring. He writes: 'US television, with *The Green Hornet*, 1966–67, embraced Bruce Lee to play the Asian, just as the state acknowledged the role of Asians in the creation of a cold war United States'. Here, a connection is made between the televisual emergence of Lee and certain legislative changes. But *is* there a connection? If so, what is it, where is it, who is it a connection 'for', how does it 'work', where and why did or does it happen?

Kato is most helpful with the suggestion that the connection between Bruce Lee and 'popular cultural revolution' is 'expressed in two narrative modes: symbolic articulation and kinetic articulation' (2007: 41). By this, Kato refers to the way in which the narrative and choreographic styles, techniques and formulas employed by Bruce Lee's films tapped into ongoing struggles in ways that appealed to certain constituencies at a particular historical political moment – a moment Kato characterises as dominated by 'decolonization struggles'. Thus, for Kato, in Lee, it's not just *that* the underdog wins, but it is the *way* the underdog wins, and *who* he beats. This suggests that the 'reality' of Lee's relation to wider struggles is a *visibility* produced by the combination of two factors: first, the encoding of historical and ongoing cultural struggles, dramas and conflicts within the semiotic structure of the text, combined with a context of reception in which the interpretive tendencies of the audience are more or less attuned or inclined towards *seeing* such connections. This is why, although many texts employ the same sorts of familiar devices as those that are found in Bruce Lee films – devices which are little more than dramatic and semiotic clichés – in certain times and places, these can become politically affective. Or, as Kato puts it, 'only through rigorous historical and social contextualization can this symbolic narrative become legible, thereby unfolding the means by which it liberated the unconscious of the Asian people faced with the image of colonization by the neo-imperialist cultural industry' (2007: 40). As such, for both Kato and Prashad, the decisive factor about Lee that 'connects' him with other contexts and scenes relates to the convergence of his films' dramatisation in condensed form of ongoing tensions,

resentments and ethnically inflected power imbalances. Bruce Lee films offer the possibility of politicising consciousness – of producing a *visibility*.

'Visibility' is considered by Rey Chow to involve more than mere literal vision (as in the sense of 'There it is: I can see it!') and also more than metaphorical seeing (as in the sense of 'Aha! I see! I understand!'). Rather, Chow directs us to the sense of 'visibility as the structuration of knowability' (2007: 11). In this, Chow takes her inspiration broadly from Foucault and occasionally from Gilles Deleuze (especially in Deleuze's explicitly Foucauldian moments).[1] Similarly, one might equally evoke Jacques Rancière's notion of the 'partition of the perceptible'. But the point is that, as Chow puts it, 'becoming visible is no longer simply a matter of becoming visible in the visual sense (as an image or object)'; rather, there is also a sense in which visibility should refer not only to visible images and objects but also to 'the condition of possibility for what becomes visible' – whatever objects and images are visible, and the way in which they are visible, depends on what she calls 'this other, epistemic sense of visibility' (ibid.).

Visibility and making-visible, then, are more complex processes than simply empirical orientations could countenance (or indeed 'see'). The theoretical and conceptual issues attending to visibility involve something other than empirical considerations, such as those relating to the selection and make-up of who or what is represented where and when and how. According to Chow, in fact, there is a 'political' dimension to visibility and visuality which relates to 'the condition of possibility for what becomes visible' and involves matters to do with the 'discursive politics of (re)configuring the relation between center and margins' (ibid.). That is, *visibility* depends first on the establishment of a shared field of intelligibility as the condition of possibility for understanding ('seeing') and being understood (or 'seen').[2] The condition of possibility for any 'shared meaning' and hence 'intelligibility' or 'visibility' *per se* is always already a complex 'achievement', 'construction', 'outcome' or 'stabilisation'.

The question is what kind of visibility was Bruce Lee involved in the production or construction of. The relation between kung fu in America, America in Vietnam and Vietnam 'in America' has become a subject much remarked. However, Brown points out, such a connection was rarely perceived or proposed at the time, not least because it is 'a connection that necessarily blurs the geographic history and the heterogeneity of the martial arts'. Nevertheless, notes Brown,

The connection between a post-Vietnam moment and the moment of the kung fu 'craze' … surfaced rarely in 1973, but tellingly. David Freeman explained the craze bluntly: 'They beat us over there [and] we demand to know why. Our POWs are home and now America needs to know [the] enemy's secret weapon'. While kung

fu *per se* was certainly no secret weapon during the war, Lee's guerrilla tactics [particularly in *Fist of Fury* and *Enter the Dragon*] replicate what was taken to be the strategy by which US forces were defeated – which might be best understood not as knowledge about why 'we' lost, but as knowledge about how 'they' won. The conservative commentary on the martial arts, long after 1973, still considered their popularity an expression of global conflict. One satirical reporter claimed of the All-American Open Karate Competition that 'half the contestants and more than half the audience are black or hispanic: karate is Third World anger release. Anyone can guess the unspoken implication: that those little, wiry yellow folk are superior'. It would be wrong to perceive in this anything less than anxieties about a new yellow peril, exacerbated by the image of an interethnic bond. (1997: 36)

Much has been written about the 'interethnic bond' indexed by the appeal of Asian martial arts to black Americans. Some have connected it to a 'countercultural investment in Taoism and Buddhism' (1997: 32); others to slick and targeted trailers for the films themselves; whilst 'Raymond Chow himself pointed to Nixon's visit to China in 1972, and the subsequent US interest in Chinese culture' (ibid.). But for Brown, 'it is less the ethnic specificity of Bruce Lee than what we might call his generic ethnicity that seems to have inspired the enthusiasm of the US black inner-city audience' (ibid.). This 'generic ethnicity', he proposes, was accompanied by 'an implicit invitation to translate the ethnonationalist conflicts staged within the kung fu film into the conflict of class' (ibid.).

Many Hong Kong kung fu films, including Lee's, are strongly organised by class antagonisms. Indeed, says Brown, 'if we're to believe the accounts of this international *mass* spectatorship, we might imagine a (failed) moment of international *class* longing' (ibid.). In any eventuality, if there was a lag in scholarly knowledge about martial arts culture and its connections with ethnic groups globally ('commentators groped for a rationale to explain the particular attraction of kung fu for black audiences', writes Brown (ibid.)), market mechanisms in the form of marketing strategies were quick to respond: 'the industry's report on the primary audience for the twenty-one kung fu films that appeared in the United States in 1973 made it clear to producers that a new market had emerged'; as such, continues Brown, 'not unpredictably, *Black Belt Jones*, in which black martial arts students battle white gangsters, became the "first U.S.-lensed martial arts actioner"' (ibid.). Thus, notes Brown, 'While "invisibility" had come to be understood, by some, as the provocation of the city riots of the 1960s, in the early 1970s the black population had become visible to the film industry as a potent consumer constituency' (ibid.). The interethnic bond, then, could be said to be structured by the visual contours of a common process of ethnicisation shared by

black and Asian subjects and organised by cinematic texts with Bruce Lee, who instantly 'became synonymous with kung fu' (1997: 31), at the forefront.

We see here the workings of a complex relation between visibility and invisibility around martial arts and cultural politics. Invisibility, exclusion, subordination and marginalisation in social, cultural and political realms and registers help add an affective interpretive charge to moments of visibility. Even texts that are, semiotically-speaking, simplistic, clichéd or hackneyed may then be said to become variously 'related' to wider social issues. A claim such as this implies that articulation involves processes of displacement *and* directness, fantasy *and* social engagement, escapism *and* expression. As Brown puts it, 'The slippage between race, nationality, and class – not in oppositional thought but in urban culture – is precisely what seems to underlie the attraction to kung fu in 1973' (1997: 36).

Yet there is a double movement involved here, which suggests that we should hesitate before rushing to the conclusion that the interethnic bond activated in the process of cinematic identification is *simple* or *simply emancipatory* in any way. For, first of all, it is not simply 'hispanics', 'blacks' and 'Asians' who are somehow 'united' or 'hybridised'. Rather, any 'postnational political affiliation' that may emerge is clearly predicated on 'the affiliation between Hong Kong and Hollywood'. This affiliation is easy to specify. Its nature is financial. It 'worked' to the extent that it was, in Brown's words, 'affectively subsidized by the longing of the urban masses' (1997: 36–7). So, as Brown emphasises, we also need 'to understand the attraction to kung fu films as taking the place of, as displacing, any sustained attraction to the radical postnationalizing imagination' (1997: 36). Indeed, he notes: 'As one French commentator dismissively put it, the films offer a "dream where politics are resolved by a boxing match"' (ibid.). So, the potentially problematic or complicating dimension to martial arts films is that the 'kung fu craze thus seems explicable within the cultural logic of urban history as explained by David Harvey, intensifying his sense of 1973 as the pivotal year in the transition to what he calls postmodernity' (ibid.). In a sense, then, what this means is that the 'urban spectacle of mass opposition that violently disorganized the space of American cities in the 1960s was finally transformed into the organized spectacle of consumption. In this, the 'countercultural scene resurfaces as the commodification of subculture' (ibid.). And it is within such a movement that, with their films that include 'the local display of local ethnicity and multiethnic harmony, Golden Harvest, the Shaw Brothers, and Cathay Studios displayed interethnic and interclass violence that marked and managed the otherwise suppressed conflicts of the inner city' (1997: 37).

Thus, the move to the multicultural moment also involves a distinct displacement away from politics as such. Indeed, Brown's entire essay is an analysis of

'how the political resistance of the 1960s transforms into the consumer plea-sure of the 1970s and 1980s and, further, how collective radicality becomes transcoded into a privatizing politics of consumption' (1997: 25–6). However, unlike cultural critics who bemoan this familiar movement of cultural appropria-tion and domestication, what Brown seeks to emphasise is the way that 'the conditions of postnational possibility – the structural costs of what we might call *outward mobility* – are inscribed within the everyday' (1997: 26; emphasis in original). Indeed, Brown concludes, it might be said to be the case that, at least sometimes, 'postnationality finally exists neither as the work of "international-ists," nor as the local instantiation of an interethnic and international bond, but as a physical feat consumed as an image in the register of mass culture' (1997: 42). As a visual 'physical feat' *par excellence*, Bruce Lee – even though always-already commodified – can similarly be seen to constitute a pole of identification enabling the possibility of consciousness:

> If the reception of Lee's films seems to displace an overtly political and explicitly postnational affiliation with interethnic identification, then Johnson's story [a story introduced and discussed below], while metonymically recording that reception, exhibits a double displacement: violence has been evacuated from the martial arts aesthetic, and, characteristic of the growing appreciation of kung fu in the 1980s, a class-coded mode of revenge (harking back to the Boxer Rebellion) has been transcoded into a search for self. By 1980, one could learn in the pages of the *Atlantic Monthly* that the 'real value lies in what the martial arts tell us about ourselves: that we can be much more than we are now'. Existentialist struggle replaces both class and ethnic conflict in a classic case of the embourgeoisement of mass-cultural and cross-cultural novelty. (1997: 37)

In other words, in a positive register, we can say that hindsight and familiarity allow us to construe Bruce Lee's anti-institutional interdisciplinary humanist countercul-tural vitalism as something relatively typical of the late 1960s and early 1970s. These were the wonder years of political imaginaries: Paris 1968, civil rights, the counterculture, Mao, Marx, anti-psychiatry, feminism and so on. Bruce Lee cobbled together and baptised his postmodern anti-institutional inter- and antidis-ciplinary martial art 'Jeet Kune Do' in (of all places) California in (of all years) 1968 (Inosanto 1980: 66). But, in a less positive register, we can also say that perhaps hindsight obliges us to regard this change as historically or ideologically overde-termined, rather than straightforwardly emancipatory. Such would be the position of a Régis Debray or a Slavoj Žižek: it's the economy, dummy. It's the commodify-ing logic of late capitalism. As is widely known, for Žižek, the key consequence

of the student protests of 1968 was that, 'in Hegel's terms, the "truth" of the student's transgressive revolt against the Establishment is the emergence of a new establishment in which transgression is part of the game' (2001a: 24). All concomitant revolt against institutions, status quos and indeed even cultures and societies (for being constraining, stultifying structures) is merely the demand of a *zeitgeist*, which itself is produced during a time of capitalism's upheaval or readjustment to its 'late', postmodern stage.

BRUCE LEE AND THE NEW AGE SPIRIT OF CAPITALISM

It is pertinent to note here that Žižek also often asserts his conviction that ersatz forms of Buddhism and Taoism – what he calls Western Buddhism and Western Taoism – came to arise as the 'spontaneous ideology' of contemporary global capitalism. This, he claims, is because Taoist and Buddhist tropes, terms, platitudes and mantras *seem* to answer the questions and to calm the anxieties that arise in states of confusion, chaos, indeterminacy, deregulation and flows (ie in free-market capitalism), much better than more hard-line alternatives, such as the regressive retreat into nationalisms or fundamentalisms. In making this argument, Žižek follows Max Weber, explicitly supplemented by ideas from Althusser and Lacan, by claiming that just as Protestantism and beer were a large part of the hegemonic ideology of industrial-stage capitalism, so Westernised Taoism, as crystallised in fashionable practices like meditation and feng shui, are the superlative ideology of postmodern consumer capitalism. Indeed, as he sees it,

> The ultimate postmodern irony is … the strange exchange between Europe and Asia: at the very moment when, at the level of the 'economic infrastructure,' 'European' technology and capitalism are triumphing world-wide, at the level of 'ideological superstructure,' the Judeo-Christian legacy is threatened in the European space itself by the onslaught of the New Age 'Asiatic' thought, which, in its different guises, from the 'Western Buddhism' (today's counterpart to Western Marxism, as opposed to the 'Asiatic' Marxism-Leninism) to different 'Taos', is establishing itself as the hegemonic ideology of global capitalism. Therein resides the highest speculative identity of the opposites of today's global civilization: although 'Western Buddhism' presents itself as the remedy against the stressful tension of the capitalist dynamics, allowing us to uncouple and retain inner peace and *Gelassenheit*, it actually functions as its perfect ideological supplement. (2001a: 12)

If this *is* so, then it seems reasonable to propose that Bruce Lee must *obviously*

be a part of any such strange exchange between Europe and Asia. Indeed, all the narratives about Bruce Lee's life offer versions of this strange exchange: Western-led 'success'; 'victory' of 'Eastern' ideas. And although Žižek does not assess Bruce Lee in terms of this argument, he has passed comment on the changing status of Bruce Lee's popularity, as we have already seen: the context of Žižek's comments on the popularity of Bruce Lee is his afterword to Rancière's *The Politics of Aesthetics*. Žižek's title is 'The Lesson of Rancière', a title based on a strong allusion to Rancière's own text *The Lesson of Althusser* (1974). It is in this context that Žižek mentions Bruce Lee to exemplify his argument about 'new age' ideology:

> When, three decades ago, Kung Fu films were popular (Bruce Lee, etc.), was it not obvious that we were dealing with a genuine working-class ideology of youngsters whose only means of success was the disciplinary training of their only possession, their bodies? Spontaneity and the 'let it go' attitude of indulging in excessive freedoms belong to those who have the means to afford it – those who have nothing have only their discipline. The 'bad' bodily discipline, if there is one, is not collective training, but, rather, jogging and body-building as part of the New Age myth of the realization of the Self's inner potentials – no wonder that the obsession with one's body is an almost obligatory part of the passage of ex-Leftist radicals into the 'maturity' of pragmatic politics: from Jane Fonda to Joschka Fischer, the 'period of latency' between the two phases was marked by the focus on one's own body. (2004: 78–9)

Although there is a lot going on in this argument, the essential point is that, to Žižek's mind, the initial Western interest in Bruce Lee during the kung fu craze in the early 1970s was a 'genuine working-class ideology'. By the 1990s, this interest had morphed into its monstrous double, becoming a 'perfect ideological supplement', an exemplary part of 'the hegemonic ideology of global capitalism'. In other words, in Žižek's schema, Bruce Lee iconography *once* worked aesthetico-politically as a kind of subjectivating fantasy for the working classes, for 'youngsters whose only means of success was the disciplinary training of their only possession, their bodies'. But *now*, at least to the extent that interest in martial arts has become bound up with the wider ideological tendency to focus on 'the realization of the Self's inner potentials', Bruce Lee and martial arts become disarticulated from 'class' and *therefore* (in Žižek's model) from 'resistance' (2004: 79).[3]

As this argument about Bruce Lee and 'class' is made in the afterword to *The Politics of Aesthetics*, it seems pertinent to consider Žižek's reading of Rancière.

Readers of Rancière will note that Žižek's move into a discussion of 'class' is in a strong sense a contortion of Rancière's own thinking of politics as arising from a miscount – as it were, for Rancière, politics is *not simply about class*, but rather the inevitability of *misclassification* – the impossibility of a smooth, geometrically ordered society into stable classes. But Žižek's reading of the potential politics of kung fu aesthetics (as exemplified by, as he says, 'Bruce Lee, etc') is this: the image *was good*, he suggests, the image *was generative*. But then it *became* warped or perverted – ideologically 'appropriated', 'colonized' or 'hegemonized'. In fact, Žižek's position appears to boil down to something strongly akin to a witty observation once made by the comedian Frank Skinner (2002): the difference between working-class men and middle-class 'new men' is that although both may be equally interested in fighting, 'new men' go to kickboxing or Brazilian jujitsu classes three times a week to improve themselves and to keep fit, while working-class men simply really fight – in pubs and on the street. In other words, for Žižek, if the emergence of the image was a pole of *subjectivating identification*, the future of the image is ideological phantasy. So, like many thinkers, Žižek's point is that images, moments, events, become (to use an overburdened and deeply problematic word) '*co-opted*' – ideologically recuperated: domesticated, channelled, moved into a place.

Taken on the strength of his reading of Bruce Lee alone, then (or rather, Lee-inspired martial artists), Žižek's reading of *The Politics of Aesthetics* (and his assessment of Bruce Lee's intervention) appears rather awkward and limited. Nevertheless, his proposition that *something about* Bruce Lee's image has (or had) 'aesthetico-political' potential remains tantalising. This is especially so given the double or *chiasmatic* status that such a figure as Bruce Lee must ineluctably have within Žižek's idiosyncratic ideological cosmology. For if – as Žižek repeatedly claims – the hegemonic ideology of contemporary capitalism can be seen in 'the strange exchange between Europe and Asia' (with 'Western Buddhism' and 'Taoism' becoming the hegemonic ideology of contemporary capitalism) then therefore we must surely accord a central status to the exchanges facilitated by *precisely* such figures as the star of 'the first American produced martial arts spectacular'.

How are we to assess the strange exchanges taking place in, around and through a transnational text like *Enter the Dragon*? Whilst analyses like those of Prashad and Kato are compelling and detailed, their outright blindness to the possibility of a critique of the order of Žižek's basic Marxist proposition suggests that they are organised in such a way that they stop before fully considering or focusing on the complexity of the emancipatory claims they value. That is, they do not fully interrogate their own values and investments. This is not to say that

Žižek fully interrogates his, of course. Far from it, perhaps. It is just that, in these and many other works, Bruce Lee is largely constructed as an unequivocally progressive and positive object. Yet, as Bill Brown sagely points out:

> One of Stuart Hall's reiterated points that 'this year's radical symbol or slogan will be neutralized into next year's fashion', that 'today's cultural breaks can be recuperated as a support to tomorrow's dominant system of values and meanings' – is a point easily illustrated by the history of kung fu's success. Chuck Norris, who had demonstrated martial arts at several US military bases in the early 1960s and co-starred (as the loser) with Lee in 1973, soon managed to whiten martial-art masculinity on film. The further commercialization and institutionalization of kung fu marked by the proliferation of kwoons and regional kung fu federations depended on attracting a more heterogeneous consumer group. To take a well-known case in point: on the one hand, Jamaican-born Carl Douglas, culturally cross-dressing as the martial artist to promote his hit 'Kung Fu Fighting' (1974), sustained the sign of interethnic, countercultural challenge; on the other, the song mainstreamed and streamlined the aggression by reducing it to the rhythm of disco. The 'discotized tribute to the legacy of Bruce Lee', as the music industry called it, might be understood as working to discipline the notoriously raucous audience reaction to the films by syncopating the physical response to Lee's violence, just as it worked to homogenize martial art choreography into the mainstream codes of dance. (1997: 37)

Following trends and transformations equivalent to these in other aspects of the political dimensions of popular culture, perspectives offered by many thinkers (including Régis Debray, Slavoj Žižek (2001a), Michael Hardt and Antonio Negri (2000), or Joseph Heath and Andrew Potter (2005)) often take us to this sort of point – namely, the point at which potentially revolutionary impulses are shown to have been 'co-opted', appropriated, expropriated, (re)colonised or hegemonised by 'the mainstream', or indeed by the capitalist logic of commodification. Such approaches often slide from this observation into sad conclusions about the failure of popular culture to achieve anything like a progressive political agency. In fact, it is also the case that part of Brown's own study of the martial arts phenomenon is to 'make legible the way US kung fu culture itself effectively expropriated and existentialized mass-cultural, inner-city history from the early 1970s, a history in which the radical politics of the 1960s seemed to resurface as "radical consumption"' (1997: 38). However, unlike the types of critique offered by cultural commentators such as Žižek or Heath and Potter, which are little more than the claim that 'the counterculture became the consumer culture', Bill Brown's reading of martial arts culture does not proceed according to an all-or-nothing mode,

and so does not settle on such a dramatic, fatalistic (or anti-popular-cultural) point. Rather, Brown asks: 'How does the transnational flow of goods and services extend the consuming subject's *affiliative horizon*, and how does it thus revise (or leave unrevised) existing accounts of ethnic, national, and mass subjectivity?' (1997: 24; emphasis in original)

Brown poses this question in terms of a reading of a short story by Charles Johnson, entitled 'China' (1983), which centres on the life of Rudolph and his wife Evelyn:

Rudolph Jackson is a 54-year-old national employee, a post office worker with high blood pressure, emphysema, flat feet, skinny legs, a big belly, and a 'pecker' that shrinks 'to no bigger than a pencil eraser each time' he sees his wife undress. [...] Out with his wife one Saturday night to see a 'peaceful movie', his 'eyelids droop' during the feature, but he is enthralled by a trailer for a kung fu film, which Evelyn thinks of as 'a poor excuse for Chinese actors or Japanese (she couldn't tell those people apart) to flail the air with their hands and feet, take on fifty costumed extras at once, and leap twenty feet through the air in perfect defiance of gravity'. [...] Rudolph, rather than joining her the next day at the revival meeting at their Baptist church, returns alone to watch the movie at the Commodore Theater. Even more enthralled by the 'beauty' of the martial art, he joins a kwoon, sends for eight hundred dollars' worth of equipment, starts to meditate, begins an extraordinary physical regime that prompts his complete physical and psychic rejuvenation, and finally performs his success, after eight months, by competing in a kung fu tournament held in Seattle's Kingdome. (1997: 24–5)

This familiar narrative again describes a process initiated by a cinematic experience. The process itself (its formations and its results) exceeds the bounds of cinema, of course. The 'contour of this plot is not unfamiliar', says Brown, because 'it corresponds to what Susan Jeffords has taught us to call "the remasculinization of America"' (1997: 25). Yet Brown reminds us: the putative '*process* of remasculinization ought to be understood ... as the permanent *state* of American manhood' insofar as it is 'the projected crisis' itself 'which (from James Fenimore Cooper to Robert Bly) helps to sustain the power of American men, who – appearing perpetually oppressed by the family, the economy, the state – appropriate the rhetoric of oppression to justify their self-assertion' (ibid.; emphasis in original).

What is specific to this example, though, is that Rudolph's 'access point to masculinity is ... Hong Kong's film industry' (ibid.) – and pointedly *not* the American military. For, having been prevented from entering the military for medical reasons, Rudolph nevertheless expresses his newfound passion for kung fu in

terms 'echoing the U.S. Army's famous slogan of the early 1980s: "Be All You Can Be"'. As Brown notes: 'Exasperated by his wife's failure to understand his new preoccupation, Rudolph patiently explains that he doesn't "want to be Chinese": "'I only want to be what I *can* be'" (1997: 24). Given that the military slogan that Rudolph is echoing here was designed as an interpellative device of the state ('a slogan meant to recode the post-Vietnam military as the site of postpatriotic self-realization' (ibid.)) but is reiterated by Rudolph and put to quite different ends, Brown approaches the story in 'China' as a work which engages with the question of the interaction of 'commodity culture, mass masculinity, and spectatorship' in terms of 'three different, and differently narrated histories – of "world literature", of the global reception of kung fu films, and of the war in Vietnam' (1997: 25).

So, on the one hand, if what Rudolph sought was remasculinisation, a sensuous experience of self-worth and potency, then the manner in which this became possible – and indeed, what Rudolph's 'decision' testifies to – is the subjective power of the workings of a complex discursive moment or movement. This can be most obviously seen in the fact that his 'new body is predicated on a globalizing media-distribution network' (1997: 24). The effects of this network condense in the encounter with the cinematic text of those whose experiences and existential struggles involve problems of ethnic and class prejudice and exclusion. They enable new forms of identification and practice to emerge. Accordingly, even if Žižek and other all-or-nothing thinkers are right to lament the fact that the future of the image is hegemonic incorporation and ideological domestication, there remains something more at issue and at work than straightforward politics and straightforward protest, conceived in the most prosaic or indeed Cartesian manner (in terms of the intentionally, consciously protesting political subject). What this is relates to the significance of discursive mediation, discursive 'communication'. For, what 'happened' when Bruce Lee 'happened' constituted an intervention, a displacement and a transformation, in many registers and realms – public, private, discursive, psychological, corporeal – in transnational popular culture. *Enter the Dragon*, no matter how celluloid, phantasmatic, Orientalist asiaphiliac/asiaphobic, was an *intervention* – an *event*. To borrow the words of Jacques Derrida, it seems clear that 'what happens in this case, what is transmitted or communicated, are not just phenomena of meaning or signification', for 'we are dealing neither with a semantic or conceptual content, nor with a semiotic operation, and even less with a linguistic exchange' (1982: 309). Rather, to isolate the word that Alain Badiou has made his own: we are dealing with an *event*.

THE EVENT OF BRUCE LEE

As Badiou argues, events are *encounters*. Moreover, they cannot be communicated as such – at least not in any conventional sense of the term communication. Rather, in Badiou's view,

> Communication is suited only to opinions. [...] In all that concerns truths, there must be an *encounter*. The Immortal that I am capable of being cannot be spurred in me by the effects of communicative sociality, it must be *directly* seized by fidelity. That is to say: broken ... with or without knowing it, by the eventual supplement. To enter into the composition of a subject of truth can only be something that *happens to you*. (2001: 51; emphasis in original)[4]

But what was it that happened? And how? If there is a 'change' as a result of an encounter with the cinematic text, then, in the words of Rey Chow, what is clear is 'the visual encounter and the change, but not *how* the visual encounter caused the change' (1995: 7). Thus, Chow suggests: 'The central question in all visual encounters boils down to this simple *how* ... how do we go about explaining the changes it causes in us?' (ibid.). What happened to the many who reported a profound change in light of the encounter with the celluloid Bruce Lee might perhaps be understood in terms of the Althusserian paradigm of *interpellation*, which is, after all, a theory about the mechanism of how we become (again and again) certain sorts of subjects. Yet the question remains: who or what is or was doing the interpellating, or the making of subjects of and for what power or institution? For someone like Žižek, it is the case that if the emergence of the image was once a pole of *subjectivating identification*, the future of the image is ideological phantasy. However, as Rancière has argued, there is also the process of *subjectivization*, which often exists in complete opposition to 'interpellation'. So, where Žižek (in a way that is not all that different from Althusser) would see imaginary and symbolic identification as *placing* us in a *pre-given ideological* 'place', Rancière prompts us to see *identification as a disidentification that displaces us into a political 'place'*. This is a place of what Rancière calls 'the aesthetic dimension of the reconfiguration of the relationships between doing, seeing and saying that circumscribe the being-in-common'. And this 'aesthetic dimension', he continues 'is inherent to every political or social movement' (2000: 17).

The question then must be: is the entrance of the dragon therefore part of a political or social movement? Yes and no. Not in any necessarily conscious or realist sense of 'political'. But definitely in terms of the discursive 'reconfiguration of

the relationships between doing, seeing and saying that circumscribe the being-in-common' (2000: 17). This aesthetic event is embodied in a restricted economy of movement (and stillness) punctuated by what instantly became signature gestures. Yet even so, in this, to use Derrida's words again, 'what is transmitted or communicated, are not just phenomena of meaning or signification', for 'we are dealing neither with a semantic or conceptual content, nor with a semiotic operation, and even less with a linguistic exchange' (1982: 309). But at the same time, the entrance of Bruce Lee into global popular culture constituted for many an event of the order of what Badiou makes of St. Paul's encounter on the road to Damascus – as mentioned earlier – an event producing a range of performative fidelity-procedures. And this is where we began, with Miller, Rudolph, Prashad, Kato, and countless others; even if, paradoxically, what most remains of Bruce Lee today – what remains most 'familiarly known' – are the gestures – the signatures – gestures which once punctuated and defined a discourse, but which, outside of that discourse, to borrow a phrase from Ernesto Laclau, have become fetishes, dispossessed of any precise meaning.

BRUCE LEE BEYOND BELIEF

Nevertheless, Bruce Lee arguably remains *incredible*. Certainly, every time I see him again, it is as if for the first time. I use the word 'incredible' deliberately, and not uncritically. This is because, despite its apparent simplicity and familiarity, the word 'incredible' can and often does mean *both* 'believable' *and* 'unbelievable' – at the same time. If something is incredible, it is hard to believe. You want to, but you cannot entirely commit to it. Bruce Lee remains incredible in this way: incredible in a paradoxical and ambivalent sense. The cinematic spectacle of Bruce Lee seems to testify to something believable (Bruce Lee's apparently real – incredible – skill), but at the same time, what the image shows us also appears to be an incredible, unbelievable, constructed, spectacular simulation.

This ambivalence is a characteristic problem of all representation. In this context, representation drags the cinematic spectacle and the uncertain reality or unreality of bodily ability into an incredible relation. Yet is this essentially distinct from other forms of representation, or indeed from representation as such? According to Alain Badiou, there is a 'preformed philosophical response' to cinema, which 'comes down to saying that cinema is an untenable relation between total artifice and total reality' (2009). He writes: 'Cinema simultaneously offers the possibility of a copy of reality and the entirely artificial dimension of this copy'; what is more, this preformed response asserts that 'with contemporary

technologies, cinema is capable of producing the real artifice of the copy of a false copy of the real, or again, the false real copy of a false real. And other variations'. As such, 'This amounts to saying that cinema has become the immediate form (or "technique") of an ancient paradox, that of the relations between being and appearance' (ibid.).

Writing about written and spoken testimony and belief, Jacques Derrida proposed that

> one can testify only to the unbelievable. To what can, at any rate, only be believed; to what appeals only to belief and hence to the given word, since it lies beyond the limits of proof, indication, certified acknowledgement, and knowledge. [...] It is always a matter of what is offered to faith and of appealing to faith, a matter of what is only 'believable' and hence as unbelievable as a miracle. Unbelievable because merely 'credible'. The order of attestation itself testifies to the miraculous, to the unbelievable believable: to what must be believed all the same, whether believable or not. (1998a: 20)

Although Derrida's words here refer to spoken and written *words*, it is clear that the complex ambivalence of such representation is active in terms of the status and work of the visual image or spectacle. As both Brooks Landon (1992) and Leon Hunt (2003) have depicted it, what they call 'the aesthetics of ambivalence' permeates all kung fu films. Hunt characterises this in terms of 'an ambivalence predicated on the paradox of cinematic trickery (accepting the 'fake' as 'real')' that is involved in all action cinema, combined with 'a seemingly impossible investment in both documentary realism and fantasy' that characterises martial arts fandom in particular (2003: 28). As has been widely remarked, watching Bruce Lee move and fight seems to involve all three components, in a way that is rare even in martial arts film: yes, we know it is a fictional film with staged and edited choreography, yet Bruce Lee's skill seems persuasive, plausible and real (incredible yet credible); yes, we know this is fantasy, yet it seems so convincing, and so on, in a vertiginous circle of belief and disbelief, with each element feeding and frustrating the other, in terms of a desire to believe combined with a knowledge that, in any case, there is always going to be something fundamentally fantastical, phantasmatic and fake about the spectacle ... *and yet* always also something that is going to seem ineradicably to be fundamentally believable.

One way to encapsulate a dimension of this is to state that the aesthetics of ambivalence involve knowing very well that something here is fake, but nevertheless desiring it, believing it. According to Žižek, in psychoanalytic terms, the perspective or attitude of 'I know very well, but nevertheless...' is the very formula

of the fetish. (This is reiterated so often throughout Žižek's work as to make one reference superfluous.) So, martial arts fandom might easily be 'diagnosed' as fetishistic. And this may be so. Yet such a diagnosis too hastily downplays the complexity of the doubt and desire that can arise in response to the spectacle. For it is not as if viewers who *come* to enjoy the spectacle or *sometimes* enjoy the spectacle *always* knew this, in advance, or came to view it *in order* to get a 'fix', or to 'get off' on the violence, *because* it is their fetish and they are fetishists. That is to say, such a perspective is too quick to characterise viewers as 'types' – as groups, as pre-constituted viewing constituencies. Moreover, such a diagnosis does not in itself tell us anything about *how* or *why* this might happen: *how* one might 'become' such a fetishist/fan, *how* or *why* one might be affected, altered by a visual spectacle – and *when*, *where*, in what contexts, with what effects. How does 'being' a fetishist/fan affect my 'being'? Is it the case that martial arts fans are a 'group', a 'type', in the sense that they all share some psychological or sociological similarity – some shared developmental 'tic' in common? Is the film a spark which can only ignite certain socio- or psycho-logical 'types'?

There are many psychological and sociological approaches available to scholarship, which pursue such a thread. Many of these approaches move swiftly into empirical, ethnographic and quantitative styles of scholarship. In doing so, they inevitably turn away from the textual moment or event, preferring instead to conduct 'fieldwork' or to ask questions about race, gender, class and other psychological and sociological formations in the determination and significance of 'taste'. Without disparaging such orientations, my own approach does not seek to follow such a line. Rather, it is concerned first of all with focusing on what we might call the *event*, the *cinematic event*, the complexity of the textual moment of *encountering* the cinematic text or spectacle. Bruce Lee is primarily – although not exclusively – a cinematic textual construct. What we 'know' of him, and the way in which we know him, has been constituted overwhelmingly by the cinematic apparatus. As such, if 'Bruce Lee' is ever involved in anything like a 'change' (whether in 'us' or 'them', whether here or there), then it is the *encounter* with the cinematic spectacle would seem to define the 'actual moment' or scene in or from which a change – whether a change into fan-fetishist, practicing martial artist, or whatever – could be said to 'happen', no matter what socio-cultural or subjective ingredients could be said to have been 'in' us beforehand.

This is not to *abstract* film from a social context. On the contrary, Bruce Lee clearly informs, defines, determines or supplements many and varied 'popular cultural formations'. Such formations clearly matter – at least, if culture 'matters'. But it seems important to emphasise that such formations are constituted, called into being or organised around or through a cinematic spectacle, becoming what

Meaghan Morris calls a 'popular cultural genre', in which 'people take up aesthetic materials from the media and elaborate them in other aspects of their lives, whether in dreams and fantasies, in ethical formulations of values and ideals, or in social and sometimes political activities' (2005: 1). It is towards this productive, 'pedagogical' dimension to Bruce Lee that we will now turn.

notes

1 Chow quotes from Deleuze (1988: 52, 58, 59; see also Chow 2007: 11).

2 For Jacques Rancière, the political moment is a certain kind of 'speech situation' – which he calls one of 'disagreement'. It is 'one in which one of the interlocutors at once understands and does not understand what the other is saying. Disagreement is not the conflict between one who says white and another who says black. It is the conflict between one who says white and another who also says white but does not understand the same thing by it' (1999: x; see also Arditi 2007: 115).

3 Of course, quite *how* an 'authentic' interest in physical violence (working class or otherwise) amounts to 'aesthetico-political protest' or 'resistance' is left unsaid by Žižek. Indeed, this is a problematic assertion, given that most studies of working-class or indeed underclass pugilism and prize-fighting among 'those who have nothing [but] their discipline' (such as illegal immigrants in the southern USA, for instance) suggest that the ideals and aspirations of those involved are straightforwardly financial, rather than aesthetico-political (see Wacquant 1995; Heiskanen 2006). Žižek does not address any of this, or anything like it, at all. Rather, his aim is simply to evoke the way in which the *image*, the *aesthetic*, opens a door in perception which can transform not only a viewer's relation to reality but also lived reality itself.

4 In its simplest form, the event of Bruce Lee boils down to this: in viewing Bruce Lee, something happened to many people. This took place overwhelmingly at a certain historical moment, and in certain places (although it is not limited to that time or those places). And the effects of this cinematic encounter had effects whose resonances can be felt widely throughout transnational popular culture. This is the case *even though* – as already mentioned – the entrance of the dragon was primarily a cinematic event of the order of what postmodernists called the 'simulacrum', namely, of the fake or entirely constructed representation; or what psychoanalytical cultural theory calls fantasy (or 'phantasy'). For, to reiterate, fantasy and physical reality cannot really be divorced. Instead, explains John Mowitt, even 'in what makes reality seem original to us, fantasy is at work' (2002: 143). In other words, fantasy ought to be understood in a way that frustrates the possibility of a simple or sharp distinction between objective and subjective, and indeed between the inside and the outside of the subject.

BRUCE LEE
BEYOND PEDAGOGY

No consideration of Bruce Lee – or indeed of the *beyond* of Bruce Lee – can overlook his importance as a muse, an inspiration and an educator. I have followed the likes of Meaghan Morris and Davis Miller before in foregrounding this dimension of Lee's legacies, and want to do so again in this chapter, because of the fundamental and perennial significance of this topic for studies of Lee, of martial arts, and indeed of culture *tout court*. So, in this chapter, I return to key examples and instances of Bruce Lee (and) pedagogy, in order to set out and then to move beyond the established ground, and into some vexed debates about philosophy, ideology and cultural translation. The chapter begins with a discussion of Bruce Lee's philosophy of Jeet Kune Do, before moving into reconsiderations of the relations between film and philosophy, culture and ideology, as well as politics and ethics. It draws Lee's oeuvre and intervention into relations with (other) Western popularisers of Zen, Taoism and Buddhism, as well as with thinkers such as Jacques Rancière, Alain Badiou and Slavoj Žižek.

MARGINS OF PEDAGOGY

In September 1971, *Black Belt Magazine* published an article called 'Liberate Yourself from Classical Karate' written by Bruce Lee. This article is arguably

Figure 8: The Spirit of 1968: Bruce Lee and Dan Inosanto

epochal, in many ways. Certainly, 'Liberate Yourself from Classical Karate' is significant because it is one of the few definitive written statements given by Bruce Lee on the subject of what he wanted to teach – namely a revolutionary approach to martial arts that he called 'Jeet Kune Do'. It is important to note this because, since his death, Lee's name has been attached to the wholesale and indiscriminate posthumous publication of selections from his notebooks, college essays, journals and jotters, and these include many unattributed but readily traceable quotations from other thinkers – all of which ultimately make Bruce Lee seem to be a barefaced plagiarist – as if he himself made the decision to publish 'his' words in that form, after he died. We will return to this, below.[1] But 'Liberate Yourself from Classical Karate' was signed by Bruce Lee. It is his manifesto for 'Jeet Kune Do'.

In Bruce Lee's words: 'Literally, "jeet" means to intercept or to stop; "kune" is the fist; and "do" is the way, the ultimate reality'; so, Jeet Kune Do means 'the way of the intercepting fist' (1971: 24). Yet Lee insists: 'Do remember, however, that "Jeet Kune Do" is merely a convenient name. I am not interested with the term itself; I am interested in its effect of liberation when JKD is used as a mirror for self-examination' (ibid.). Thus, rather than a style, a method or a syllabus, Bruce Lee's 'Jeet Kune Do' was originally an experimental ethos organised in

terms of liberation. This is not (yet) the 'self-actualisation' of the existentialisation of martial arts discussed by Brown (1997), which we looked at in the previous chapter. It is rather the liberation from the strictures of hidebound martial arts training practices.

Given this, it seems pertinent to reflect on the fact that many academics who have sought to study Bruce Lee, to 'read' Bruce Lee, and to learn 'from' Bruce Lee – in film studies, gender studies, postcolonialism and so on – have overwhelmingly overlooked the fact that Bruce Lee – *himself* – actually *sought* to teach at all. Many have overlooked *that* he sought to teach and *what* he sought to teach. Yet when we enquire into the nature of the 'lesson' that Bruce Lee sought to teach – the final signified that he intended to impress upon the world – we encounter a lesson that is uncannily similar to the radical lesson about teaching and learning and its connection to inegalitarian power hierarchies within all sorts of pedagogical institutions as developed by Jacques Rancière in his reading of the work of Joseph Jacotot: you can learn without being taught and you can teach what you do not know.

The term 'Jeet Kune Do' had been coined by Lee to evoke the guiding prin-ciples ('Do') or ultimate aim in fighting – quick and decisive victory. Lee believed these to be encapsulated in anything that could simultaneously intercept/interrupt an attack ('Jeet') and deliver a simultaneous hit of one's own ('Kune'). According to his senior student, Dan Inosanto, Lee was particularly enamoured of Western fencing's 'stop-hit' technique – the act of blocking and striking simultaneously in one movement – hence, the name (and indeed, the look and feel of) Jeet Kune Do. But Lee was at pains to emphasise that in itself JKD was not a 'style': 'Unlike a "classical" martial art, there is no series of rules or classification of technique that constitutes a distinct "Jeet Kune Do" method of fighting' (1971: 24), he insisted. He continues: 'JKD is not a form of special conditioning with its own rigid philosophy. It looks at combat not from a single angle, but from all possible angles. [...] There are no prearranged sets or "kata" in the teaching of JKD, nor are they necessary' (ibid.). The point, instead, writes Lee, is that 'through instinctive body feeling, each of us "knows" our own most efficient and dynamic manner of achieving effective leverage, balance in motion, economical use of energy, etc' (ibid.). Thus, *we all already know* how to move, how to fight. At the same time, learning formal 'patterns, techniques or forms touch[es] only the fringe of genuine understanding' (ibid.). Formal training in martial arts actu-ally *stultifies* the learner. According to Lee, the 'core of understanding lies in the individual mind, and until that is touched, everything is uncertain and superficial' (ibid.). He claims: 'Truth cannot be perceived until we come to fully understand ourselves and our potentials. After all, knowledge in the martial arts ultimately

means self-knowledge' (ibid.). It is worth quoting from Lee's article at length:

> At this point you may ask, 'How do I gain this knowledge?' That you will have to
> find out all by yourself. You must accept the fact that there is no help but self-help.
> For the same reason I cannot tell you how to 'gain' freedom, since freedom exists
> within you. I cannot tell you what 'not' to do, I cannot tell you what you 'should'
> do, since that would be confining you to a particular approach. Formulas can only
> inhibit freedom, externally dictated prescriptions only squelch creativity and assure
> mediocrity. Bear in mind that the freedom that accrues from self-knowledge cannot
> be acquired through strict adherence to a formula; we do not suddenly 'become'
> free, we simply 'are' free.
>
> Learning is definitely not mere imitation, nor is it the ability to accumulate and
> regurgitate fixed knowledge. Learning is a constant process of discovery, a process
> without end. In JKD we begin not by accumulation but by discovering the cause of
> our ignorance, a discovery that involves a shedding process.
>
> Unfortunately, most students in the martial arts are conformists. Instead of
> learning to depend on themselves for expression, they blindly follow their instruc-
> tors, no longer feeling alone, and finding security in mass imitation. The product
> of this imitation is a dependent mind. Independent inquiry, which is essential to
> genuine understanding, is sacrificed. Look around the martial arts and witness the
> assortment of routine performers, trick artists, desensitized robots, glorifiers of the
> past and so on – all followers or exponents of organized despair. (1971: 25)

In place of formal pedagogical structures, Bruce Lee – who had no formal
qualification in any martial art but who could demonstrate 'mastery' in many –
advocated autodidacticism, self-help, constant innovation, testing, exploration,
experiment and dynamic verification. In other words, Bruce Lee was quite radical
or revolutionary. Indeed, suggests Daniele Bolelli: 'At a time when no forms of
established authority went unchallenged, it seems only natural that even the field
of martial arts was destined to experience some drastic change' (2003: 182–3).
After characterising Bruce Lee's 'time' – the late 1960s – as an era of all things
anti-authoritarian, Bolelli concludes that

> The philosophy of JKD can therefore be seen as the gift (or the curse, depend-
> ing on your point of view) of the alchemical mixing of Taoism, Zen Buddhism, the
> antiauthoritarian culture of the 1960s, and Bruce Lee's own personality. Regardless
> of whether we agree with Lee's approach or not, his example remains as an open
> invitation to do one of the healthiest things that anyone, martial artist or not, can
> do; questioning one's own beliefs. (2003: 183)

The only help is self-help. Push yourself. Know thyself. You already know yourself, in yourself. Subject all institutions to a deconstructive questioning. Don't follow leaders. Question all beliefs. Experiment with interdisciplinarity in the name of antidisciplinarity. This is the lesson of Bruce Lee. At least, this can be plotted in his writings. Indeed, it is often said that a vague (but violent) ethnic Chinese 'cultural nationalism' comes out in Lee's films, whilst this radical egalitarian/universalist individualism comes out in his martial arts 'philosophy' and written texts. However, even in Lee's early films (largely written and directed by others and following stock formulas) Lee's nationalism always comes in response to nationalistically-inflected aggression against 'innocent' Chinese underdogs. Moreover, Lee's later and increasingly self-controlled works (such as the incomplete *Game of Death*) all seek to emphasise themes of universalistic equality and individualistic emancipation. So it is clear that what subtends all of Lee's texts is the *egalitarian* impulse that can be seen in 'Liberate Yourself'. This article ends:

> There is no standard in total combat, and expression must be free. This liberating truth is a reality only in so far as it is 'experienced and lived' by the individual himself; it is a truth that transcends styles or disciplines. Remember, too, that Jeet Kune Do is merely a term, a label to be used as a boat to get one across; once across, it is to be discarded and not carried on one's back.
>
> These few paragraphs are, at best, a 'finger pointing to the moon'. Please do not take the finger to be the moon or fix your gaze so intently on the finger as to miss all the beautiful sights of heaven. After all, the usefulness of the finger is in pointing away from itself to the light which illumines finger and all. (1971: 27)

Lee was to use this 'finger pointing' analogy again. It reoccurs at the start of *Enter the Dragon*, during one of the initial establishing scenes. The opening scenes of the film are of course all about establishing an interpretive context, and what these opening scenes chiefly provide will undoubtedly have been many viewers' first 'experience' or inkling of the discipline and mysticism of the legendary Shaolin Temple and its mythical warrior monks. This 'mysticism' is condensed in one of the very first scenes, in which Lee tutors a young monk, Lau. This scene runs like this:

Lee: It's Lau's time.
Braithwaite [surprised and somewhat puzzled]: Yes, of course…
Lee: Kick me. [*Lau seems puzzled*] Kick me. [*Lau throws a side-kick*] What was that? An exhibition? We need [*pointing to his head*] emotional content. Try again! [*Lau kicks again*] I said emotional content. Not anger! Now try again!

> With *me*! [*Lau throws two more kicks, causing Lee to respond*] That's it! How
> did it feel to you?
> *Lau*: Let me think.
> *Lee*: [*Slaps Lau's head*] Don't think! *Feel!* It is like a finger pointing away to the
> moon. [*Slaps Lau's head*] *Don't* concentrate on the finger or you will miss all
> that heavenly glory. Do you understand?
> *Lau*: [*smiles, nods, bows*]
> *Lee*: [*Slaps the back of Lau's head*] *Never* take your eyes off your opponent, even
> when you bow. ... That's it.

The behaviour of Lee's character in this 'teacherly' mode is not without prec-
edent. According to Avital Ronell, Zen teachers often liberally strike students
who give the wrong answers to Zen koans (koans are riddles, essentially); an
act which arguably has various pedagogical functions. The main function of the
strike is to jolt the student into 'realization', 'awakening', or 'satori' (2004: 62). In
Ronell's words:

> The hit seals a sort of 'compliment' conferred by the attentive master, who prods
> the physical body for the purpose of uninhibiting a scene of contemplation, new
> and unanticipated. The shock is crucial to the experience of the koan: it stages the
> opening of thought exceeding itself in the jolt. (Ibid.)

But, in 'Liberate Yourself' and in *Enter the Dragon*, what is the thought? In an essay
on the pedagogy of Buddhism, an essay which involves an analysis of some of the
occurrences of the 'finger pointing to the moon' riddle in Zen Buddhist writings,
Eve Kosofsky Sedgwick observes that whilst on the one hand Western education
largely proceeds by 'assuming that every lesson can be divided into ever more
bite-sized, ever more assimilable bits', on the other hand, the 'wisdom traditions'
of Buddhism principally 'assume that students have already surmounted a fairly
high threshold of recognition' (2003: 171–2). This is coupled with what she calls
a 'radical doubt that a basic realization can be communicated at all' (2003: 172).
It is in this, she suggests, that the difference between Western and Buddhist
pedagogy consists: Buddhist pedagogy does not 'teach'; rather it attempts to
establish – to verify; to test – 'recognition', or 'realisation'. As Ronell formulates
this, 'the koan, offered by the teacher – the "master" – is meant to "open" the
pupil to the possibility of Saying. The master is responsible for initiating the call of
such an opening'; this 'call of such an opening', she continues, is often 'attained
by the administration of a shock' – this is why the master 'is frequently figured as
beating, hitting, or slugging the pupil' (2004: 62).

Ronell jolts her consideration of Buddhist pedagogy back to questions of Western philosophy. Sedgwick, too, quickly returns the discussion back to 'Philosophy proper', so to speak.[2] However, she is guided by a fascination with the Buddha's claim: 'I have not taught a single word during the forty-nine years of my Dharma preaching'; and that, rather than teaching *as such*, 'the Buddha spoke many sutras, which should only be taken as "the finger that points to the moon", not the moon itself' (2003: 170).

If such pedagogies can be taken seriously by both queer and other radical emancipatory theorists in the realms of philosophy, 'wisdom traditions' and pedagogy 'proper', one question is that of the pedagogical status of Bruce Lee's cinematic and journalistic non-teaching of exactly the same things (if it still makes sense to put it like this). Moreover, it deserves to be noted that the moment of Lee's emergence was also the moment of high-hippy countercultural utopianism (the late 1960s and early 1970s). What is to be made of the fact that this period is also the period that spurred so many critiques of institutions – and particularly pedagogical institutions – including those coming from deconstruction, cultural studies, feminism, postcolonialism, gender and sexuality studies, Bourdieu and Rancière and beyond? In other words, it seems it would be fair to say that Bruce Lee's finger is pointing not just to the moon, but to problems of referentiality, indexicality and ontology, all of which at a certain time coalesced into one hell of a discursive convergence. As already noted, the dialectical synthesis of the apparently diametrically opposing 'lessons' of Bruce Lee (the Chinese nationalism of the 'lesson of the early celluloid Lee' versus the pragmatic, egalitarian inter- and antidisciplinary 'lesson of JKD') can be found in what might be called a certain 'spirit'. This can be seen to be subtending, infusing and suffusing (if not simply sublating) 'both' lessons of Bruce Lee. This spirit is often too quickly represented as the spirit of Zen – a putatively timeless, 'transcultural' spirit. However, such a spirit surely can and should be historicised. According to Sedgwick:

> In the United States it seems to have fallen to the twentieth-century popularizers of Zen, after World War II, to begin to articulate the centrality in many forms of Buddhism of [a] radical doubt that a basic realization can be communicated at all. After all, if Zen practice cannot promise to bring one methodically over the high learning threshold of satori ['awakening', 'realization'], it at least offers distinct practices, such as wrestling with koans, for dramatizing and perhaps exhausting the impossibility of methodical learning. Furthermore, the anti-scholasticism of Zen and the often anti-intellectualism of the counterculture merged in a durable consciousness of the limits of verbal articulation. The 1960s heyday of these explorations … was one when a critique of school institutions became the vehicle of almost every

form of utopian investment; if Buddhist explorations were peripheral to the student movement, they nonetheless both enabled and were enabled by it. (2003: 172)

Quite how one ultimately judges the value and lasting effects of such a movement remains to be decided. What is clear is the central place of Bruce Lee within this movement, as expression and agency, bringing many elements of the cultural and political margins right to the centre of global popular culture. This is why Lee can be regarded as providing what Rancière calls 'the aesthetic dimension of the reconfiguration of the relationships between doing, seeing and saying that circumscribe the being-in-common [which] is inherent to every political or social movement' (2000: 17). Of course, Rancière adds, 'this aesthetic component of politics does not lead me to seek the political everywhere that there is a reconfiguration of perceptible attributes in general. I am far from believing that "everything is political"'; yet, he continues: 'On the other hand, I believe it's important to note that the political dimension of the arts can be seen first of all in the way that their forms materially propose the paradigms of the community' (ibid.). This is not to suggest that Bruce Lee was a herald and trailblazer of a PC utopia, although his relation to the ensuing movement that became known as 'political correctness' certainly has been remarked upon (see Morris 2001). But it is, at least, to locate Bruce Lee firmly at the shifting centre of enduring anti-institutional, intercultural and cross-ethnic representation. As Rey Chow sees it, this is

a process in which the acceleration and intensification of contacts brought by technology and commerce entail[s] an acceleration and intensification of stereotypes, stereotypes that, rather than simply being false or incorrect (and thus dismissable), have the potential of effecting changes in entire intellectual climates... (2002: 63)

These contacts are also therefore arguably irreducibly pedagogical. Many lessons have been learned about Bruce Lee. Bruce Lee is hard. Bruce Lee is sexy. Bruce Lee is cool. Bruce Lee is not white. Bruce Lee is Asian. Bruce Lee kicks white, American, Russian, Japanese, Italian, imperialist, colonialist, capitalist, gangster and indeed anyone and everyone's ass. There is something patriarchal here, in this phallic hero. There is also something homoerotic. There is something heteronormative. There is also something postcolonial. This much has been learned. But is that it? Is that all there is? Within film studies, cultural studies, postcolonial studies and various ethnic identity studies, this appears to be about the long and short of it. These are the main sorts of lessons that are regularly learned from and about Bruce Lee: lessons about identification, lack and desire, about cultural identity, the role of fantasy, about the body as bearer of ideology, the ambivalence and

polysemy of Bruce Lee's texts, the homo at the heart of the hetero. And so on (see, for example, Abbas 1997; Brown 1997; Chan 2000; Marchetti 2001; Morris 2001; Hunt 2003; Eperjesi 2004; Teo 2008).

These are of course important lessons. But there is more. There are other lessons to be learned from Bruce Lee. The ones I would like to draw attention to at this point relate to learning, to lessons that have been learned, and to the significance of the ways in which the lessons that are to be learned from Bruce Lee intersect unexpectedly with lessons in and about the 'project' of cultural studies and its critics. In saying this, I am using the term 'cultural studies' as short-hand, as an umbrella term to evoke the genealogically and ethico-politically entangled discursive formation of work in postcolonialism, history from below, gender studies, post-structuralism, queer theory and – as is so easy to say – so on. My decision to elevate 'cultural studies' as the umbrella-term to cover such a wide, complex and contradictory field will, I hope, neither be received as particularly controversial nor as especially unusual, as each of these overlapping fields always also folds into the others and has them folded into 'itself' in more than one way.

However, what is less straightforward is the fact that, when I evoke this formation's 'critics', I will not be referring to those whose work is clearly and decidedly (or decidably) 'outside' the fields of queer-, postcolonial- and so on cultural studies. Rather, I will be lining up the rather unlikely (non)couple of Slavoj Žižek and Jacques Rancière. This is not because I see their work as being even remotely similar, in its own right. It is rather in order to show that, despite the immense differences between Rancière and a character like Žižek, they both occupy (*equivalently but differently*) a fraught border on the shores of this (or these) cultural studies that they both so clearly take their distances from. To experience both the beaches and the ports of these shores – the points of convergence and play as well as of articulation, communication and control – my primary contention is that we might do no better than taking seriously the question of the lessons to be learned from Bruce Lee. Reciprocally, to learn something more from Bruce Lee, and to pose a rather more tantalising challenge to cultural studies in all its forms than the ones we are familiar with, we might do no better than taking seriously the question of the lessons to be learned from Jacques Rancière.

In the face of studying Bruce Lee, and despite the apparently trivial status of this long-departed Hong Kong American celebrity martial artist, it is of more than 'academic' interest to reiterate here, once again, the extent to which 'China' or 'Chineseness' is inscribed (indeed, *hegemonic*) within the current theoretical and political discourses of cultural studies, post-structuralism, ethnicity and feminism. As Rey Chow has made plain, as already mentioned, this is so in at least three ways. First, the Chinese 'other' played a constitutive (haunting) role

in the deconstructive critique of logocentrism and phonocentrism, in ways that far exceed the general 'turn East' (in the search for alternatives) characteristic of 'French' theory and much more besides of the 1960s and 1970s. Second, the feminism of the 1960s and 1970s actively admired and championed the Chinese encouragement of women to 'speak bitterness' against patriarchy. And third, the enduring interest in the 'subaltern' among politicised projects in the West has always found an exemplary instance in the case of the Chinese peasantry. Indeed, says Chow, in these ways and more, '"modern China" is, whether we know it or not, the foundation of contemporary cultural studies' (1993: 18).

This sort of (unhomely) historicisation of the interplay of forces constitutive of the contours, investments and impulses of contemporary cultural studies (and its critics) can 'hurt'. This is especially so when we want to believe that our own position is unique, superior, untainted or uncompromised by the messy and often ugly intertwined forces that have produced the present conjuncture. But acknowledging the fraught genealogy of the present is surely an essential stage of any work – a harrowing ordeal that may nevertheless provide an enlivening jolt.

There are many ways to do this. If Chow recasts the investments and orientations of cultural studies, post-structuralism and the politicised 'studies-suffix' subjects in terms of what she calls an unacknowledged but constitutive 'Chinese prejudice', theorists such as Žižek, Bourdieu and others have often cast cultural studies as being at the forefront of the ideology of 'political correctness' which itself is recast as the cutting-edge ideology of neoliberalism. There are many versions of such challenges to cultural studies' putative ethical and political values and virtues, of course, just as there are many different forms of response to and engagement with such questions within the various fields and forms of cultural studies. In fact, no footnote could suffice to indicate the breadth and depth of these debates. But we could look quickly at one provocative and pertinent contribution to it.

Meaghan Morris's essay, 'Learning from Bruce Lee: Pedagogy and Political Correctness in Martial Arts Cinema' (2001), remains particularly apposite here because in it Morris examines the relationship between film and cultural criticism and the forces, discourses and impulses of 'PC' or 'political correctness'. Crucially, Morris concedes the disappointing links between contemporary film and cultural criticism and the much vilified and stereotyped PC (a link which boils down to their shared moralism), but she seeks nevertheless to find a way to redeem both. She tries to do this by focusing on the theme of pedagogy. Before we get to pedagogy, it is helpful to note that Morris' primary argument is as follows:

PC is not primarily a code regulating expression but a spectators' revolt. Aesthetically

focused but social in resonance, PC is an act or a movement of criticism initiated by groups of people who develop shared responses to particular cultural conventions, and begin to form 'an' audience in the marketing sense: by articulating a collective 'commentary on cinema', they announce themselves as an audience. And they vocally object to the quality of something which cinema provides. Understood this way, PC as a critical formation has less in common with the grim radicals of media bad dreams (real as dreams may be) than with those highly respectable 'consumer movements' which have, through the very same media, powerfully influenced business and advertising practices in recent decades. (2001: 181)

Of course, in affiliating 'aesthetic dissensus' with 'consumer movements' that are 'highly respectable', Morris opens the door for the Žižekian retort that such 'movements' are therefore *not political*, precisely because they are both *respectable* and *consumerist*. The Žižekian insistence on the internal dynamics of capitalism as the Real (and) backdrop or horizon against which any claim of 'the political' is to be judged is a challenge that – no matter how hyperbolical, (performatively) self-contradictory, and no matter how 'logically' refutable it may be – nevertheless *haunts* my own thinking here and elsewhere. For, whatever else may be said about Žižek, he nevertheless *has a point*. And it will not just go away. So, without attempting to exorcise the Žižekian spectre, but whilst refusing to be dominated by it, I will attempt to use it, along with the coordinates provided by Chow and Morris, to triangulate a point from which to craft a manoeuvre informed by, equivalent to but different from, those executed by the likes of Chow, Morris, Žižek and, ultimately, Rancière. This manoeuvre relates to rethinking pedagogy.

THE LESSON OF BRUCE LEE

Meaghan Morris tries to look at Bruce Lee 'otherwise' by focusing on the peculiar importance of pedagogy when it comes to grasping his significance. She points out the enduring centrality of pedagogy in martial arts films and the often overlooked importance of Bruce Lee as a teacher. It is crucial to approach Bruce Lee in terms of pedagogy, argues Morris, because 'the overwhelming concern with "the body" in recent cultural criticism can obscure this aspect of (Western) Bruce Lee worship and narrow unduly our approach to action cinema in general' (2001: 175). So Morris draws attention to the significant 'persistence of the training film in Hollywood cinema', and to the ways that 'training films give us lessons in using aesthetics understood as a practical discipline – "the study of the mind and emotions in relation to the sense of beauty" – to overcome personal and social

adversity' (2001: 176).[3]

Of course, we should note straight away that the kind of *looking otherwise* (or *reading differently*) that Morris undertakes is not deliberately provocative or controversial. Morris does not seek to offer the kind of reading which would boil the blood of conservatives or anti-PC militants of 'common sense'. In fact, although Morris does suggest that 'the technique of "queering" is [the] liveliest recent manifestation' of a key interpretative drive in film studies, one that 'can be creative', she actually suggests that queering can also be 'blinkered and narrow in its relentlessness' (2001: 184). So, although Morris wants to read Bruce Lee 'otherwise', she does not want to rush headlong into acts of 'queering' or 'othering'. At least not directly. Rather, Morris operates in terms of the insight that there can only be so many times that looking at Bruce Lee 'otherwise', by for instance revealing the *homo* at the disavowed heart of the *hetero*, can be regarded as news.[4] Which is why *what* Morris seeks to 'learn' from Bruce Lee does not relate to the erotic and does not simply relate to issues of patriarchy, phallocentricity, heteronormativity, masculinity, or suchlike. Instead, she chooses to learn something *else* from Bruce Lee. This is a lesson about learning from cinematic images – or rather about *realising*, becoming aware, being transformed by *experiencing* through cinematic images, and the overall complexity of the experience of films.

Amid a discussion of the aesthetics (including, of course, the camp and kitsch dimensions) of many American martial arts films, Morris turns her attention to a scene within the film, *Dragon: The Bruce Lee Story* (1993). This film is, in Morris's words, 'a sanitized as well as hagiographic interpretation of Bruce Lee's life as authorized by his widow', Linda Lee-Cadwell (2001: 180). In it, Bruce (played by Jason Scott Lee) and Linda (Lauren Holly), on one of their first dates, end up in a cinema watching *Breakfast at Tiffany's* (1961). It is significant – indeed foregrounded and emphasised by the film – that they have ended up in the cinema because they have been refused entry to a restaurant for obviously racist reasons. So they find themselves in a 'laff fest revival'. In the cinema, we watch them watching the spectacle of Mickey Rooney bumbling around as the slapstick Japanese character, Mr Yunioshi. Morris deftly points out the way that the camera shows us Bruce and Linda watching the same scene *differently*: Linda initially laughs along with the rest of the audience, until she notices Bruce's distinct lack of enjoyment. Then the camera shows us a very significant moment of realisation. According to Morris, this scene actually shows a viewing subject 'enter into another subjectivity' (2001: 181) through the act of viewing – and, specifically, through viewing an other(s) way of viewing and being viewed. As she sees it,

when Linda suddenly connects the Chinese man beside her, the 'Oriental' on

screen, and her pleasure in both, she makes an imaginative leap outside the logic of her own familiar dreams which allows her to experience something new. Putting 'herself' in another's position, she finds that her companion lives a connection between his body and the grotesque parody on screen – one fictionally modeled on a fleeting moment of cinema but relayed and sustained in its everyday life by the gazes (and the voices) of other people. (Ibid.)

In the terms of Jacques Rancière, we could conceptualise this scene as a moment of 'aesthetic dissensus', in which the experience by Linda and (perhaps) Bruce amounts to a moment of 'subjectivization', or, in Rancière's words, 'the formation of a one that is not a self but is the relation of a self to an other' through 'a process of disidentification or declassification' (1992: 60, 61). Thus, at this point, Linda could be regarded as becoming 'an outsider or, more, an *in-between*' (1992: 61) by way of what Rancière calls an 'impossible identification' (ibid.). It is 'impossible' because Linda is not that which she has just realised; or, in Rancière's terms, Linda's is an identification that cannot be *embodied* by her, herself. As Rancière theorises it, political subjectivisation 'always involves an impossible identification, an identification that cannot be embodied by he or she who utters it'; it is rather, according to Rancière, 'a heterology, a logic of the other'; 'it is never the simple assertion of an identity; it is always, at the same time, the denial of an identity given by an other, given by the ruling order of policy' (1992: 62).

LEARNING FROM PEDAGOGY

However, there is more to a Rancièrean reading than providing lessons in identity formation or the production of new subjectivities that occupy new subject-positions. That is, there *is* a difference between Rancière and Morris here. This devolves on different notions of pedagogy, but it has a far wider significance. This can be seen if we use Rancière to focus on the way pedagogy itself organises Morris's vision when she is 'learning from Bruce Lee'. For, although what Morris would rightly have us learn is a lesson about the dubious ethics and orientations of much film criticism itself, it is nevertheless the case that Morris still ultimately identifies with and prioritises a certain 'classical' pedagogical position. Morris will go on to propose that 'Linda returns to *Breakfast at Tiffany's* with the eyes and ears of a critic, or so I like to think; as a student, she is certainly able to "enter into" another subjectivity...' (2001: 181).

But let us hesitate before making such a step ourselves; for, as Rancière (1987) has urged us to notice, an interpretive decision such as this also carries the

connotation that becoming 'a critic' amounts to *maturing* into a critic, or, in the case of Linda's moment of revelation, being re-born (satori-like) as an 'enlightened one'. Identifying such a moment of transformation, realisation or 'subjectivization' (Rancière 1992) with an already-instituted institutional category (The Critic) is, in Rancière (as in Barthes (1977)), to rob it of its *emancipatory* potential. Indeed, as Rancière sees it, this would be to participate in 'a logic whereby the social critic gains by showing democracy losing' (Ross 1987: xi) – by claiming that the insight, the knowledge, or the wisdom is always and already the property of 'the critic'. As Kristin Ross puts this:

> if science belongs to the intellectuals... and the critique of bourgeois content is reserved for those who already know, then there is only one way for students to criticize their masters' knowledge ... and that is to become their peers. (1987: xvii)

Thus, even though Morris figures spec(tac)ular cultural relations as potentially politicising, her own fundamental identification remains with the position of the pedagogue. In this, Morris exemplifies the post-Gramscian tendency in cultural studies to regard 'culture as pedagogy' and, accordingly, to seek to find and to teach (about) the best that has been thought, said and broadcast. This is the 'improving', 'educating' rationale that Jacques Rancière identifies in so many philosophers, critics, theorists and pedagogues, including, most famously, Louis Althusser and Pierre Bourdieu. To Rancière's list of 'philosophers and their poor', we might add perhaps *all* of the key figures of cultural studies and cultural theory.

It is not their motives but their *orientations* that Rancière critiques. This is because, as is well known, the lesson of Rancière is the lesson of *equality*. Here, the lesson to be learned from Rancière is that pedagogy premised on imparting knowledge to the ignorant *stultifies*. In *The Ignorant Schoolmaster* (1987), Rancière devotes himself to a consideration of the fact that everyone – demonstrably, verifiably – can and very often does learn without being taught in the mode of what he calls 'explication' (the intellectual intervention of an explicator). Classical pedagogy Rancière calls 'the explicative order', and his deconstructive contention is that it is 'the explicator who needs the incapable and not the other way around; it is he who constitutes the incapable as such' (1987: 6; Rancière's thinking shares a lot with Roland Barthes on this point); and hence his contention is that

> Explication is not necessary to remedy an incapacity to understand. On the contrary, that very incapacity provides the structuring fiction of the explicative conception of the world. [...] To explain something to someone is first of all to show him he

cannot understand it by himself. Before being the act of the pedagogue, explication is the myth of pedagogy, the parable of a world divided into knowing minds and ignorant ones, ripe minds and immature ones, the capable and the incapable, the intelligent and the stupid. (1987: 6)

This, Rancière calls the 'double inaugural gesture' (ibid.) of the 'explicative order' – the thinking which 'divides the world into two', or 'divides intelligence into two', by proceeding as if 'there is an inferior intelligence and a superior one':

The former registers perceptions by chance, retains them, interprets and repeats them empirically, within the closed circle of habit and need. This is the intelligence of the young child and the common man. The superior intelligence knows things by reason, proceeds by method, from the simple to the complex, from the part to the whole. It is this intelligence that allows the master to transmit his knowledge by adapting it to the intellectual capacities of the student and allows him to verify that the student has satisfactorily understood what he learned. Such is the principle of explication. (1991: 7)

Following Joseph Jacotot, the eighteenth-century educator that Rancière reads in *The Ignorant Schoolmaster*, he concludes that this – the dominant – conception of education is to be regarded as 'the principle of *enforced stultification*' (ibid.). The logic of self-legitimation of the explicator runs: 'Until [the teacher] came along, the child has been groping blindly, figuring out riddles. Now he will learn' (ibid.). Proceeding by 'figuring out riddles', says Rancière, is overwhelmingly regarded by explicators as proceeding *incorrectly*, *outrageously*: moving 'along in a manner one shouldn't move along – the way children move, blindly, figuring out riddles' (1987: 10) is disparaged.

Rather than enforcing, as a matter of routine or principle, this disciplined hierarchy as if it were the necessary character of all learning, Rancière advocates Jacotot's postulate that the universal process of learning is something shared alike by 'the child, the learned man, and the revolutionary' (1987: 12). Its key coordinates are called chance, *experiment*, *equality* and *will*. 'The method of equality was above all a method of the will', writes Rancière: 'One could learn by oneself and without a master explicator when one wanted to, propelled by one's own desire or by the constraint of the situation' (ibid.). Without a *master explicator*, concludes Jacotot; but *not without a master per se* (1987: 12–13). In other words, the role of the master is not that of a subject supposed to know, to be followed, listened to, obeyed, as ignorant to learned. Rather, the master is the one who issues a command. Solve this. Work out that. The master's *intelligence* is by the

by. The notion of the 'master', and specifically the 'will' of the master, is separated from that of 'intelligence'. Realising this, says Rancière, allows 'the jumbled categories of the pedagogical act to be sorted out, and explicative stultification to be precisely defined' (1987: 13). Thus, concludes Rancière/Jacotot: 'there is stultification whenever one intelligence is subordinated to another'; although 'a person – and a child in particular – may need a master when his own will is not strong enough to set him on track and keep him there … that subjection is purely one of will over will' (ibid.). And this – it deserves to be said – is no bad thing. However,

> It becomes stultification when it links an intelligence to another intelligence. In the act of teaching and learning there are two wills and two intelligences. We will call their coincidence *stultification*. […] We will call the known and maintained difference of the two relations – the act of an intelligence obeying only itself even while the will obeys another will – *emancipation*. (Ibid.; emphasis in original)

Rancière is unequivocal about the significance of this: 'This pedagogical experiment created a rupture with the logic of all pedagogies'; Jacotot's experiment – simply *telling* students to learn both the French and the Flemish pages of the bilingual book *Télémaque*, an experiment which led the students to learn excellent French very quickly – did not involve 'the transmission of the master's knowledge to the students' (1987: 14). In fact, 'Jacotot had transmitted nothing':

> He had not used any method. The method was purely the student's. And whether one learns French more quickly or less quickly is in itself a matter of little consequence. The comparison was no longer between methods but rather between two uses of intelligence and two conceptions of the intellectual order. The rapid route was not that of a better pedagogy. It was another route, that of liberty. (Ibid.)

The rest of *The Ignorant Schoolmaster* charts the ensuing misappropriations and misadventures of Jacotot's 'realisation' once it was picked up, turned over, assessed, implemented or instituted by others, all over the world. However, it seems noteworthy that Rancière's book stops before the moment of the post-1968 institutional reformation which in some sense inspired Rancière's critique in the first place. So, the question is: what became of Jacotot's universal learning?

One of the places it reappeared was undoubtedly in Bruce Lee's anti-pedagogical liberation philosophy. Another place is the Hollywood and Hong Kong institution of the training film. From *The 36th Chamber of Shaolin* (1978) through to *The Karate Kid* (2010) and way beyond, the lesson is always – as Mr Han (Jackie Chan) tells 'Siao' Dre (Jaden Smith) – the Rancièrean one that everything

is in everything – that kung fu is in everything: every movement is both natural and contains a lesson; nothing can be 'taught' as such (lessons are not passed 'down' from one intelligence to another), but everything can be learned from everything – whether that be karate from waxing on, waxing off or kung fu from picking up, dropping, hanging up, taking off and putting on a coat. Moreover, nor is this constrained to the action film. The subtitle of Rancière's book *The Ignorant Schoolmaster* is *Five Lessons in Intellectual Emancipation*. In the children's film *Nanny McPhee* (2005) – a film which has more than a passing resemblance to *Mary Poppins* (1964) – there are similarly five lessons. These are mundane, everyday, often domestic; but contained within them are holistic connections to profound insights about daily living or, to echo Lyotard (1984), cultural 'savoirs'. Popular film loves this lesson. Is it a philosophical lesson? In what ways might it relate to traditional book-bound philosophy?

It is certainly worth being aware that Bruce Lee had lots of books. Those who have had access to his library assure us that these books were all well read, and were often annotated and underlined, with frequent marginal comments and cross-references. Lee evidently studied his books. He also took copious notes. His many notebooks and personal writings were posthumously plundered, filtered, edited, reassembled, packaged and marketed as Bruce Lee 'words of wisdom', in a publishing initiative that currently stretches to over a dozen books nominally authored or co-authored by the late Bruce Lee. Although such publications are surely of interest to fans and disciples, one problem with this whole drive is that many of the notes and quotations from which these books are constructed amount to ideas that Lee had simply collected himself. In other words, these edited collections are not simply edited collections of Lee's words. Rather, they are also edited collections of Lee's edited collections. Many of his putative writings had simply been taken verbatim and unattributed from the books in his library. They were merely quotes that he liked. However, when they were included in books supposedly 'by' Bruce Lee, these borrowings remained unattributed.

Consequently, two things have happened. First, Lee has been posthumously represented – reinvented or reconstructed – as a rent-a-quote 'sage'. Second, Lee has subsequently been 'outed' as a plagiarist. In many discussions, either or both of these procedures have been regarded as unfortunate and damaging in terms of his 'reputation' or 'credentials' – whether as an originator or mouthpiece of wisdom or philosophy, or whether as a serious martial artist who has been commodified and Orientalised in his own absence. Thus, this process chiefly stokes the coals of a debate that is organised in terms of the question of Lee's philosophical 'originality' or 'authenticity' (was he/wasn't he 'original' or 'authentic' in

his own right?). But what it tends to overlook are the cultural issues of the very *appeal* or *currency* of these ideas, first to Bruce Lee (who 'originally' copied them) and then to the audience that consumes them as 'original' – and yet somehow 'timeless' – 'wisdom'.

THE ETERNALLY RETURNING TURN EAST

The fact that Bruce Lee 'wisdom' is often regarded as simultaneously 'original' and 'timeless' is a curious feature of his construction or reception. But it reflects a wider tendency to approach all putatively 'Chinese thought' in ways that are *allochronistic* and *Orientalist*. Of course, there is a sense in which this approach to Bruce Lee has been licensed to be Orientalist by Bruce Lee's own counter-signature. For, as we have seen, Bruce Lee's 'approach' can be regarded as a disjointed hybrid of 'Western rationality' and 'Eastern rhetoric'. In itself, this may be taken as a version of the Chinese saying, 'Chinese studies as the cultural essence; Western guides for practical application'. And indeed, it would seem that the 'turn' Eastwards, whether in the form of nineteenth-century colonialist/ imperialist Orientalism, or in terms of the post-World War II Area Studies which is its modern variant, or indeed in terms of countercultural Asiaphilia, is not an exclusively 'Western' phenomenon. A turn East, a turn to China, has also been a key aspect of any Chinese nationalism.

Indeed, Douglas Wile (1996) has proposed that in the light of (Western) modernity, even Chinese intellectual and physical culture itself deliberately 'turned East'. Moreover, the Chinese turn East, or turn inwards, has often predominantly come as a response to the turn eastwards of the West. Wile's own case study is the historical development of that most 'mystical' and 'Oriental' of martial arts, tai chi ch'üan (*taijiquan*). And what could be a better example of something that is widely regarded in both East and West as an exemplary repository of ancient Chinese universal wisdom? However, as Wile puts it, even though any Chinese time or event that is 'earlier than the Republican period (1911–49) tends to slip into the mist of "ancient China"' (1996: 3), it is nevertheless the case that all of the 'momentous events for the evolution of t'ai-chi ch'üan did not take place on mist-wrapped mountains' (1996: 4). Rather, the theorists and institutors of t'ai chi ch'üan (Yang Lu-ch'an and the Wu brothers)

> were of the same generation as Darwin and Marx, and the Li brothers were contemporaries of Einstein, Freud, and Gandhi. Railroads, telegraph, and missionary schools were already part of the Chinese landscape, and Chinese armies (and

rebels) sometimes carried modern Western rifles. How often have we stopped to reflect that Yang Lu-ch'an was probably in Beijing in 1860 when British and French troops stormed the capital and the Manchu Emperor took flight. It is our proposition, then, that this watershed period in the evolution of the art and theory of t'ai-chi ch'üan did not take place in spite of larger social and historical events but somehow in response to them. (1996: 3)

The key writers, interlocutors and disseminators of t'ai-chi ch'üan were the Wu brothers. They 'came of age at the turn of the nineteenth century, a time when Manchu overthrow, defeat at the hands of the West, and large-scale peasant rebellion were all unthinkable', notes Wile (1996: 4). However, 'As the Wu brothers entered middle age, the Opium Wars and Taiping Rebellion shook the foundations of the dynasty and caused the near collapse of the world as they knew it' (ibid.). Thus, Wile proposes that just as 'historians are able to place the ancient Greek Olympics in the context of classical ideals of physical beauty and health and admiration for feats of strength and endurance' and just as 'nineteenth-century romantics' rage for swimming can likewise be seen in light of their reaction against crass industrialism and bourgeois conformity' (as illustrated by the Romantics' collective 'desire to commune with the gods and goddesses of woods and water, and their flirting with the mystery and danger of the sea'), then surely the origination and development of t'ai-chi ch'üan should be similarly historicised. Unfortunately, he continues, the tendency has been 'to treat the story of t'ai-chi ch'üan in an historical vacuum' (ibid.). T'ai-chi ch'üan, then, like all 'Chinese wisdom', up to and including Bruce Lee's, has been *Orientalised* and *allochronised*: constructed as ancient, timeless, unique and decidedly other.

Quite contrary to such mythologising, Wile proposes that the salient factors in the ideological self-Orientalising that led to such philosophies and practices as t'ai-chi ch'üan devolve on complex macropolitical phenomena and cultural anxieties. Thus, Wile points out that 'by the early 1800s, fired by industrialism, science, democracy, evangelical Christianity, and, above all, a belief in the divine right of trade, the West, led by Great Britain, would not be barred from China' (ibid.). In this context, he proposes, for a China whose 'cultural self-image was still one of centrality and superiority, to confront a swarm of new barbarians "from across the sea" while old barbarians from the north still sat on the dragon throne was a complex political and psychological ordeal' (ibid.). This took the form of a series of events in which 'China suffered a humiliating defeat and substantial loss of sovereignty': the Opium War of 1839, the Treaty of Nanking of 1842 'and subsequent "unequal treaties" [which] wrested from China Hong Kong, five Treaty Ports, the International Settlement, extraterritoriality, a war indemnity, a five percent tariff

limit, most-favored-nation protection, and missionary access' (ibid.), continued British and French aggressions and seizures of territories in 1856, 1858 (Canton) and 1860 (Beijing), the Russian winning of access to the coast of Manchuria in 1860, the Japanese seizure of the Ryukyu Islands in 1872, the Sino-French War in 1883, and so on.

Accordingly, Wile proposes that we need to be aware that 'the shapers of modern t'ai-chi ch'üan thus witnessed repeated military defeat and reduction of the empire to semicolonial status'; T'ai-chi ch'üan as we 'know it today rose from the ashes of a collapsing empire' (1996: 5). Of course, it has 'roots that clearly reach back farther than the nineteenth century', and its 'association with national revival did not become explicit until the twentieth century [but] China's anti-imperialist struggles began in the nineteenth century' and t'ai-chi ch'üan may well be regarded as a 'cultural response to China's political predicament' (ibid.).

The specific 'predicament' of the nineteenth-century European onslaught against China boils down to the fact that before then, 'peoples who challenged China militarily (northern warriors) did not also do so intellectually, and those who challenged China intellectually (Indian Buddhism) did not also do so militarily'; however, the nineteenth century 'saw a total assault on Chinese culture' (1996: 20). It was in this context that the Wu and Li families became involved in the development of t'ai-chi ch'üan – which is perhaps the most 'philosophical', 'esoteric' and 'Eastern' of all the martial arts. The reason for the involvement of the Wu and Li families in t'ai-chi ch'üan' – and, similarly, their highly uncharacteristic interest in Taoism (1996: 9) – cannot be adequately explained other than by regarding it as being symptomatic of 'China's response to the West', 'semicolonialism', 'millenarian rebellion', and 'the fall of the last dynasty' (1996: 20). For, says Wile, if the 'stereotype of the effete Confucian literati has long made it difficult to explain the intense involvement in martial arts of the Wu and Li families of Yung-nien', the 'extraordinarily violent nineteenth century and the martial tradition of the North China plain go a long way to clarifying the picture' (1996: 9).

This is because this period 'forced intellectuals into a period of intense soul-searching as the alien dynasty closed its grip on China' (1996: 12). 'As all hope of restoration faded, attention turned to analyzing the reasons for the failure of the previous dynasty' (ibid.), and part of that analysis entailed a philosophical dimension. Thus, says Wile, although at the time 'an interest in Taoism was rare indeed' (1996: 15), what the creators of t'ai-chi ch'üan

> have in common is that in approaching the native tradition they attempted to uncover the true Confucian essence buried beneath Buddhist and Taoist influence, and in approaching the West they tried to assert the priority and superiority of Chinese

science and mathematics. The movement to exhume evidence of China's superi-
ority to the West may be related to the Wu and Li brothers' creation of a superior
fighting art based on the quintessential Chinese principle of softness overcom-
ing hardness. In this way, when the 'Treatise' says, 'There are many other styles
of martial arts, but they are nothing more than the strong bullying the weak', we
cannot rule out the possibility that Wu was thinking of the West as much as other
schools of Chinese martial arts. The appeal to Chang Sang-feng and Tsung-yǔeh
may also be an attempt to give the art deeper routes and to make it seem less like
a contemporary creation. (1996: 15–16)

Thus, argues Wile: T'ai-chi ch'üan in the nineteenth century may be seen as 'a
psychological defense against Western cultural imperialism, a clinging to chivalry
in the face of modernity' (1996: 26). He cites Joseph Alter's argument about the
role of wrestling in postcolonial Indian culture that:

The notion of a fit and healthy body being an ideological construct is a fairly com-
mon theme in discourse of nationalism and power. [...] If one considers Gandhi's
adherence to yogic principles it is indeed difficult to draw any line between the
physical, mental, and the political. [...] The wrestler's way of life is seen as a form of
protest against self-indulgence and public immorality. By disciplining his body the
wrestler is seeking to implement ethical national reform. [...] Shastri and others
believe fundamentally that the body is the site of national reform, that nationalism
must be embodied to have any real effect. (Alter, quoted in Wile 1996: 27)

Accordingly, Wile argues that in a context in which 'there were few advocates
of wholesale Westernization', then the development of the theory and practice
of t'ai-chi ch'üan should be distinguished from the practice of 'escapism' and
regarded as 'the attempt to create a space where purely Chinese values and
worldview could survive':

Thus, as China's political body was losing control (sovereignty), t'ai-chi ch'üan
became a way to maintain a measure of autonomy in the practitioner's body. It
must have been clear to China's elites in the second half of the nineteenth century
that the West could not be beaten at their own game. They were thus thrown back
on their own bodies, the microcosm where traditional Taoist self-cultivation sought
to discover and become attuned to the tao. This was to pursue a Chinese brand of
strength. (ibid.)

Of course, he continues,

> Could t'ai-chi ch'üan represent, in part, an attempt by colonized males to regain a
> sense of power and charisma, to hold their heads up in a world where they could
> not compete on the terms dictated by the West and the West's precocious disciple,
> Japan? Men made to feel inferior in relation to other groups of men will inevita-
> bly engage in some form of compensatory behavior in order to preserve face and
> hence control over their own women. Perhaps the t'ai-chi training hall, like the pub
> or playing field in the West, was a space where male psyches, wounded in the real
> world, could indulge in collective fantasies of power. (Ibid.)

We have encountered this kind of argument before, most recently in Žižek's argu-
ments about the ways that those who have nothing have only their bodies and
their discipline. But there are many versions of it, all deriving from the broadly
post-structuralist insight that identity is always an effect or reaction formation
vis-à-vis something perceived as external. As Jian Xu has also put it, all of the
recent key studies of martial arts 'place the body-in-cultivation in a specific his-
torical context; they maintain that the individual, physical body both registers and
reveals the national sociopolitical landscape [and that] the body can [also/even]
express the emotional self repressed by the state' (1999: 961). And this is one of
the senses in which both Bruce Lee's body and Bruce Lee's body of writing and
filmic production can be regarded as *intertextual* – as feeding from and feeding
back into ongoing historical discourses.

FROM BRUCE LEE WORK TO BRUCE LEE TEXT

To the extent that Bruce Lee's words are quotations, allusions, paraphrases
and reiterations of a very wide range of material, what they are, then, is *text*.
Moreover, they are *text* in the very particular theoretical sense given to this word
by Roland Barthes: 'his' writings are obviously not simply 'his', in the conventional
understanding of originating somehow within the author's mind, but are clearly
'woven entirely with citations, references, echoes, cultural languages (what lan-
guage is not?), antecedent or contemporary, which cut across it through and
through in a vast stereophony' (1977: 60). As the parenthetical question – 'what
language is not?' – makes clear, though, what Barthes is proposing with this
theoretical elaboration of the notion of the text is something much more general:
many if not all texts are ultimately constructed from pre-existing cultural material.
As Barthes' contemporary and intellectual colleague Jacques Derrida put it, all
speech, writing and meaning-production, circulation or dissemination in general
must to some extent be 'identifiable as *conforming* to an iterable model, and

therefore … identifiable in a way as "citation"' (1982: 326; emphasis in original). Derrida in fact proposes that this process – what he elevates to the status of an existential, phenomenological or even ontological 'law' – is actually 'to be found in all language, for example in spoken language, and ultimately in the totality of "experience"' (1982: 317).

The implications of the various deconstructions of language, literature and other aspects of culture are far reaching. Here, what is most salient is the emergence of the idea that texts as such ought to be regarded as cultural tapestries, palimpsests and repositories of more or less reworked cultural material. As such, if we 'read into' these texts, what we ought to look for is 'something about culture' – for what we can only really discover is never simply going to be 'something about Bruce Lee' *the psychological individual*, but rather 'something about culture' – the culture which 'influenced' or to some extent constituted his writing.

Despite being persuasively elaborated in the early 1970s, such a mode of reading as that proposed by Barthes, Derrida, Kristeva and other writers associated with 'deconstruction' generally and the journal *Tel Quel* specifically still receives a lot of resistance and hostility. It certainly still requires some explanation and justification. This is because, says Barthes, cultural works such as literature are 'caught up in a process of filiation' (1977: 61). That is, forces of traditional (institutional) habit insist on trying to explain or account for works according to certain criteria. Specifically, Barthes argues, works tend to be explained 'by race, then by History' (ibid.). Thus, Bruce Lee can be – and regularly is – 'explained' according to his ethnicity. Moreover, in fact, as the existence of a 'Bruce Lee Industry' illustrates, he is 'explained' in advance – being packaged and sold as a modern font of ancient/ timeless Oriental wisdom. But to 'understand' Lee according to this manner of reading is certainly not to *read* his texts. It is rather to assume an understanding of them according to some conventional (ethnocentric) prejudices.

A competing force seeking to determine the way we receive Lee's writings is what Barthes calls 'a conformity of the work to the author' (ibid.). In other words, we assume we know what the author must have intended, and we read the words accordingly, and refuse to allow any other meaning to the words – other than what we assume the author must have intended (determined, of course, by our presumptions about their 'race' and their 'place' in terms of country, culture and class as well as historical moment, of course). In Barthes' expression: 'The author is reputed [to be] the father and the owner of his work'; yet, he proposes:

> As for the Text, it reads without the inscription of the Father … [T]he metaphor
> of the Text is that of the network; if the Text extends itself, it is as a result of a

combinatory systematic. […] Hence no vital 'respect' is due to the Text: it can be broken (which is just what the Middle Ages did with two nevertheless authoritative texts – Holy Scripture and Aristotle); it can be read without the guarantee of its father, the restitution of the inter-text paradoxically abolishing any legacy. It is not that the Author may not 'come back' in the Text, in his text, but he then does so as a 'guest'. If he is a novelist, he is inscribed in the novel like one of his characters, figured in the carpet; no longer privileged, paternal, aletheological, his inscription is ludic. He becomes, as it were, a paper-author: his life is no longer the origin of his fictions but a fiction contributing to his work; there is a reversion of the work on to the life (and no longer the contrary); it is the work of Proust, of Genet which allows their lives to be read as a text. The word 'bio-graphy' re-acquires a strong, etymological sense, at the same time as the sincerity of the enunciation – veritable 'cross' borne by literary morality – becomes a false problem: the I which writes the text, it too, is never more than a paper-I. (1977: 61–2)

Within what 'network' could Lee's writings be said to participate? What is the nature of the 'paper-I' or persona that Lee's (re)writings have produced? Given Barthes' signalling of the crucial status of 'race' and 'History' in any readings, it is according to an awareness of these coordinates that this (re)reading (rewriting) of Bruce Lee shall continue to organise itself.

WALK ON *AND* KEEP GOING

According to the regularly recurring and often reiterated themes and sentiments within Bruce Lee's multimedia oeuvre, it seems that he was evidently a great believer in universal truths. His most repeated aphorisms insist upon Taoist-sounding universal laws and principles and a shared universal humanity. Hiss note-taking and writing was clearly led by an investment in expressions and formulations that could be said to relate to some truth of the human condition in general – a 'truth' about humanity regarded in terms both psychological and cultural; truths believed to be available to any, any time, any place, anywhere – as long as they are able and inclined to free their minds from the blinkers of strictures and conventions. Lee had a lot to say in this regard about conventions, traditions and institutions, as we have seen. But Lee also held a particular predilection for what might be called *ethical* truths couched in the form of injunctions: injunctions and imperatives to do with *how* to live, *how* to act, *how* to think, *how* to proceed, *how* to be. This is undoubtedly exemplified in one of his favourite maxims or axioms: 'Walk on!'

Figure 9: 'Keep Calm and Carry on': A poster produced by the British Government in 1939 at the outbreak of World War II

This injunction is often attributed to Lee. In *Bruce Lee: Words of the Dragon: Interviews, 1958–1973*, the editor observes:

> The phrase 'walk on' was an important one in Bruce Lee's philosophy. He even had it written on the back of one of his business cards, which he displayed on his desk to remind himself to walk on, or flow on, in the current of life. (Lee and Little 1997: 75)

In an interview for *TV and Movie Screen* in 1966, Lee is quoted as responding to a question about his method of parenting his son Brandon:

> I will teach him to walk on. Walk on and he will see a new view. Walk on and he will see the birds fly. Walk on and leave behind all things that would dam up the inlet, or clog the outlet, of experience. (Lee and Little 1997: 46)

There are many other instances of this phrase being used to organise Lee's words. However, it is surely significant that one of the books contained in Lee's personal collection was itself called *Walk On!* It was written by the British populariser of Buddhism, Christmas Humphreys (1901–83), and the first words of chapter one are these: 'Asked "What is truth?", a master of Zen Buddhism replied, "Walk on!", and though there will be many words between these at the beginning and the same two at the end of this small book they will say no more' (1947: 7). Two paragraphs later, the book reads:

> Walk on. For life is movement, ceaseless movement, and uses forms as it has need of them. These endless warriors, spirit and matter, life and form are the warp and weft whereon the Namelessness creates the pattern of our days. Form, of the two, is easier to understand, for things and 'facts', and the houses and places and jobs which make up circumstance are here to be handled and seen, while life is in itself invisible. Yet whether we see it or not, it will not wait for us, nor pause while we argue that we do not understand. Life moves on, and we, flames in the light of a prison of our own devising, must move on likewise, or be left behind. (1947: 8)

If this claim that we 'must move on … or be left behind' sounds a bit too much like it harbours a very non-Buddhist melancholy or implicit advocation of moving in terms of trying to keep up and hence 'clinging', Humphreys soon clarifies things with a rather more complex argument – one which is noteworthy for more than one reason, especially as it pre-empts the familiar claim that Buddhism equals passive acceptance of circumstances, docility and inactivity:

All experience, therefore, whether labelled as pleasant or unpleasant, is valuable so long as we handle it on the move, as it were, and still walk on. Methods of self-development vary enormously, but anything in the way of experience is worth the while providing that it teaches a lesson which is thereby learnt. At a later stage on the way the pilgrim begins to create his circumstances as he will, and to this extent to control his experience. He will resort to a vast array of what in the East are referred to as 'devices', and what in the West we should call the technique of our self-becoming. But whatever the method or path adopted, whether by learning, love or noble action, whether pursuing the good, the beautiful or the true, the device when its purpose is fulfilled should be abandoned. Too many of us still walk on with the raft by which we crossed that river strapped to our backs in perpetuity, and all these partial methods must be expanded sooner or later to include all other points of view. (1947: 11–12)

Readers of Bruce Lee will be familiar with such sentiments, which resonate through all of his written notes and quotes. As this case seems to suggest though, Lee's words (and doubtless those of Humphreys too) evidently derive from at least one and presumably an extremely eclectic range of sources, rather than originating 'in' the author. Supporters and critics alike have expended huge amounts of time and energy tracking down these sources; and such excavations are not an uncommon response to any successful or popular author. But establishing 'influence' or 'inspiration' is not in any sense a complete project in and of itself. For the question remains of its significance and effects. Before judging Lee – indeed, *instead* of judging Lee as such – there is a pertinent question about the cultural significance, status and effects of his 'interventions', however 'secondary' or 'derived' they may putatively be.

There are at least two ways to approach the significance of the diversity of Lee's sources. The first is to conclude that because the truths championed by Taoism, Zen and Buddhism are apparently universal and timeless, we should not be surprised to find them everywhere: everyone is human, so every thinker will experience the existential issues of 'the human condition'; just as you do not need to be a doctor to know that you are unwell, so you do not have to be Lau Tzu to hit upon a universal truth; and the 'genius' of Lee boils down to his ability to recognise the profundity of myriad observations in the works of writers from many cultures, East and West. This sort of interpretation is shared by many interlocutors. However, there is another form of interpretation. This is to approach Lee's synthesis of diverse sources in terms of the theme of *discourse*, *hegemony* or *ideology*. This is to propose that there may be something significant in the fact that all of these heterogeneous sources seem so easily to have been brought into

a kind of overarching coherence and consistency by Lee, a consistency that has a distinctly 'Taoist' flavour.

The possibility that this smooth transformation of diverse material into a sleek 'Taoist' form may be 'ideological' finds its warrant in that argument about ideology developed by Žižek, which we have already encountered. To recap, Žižek has posited the existence of a 'hegemonic ideology' of contemporary capitalism; and he has suggested that this ideology is characterised by the dominance of putatively 'Oriental' belief systems (2001a: 12). Žižek's is, of course, a strident critique of this 'ideology'. It is a critique he shares with many other self-declared contemporary 'radicals', such as Alain Badiou, Régis Debray, Michael Hardt and Antonio Negri. The respective positions of these writers differ in some respects, but they nevertheless share a lot. We have already encountered the Žižekian critique, so we need not rehearse the main features of the argument about the 'hegemonic ideology' of 'contemporary capitalism' in general once again here. But there is another element of this 'radical-ideology-critique' which does seem to call out for some specific attention in this context. This again relates to Alain Badiou's widely known and influential book, *Ethics: An Essay on the Understanding of Evil* (2001). (Indeed, it at least seems to be the case that Žižek's own argument has been 'influenced' to some extent by Badiou's *Ethics*, if only in tenor: Žižek's own argument seems to reiterate and echo many of the points Badiou makes – although one of Žižek's specific contributions is to alert us to the possibility of a complex *ideological* interrelation of 'Eastern' and 'Western' in this discursive formation.)

What is particularly pertinent about Badiou's book for us is that despite it being organised as a 'politicised' philosophical critique of what he perceives to be the growing belief in the possibility or existence of a global 'ethical consensus', made up of a shared revulsion towards atrocity combined with a respect for (multi)cultural difference, the 'ethics' that Badiou proposes as a supposedly genuine alternative to the duplicitously wishy-washy/crypto-fascist neoliberal belief in ethical consensus (let's all just be nice to each other) boils down to this formulation: 'Keep going!' (2001: 51). ... Keep going? How far from 'walk on' is 'keep going'?

If we foreground the similarity of Badiou's and Žižek's critiques, then the proximity of the ethical maxim 'keep going' to the supposedly 'ideologically' problematic 'Western' Buddhist aphorism 'walk on' becomes provocative. For, insofar as 'Western' Buddhism might be read as an index of the ideology of a dubious 'multiculturalist consensus', then what is the status of the close semantic relation between Badiou's ('good') ethical maxim of 'keep going' and the (presumably 'bad') Westernised-Buddhist injunction 'walk on'? The Badiouian answer hinges on the necessity of 'keeping going' in terms of maintaining 'a fidelity' to the truth

of an event ('a truth event'), and not being faithful to a simulacrum. To clarify what this entails, and to examine its relation to the object of Badiou's critique – a certain liberal multicultural humanist ethical consensus, of which Bruce Lee will of course be taken as exemplary – we will need to set out some of the key terms of Badiou's argument. Rather than laying this out from the ground up, let us rather get straight to the heart of the matter. He writes:

> Communication is suited only to opinions (and again, we are unable to manage without them). In all that concerns truths, there must be an *encounter*. The Immortal that I am capable of being cannot be spurred in me by the effects of communicative sociality, it must be *directly* seized by fidelity. That is to say: broken, in its multiple-being, by the course of an immanent break, and convoked *[requis]*, finally, with or without knowing it, by the evental supplement. To enter into the composition of a subject of truth can only be something that *happens to you*.
>
> Confirmation of the point is provided by the concrete circumstances in which someone is seized by a fidelity: an amorous encounter, the sudden feeling that this poem was addressed to you, a scientific theory whose initially obscure beauty overwhelms you, or the active intelligence of a political place. [...] Philosophy is no exception here, since everyone knows that to endure the requirement of a philosophically disinterested-interest, you have to have encountered, at least once in your life, the voice of a Master.
>
> As a result, the ethic of a truth is the complete opposite of an 'ethics of communication'. It is an ethic of the Real, if it is true that – as Lacan suggests – all access to the Real is of the order of an encounter. And consistency, which is the content of the ethical maxim 'Keep going!' *[Continuer!]*, keeps going only by following the thread of this Real. (Ibid.; emphasis in original)

I have already sought to represent the experience of the cinematic emergence of Bruce Lee as an event which has definitively transformed certain subjects. The logic or workings of this 'evental' or transformative process was approached using the arguments of Rancière and Meaghan Morris, earlier. Badiou's own thinking here can also be used to supplement this line of reasoning. And this would make the moment of experiencing Bruce Lee on screen into an event. If this seems ontologically problematic (given that the cinema is all too often and all too quickly written off as the exemplary example of the simulacrum), one need merely pause to consider, for instance, Rey Chow's (1995) reading of the well documented accounts of the ways in which the emergence of cinematically disseminated news broadcasts radically changed the orientations of the lives of key cultural and political actors and agents in China and elsewhere. The emergence

of cinema was itself an epochal event. Cinematic experience can always also amount to an event.

As Badiou puts it, 'To enter into the composition of a subject of truth can only be something that *happens to you*'. And here we have the kernel of his ethical formula or system. As Badiou construes it, truth cannot be communicated as such. The accounts of the cinematically mediated encounters with Bruce Lee that we have already considered seem to concur with this statement. Being seized by what Badiou calls 'affects of truth' is not something that can be 'communicated'. Rather, he says, 'this seizure manifests itself by unequalled intensities of existence' (2001: 52). I tend to think that his ensuing list of affects of truth seems rather simplistic and naive ('in love, there is happiness; in science, there is joy (in Spinoza's sense: intellectual beatitude); in politics, there is enthusiasm; and in art, there is pleasure'), but Badiou's essential point is that

> These 'affects of truth', at the same moment that they signal the entry of some-
> one into a subjective composition, render empty all considerations of renunciation.
> Experience amply demonstrates the point, more than amply.
>
> But ethics is not of the order of pure seizure. It regulates subjective consistency,
> inasmuch as its maxim is: 'Keep going!' And we have seen that this continuation
> presumes a genuine subversion *[detournement]* of the 'perseverance in being'. The
> materials of our multiple-being are now organized by the subjective composition, by
> fidelity to a fidelity, and no longer by the simple pursuit of our interest. (Ibid.)

Such an encounter or experience, then, is not a matter of 'opinion'. According to Badiou, opinion is just the oil of life and sociality, with no necessary relation to truth. Truth, however, is an experience, an event, to which (and this is Badiou's ethical injunction) one must be faithful. There are different ways of maintaining 'a fidelity', Badiou regularly reiterates – potentially as many ways as there are sub- jects. As Humphreys might put it, you could call these 'devices' or 'techniques of self-becoming'. But Badiou's caveat about the unpredictability and multiplicity of ways of maintaining fidelity to the event ultimately problematises the possibil- ity that his 'philosophy' could be regarded as 'practical' or 'useful' – or, at least, *more* useful or practical in a way that is *essentially different* from any self-help handbook (like, for example, Spencer Johnson's book, *Who Moved My Cheese?* (1998), or indeed Lee's own *Striking Thoughts: Bruce Lee's Wisdom For Daily Living* (2002)).

Nevertheless, for Badiou, truth consists in the subjective experience of an event (an event which cannot be communicated). For Badiou, there can be one of four types of truth. These are those of mathematics, love, art and politics, as

indicated above in his list of situations in which one may be 'seized by a fidelity: an amorous encounter, the sudden feeling that this poem was addressed to you, a scientific theory whose initially obscure beauty overwhelms you, or the active intelligence of a political place [...] But ethics is not of the order of pure seizure'; rather, it 'regulates subjective consistency, inasmuch as its maxim is: "Keep going!" And we have seen that this continuation presumes a genuine subversion *[detournement]* of the "perseverance in being"'(ibid.). In other words, it is by responding to the injunction to keep 'fidelity' to a truth that someone becomes 'some-one' – 'Immortal', rather than merely 'animal'. It is in being faithful to the experience of a truth that, says Badiou, 'the materials of our multiple-being are now organized by the subjective composition, by fidelity to a fidelity, and no longer by the simple pursuit of our interest' (ibid.).

ETHICS AS KUNG FU

Ultimately, Badiou regards ethics as hard work; or, you might say – evoking the literal translation of the term – ethics as *kung fu*. Anyone can experience an event. The task is to be faithful to its truth, and not to return to the easy life of our animal nature. The real trick – the really tricky bit – is not to be taken in by simulacra, which are, according to Badiou, 'evil'. In his schema, people are, as a rule, *below* good and evil. Life is just life. Good and evil arise in terms of a response to an event. Evil arises through the misfortune or mistake of being faithful to a simulacrum – such as Nazism or nationalism, for instance. As Badiou puts it, 'Every invocation of blood and soil, of race, of custom, of community, works directly against truths; and it is this very collection *[ensemble]* that is named as the enemy in the ethic of truths' (2001: 76). In other words: 'Fidelity to a simulacrum, unlike fidelity to an event, regulates its break with the situation not by the universality of the void, but by the closed particularity of an abstract set *[ensemble]* (the "Germans" or the "Aryans")' (2001: 74). Hence: 'fidelity to the simulacrum ... promotes the community, blood, race, and so on [and] names as its enemy – for example, under the name of "Jew" – precisely the abstract universality and eternity of truths, the address to all' (2001: 76). Thus, Badiou challenges the 'post/modern' belief that ethics can be based on a liberal humanist consensus about the necessity of the avoidance of acts of evil *and* the 'pre/modern' belief in ethics being based on the lines set up by racial, cultural, ethnic, communitarian and national borders, boundaries and differences. What he proposes in its place is an ethics of truth: an ethics of being faithful to the truth (of an) event. The opportunity to be faithful to the truth (of an) event is available to all, but it will always divide a community and

will never produce consensus: there are as many different ways of responding and of responding to an event, or being faithful or not to other events as there are people. So, we might ask, where does this leave us, other than in the realms of either self-help platitudes or those of an unverifiable abstract system whose ultimate contribution is to offer (and obfuscate) an account of why the world is unsystematisable?

On the last page of the conclusion of *Ethics*, Badiou summarises: 'This ethics combines, then, under the imperative to 'Keep going!', resources of discernment (do not fall for simulacra), of courage (do not give up), and of moderation [*réserve*] (do not get carried away to the extremes of Totality)' (2001: 91). This all sounds very well and good. But it raises more questions than it answers. If we quickly consider merely one paragraph with an eye to the questions of coherence and pragmatics; Badiou writes about the (phallic) heroes of his four ontological truth situations:

'Some-one' can thus be *this* spectator whose thinking has been set in motion, who has been seized and bewildered by a burst of theatrical fire, and who thus enters into the complex configuration of a moment of art. Or this assiduous student of a mathematical problem, after the thankless and exhausting confusion of work-ing in the dark, at the precise moment enlightened by its solution. Or that lover whose vision of reality is befuddled and displaced since, supported by the other, he remembers the instant of the declaration of their love. Or this militant who manages, at the end of a complicated meeting, to find simple words to express the hitherto elusive statement which, everyone agrees, declares what must be pursued in the situation. (2001: 45)

Given Badiou's debts to Lacan, we might perhaps want to problematise the phan-tasy character of the evidently phallic hero as agent and agency here. But first, given his contention of the radical heterogeneity of 'communication' to 'truth', we might enquire into the status of the fantasy scenario about the 'militant who manages, at the end of a complicated meeting, to find simple words to express the hitherto elusive statement which, everyone agrees, declares what must be pursued in the situation'. For, the question is: have those who are now listening to the interlocutor themselves just experienced an event, or is something being communicated to them – perhaps even a simulacrum? The answer is far from clear.

Nevertheless, Badiou enjoins us to maintain the finest 'resources of discern-ment', otherwise our ethics risk being led astray by a simulacrum, or we might simply stop:

I have explained where such experiences come from: under pressure from the demands of interest – or, on the contrary, because of difficult new demands within the subjective continuation of fidelity – there is a breakdown of the fiction I use to maintain, as an image of myself, the confusion between my ordinary interests and disinterested-interest, between human animal and subject, between mortal and immortal. And at this point, I am confronted with a pure choice between the 'Keep going!' proposed by the ethic of this truth, and the logic of the 'perseverance in being' of the mere mortal that I am… (2001: 78)

Do not fall for simulacra, says Badiou; do not give up, keep going. This is much the same as Bruce Lee's Westernised Buddhist injunction 'walk on'. In Badiou's words: 'This ethics combines, then, under the imperative to "Keep going!", resources of discernment (do not fall for simulacra), of courage (do not give up), and of moderation [*réserve*] (do not get carried away to the extremes of Totality)' (2001: 91). As Lee observed, of falling for simulacra:

Instead of facing combat in its suchness, then, most systems of martial art accumulate a 'fancy mess' that distorts and cramps their practitioners and distracts them from the actual reality of combat, which is simple and direct. Instead of going immediately to the heart of things, flowery forms (organized despair) and artificial techniques are ritualistically practised to simulate actual combat. Thus, instead of 'being' in combat these practitioners are 'doing' something 'about' combat. (1975: 14)

The alternative error to falling for simulacra is falling by the wayside because of the 'collapse' of an image leading to 'a crisis of fidelity' (Badiou 2001: 78):

A crisis of fidelity is always what puts to the test, following the collapse of an image, the sole maxim of consistency (and thus of ethics): 'Keep going!' Keep going even when you have lost the thread, when you no longer feel 'caught up' in the process, when the event itself has become obscure, when its name is lost, or when it seems that it may have named a mistake, if not a simulacrum. (2001: 78–9)

So much is uncertain here. Maintain fidelity to the event. But which event? And how? Do not lose the way. But, what is the way? Do not lose faith. But, what if your faith is faith in a simulacrum? Continue! Keep going! Walk on! The distance between profundity and platitude, politico-academic philosophy and self-help ideology seems to collapse here. The boundaries and borders between philosophy and popular culture seem obscure, uncertain, perhaps even untenable. The same goes for philosophy and psychology, philosophy and ideology.

'Keep going' commands Bruce Lee; 'keep going' command Hollywood training films; 'keep going' commands 'radical' philosopher Alain Badiou: 'Continue to be this "some-one", a human animal among others, which nevertheless finds itself *seized* and *displaced* by the evental process of a truth' (2001: 90–1; emphasis in original). Quite what these proximities, connections and contiguities signify is also uncertain. Is film philosophical? Is contemporary continental philosophy cinematographic? Can the one be translated into the other, and with or without loss, transformation or remainder? In any case what seems called for is a consideration of cultural translation.

notes

1 James Bishop (2004) provides an expansive and fascinating list of Bruce Lee's sources, tracing Lee's 'own words' back to the places he most likely found them (mainly books in Lee's own library).

2 Sedgwick chases the interpretation of the 'finger pointing at the moon' riddle through the archives of Zen Buddhist writings; for the 'implication of the finger/moon image is that pointing may invite less misunderstanding than speech, but that even its non-linguistic concreteness cannot shield it from the slippery problems that surround reference' (2003: 170). As she concludes: 'Perhaps the most distinctive way Mahayana Buddhism has tried to negotiate the "finger pointing at the moon" issue is through the ostentive language of thusness or suchness' (ibid.). However, ostention, indexicality, acts of reference, and suchlike, produce a 'resonant double movement' (2003: 171), which Kosofsky Sedgwick prefers to approach through the terms and poetics of Buddhism itself. This preference allows her to propose that 'finally, in the view of thusness, even the distinction between finger and moon dissolves, and with it perhaps the immemorial injunction against confusing them. [...] As a contemporary Zen abbot notes, "The finger pointing to the moon is the moon, and the moon is the finger ... they realize each other". [...] A koan commentary elaborates: "When the monk asked about the meaning of 'the moon', the master [Fa Yen] answered 'to point at'; when someone else asked about the meaning of 'to point at' the master replied 'the moon': Why was it so? The deepest reasoning, probably, was in the Enlightened mind of the Ch'an master, where there was no distinction between what the ordinary mind called 'to point at' and 'the moon': To him, the relation between the two was similar to the relation of an ocean to its waves" (ibid.).

3 Bruce Lee has long been recognised as a muse for postmodern self-construction: Morris clarifies this by discussing his role in the camp US martial arts film *No Retreat, No Surrender*, in which the ghost of Lee comes back to enable the teen hero to reconstruct himself to vanquish his foes.

4 In fact, the crux of Morris's entire article in this regard is that although she sees the grain of truth in Robert Hughes' caricatural comment that 'the world changes more widely, deeply, thrillingly than at any moment since 1917, and the American academic left keeps fretting about how phallocentricity is inscribed in Dickens's portrayal of Little Nell' (2001: 184); on the other hand, Morris believes that there has in fact been 'a wide, deep, thrilling change

in the world which Robert Hughes has missed' – namely, that 'fretting over phallocentricity is now a popular occupation' (ibid.). We may or may not accept Morris's contention that 'fretting over phallocentricity is now a popular occupation'. Personally, I do not, although I think that in the mid-to-late 1990s perhaps it looked like it was *about to become* more of 'a popular occupation'; and maybe it did briefly become slightly more common than it had been, at least journalistically.

BRUCE LEE FILM IN CULTURAL TRANSLATION

Jīng Wu student: "Look here! Now, just what is the point of this?"

Translator: "Just that the Chinese are a race of weaklings, no comparison to us Japanese."

— *Fist of Fury*, dubbed version

Jīng Wu student: "One question, are you Chinese?"

Translator: "Yes, but even though we are of the same kind, our paths in life are vastly different"

— *Fist of Fury*, subtitled version[1]

DIFFERENT LEE

Bruce Lee has always been construed as a figure who existed at various cross-roads – a kind of chiasmatic figure, into which much was condensed, and displaced. His films, even though in a sense being relatively juvenile action flicks, have also been regarded as spanning the borders and bridging the gaps between 'trivial' popular culture and 'politicised' cultural movements (see Brown 1997;

Figure 10: *Fist of Fury*

Morris 2001; Prashad 2001; Kato 2007). That is, although on the one hand, they are all little more than fantastic choreographies of aestheticised masculinist violence, on the other, they worked to produce politicised identifications and modes of subjectivisation that supplemented many popular-cultural-political movements: his striking(ly) nonwhite face and unquestionable physical supremacy in the face of often white, always colonialist and imperialist bad-guys became a symbol of and for multiple ethnic, diasporic, civil rights, anti-racist and postcolonial cultural movements across the globe (see Prashad 2001; Kato 2007). Both within and 'around' his films – that is, both in terms of their internal textual features and in terms of the 'effects' of his texts on certain viewing constituencies – it is possible to trace a movement from ethnonationalism to a postnational, decolonising, multicultural imaginary (see Hunt 2003). This is why his films have been considered in terms of the interfaces and interplays of popular culture, postcolonial, postmodern and multiculturalist issues that they have been deemed to 'reflect', engage, dramatise, explore or develop (see Abbas 1997; Hunt 2003; Teo 2008). Lee has been credited with transforming intra- and inter-ethnic identification, cultural capital and cultural fantasies in global popular culture, and in particular as having been central to revising the discursive constitutions and hierarchies of Eastern and Western models of masculinity (see Thomas 1994; Chan 2000; Miller 2000; Hunt 2003; Preston 2007).

In the wake of such well-known and well-worn approaches to Bruce Lee, I would prefer at this point to take these types of arguments as read, and propose from here on to approach Lee somewhat differently – maybe peculiarly, perhaps even queerly. Specifically, I would like to propose that his celluloid cinematic interventions – no matter how fantastic and fabulous – ought to be

approached as texts and contexts of *cultural translation*. However, to say this, a rather twisted or indeed 'queer' notion of translation needs to be established. To speak of *cultural* translation is not to simply refer to *translation* in a linguistic or hermeneutic sense. It is rather to be understood as something less 'literal' (or logocentric); as what Rey Chow calls 'an activity, a transportation between two "media", two kinds of already-mediated data' (1995: 193). Furthermore, cultural translation would also be understood as a range of processes which mean that, for academics, 'the "translation" is often what we must work with because, for one reason or another, the "original" as such is unavailable – lost, cryptic, already heavily mediated, already heavily translated' (ibid.).

This is not a particularly unusual situation, of course. It is, rather, everyday. Such translated, mediated, commodified, technologised exchanges between cultures happen every day. This is also the situation we are in when encountering film, especially films that are dubbed or subtitled, of course, as in the case of Bruce Lee's Hong Kong-produced films. Such films are translated, dubbed and subtitled. But this is not the start or end of translation. For the notion of cultural translation demands that we extend our attention beyond the scripts and into the matter of the very medium of film itself, the relations between films, between film and other media, and so on. This is important to emphasise because, despite its everydayness, despite its reality, and despite the arguable primacy of the situation of cultural translation between 'translations' with no (access to any) original, this situation of cultural translation is not often accorded the status it could be said to deserve. It is rather more likely to be disparaged by scholars, insofar as it occurs predominantly in the so-called 'realms' of popular culture and does not conform to a model of translation organised by the binary of 'primary/original' and 'derived/copy' (Chow 1995: 182). As Chow asks:

> how is it that colleagues in the discipline of comparative literature tend to love the idea of translation – which, as a topic, is perhaps one of the most heavily theorized in the field – but at the same time seem to scorn the use of translated works for research and pedagogical purposes as improper, inauthentic, low-rent, etc., even in a comparative context? (2010: 456)

In awareness of this, Chow proposes that 'the problems of cross-cultural exchange – especially in regard to the commodified, technologized image – in the postcolonial, postmodern age' (1995: 182) demand an approach that moves beyond many traditional approaches. For instance, she points out, as well as the 'literal' matters of translation that arise within film, 'there are at least two [other] types of translation at work in cinema' (ibid.). The first involves translation understood

'as inscription': any film is a kind of writing into existence of something which was not there as such or in anything like that way before its constitution in film. The second type of translation associated with film, proposes Chow, involves understanding translation 'as transformation of tradition and change between media'; in this second sense, film is translation insofar as a putative entity (she suggests, 'a generation, a nation, [or] a culture') are 'translated or permuted into the medium of film' (ibid.). So, film as such can be regarded as a kind of epochal translation, in the sense that cultures 'oriented around the written text' were and continue to be 'in the process of transition and of being translated into one dominated by the image' (ibid.). As such,

> the translation between cultures is never West translating East or East translating West in terms of verbal languages alone but rather a process that encompasses an entire range of activities, including the change from tradition to modernity, from literature to visuality, from elite scholastic culture to mass culture, from the native to the foreign and back, and so forth. (1995: 192)

It is here that Bruce Lee should be placed. However, given the complexity of this 'place' – this relation or these relations – it seems likely that any translation or indeed any knowledge we hope might be attained cannot henceforth be understood as simple unity-to-unity transport. This is not least because the relations and connections between Bruce Lee and … well, anything else, will now come to seem always shifting, immanent, virtual, open-ended, ongoing and uncertain. This is so much so that the very notions of completeness, totality or completion are what become unclear or incomplete in the wake of 'cultural translation'. In other words, this realisation of the complexity of cultural relations, articulations and encounters jeopardises traditional, established notions of translation and knowledge-establishment. Yet it does not 'reject' them or 'retreat' from them. Rather, it transforms them.[2]

To elucidate this transformation, Chow retraces Foucault's analyses and argument in *The Order of Things* (1970) in order to argue that both translation and knowledge *per se* must henceforth be understood as 'a matter of tracking the broken lines, shapes, and patterns that may have become occluded, gone underground, or taken flight' (2006: 81).[3] Referring to Foucault's genealogical work on the history of knowledge epistemes in *The Order of Things*, Chow notes his contention that 'the premodern ways of knowledge production, with their key mechanism of cumulative (and inexhaustible) inclusion, came to an end in modern times'; the consequence of this has been that 'the spatial logic of the grid' has given way 'to an archaeological network wherein the once assumed clear

continuities (and unities) among differentiated knowledge items are displaced onto fissures, mutations, and subterranean genealogies, the totality of which can never again be mapped out in taxonomic certitude and coherence' (ibid.). As such, any 'comparison' must henceforth become 'an act that, because it is inseparable from history, would have to remain speculative rather than conclusive, and ready to subject itself periodically to revamped semiotic relations'; this is so because 'the violent yoking together of disparate things has become inevitable in modern and postmodern times' (ibid.). As such, even an act of 'comparison would also be an unfinalizable event because its meanings have to be repeatedly negoti-ated'; this situation arises 'not merely on the basis of the constantly increasing quantity of materials involved but more importantly on the basis of the partialities, anachronisms, and disappearances that have been inscribed over time on such materials' seemingly positivistic existences' (ibid.).

To call this 'queer' may seem to be stretching – or twisting, contorting – things a bit. Clearly, such a notion of translation can only be said to be queer when 'queer' is understood in an etymological or associative sense, rather than a sexual one. Nevertheless, it strikes me that the most important impulse of queer studies was its initial and initialising ethico-political investment in stretching, twisting and contorting – with the aim of transforming – contingent, biased and partial societal and cultural norms.[4] This is an element of queering that deserves to be reiterated, perhaps over and above queer studies' always-possibly socially 'conservative' investment in sexuality as such (see Chambers and O'Rourke 2009). This is so if queering has an interest in transforming a terrain or a context rather than just establishing a local, individual enclave for new norms to be laid down. I believe that it does, which is one of the reasons that it seems worthwhile to draw a relation between cultural translation and queering, given their shared investments in 'crossing over', change, twisting, turning and warping. Given the undisputed and ongoing importance of Bruce Lee within or across the circuits of global popular culture, crossing from East to West and back again, as well as from film to fantasy to physicality, and other such shifting circuits, it seems worthwhile to consider the status of 'crossing over' in (and around) Bruce Lee films.

EXCESSIVE LEE

To bring such a complicated theoretical apparatus to bear on Bruce Lee films may seem excessive. This will be especially so because, as Kwai-Cheung Lo argues, most dubbed and subtitled martial arts films from Hong Kong, China or Japan have traditionally been approached not with cultural theories to hand but

rather with buckets of popcorn and crates of beer, as they have overwhelmingly been treated as a source of cheap laughs for Westerners (2005: 48–54). Indeed, as Leon Hunt has noted, what is 'loved' in the 'Asiaphilia' of kung fu film fans is mainly 'mindlessness' – the mindless violence of martial arts. Like Lo, Hunt suggests that therefore even the Asiaphilia of Westerners interested in Eastern martial arts 'subtly' amounts to yet another kind of Orientalist 'encounter marked by conquest and appropriation' (2003: 12).

Lo's argument has an extra dimension, however, in that as well as focusing on the reception of these filmic texts in different linguistic and cultural contexts, he also draws attention to the realm of production. Yet even this, in Lo's terms, is far from theoretically complex: in Hong Kong film, he writes, 'the process of subtitling often draws attention to itself, if only because of its tendency toward incompetence' (2005: 48). Nevertheless, he suggests, 'as a specific form of making sense of things in cross-cultural and cross-linguistic encounters, subtitling reveals realities of cultural domination and subordination and serves as a site of ideological dissemination and its subversion' (2005: 46).[5] For Lo, then, despite a base level of material 'simplicity' here, complex issues of translation do arise, and not simply with the Western reception of Eastern texts, but actually at the site of production itself, no matter how slapdash. As he sees it,

> Unlike film industries that put a great deal of care into subtitles, Hong Kong cinema is famous for its slipshod English subtitling. The subtitlers of Hong Kong films, who are typically not well educated, are paid poorly and must translate an entire film in two or three days. (2005: 53)

At the point of reception or consumption, Lo claims, the 'English subtitles in Hong Kong film often appear excessive and intrusive to the Western viewer'. Drawing on a broad range of Žižeko-Lacanian cultural theory, Lo suggests that the subtitles are 'stains' and that 'just as stains on the screen affect the visual experience, subtitles undermine the primacy and immediacy of the voice and alienate the aural from the visual' (2005: 49). In this way, by using one of Žižek's favourite double-entendres – the crypto-smutty, connotatively 'dirty' word 'stain' (a word which, for Žižek, often signals the presence or workings of 'the real' itself) – and by combining it with a broadly Derridean observation about the interruption of the self-presence of auto-affection in the frustration of cinematic identification caused by non-synchronised image-and-voice and image-and-written-word, Lo crafts an argument that is all about *excess*.

The subtitles are excess. Their meaning is excess: an excess of *sameness* for bilingual viewers, and an excess of *alterity* for monolingual viewers. For

the bilingual, who both hear and read the words, they produce both excessive emphases and certain discordances of meaning, because of their spatial and temporal discordances and syncopations with the soundtrack. But, Lo claims, 'to a presumptuous Western audience, the poor English subtitles make Hong Kong films more "Chinese" by underscoring the linguistic difference' (2005: 51). Thus, for bilingual viewerships (such as many Hong Kong Chinese, who have historically been able to speak both English and Cantonese), the subtitles introduce an excess that simultaneously introduces alterity through their fracturing and alienating effects. For monolingual 'foreign' viewerships, Lo argues, the subtitles also produce an 'extra' dimension: a very particular, form of pleasure and enjoyment. This extra is not extra to a primary or proper. It is rather an excess generated from a lack. It is an excess – pleasure, amusement, finding the subtitles 'funny'. And Lo's primary contention is that, in this sense, the subtitles actually preclude the possibility of a proper 'weight' or 'gravity' for the films; that they are a supplement that precludes the establishment of a proper status, a proper meaning, a properly 'non-excessive' non-'lite'/trite status.

Thus, the subtitles are a visual excess, Lo contends.[6] For monolingual or eurolingual viewers, the visual excess is the mark (or stain) which signifies a semantic lack. This might be a mark of viewers' own inability and lack of linguistic and cultural knowledge rather than any necessary semantic deficiency in the text itself; but the point is, argues Lo, 'the words onscreen always consciously remind viewers of the other's existence' (2005: 48). In either case, this very lack generates an excess. As Lo puts it, 'the fractured subtitles may puzzle the viewers who need them, and yet they also give rise to a peculiar kind of pleasure'; that is, 'the articulation of the loss of proper meaning offers a pleasure of its own to those who treasure alternative aesthetics and practice a radical connoisseurship that views mass culture's vulgarity as the equal of avant-garde high art' (2005: 54). Lo calls this the pleasure of 'being adrift': 'Drifting pleasure occurs when definite meaning can no longer be grasped. Bad English subtitles may kindle a kind of pleasure that was never meant to be there' (ibid.), he proposes; going on to insist that

> A subtitled Hong Kong film received in the West produces a residual irrationality that fascinates its hardcore fans. Apparently, a dubbed Hong Kong film would not offer the same sort of additional fun. The distorted meaning of the English subtitles is not to be overlooked. On the contrary, the distortion is written into the very essence of Hong Kong films and is one of the major appeals for Western fans. It is an unexpected boon that increases the viewer's already considerable enjoyment. (2005: 56)

Thus, he argues against the suggestions of commentators like Antje Ascheid

who have proposed that subtitled film fundamentally 'contains a number of reflexive elements which hold a much larger potential to break cinematic identification, the suspension of disbelief and a continuous experience of unruptured pleasure' (quoted in ibid.). Ascheid argues that subtitled films construct a ruptured space 'for intellectual evaluation and analysis' insofar as this confluence of features 'destroys the usual unity between the spectator and the cinematic world he or she experiences [and] results in the perception of "difference" rather than the confirmation of "sameness" and identity', which 'potentially leads to a considerable loss of pleasure during the experience' (quoted in ibid.). Against such arguments, Lo proposes that 'In the case of subtitled Hong Kong films, these arguments are no longer valid'; this is because, with these martial arts films, the 'disruption of cinematic identification and the perception of difference might generate extra enjoyment but never a loss of pleasure' – in martial arts films, suggests Lo, 'rupture does not necessarily give rise to "intellectual evaluation and analysis"; rather, it lends to a film's fetishistic appeal' (ibid.).

STUPID LEE

So, the subtitles are constructed with 'incompetence' by the undereducated and underpaid subtitlers. They are destined to be an *unnecessary* supplement for Chinese speakers and an *excessive* supplement for those who can also read Chinese. For Westerners, these supplements are destined to work to turn the movies into a joke. Indeed, apart from the thrills to be gained from watching the physical action of the martial choreography, the subtitles are destined to become the fetish defining the nature of Western viewers' interest in Hong Kong films.

> It has been well-documented in Western film guides and critical studies of Hong Kong films that the English subtitles are not viewed simply as troublesome but also as great fun for Western viewers. In the West, Hong Kong cinema enjoys great popularity among nonconformist subcultures – festival circuits, college film clubs, Internet fanzines, and fan groups – in which cult followers and lovers of camp celebrate the exploitation and peculiarities on display [...]; its wild and weird subtitles further elevate the cinema's fetishistic status and exotic flavor. The tainted object that obscures part of the screen and confuses the signification has been sublimated into a cult element by hardcore fans who look for off-center culture and down-market amusements. (Lo 2005: 54)

Fun, off-centre, camp, incompetent, uneducated, excessive, physical, intrusive:

the way Lo constructs and represents Hong Kong cinema 'in general' is not particularly far removed from the way that the Hollywood camera constructs the bumbling, bothersome Mr Yunioshi in *Breakfast at Tiffany's* (see Morris 2001). Of course, Lo is putatively dealing with the 'reception' and 'interpretation' of Hong Kong films by *Western* viewers. Thus, according to him, it is the Western viewers, in (and through) their ignorance, who construct the dubbed Hong Kong films as low-brow, 'down-market amusements'. But the likelihood or generality of such a reception is overdetermined by the conspiring factors of undereducated subtitlers who are, moreover, overworked and underpaid by an industry in a hurry to shift its product. Thus, even if the Hong Kong films *are* sophisticated, complex texts, this dimension is going to be forever foreclosed to the monolingual or euro-lingual Western viewer. What is lost in the double translation from living speech to incompetent writing is *logos*. What remains is the nonsense of the body and some gibberish, unintelligible baby-talk. As such, the only people could possibly be interested in such a spectacle, are, of course, *stupid people*.

Lo does not say this explicitly, but everything in his argument suggests the operation of a very familiar logic: the denigration of popular culture; the conviction that it is *stupid*. In his own words, the badly subtitled film entails 'the loss of proper meaning [which] offers a pleasure of its own to those who treasure alternative aesthetics and practice a radical connoisseurship that views mass culture's vulgarity as the equal of avant-garde high art' (2005: 54). Thus, to Lo, 'mass culture' is characterised by 'vulgarity' and is not the equal of 'avant-garde high art'. Popular culture is stupid.

Lo's attendant argument, that the clunky subtitles are not really an 'obstacle' to the smooth global circulation of commodities, but rather the condition of possibility for the success of the martial arts films, is similar. As he claims: 'globalization is facilitated by the "hindrance" or the "symbolic resistance" inherent in the clumsy English subtitles – which represent a certain cultural specificity or designate certain ethnic characteristics of the port city' (ibid.). Thus, Lo imagines the appeal of such films to be entirely fetishistic and ultimately racist. For, in his conceptualization, what Western audiences want is a foreignness to laugh at. As such, it is the films' very palpable foreignness which helps them to succeed. Indeed, he concludes, 'the subtitles as good and pleasing otherness are actually founded on the exclusion of the political dimension usually immanent in the encounter of the cultural other' (2005: 58). This is a core dimension of Lo's argument: 'Hong Kong cinema is basically perceived as a "good other" to the American viewer insofar as it is analogous to the old Hollywood' (2005: 57). Thus, for Lo, the matter of subtitles in Hong Kong film ultimately amounts to a process of depoliticisation. Yet is this in fact the case?

One question, are you Chinese?

Figure 11: Questioning the Translator

ORIGINAL LEE

The 1972 international blockbuster *Fist of Fury* (also known as *Jīng Wu Mén* in Chinese and *The Chinese Connection* in America) begins with a burial. The founder of the Jīng Wu martial arts school in the Shanghai International Settlement (1854–1943) – the much mythologised historical figure, Huo Yuanjia – has died (1910). Before the very first scene, a narrator tells us that the events surrounding Master Huo's death have always been shrouded in mystery, and that the film we are about to watch offers 'one possible version' ('the most popular version') of what *may* have happened. What happens – or what could have happened, according to this fable – is that Huo's favourite pupil, Chen Zhen, played by Bruce Lee, returns to the Jīng Wu School and refuses to accept that his master died of natural causes.

At the official funeral the next day, an entourage from a Japanese Bushido School arrive, late. They bear a gift, as was traditional. But the gift turns out to be an insult and a provocation: a framed inscription of the words 'Sick Man of Asia' (dōng yà bìng fū). Upon delivering this, the Japanese throw down a challenge, via their intermediary, the creepy, effeminate and decidedly queer translator called Wu (or, sometimes, Hu): if any Chinese martial artist can beat them, the Japanese martial artists will 'eat these words'.

So begins what has become regarded as a martial arts classic. The film is organised by Bruce Lee's Chen Zhen's ultimately suicidal quest for revenge against what turns out to have been not merely a Japanese martial arts challenge (Lee of course picks up the gauntlet thrown down by the Japanese – besting the entire Japanese school single-handedly the next day, in a fight scene that made

Our story begins with the death of Ho Yuan-chia, a legendary Chinese hero, famous for his victories over Russia's champion wrestler and Japan's bushido experts.

He was poisoned, by whom? For what? It was not known for certain.

But there has been speculation, here we offer the most popular version.

一代大俠霍元甲，因挫俄羅斯大力士，敗日本武士道高手，一洗我「東亞病夫」之辱，名震天下。惟不幸為奸人所乘，伺機下毒，終告不治。

霍氏謝世後，死因人言人殊，本片乃根據當年部份傳言所改編，

Figure 12: The opening frames of *Fist of Fury*

martial arts choreographic history and is still clearly referenced in myriad fight scenes of all action genres to this day) but also a murderous piece of treachery: Lee subsequently discovers that his master was poisoned by two imposters who had been posing as Chinese cooks, but who were really Japanese spies. Again, their intermediary, their contact, the communicator of the orders, was the translator, Mr Wu. Thus, what begins with a crass and irreverent ethnonationalist slur at a Chinese master's funeral turns out to be part of a concerted plot to destroy the entire Chinese institution. As *Fist of Fury* makes clear, the assassination and the plot to destroy Jīng Wu arose precisely because the Japanese were deeply concerned that the Chinese were *far* from being '*sick* men', were actually too healthy, and could become too strong and pose too much of a potential challenge to Japanese power, if left to their own devices. However, as the film also makes clear, in this colonial situation, the odds have been stacked against the Chinese from the outset – no matter what they decide to do, they will not be left alone or allowed to prosper.

The translator is the first point of contact between the two cultures. The first face-to-face conscious contact follows the earlier behind-the-back, underhand and unequal contact of spying and assassination. To the Chinese, Wu is consistently belligerent, disrespectful and abusive. To the Japanese he is an obsequious crawler. On first face-to-face contact, at the funeral, Wu taunts the mourners, telling them that they are weak, pathetic and no better than cowardly dogs – simply because they are Chinese. A senior Chinese student (played by James Tien Chun) is evidently confused: he approaches Wu and demands an answer to one question. In the dubbed English version the question is: 'Look here! Now, just what is the point of this?' And the answer is given: 'Just that the Chinese are a race of weaklings, no comparison to us Japanese.' So, here, Wu is Japanese. However,

in the English subtitled version, the question and answer are somewhat different. Here, the Chinese student says: 'One question, are you Chinese?' To this, the answer is: 'Yes, but even though we are of the same kind, our paths in life are vastly different.' So here, Wu is Chinese.

This disjunction between the subtitled version and the dubbed version may seem only to raise some fairly mundane questions of translation: namely, which version is correct, which version is faithful to the original? If by original we mean the Cantonese audio track, then, in this instance at least, it is the subtitles which follow it most closely.[7] But, as my act of distinguishing the audio tracks from the visual material implies, it seems valid to suggest, precisely because it is possible to separate out these various elements, that it is the very notion of the *original* here that should be engaged. For, the film was 'shot post-synch', with the sound-track added to the film only after the entire film was shot (see Lo 2005: 50). As such, the visual and the aural are already technically divergent, distinct textual combinations, even in the putative 'original'. So, if we wish to refer to it, the question must be: *which original?*

It is of more than anecdotal interest to note at this point that the actor who plays the translator here – Paul Wei Ping-Ao – provided the voice over not only for the Cantonese audio but also for the English audio. This means that the actor who *plays* the translator is also *actually* an active part of the translation of the text. It also means that *the translated version of this film is also another/different 'original' version*; a secondary, supplementary original, playing the part of a translation. It equally means that, given the overlapping production and translation processes involved in the technical construction of *not 'this film'* but rather *'these films'*, the quest to establish and separate the original from the copy or the original from the translation becomes vertiginous.

Certain binaries are blurred because of this fractured bilinguality. These are the very binaries which fundamentally structure and hierarchise many approaches to translation: fidelity/infidelity, primary/secondary, original/copy, authentic/construction and so on. In fact, these several senses of translation, treachery and tradition all coalesce in the early scene in *Fist of Fury*. As we have seen, this scene – which initiates and initialises the action of the film – is dominated by an accusation: the Japanese declare that an unnamed addressee is the 'Sick Man of Asia'. This is a brilliantly efficient insult, as it operates on all salient levels at once: This is the funeral of a Chinese martial arts master who apparently died of a sickness, so he was the sick man; but it is also directed at all Chinese, and equally to the nation of China, whose independence and powers had been drastically compromised by a wide range of foreign onslaughts. Reciprocally, of course, as Jachinson W. Chan (2000) emphasises, this is all organised through the other element of this

copula: masculinity. Thus, the vocalisation of the accusation of sickness on all levels comes at a moment of profound cultural crisis. China is in a weakened state – hence the presence of such powerful Japanese in Shanghai. The funeral is that of the traditional Chinese master. Moreover, the deceased master was also the actual founder.

Here, the fractured bilinguality is itself symptomatic of what we might call (following Benjamin) a Chinese 'intention' in a text produced in *British* Hong Kong about *Japanese* coloniality. This is a multiple-colonised text about a colonial situation produced in a different colonial context. In it, the supposedly stable binaries of text and translation are substantially unsettled. Indeed, this is so much so, I think, that what we are able to see here is what Rey Chow calls a 'materialist though elusive fact about translation'; namely, to use Walter Benjamin's proposition, that 'translation is primarily a process of *putting together*' – as Chow explains, for Benjamin, translation is a process which 'demonstrates that the "original", too, is something that has been put together' – and she, following this, adds: 'in its violence' (1995: 185). What part does 'violence' play, here?

VIOLENT LEE

There are several obvious forms of violence in the putting together of both the English and the Cantonese versions. Obviously there is the well-worn theme of the ethnonationalist violence of the film's primary drama: Bruce Lee's fantastic, phantasmatic, suicidal, symbolic victory (even in death) over the Japanese oppressors. But there is also the more subtle 'violence' or 'forcing' involved in constraining the English dubbing to synching with the lip movements of a different-language dialogue. This is 'violent' in its semiotic consequences. For instance, as we have already seen, it violently simplifies the complexity of the translator, Mr Wu. In the dubbed version, he becomes *simply* Japanese and therefore *simply* other. And this signals or exemplifies a further dimension. The dubbed version seems consistently to drastically simplify the *situation* of the film. That is, it dislodges the visibility of the themes of the politics of coloniality that are central to the subtitled (and presumably also to the Cantonese) versions, and empties out the socio-political complexity of the film, transforming it into a rather childish tale of bullies and bullying: in the dubbed version, the Japanese simply bully the innocent and consistently confused Chinese, simply because they are bullies. More complex issues are often elided. This is nowhere more clear than in the difference between the question 'ni shì Zhōng guó rén ma?' ('are you Chinese?') and the alternative question, 'just what is the point of this?'

Figure 13: A very symbolic slap in the face; *Fist of Fury*

However, although 'are you Chinese?' is *literally* faithful to the Cantonese, and although 'what is the point of this?' is not, and is more simplistic, I do not want to discount, discard or disparage this literally inadequate translation. This is not least because the question 'just what is the point of this?' is surely one of the most challenging and important questions to which academics really ought to respond. It is also because the unfaithful translation is the one which perhaps most enables the film to be *transmissible* – that is, to *make sense* elsewhere, in the non-Chinese contexts of the film's own transnational diasporic dissemination. It has an element of universality. This is to recall Benjamin's proposal that a work's 'transmissibility' actually arises 'in opposition to its "truth"' (Chow 1995: 199). This contention arises in Benjamin's discussion of Kafka, in which he asserts that: 'Kafka's work presents a *sickness of tradition*' in which the 'consistency of truth … has been lost'; thus, suggests Benjamin, Kafka 'sacrificed truth for the sake of *clinging to its transmissibility*' (quoted in ibid.). Picking up on this, Chow adds Vattimo's Nietzschean proposal that this 'sickness' is constitutive of transmissibility and is what enables and drives the 'turning and twisting of tradition away from its metaphysical foundations, a movement that makes way for the hybrid cultures of contemporary society' (ibid.).

The primary field of such twisting, turning, concatenation and warping is, of course, that supposed 'realm' (which could perhaps be rather better understood as the condition) called mass or popular culture. Thus, argues Chow:

> There are multiple reasons why a consideration of mass culture is crucial to cultural translation, but the predominant one, for me, is precisely that asymmetry of power relations between the 'first' and the 'third' worlds. […] Critiquing the great disparity between Europe and the rest of the world means not simply a deconstruction of Europe as origin or simply a restitution of the origin that is Europe's others but a thorough dismantling of *both* the notion of origin and the notion of alterity as we know them today. (1995: 193–4)

JUST WHAT IS THE POINT OF THIS?

The issue of transmissibility might be taken to suggest one of two things: *either*, 'just what is the point of this?' is the more primary or more 'universal' question, because it is more transmissible; *or* this translation/transformation *loses* the essential stakes of the local specificity of the ethnonationalist question 'Are you Chinese?'

Rather than adjudicating on the question of transmissibility *and* (or *versus*) truth in 'direct' terms, it strikes me as more responsible to expose each of these questions to each other. Thus, in the face of the question 'Are you Chinese?' we might ask: 'Just what is the point of *this*?' and vice versa. In doing so, we ought to be able to perceive a certain ethnonationalist 'violence' lurking in the construction of the former question. For instance, 'Are you Chinese?' is *regularly* levelled – accusingly – at translated or globally successful 'Chinese' films. It is often asked aggressively, pejoratively, dismissively – as if simultaneously demanding fidelity and essence, *at and the same time* suggesting treachery.

The accusative question levelled at Hu the translator strongly implies that if Hu *is* Chinese, then he, in being a translator, is a traitor. But in *Fist of Fury* there is more. The translator is a pervertor: a pervertor of tradition, first of all. And also: a very queer character. The film draws a relation between the translator and queerness. It makes the translator queer. Because he crosses over.

According to the Italian expression '*traduttore, traditore*', a translator is a traitor. Chow starts from this expression and the etymological intertwining of translation, tradition and treachery to consider the always-uneasy cultural *place* or plight of translation, translating and translators, and the overwhelming tendency for thinking about translation to be ineluctably involved in a fraught negotiation of the 'ideology of fidelity' (1995: 183). For the translator and the translation must be 'faithful', in some sense. But what is being asked of any act of translation would seem to be an act of infidelity, of moving over into alterity. Furthermore, Chow's work implies, the problematic of fidelity and infidelity here has at least two kinds of connotation. The first is related to depth versus superficiality. The second is related to transmission, transgression and tradition. An incompetent translation is easily thought of as one which is unable to 'plumb the depths' and transfer them with fidelity; it is regarded as merely 'surface' or 'superficial' in some way. In other words, unless the translated work can somehow prove itself to have carried over the 'depth' of the original, it is merely shallow, superficial and unfaithful to the tradition of the original. In a discussion of the discourse of translation as it relates to 'China' in 'Chinese' film (and films about China produced for or consumed by non-Chinese viewerships), Chow puts the case rhetorically: 'is not the

distrust of "surfaces" ... a way of saying that surfaces are "traitors" to the historical depth that is "traditional China"?' (1995: 183). 'And yet', she immediately continues, 'the word *tradition* itself, linked in its roots to translation and betrayal, has to do with handing over. Tradition itself is nothing if it is not a transmission. How is tradition to be transmitted, to be passed on, if not through translation? (ibid.).

Given Chow's rhetorical formulation, she goes on, as one might hope and expect, to zone in on and problematise the terms she has identified as structuring so many approaches to questions of cultural translation: surface/depth, fidelity/infidelity, original/translation, culture/tradition/transmission/translation and so on. We will explore aspects of Chow's discussion of the possibilities of 'cultural translation' in our discussion of dubbing, subtitling and translation in relation to *Fist of Fury*. For, these several senses of translation, treachery and tradition all coalesce in the early scene in *Fist of Fury*.

TRANSMISSION, TRANSGRESSION

The translator and two Japanese martial artists enter the Jing Wu School in the midst of the funeral of the Chinese master, Huo Yuanjia. They enter whilst a senior Chinese is giving an impassioned oration about what the Jing Wu School 'stands for'. The threnody is, of course, also a 'pep talk' or rallying call which is insisting that even though their institution has been struck hard by the death of their founder and master, his demise does not signal the demise of the institution, for Huo Yuanjia has taught them all well enough to ensure that the institution might continue, by following the principles he sought to inculcate. In other words, the threnody is also very much an appeal for continuity during a tense and difficult moment of crossing-over: the transition/translation from one cultural moment and institutional order to another. That is, at this point, upon the death of the master, what comes to the fore are urgent matters of transmission and tradition. What need to be transmitted now, more than ever, are the means to maintain stability. The tradition needs to be reiterated, reasserted, taking the form of emphatic words, in order to clarify what is to survive.

Immediately upon completing this (teleiopoietic) appeal, an entourage from the Japanese School arrive. They arrive in a literal hiatus: a moment's silence during the service. They show great disrespect, offer a personally, ethnically and nationally insulting gift, and throw down physical challenges. This is all articulated by Mr Wu, the translator. Chen Zhen (Bruce Lee) wishes to pick up the gauntlet and to fight the challengers, but is verbally restrained by his senior. He has to be

called to order by his superior. What is clear is that it is *only* because of the material presence of hierarchy, tradition and convention – in terms of the gaze and commands of his superiors – that Chen Zhen will restrain himself. We feel sure that, left to his own devices, Chen would have responded to the challenge. And the next scene confirms this when Chen enters the Japanese Bushido School alone, walks into the middle of their martial arts class and beats them all single-handedly. But, before this, Chen and all of the Chinese have to suffer the humiliation of respecting another tradition: the order and decorum of the funeral.

After this point, all hell breaks loose. Other than by focusing on the dimension of the Japanese aggression, one way to represent the reasons for the strife and pain experienced by all of the Chinese throughout *Fist of Fury* (although there are, of course, many different ways to represent this, depending on one's concerns) devolves on the splitting of a stabilised entity that was putatively *one* into more (and less) than one, caused by *two* interpretations. The death of the univocal and unequivocal master is always a moment of great institutional jeopardy anyway. The eulogy given in *Fist of Fury* is an attempt to pre-empt problems of transmission and ward off a crisis. But then the Japanese agitators enter and provoke a very real crisis that demands to be answered there and then.

Chen Zhen, like many of the students, evidently wants to respond to the martial challenge. Certainly, there is an element of decorum and obligation to throwing down and picking up martial gauntlets in the world of martial arts schools. However, a funeral seems hardly the time or the place to start a fight. This is obviously the senior members' interpretation: preserve *this* decorum. But, to the younger students, given that the Japanese have so completely transgressed the decorum of the official funeral ceremony already by offering the offensive 'gift', throwing down insults and offering to fight any of them there and then, the weight of obligation is taken to fall on answering the challenge. Yet, as Captain puts it after the Japanese leave, upon being asked why he would not let the Chinese fight: he 'wanted to' but 'teacher taught us that we shouldn't'.

The reasons for stoicism given repeatedly by Captain throughout the first half of *Fist of Fury* always involve insisting that the Jing Wu School studies martial arts to make healthy bodies, minds and subjects that will be available to serve the Chinese nation should they ever be required. To his mind, at first, the Japanese aggression is merely inter-school feuding; so rising to their challenge would be to abuse their skills, training, ethos and lineage. Little does he know – little do *any* of the Chinese know – how wrong this interpretation is. Captain is wrong to dismiss the ethnically inflected inter-school challenge as mere trouble. But by the time he realises that the challenge is actually a challenge to their very presence within the Japanese-controlled section of the international settlement of Shanghai it is too

late. In other words, Captain imagines that fidelity to the nation-building ethos of the Jing Wu School involves ignoring this ethnically-inflected aggression and waiting for something like an official Chinese state call to arms.

Chen Zhen interprets things somewhat differently. According to his interpretation, propriety demands that the rude challenge be answered. After being reined in by his superior, Captain, Chen takes the first opportunity the next day to execute an exemplary demonstration of propriety in martial arts etiquette: he walks alone into the Japanese School, whilst they are all training, says he is returning the 'gift' and that he is prepared to fight 'any Japanese here'.

Thus, the emergence of a challenge to the already precarious status of the Jing Wu institution in a moment of transition/translation introduces a disunity which causes the institution to fracture. The master constituted the embodiment of the actuality of the institution, its direction and its principles, and so could have decided unequivocally. His death transforms him into the absent spectral figure or 'spirit' in terms of which interpretations and decisions are to be made. Because operating with fidelity to his terms or ethos in his absence demands an engagement with the terms he used, then, because he is not there to take their decisions for them, and because analysing the key terms inevitably reveals them to be ambiguous, ambivalent and uncertain, then conflicting and contradictory interpretations inevitably enter. What has literally entered to precipitate such a crisis is the inevitability of translation.

QUEER LEE

The translator clearly requires some attention. In *Fist of Fury* the translator adopts Western sartorial norms and works for the powerful Japanese presence that exerts such a considerable force in the international settlement in Shanghai. He enables communication between the Chinese and the Japanese institutions, and also sabotages one institution's development at a particularly fraught moment – the funeral, the moment of transition/translation/passing over from one generation to the next, from the stability of the founding master's presence and protection to the uncertain leadership of his multiple senior students. As it turns out, the translator in fact *precipitated* this unnatural crisis in the first place – installing spies and transmitting assassination orders. The translator is a pervertor. So, it is unsurprising that he has been constructed as certainly 'queer' and probably gay.

In this largely erotically-neutered film, Mr Hu's sexuality is unclear. All that is clear is that he is creepy and effeminate. But if we are in any doubt about his sexuality, this same character, played by the same actor, was to return in Lee's

next film, *Way of the Dragon* (1972). *Way of the Dragon* is a film that Lee himself directed and in which he plays Tang Lung, a mainland/New Territories Hong Kong martial artist who flies to Rome to help his friend's niece when her restaurant business is threatened by a veritably multicultural, interracial 'mafia' gang. The Chinese title of *Way of the Dragon* (*Meng Long Guo Jiang*) is rendered literally as something like 'the fierce dragon crosses the river', which refers to travel and migration, and hence to the diasporic Chinese crossing over to Europe.

In both *Fist of Fury* and *Way of the Dragon*, the same actor plays virtually the same character. However, in the European location of *Way of the Dragon*, we have crossed over from 'traditional' China to 'modern' Europe. So the translator becomes *blatantly* gay: wearing flamboyant clothing and behaving flirtatiously with Lee's character, Tang Lung (see Chan 2000). In the later film, the translator is queerness unleashed. But the point to be emphasised here is that essentially the same reiterated rendering of the translator as creepy and queer is central to both films – in much the same way that Judas is central to the story of Jesus. If it were not for him, none of this would be possible, but as a contact zone or agency of communication and movement, he is responsible for warping and perverting things. In both films, the translator enters at a moment or situation of crossing over, and signals the break, the end of stability, the severance from paternal protection, from tradition. 'And yet', as Chow has noted, 'the word *tradition* itself, linked in its roots to translation and betrayal, has to do with handing over. Tradition itself is nothing if it is not a transmission. How is tradition to be transmitted, to be passed on, if not through translation?' (1995: 183)

Chow's championing of such translation notwithstanding, the answer to her rhetorical question ('how is tradition to be transmitted, to be passed on, if not through translation?') as (if) it is given by both films is *not* that 'tradition ought to be transmitted through translation', but rather that 'tradition *ought* to be transmitted through monolingualism and monoculturalism'. The *problem* – and it is presented *as a problem* in the films – is that culture does not stay 'mono'. Its authorities *want* it to be; its institutions try to *make* it stay so; but it cannot. Even the most pure repetition is never *pure*, but is rather *impure* – a *reiteration* which differs and alters, introducing alterity, however slightly: re-*itera*, as Derrida alerted us. Basically, that is, one does not 'need' an insidious translator to pervert things. The unstoppable flow of transnational popular cultural products, commodities and practices, mass media sounds and images, and filmic texts does the job of the pervertor quite well enough. And surely far more cross-cultural encounters, exchanges and transactions are enacted by way of mass commodities than by way of dry hermeneutic or linguistic translation.

Given this plague of contact zones, Chow argues: 'cultural translation can

no longer be thought of simply in linguistic terms, as the translation between Western and Eastern verbal languages alone' (1995: 196–7). Rather, she proposes, 'cultural translation needs to be rethought as the co-temporal exchange and contention between different social groups deploying different sign systems that may not be synthesizable to one particular model of language or representation' (1995: 197). As such:

> Considerations of the translation of or between cultures […] have to move beyond verbal and literary languages to include events of the media such as radio, film, television, video, pop music, and so forth, without writing such events off as mere examples of mass indoctrination. Conversely, the media, as the loci of cultural translation, can now be seen as what helps to weaken the (literary, philosophical, and epistemological) foundations of Western domination and what makes the encounter between cultures a fluid and open-ended experience. (Ibid.)

Once again, it strikes me as important to reiterate at this point that although the *encounters* of cultural translation *may* be fluid and open-ended, the *treatment* of such encounters by academics and cultural commentators is far from fluid and open-ended. On the contrary, such treatment seems rigid; overdetermined, even. Translatory encounters of or between cultures are, in fact, regularly treated by academics and cultural commentators in a manner akin to the way the translator is treated in these films: ridiculed, reviled, rejected and killed – but too late. Such films, whether putatively lowbrow like these or supposedly highbrow like those of Zhang Yimou or Ang Lee are often regarded with disdain: as not 'real', not 'true' or not 'faithful' translations of that fantastic phantasmatic essentialised entity known as 'China'. Chow writes:

> Using contemporary Chinese cinema as a case in point, I think the criticism (by some Chinese audiences) that Zhang and his contemporaries 'pander to the tastes of the foreign devil' can itself be recast by way of our conventional assumptions about translation. The 'original' here is not a language in the strict linguistic sense but rather 'China' – 'China' as the sum total of the history and culture of a people; 'China' as a content, a core meaning that exists 'prior to' film. When critics say that Zhang's films lack depth, what they mean is that the language/vehicle in which he renders 'China' is a poor translation, a translation that does not give the truth about 'China'. For such critics, the film medium, precisely because it is so 'superficial' – that is, organized around surfaces – mystifies and thus distorts China's authenticity. What is implicitly assumed in their judgment is not simply the untranslatability of the 'original' but that translation is a unidirectional, one-way process. It is assumed

that translation means a movement from the 'original' to the language of 'trans-
lation' but not vice versa; it is assumed that the value of translation is derived
solely from the 'original,' which is the authenticator of itself and of its subsequent
versions. Of the 'translation', a tyrannical demand is made: the translation must
perform its task of conveying the 'original' without leaving its own traces; the 'origi-
nality of translation' must lie 'in self-effacement, a vanishing act'. (1995: 184)

Such texts are regularly written off as trivial and trivialising, commodified,
Orientalist, unfaithful, secondary, derived, warped, warping, and so on. But as the
works of thinkers like Chow have proposed, such responses to migrant texts like
these might be (essentialised as) *essentialist*. Nevertheless, asks Chow: 'can we
theorize translation between cultures without somehow valorizing some "origi-
nal"?'; moreover, 'can we theorize translation between cultures in a manner that
does not implicitly turn translation into an interpretation toward depth, toward
"profound meaning"?' (1995: 192). She asks these questions not simply in the
spirit of the post-structuralist, deconstructive or anti-essentialist problematisa-
tion of 'essences' and fixed/stable identities; but rather because of the extent to
which many theories of translation focus exclusively on the 'intralingual and inter-
lingual dimensions of translation' (ibid.) and hence miss the cultural significance
'of intersemiotic practices, of translating from one sign system to another' (1995:
193). Her answer urges us to rethink translation by way of mass commodities,
whose 'transmissibility' arguably arises 'in opposition to ... "truth"' (1995: 199)
in the context of a '*sickness of tradition*'. This 'sickness' is actually constitutive of
transmissibility, suggests Chow.

To this I would add: this sickness is queer. In constructing the translator as a
traitor and *therefore* as queer, both of these films cling to tradition – a tradition
that seems universal and seems to need no translating. If we ask of this tradi-
tion, 'Are you Chinese?' the answer must be: yes, but no; yes and no.[8] And if we
ask 'Just what is the point of this?' one answer must be that it points to a queer
relation – but a clear relation – between translation and queering. About which
much could be said. But the point I want to emphasise here is that the primary
field of 'translation between cultures', through their twisting, turning, concatena-
tion, warping and 'queering' is, of course, that supposed 'realm' (which of course
really should be rather better understood as the condition) called mass or popular
culture.

As we have seen, Chow's contention is that 'there are multiple reasons why
a consideration of mass culture is crucial to cultural translation'; to her mind, 'the
predominant one' is to examine 'that asymmetry of power relations between
the "first" and the "third" worlds' (1995: 193). However, as she continues

immediately, 'critiquing the great disparity between Europe and the rest of the world means not simply a deconstruction of Europe as origin or simply a restitution of the origin that is Europe's others but a thorough dismantling of *both* the notion of origin and the notion of alterity as we know them today' (1995: 193–4). In Bruce Lee films, of course – in a manner akin to the arguments of the critics who regard popular filmic representations as betrayals of 'China' – the 'origin' is avowedly not Europe, but 'China' – the spectral, haunting, 'absent presence', the evocation (or illusion-allusion) of 'China'. From this perspective, there are two alterities: the 'simple' alterity of the enemy, and the 'double' alterity of the translator. In *Fist of Fury*, alterity seems unequivocal: an enemy (the colonisers – Japan in particular). When the Hong Kong films cross over to Europe or America, for *Way of the Dragon*, however, origin and alterity become more complicated.

EURO-AMERICAN LEE

In Lee's first martial arts film, *The Big Boss* (1971), he plays a migrant Chinese worker in Thailand – a country boy cum migrant proletarian whose enemy is a foreign capitalist/criminal. In *Fist of Fury*, when hiding from the authorities, Chen Zhen's peers emphasise that even though they cannot find him he surely cannot be far away because he is a country boy who does not know Shanghai. In *Way of the Dragon*, in Italy, Lee's character rejoices in the fact that he comes not from urban Hong Kong Island but from the rural *mainland* New Territories. Dragged grudgingly on a tour of the sites of Rome, he is evidently rather under-whelmed. In the sole scene of *Fist of Fury* that was filmed outdoors, at the entrance to a segregated public park, Lee's character evidently *only* wants to go into the park because, being Chinese, he is not allowed – because China has been *provincialised*: a turban-wearing, English-speaking Indian official at the gate directs Lee's attention to a sign which says 'No Chinese and Dogs Allowed'.

In other words, all of the injustices in Lee's Hong Kong films are organised along ethnonationalist and class lines, and the notion of the origin in these films is the *idea* of mainland China. This idea in itself provincialises the various locations of each of the films. All of the places that are 'not China' are just vaguely 'somewhere else', and that elsewhere is 'bad' (or at least not very good) because, wherever it is, it is 'not China' – not the free, proud, strong, independent 'imagined community' China 'to come'.

Of course, in sharing this tendency, these films construct a Chinese identity that is also based on actively celebrating or enjoying *being* what Chow calls 'the West's "primitive others"' (1995: 194). (In other words, actively involved

in a complex dialectical identification akin to Hegel's (1977) much (re)theorised dialectic of Lord and Bondsman, within which each identity depends on (is constituted and compromised by) the other's (mis)recognition.) To this extent these films may easily seem, in Chow's words, to be 'equally caught up in the generalized atmosphere of unequal power distribution and [to be] actively (re)producing *within themselves* the structures of domination and hierarchy that are as typical of non-European cultural histories as they are of European imperialism' (ibid.). Yet, at the same time, they are also and nevertheless (to use Dipesh Chakrabarty's term) actively involved in 'provincializing Europe', albeit without any reciprocal (self-reflexive) problematisation of 'China' (see Chow 1995: 195).

However, it strikes me that such a problematisation was palpably embryonic and growing in many of Lee's other works: in his TV roles, personal writings and interviews, Lee increasingly gestured to a postnationalist, liberal multiculturalist ideology; and it was perhaps 'in the post' at the time of his death in the form of his declared intentions for his unfinished film *Game of Death*. But even in his 'early' film, *Way of the Dragon*, even though it is certainly caught up in a degree of masochistic enjoyment of Chinese victimhood, the film arguably enacts what Chow's proposed approach to film ('as ethnography') could construe as a significant discursive move. So it is with a brief – summary – consideration of this embryonic impulse that I would like to conclude this chapter.

The very first scenes of *Way of the Dragon* place Lee in the arrivals area of an airport in Rome. Lee is surrounded by white Westerners and is being stared at, implacably, unremittingly, and *inscrutably* by a middle-aged white woman. This lengthy, awkward and tense scene goes nowhere. The woman is eventually dragged away by a man who comes to meet her. It is followed immediately by an excruciatingly lengthy scene in which Lee's character goes in search of food within the airport. First he approaches a child and asks 'food?', 'eat?', and then, pointing to his mouth, 'eggs?', whereupon the camera changes to the child's point of view, showing a huge towering man looming over the child, pointing at his own mouth and making horrendous gurgling sounds. The child screams, and Lee's Tang Lung hurries away. He soon stumbles across a restaurant, which he enters. Unable to make sense of the Italian menu, he jabs his finger confidently to more than half a dozen dishes – all of which turn out to be different kinds of soup. So Lee is presented with a ludicrous dinner of multiple bowls of soup, which he brazenly pretends he knew he had ordered.

These slow, clumsy and somewhat bizarre scenes could easily strike viewers, especially white Western viewers, as a peculiar way to begin a martial arts film – a film, it should be noted, that very soon opens out into extreme violence, murder, mortal treachery, and even a gladiatorial fight to the death in the Roman

Coliseum. Beginning such a film with these rather torturous efforts at comedy seems to be a peculiar directorial decision.

However, there is something significant in the way that these opening scenes dramatise ethnic experience. The film shows us an ethnic 'viewed object'. But it does so from a crucial point of view; one in which '"viewed object" is now looking at "viewing subject" looking' (Chow 1995: 180–1). Thus, over twenty years before Chow proposed precisely such a twisting (or queering) of specular relations away from a simple subject/object diaeresis as the way to escape the deadlock of Western anthropology, 'simple' popular cultural artefacts like this film were already actively engaged in this deconstruction, in which Europe is not the viewing subject and Europe is not 'the gaze', and in which – as *Way of the Dragon* seems to be at pains to make plain – Europe is *just some place* in an increasingly fluid globality.

Europe never becomes origin or destination in the film. In fact Italy itself never really becomes much more than an airport lounge – a zone of indeterminacy, a contact zone; just some place or other, between origin A and destination B, C or D, or X, Y or Z. Lee left Hong Kong in the first place to help a diasporic working community. He flies to Europe. The Europeans cannot defeat him. Frustrated, they arrange to fly in 'America's best'. America's best takes the form of 'Colt', a martial artist played by Chuck Norris. Colt flies in. His arrival is filmed from a low angle. He walks down from a jet plane, and towards the camera. A drum beat marks his every powerful step. As he approaches, what is more and more fore-grounded is his crotch. When he reaches the camera, it is his crotch that comes to fill the entire screen and close the scene. And so it continues: as has been much remarked, Colt is all crotch, Lee is all lithe, striated torso. Their pre-fight warm-ups are more like foreplay; their fighting is more like love-making (see Chan 2000; Hunt 2003). But the film plays the standard semiotics of powerful masculinity; in other words, treading a fine line between emphasising heterornormativity and crossing over into outright homoeroticism. Hating the queer element is impor-tant in order to assert that this text itself is not of or for the queer; whilst all the time exemplifying the polymorphously perverse recombination, intermingling and reconstitution of cultures, provincialising and queering Europe. We will return to this in the next chapter.

notes

1 Another possible translation of these words could be: "One question, are you Chinese?"

/ "Our ancestors are the same, but our destinies are completely different … nothing you can compare with!" My thanks to Weihua Ye for helping me with this translation. Thanks also to Fan Yang and other members of the cultstud-l mailing list for offers of help and suggestions about the translations.

2 For a related discussion of the implications of this and of the discussion of Foucault in the paragraph which follows, see also Weber (1987: xii).

3 Similarly, Weber reminds us of Bachelard's reflections on the implications that contemporary science has for our understanding of knowledge: 'All the basic notions can in a certain manner be doubled; they can be bordered by complementary notions. Henceforth, every intuition will proceed from a choice; there will thus be a kind of essential ambiguity at the basis of scientific description and the immediacy of the Cartesian notion of evidence will be perturbed' (Bachelard in Weber 1987: xii).

4 See Chambers and O'Rourke (2009) for a recent discussion of the etymological, conceptual and cultural connections between torsion and queering, and between queer studies and ethico-political torsions.

5 Elsewhere, he argues: 'When the concept of modernity still implies "progress" and "westernization," any translation or introduction of modern texts is by no means free from cultural imperialism' (quoted in Chow 1995: 176). This claim by Lo is the very first quotation that Rey Chow makes in the essay 'Film as Ethnography' from which I am drawing here.

6 'The subtitles become a kind of verbal "stain" that partially obscures the field of vision. It is like living in a world of comics, where one would continuously see one's own speech and the speech of others' (2005: 50).

7 As mentioned, there are other possible renderings of the Chinese, such as 'our ancestors are the same, but our destinies are completely different,' which, in referring to a shared *ancestry* rather than a shared *present*, could be taken to mean one of several different things and hence change the implications.

8 This tradition, it should be noted, is not an exclusively Chinese tradition. It is of course always and already transnational – some might even say universal. It is *transmissible*, communicable. This is not the case with the question 'Are you Chinese?' Such a question only means something barbed and precise within certain contexts. So, the switch, the non-translation transformation of the question 'Are you Chinese?' into 'Just what is the point of this?' is an act which clings to transmissibility rather than to truth.

BRUCE LEE IN THE POST
POST-COLONIAL, POST-MODERN, POST-PROTESTANT, POST-HUMAN

Many studies and narratives about Bruce Lee end in disappointment. This disappointment, I intend to show, is a specific consequence of the approach which is characterised by *nostalgia*. This nostalgia takes many forms. Here are some of the most common narratives: Bruce Lee once politicised ethnic, subaltern and postcolonial consciousness, but this energy dissipated; Bruce Lee smashed certain Orientalist stereotypes about Asian males, but this ultimately intensified other stereotypes; Bruce Lee diversified and ethnicised the previously white realm of international film and the associated global popular cultural imaginary, but the effects of this achievement were limited by the subsequent easy pigeon-holing of ethnic Asian characters as martial arts 'types'; Bruce Lee introduced a uniquely Asian cultural phenomenon into global discourse, but this was quickly 'lactified' or appropriated and hence 'whitened' by Euro-American martial arts actors; Bruce Lee's models of masculinity proposed new paradigms of maleness, yet these never caught on or at least were quickly supplanted; Bruce Lee 'bridged cultures', yet these encounters have now come to seem less like new multicultural conduits or establishments, new hybridised cross-cultural enclaves or settlements, and more like brief forays, smash and grab raids, appropriations and expropriations of and from different cultural repositories; Bruce Lee spearheaded the possibility of inter-ethnic identifications and cross-cultural mobility, but this soon became thoroughly depoliticised; Bruce Lee was the exemplary

'protestant ethnic', but nowadays that kind of protest and that kind of ethnic struggle has settled down.

This chapter will look more closely at some of these narratives and consider the reasons for their trajectory towards disappointment. In the ensuing awareness of the ways that certain narrative structures or conceptual paradigms tend to lead analyses to disappointment, the chapter will propose alternative approaches – not alternatives that refuse to acknowledge disappointment or failure, but rather alternatives that may enable us to regard the times and places *beyond* Bruce Lee without either running into nostalgia for lost promise or delusions about the radical propensities of current or future conjunctures. Taking our lead from the directions given in the previous chapter – specifically, the queer conjunction of cultural translation and sexuality – the journey of this chapter will be from subject-centred approaches to Bruce Lee to what might be classified as more materialist or post-humanist perspectives on his interventions.

BRUCE LEE, FROM MASCULINITY TO BIOPOWER

Many have theorised the significance of Bruce Lee's intervention in terms of masculinity and identity. Scholars of popular culture have overwhelmingly wanted to read him as 'progressive' in several main senses *vis-à-vis* white Euro-American hegemonic heteronormative patriarchal masculinities. In 2000, Jachinson Chan made the important point that 'the way in which Bruce Lee constructs a Chinese masculinity is potentially insightful in that his form of masculinity does not buy into a compulsory heterosexuality and his characters seem to encourage a homo-erotic desire for his body' (2000: 385). But how far does or did the Bruce Lee rearticulation of masculinity *vis-à-vis* established (and) Euro-American models, tropes, types and norms, via his reconstitution of Asian masculinity, actually go? Chan undertakes a systematic reading of Lee's films in order to show the extent to which 'Lee's characters refuse to conflate masculinity with heterosexuality' (ibid.). He asks the organising rhetorical question: 'physical superiority can also be a sign of manhood, but does it necessarily signify a heterosexual identity?' Chan's answer is of course no, but the argument he wants to see realised is the possibility that 'by de-linking this connection, Lee's characters question other markers of manhood such as physical violence' (ibid.). Thus, he argues, by questioning the heterosexual assumption in the construction of manhood … an ambisexual model of masculinity provides a discursive space that opens up the possibilities of alternative and contradictory models of masculinity that are not easily catego-rizable' (ibid.). To Chan's mind,

Although Lee's films create a male-centered cinematic world that exhibits a mas-culinity based on men who dominate other men through violence, the characters he portrays are not typically patriarchal or misogynistic. Lee's characters do not oppress the female characters, nor do they exhibit an exaggerated James Bond-like heterosexism. In other words, Lee's characters seem to de-link the compulsory heterosexual component of a hegemonic masculinity with normative masculinity, thereby providing a more complex masculinity that upholds violence and power over other men as markers of manhood while denying an exaggerated heterosexist assumption. (2000: 379–80)

This is regarded as essentially progressive, then. One question which arises, however, is whether such a 'model' of masculinity ever 'caught on'. Such a propo-sition could be empirically tested or explored in any number of ways; but the role of Bruce Lee or anything else here would always remain debatable. So, before rushing into any such empirical route of trying to count the number of men who followed Lee into some kind of ambisexual version of masculinity, one first needs to note that Chan's own reading itself actually suggests that things might not be so simple. Indeed, his reflection on Lee's masculinity could be said to supplement approaches such as those of Brown, Žižek or Lo that we have already considered insofar as it proposes that 'the genre itself subverts its own ability to present social and cultural critiques' (2000: 385). This self-subversion would necessarily constitute something of a problem. We see this for instance in the following pas-sage in Chan's consideration of masculinity, when he proposes that

Due to its excessiveness, Lee's signature scream undercuts the legitimacy of Lee's warrior status. The excessive display of martial arts, violence, war cry, and the sensuousness of his body all contribute to an effective visual strategy to seduce viewers into their own perceptions of physical beauty, sexuality, and masculinity. By displaying his body and martial arts skills, Lee acquires the admiration of those who want to emulate him while simultaneously evoking comical disdain for kung fu films themselves. (Even Tang Lung, in *Return of the Dragon*, does not take himself seriously. In one scene, he exercises in front of the camera, showing off his finely tuned muscles but is distracted by Miss Chan's cooking and a silhouette of a couple making love.) If the genre itself subverts its own ability to present social and cul-tural critiques, then, Lee's work loses some of its social impact to redeem a heroic Chinese manhood. (2000: 384–5)

Whether or not one agrees with Chan's various assertions in his reading at this point (which I have to say I do not – you can take yourself seriously, seriously

enough to work out every day, and still be distracted by smells, sights, scenes and sounds, the way that Tang Lung in *Return of the Dragon*, in a strange apartment in a capital city in a different country is distracted), the point is that Chan himself points to the problem of his own argument. Lee *may* offer a 'different' kind of masculinity – an 'ambisexuality', or at least an assumed heterosexuality that is not predatory or apparently not homophobic (although as we saw in the previous chapter, this is not an entirely sustainable position *vis-à-vis* Bruce Lee's films overall), or whose realisation is permanently deferred for whatever reason (whether that be because of the decorum of Confucian ethics, warrior-like chivalry, a business-like relation to his quest in the film, schoolboy immaturity or monastic vows of celibacy and so on). But at the same time, this is not at all certain. (So much so that perhaps where the critic would like to see ambisexuality we might instead propose that we are looking at a kind of ambihermeneutics on the part of the critic.) Of course, as suggested in the previous chapter, rather than reading Lee's films as if what they do is primarily offer viewers repositories of 'types' – types of, so to speak, 'role models' – what remains most suggestive about Chan's analysis is his focus on the significant appearance of gay characters within Lee's films. Specifically, once more, what strikes me as perhaps most significant about these characters is the fact that not only are they gay, but they are also translators.

As Chan points out, 'in contradistinction to Lee's blatant display of his masculinity, homosexuality, as constructed in the text, suggests effeminacy and betrayal of one's country' (2000: 375). However, he takes great pains to emphasise that 'the narrative logic [of *Fist of Fury*] seems to imply that Mr. Woo [the effeminate translator] is a villain who happens to be gay rather than Mr. Woo is a villain because he is gay' (2000: 376). In Chan's reading, something similar also pertains to the gay translator in *Way of the Dragon*:

> The gay Chinese is, once again, a traitor who has neither political nor physical powers, much like Mr. Woo in *The Chinese Connection* [aka *Way of the Dragon*]. He is unable to protect himself and is physically inept. However, Mr. Ho has an important function as he sexualizes Lee's character, a function he shares with the female owner of the restaurant, Miss Chen. (2000: 379)

In both films, argues Chan, the translator's 'effeminate behavior is condemned because it parallels his own political "deviance", rejecting his country, nation, and masculinity' (2000: 375). In *Fist of Fury*, argues Chan, Bruce Lee's character's 'heroic act of resistance toward the oppressive Japanese presence in China counters Mr. Woo's subservience and cowardice; and yet, on closer analysis,

Figure 15: The Queer Translator

Chen's character shows more disdain toward Mr. Woo's traitorous behavior than his homosexuality' (2000: 376).

Insightful as Chan's reading is, these latter comments demonstrate the manner in which it is ultimately limited by what we might call its subject-centricity. The readings focus overwhelmingly on *characters* and psychologistic interpretations of their actions, rather than on the biases and lines of force which structure the values of the film. Thus, Chan emphasises that Lee's *character* is not actively homophobic but does not pause to consider the significance of the reiterated coincidence of gay-translator-traitor in more than one of Lee's films. The symbolic order of these films is clearly homo-averse if not unequivocally homophobic.

Moreover, in Chan's reading, the translator 'has neither political nor physical powers'. Yet it is crucial to note that it is through the entrance of the translator that *institutional* instability is introduced. As we saw in the previous chapter, the translator and two Japanese martial artists enter the Jing Wu School in the midst of the official funeral of the Chinese master, Huo Yuanjia. They enter whilst a senior Chinese is giving an impassioned oration about what the Jing Wu School 'stands for'. The eulogy is also a 'pep talk' or rallying call which is insisting that even though their institution has been struck hard by the death of their founder and master, his demise does not signal the demise of the institution; for Huo Yuanjia has taught them all well enough to ensure that the institution might continue, by following the principles he sought to inculcate. In other words, the threnody is also an appeal for continuity during a tense and difficult moment of crossing-over: the transition/translation from one cultural moment and institutional order to another. As argued in the previous chapter, at this point, upon the death of the master, what comes to the fore are urgent matters of transmission and tradition. What need to be transmitted now, more than ever, are the means to maintain stability, continuity. The tradition needs to be reiterated, reasserted, taking the form of emphatic words, in order to clarify what is to survive. The point being that *agency* exceeds (and arguably precedes) the individual subject, character, or agent. Agency is institutional. Chan is, certainly, aware of this. As he states about his own intentions for his study of Bruce Lee:

> My purpose here is to explore the different ways in which Chinese masculinities are constructed to frame the discourse on Chinese American masculinities around a set of anxieties. Specifically, what are the risks involved in articulating alternative models of masculinities that are not categorized as normative and heteromasculine while disparate sociopolitical power structures still exist? The masculine model I am pursuing is based on a rejection of a compulsory heteromasculine norm while acknowledging that Chinese American men are still disempowered structurally due to institutionalized racism. (2000: 385–6)

As indicated by Chan's awareness of 'institutionalized' biases as forces of agency in this passage, the 'institutional' dimension should not be sacrificed for a focus on characters. It should certainly not be downplayed or overlooked in any study concerned with cultural agency. But nor can the focus simply be on the power of this or that 'institution', however conceived. Any study must also consider the forces which constitute, form, deform and transform agencies and institutions, such as the productive and destructive forces of capitalism.

THE PROTESTANT ETHNIC AND POST(AL)-IDENTITY

Keiko Nitta has also recently reassessed Chan's pioneering study of Bruce Lee, proposing that 'ten years after Chan's classical identitarian approach to Lee, we are now able to analyze more broadly the functioning of the worldwide popularity of martial arts' (2010: 379). Nitta reiterates the fact that within various forms of scholarship, 'the substantial impact of Bruce Lee is often attributed to his legitimatizing a different possibility of gender self-expression for Asian men vis-à-vis their Caucasian counterparts' (2010: 378). She notes that despite so many examples of cultural texts in which the Asian male 'could never be completely a man' (to use the words of Song Liling in David Cronenberg's film *M. Butterfly* (1993)), when it comes to Bruce Lee, things are very different: 'one never has any difficulty in finding plenty of testimonies about ethnic empowerment brought about by the popular cultural figure of Bruce Lee', she writes; noting that 'in one interview, Lee's younger brother Robert remarks on the enthusiasm of black and hispanic members of the American audience of *Enter the Dragon*, upon seeing the spectacle of the Asian hero defeating those who were far larger than himself' (ibid.). However, she continues, 'whilst acknowledging the significance of this sort of visual pleasure is to be respected, it strikes me that one strand of academic approach to Lee seems to have been too determined to read the actor/ martial artist as a male ethnic role model' (ibid.). At this point, Chan's study is

held up as an exemplary case by Nitta. What she homes in on specifically is what she calls Chan's 'ethical conviction about an ideal model of Chinese masculinity' (ibid.). That is to say, Chan's conviction that the model of masculinity proffered by Lee's films 'should be, unlike the dominant heteromasculinity, weak enough to be incompetent for hegemony' (ibid.). Nitta writes:

> The version of non-hegemonic masculinity that Chan envisions presumably does not come from Lee's personality, but rather from his filmic practice. In other words, a unique characteristic of martial arts, or at least such a signification attached to the practice in an American – and thus Western – context, projects Lee as a source of the legend of non-authoritarian resistance to hegemonic masculinity. (Ibid.)

Furthermore, the singular appeal of Bruce Lee for many Asian American scholars in particular relates overwhelmingly to the fact that 'he prevailed in an industry that was initially reluctant to represent him because of his ethnicity'; to many commentators, such success makes him a 'master of identity politics' (2010: 379). Moreover, as Chan's analysis testifies, in addition to the significance of this for ethnic cultural politics, Bruce Lee can be regarded as 'an exemplary case of "ambiguity" in terms of masculine gender and sexuality played out on one particular man' (ibid.), as we have seen.

Approaching Chan's study ten years on, Nitta considers Chan's own orientations and investments. She asks: 'why does Chan himself have to recognize the ethnic value of Lee's cultural expression, despite its complicity in stereotyping? Why is he, even with a hesitation, fascinated with Lee's martial arts as an ethnic-masculine practice?' (ibid.) In a deft and incisive refocusing of attention, Nitta proposes that 'rather than the ambiguity of Lee's masculine model, [it is] the Chinese American scholar's hesitation [that] symptomatically signifies the status of martial arts as an object of consumption today' (2010: 379). For, Chan's own approach to or relationship with Bruce Lee has, in Nitta's words, 'uniquely satisfied two opposing directions of interest': first, 'Asian self-expressions accented by a sense of resistance to Western cultural preoccupations', and second, 'the US reproduction of an Oriental other simultaneously exotic enough and accommodating to its principles of cultural circulation' (ibid.). With this, the problematic is rendered as double: the forces of attraction and repulsion arise simultaneously: we find ourselves once more in the eternally returning relation (or reciprocally arising interimplication) between *political agency* (protest, resistance, alteration, change) and *political passivity* (becoming smoothly ideological objects), or, again, *commodification*. Bruce Lee is at once a sign of apparent potential resistance (protest), but also a harbinger or fomite of the globalisation of a post-nationalist

ideology, and at the same time a multi-modal commodity, indeed a commodity that *displaces* political resistance, or rather commodifies and hence depoliticises resistance.

Viewed from this perspective, Nitta connects this double status with Rey Chow's notion of 'the protestant ethnic'. She reads the condition of both Bruce Lee and the ethnic studies academics as illustrative of the logics, mechanisms and double binds that Chow explores in *The Protestant Ethnic and the Spirit of Capitalism* (2002). In Nitta's account of the essential features of this work: 'Chow demonstrates how the present-day ethnos materialize themselves through protests, as illuminated by the phrase "I protest, therefore I am"' (2010: 379; Chow 2002: viii, 47). Hence, suggests Nitta, the congruency (and shared ambivalence) of so many critical appraisals and treatments of Bruce Lee and other such popularised mediated ethnic identities. For, through them, 'Martial arts … have functioned as a noticeable apparatus for both this protest and capitalist interpellation' (2010: 379). This ambivalent or double-edged status arises from the fact that (as many cultural theorists have suggested) 'late capitalism requires a cultural logic fundamentally based on tolerance, or more specifically a regime that attempts to earn the greatest profits by marketing a diversity of objects'; therefore 'a multicultural request for diversity is easily subsumed into the desires of capital' (ibid.). Hence the arising of what Nitta calls a frequent 'categorical confusion between political recognition of minorities and discovery of them as recipients of an ethnically defined marketing phenomenon' (ibid.).

TO BE ETHNIC IS TO PROTEST

This Gordian knot of a situation has entangled many thinkers. Thinking ethnicity in terms of what Chow has dubbed 'the protestant ethnic' – which Nitta reminds us entails 'rereading "protestants" as those who protest against intolerance at large, rather than literally religious protestors' (ibid.) – Chow herself recasts this situation in a way that both bypasses and also utterly transforms the status of most narratives of cultural politics, resistance and agency – many of which propose a temporal narrative of 'early authenticity' followed by 'subsequent cooptation'. This narrative arises, as we have seen, not only in Stuart Hall's thinking, but also in Slavoj Žižek's and Gilles Deleuze's and others in a list which could be massively extended. Rather than becoming ensnared in this, Chow proposes:

> In this context, *to be ethnic is to protest* – but perhaps less for actual emancipation of any kind than for the benefits of worldwide visibility, currency, and circulation.

Ethnic struggles have become, in this manner, an indisputable symptom of the thoroughly and irrevocably mediatized relations of capitalism and its biopolitics. In the age of globalization, ethnics are first and foremost protesting ethnics, but this is not because they are possessed of some 'soul' and 'humanity' that cannot be changed into commodities. Rather, it is because protesting constitutes the economically logical and socially viable vocation for them to assume. (2002: 48)

Nitta focuses on this section of Chow's work and adds: 'As if demonstrating the accuracy of the underscored statement, "*to be ethnic is to protest*", the Bruce Lee films' popularity can exactly be located in the formula that equates, or diverts, the ethnic to protest' (2000: 380). And not only the ethnic: As Nitta immediately points out, citing the intertextual presence of Bruce Lee in such films as *Saturday Night Fever* (1977) and *Boogie Nights* (1997), 'contemporary cinema has repeatedly reproduced Lee as the idol of not merely Asian men, supposedly confined in an emasculated stereotype, but also men socially vulnerable for disparate reasons' (ibid.). She suggests that this is a 'translation of ethnicity to social alienation or a marginalized experience of struggle in general', one that is enabled by the 'equivocality' of Lee's 'ethnic representations' (ibid.).

Such equivocality plays itself out in numerous directions and with numerous possible consequences. It will be worthwhile to elaborate some key dimensions of Chow's arguments about ethnicity at this point. For, although Chow's term 'protestant ethnic' alludes to and intertwines itself with Max Weber's work on the protestant *ethic*, in constructing it she mines the implications of the argument of Michel Foucault in *The History of Sexuality, Volume 1* (1978). This work sets out the ways in which much of our thinking about sexuality is based on material thrown up by and circulating in and as a discursive constellation about sexuality – a very old discursive constellation, says Foucault, which came together in the eighteenth-century. Chow follows Foucault's thinking, arguing for the presence and force of a similar discursive formation in a closely related field – that of ethnicity. That is, Chow proposes that today, such terms as ethnicity, identity, authenticity and even autobiography, confession, and protest, encounter each other in an overdetermined chiasmus. Thus, whenever issues of identity and ethnicity arise as a (self-reflexive, or 'personal') problem, this discursive constellation proposes that the route out is via the self-reflexive side-door of *protesting*, vocally, and often in the manner of autobiographical (self) confession – telling, showing, confessing the true state or true experience of one's victimhood or marginality and so on.

Chow's Foucauldian point is that a proliferation of 'discourses of the self' emerged in modernity. What is highly pertinent here is that these discourses

of the self emerged with an attending argument about self-referentiality's subversive (protestant) relation to power and its emancipatory relation to truth. That is to say, the sheer proliferation of talking, confessing, protesting subjects – all believing that their personal narratives are 'emancipatory' insofar as they try to 'speak truth to power' – ought to set alarm bells ringing in the heads of anyone who has learned the lessons of Foucault's *History of Sexuality*. For, this proliferation of discourses and their shared conviction that protesting in autobiographical/confessional mode is subversive of power ought to refer us directly to Foucault's argument about what he called 'the repressive hypothesis' – namely, that almost irresistible belief that power tries to silence us and actually demands our silence (Foucault 1978: 18; Chow 2002: 114). As Foucault argued, however, almost the exact opposite is the case. Or rather, even if there are places where power demands silence or discipline, these are more than matched by an exponential explosion and proliferation of discourses – in this case, about the self.

These discourses include arguments about self-referentiality's subversive relation to power and its emancipatory relation to truth, which relates to the Enlightenment idea that an introspective turn to the self is emancipatory: the ingrained idea (whose prehistory is the Catholic confessional, and whose contemporary ministers Foucault finds in the psychiatrist and psychoanalyst) that seeking to speak the truth of oneself is the best method of getting at our essential truth *and* the best way to resist power. Similarly, modern literary self-referentiality emerged with an attending discourse of resistance – a discourse which regarded things like literature (as such) as resistance to the instrumentalisation of technical and bureaucratic language, first and foremost. And, by the same token, self-referentiality emerged as an apparently ideal solution to the knotty problem of representing others.

For, how do you represent others truthfully, adequately, ethically? The answer entailed within this sort of position is: *you* do not. *They* should be allowed to represent *themselves*. Here, the self-reflexivity of self-referentiality is regarded not as apartheid but as *the* way to bypass the problems of representing others – by throwing the option open for everyone to speak the truth of themselves. However, in Foucault's phrase: 'the "Enlightenment", which discovered the liberties, also invented the disciplines' (Foucault 1995: 222; see also Chow 1998: 113). In other words, the desire to refer to the self, to discuss the self, to produce the self discursively, the impulse to autobiography and confession, can be regarded as a consequence of disciplinarity. Psychiatry demands that we reveal our 'selves'. As does psychoanalysis, as do ethnographic focus groups, as do corporate marketing focus groups, not to mention the confessional, the criminologist, and the chat show. Autobiography and confession are only resistance *if* power truly tries to

repress the production of discourse. Which it does not – at least, not everywhere. The point is, autobiography and confession are genealogically wedded – if not welded – to recognisable disciplinary protocols and – perhaps most significantly – proceed according to the terms of recognisable metanarratives. Thus,

> When minority individuals think that, by referring to themselves, they are liberating themselves from the powers that subordinate them, they may actually be allowing such powers to work in the most intimate fashion – from within their hearts and souls, in a kind of voluntary surrender that is, in the end, fully complicit with the guilty verdict that has been declared on them socially long before they speak. (2002: 115)

Of course, in any engagement with or relationship to (cultural) politics of any kind, it is always going to be very difficult not to think about oneself. Indeed, even in full knowledge of Foucault, there remains something of a complex imperative to do so. For, surely one *must* factor oneself into whatever picture one is painting, in terms of the 'institutional investments that shape [our own] enunciation' (Chow 1993: 2). Indeed, suggests Chow,

> the most difficult questions surrounding the demarcation of boundaries implied by 'seeing' have to do not with positivistic taxonomic juxtapositions of self-contained identities and traditions in the manner of 'this is you' and 'that is us', but rather, who is 'seeing' whom, and how? What are the power relationships between the 'subject' and 'object' of the culturally overdetermined 'eye'? (1991: 3)

TO PROTEST AND TO SERVE

Now, although what is about to follow may seem to be the wrong way around, insofar as it takes the form of a brief reflection on *white* subject-positions, the following considerations will turn out to bear directly on our ensuing engagement with Bruce Lee's 'protestant' legacies, as exemplified by his son Brandon Lee's film, *Rapid Fire* (1992). Chow points out that:

> the white subject who now endeavors to compensate for the historical 'wrong' of being white by taking on politically correct agendas (such as desegregation) and thus distancing himself from his own ethnic history, is seldom if ever accused of being disloyal to his culture; more often than not, he tends to be applauded for being politically progressive and morally superior. (Chow 2002: 116–17)

Chow proposes that we compare and contrast this with *nonwhite* ethnic subjects (or rather, in her discussion, with nonwhite ethnic critics, scholars and academics). These subjects, she argues, are pressured directly and indirectly to behave 'properly' – to act and think and 'be' the way 'they' are supposed to act and think and be, *as* nonwhite ethnic academic subjects. If they forget their ethnicity, or their nationalistically or geographically – and hence essentialistically and positivistically – defined 'cultures' and 'heritages', such subjects are deemed to be sell-outs, traitors – *inauthentic*. But, says Chow, if such an ethnic scholar 'should [...] choose, instead, to mimic and perform her own ethnicity' – that is, to respond or perform in terms of the implicit and explicit hailing or interpellation of her as an ethnic subject as such, by playing along with the 'mimetic enactment of the automatized stereotypes that are dangled out there in public, hailing the ethnic' (2002: 110) – 'she would still be considered a turncoat, this time because she is too eagerly pandering to the Orientalist tastes of Westerners' (2002: 117), and this time most likely by other nonwhite ethnic subjects.

Thus, the ethnic subject seems damned if she does and damned if she doesn't 'be' an ethnic subject. Of course, this damnation comes from different parties, and with different implications. But, in all cases, Chow's point is that, in sharp contradistinction, 'however far he chooses to go, a white person sympathetic to or identifying with a nonwhite culture does not in any way become less white' (ibid.). Indeed, she claims,

> When it comes to nonwhite peoples doing exactly the same thing [...] – that is, becoming sympathetic to or identified with cultures other than their own – we get a drastically different kind of evaluation. If an ethnic critic should simply ignore her own ethnic history and become immersed in white culture, she would, needless to say, be deemed a turncoat (one that forgets her origins). (Ibid.)

It is important to be aware that it is not just whites who pressure the nonwhite ethnic to conform. Chow gives many examples of the ways that scholars of Chinese culture and literature, for instance, relentlessly produce an essential-ist notion of China which is used to berate modern diasporic Chinese (and their cultural productions). This essentialism is an essence that *none* can live up to, precisely *because they are alive* and as such contaminated, diluted, tainted or corrupted by non-Chinese influences.

Postcolonial critics (not to mention such popular cultural texts as, for example, the Paul Haggis film *Crash* (2004)) often recount cases in which nonwhite ethnic subjects are pressured directly and indirectly to start to behave 'properly' – to act and think and be the way 'they' are supposed to act and think and be as

nonwhite ethnic subjects – in other words, to be both *interpellated*, in Althusser's sense, and *disciplined*, in Foucault's sense. Chow calls this 'coercive mimeticism' (2002: 107). Coercive mimeticism designates the way in which the interpellating, disciplining forces of many different kinds of discourses and institutions *call* us into place, *tell* us our place, and work to *keep* us in our place. As Chow writes of the ethnic academic subject: 'Her only viable option seems to be that of repro-ducing a specific version of herself – and her ethnicity – that has, somehow, already been endorsed and approved by the specialists of her culture' (2002: 117). Accordingly, coercive mimeticism ultimately works as 'an institutionalized mechanism of knowledge production and dissemination, the point of which is to manage a non-Western ethnicity through the disciplinary promulgation of the supposed difference' (ibid.). Moreover, this disciplinary mechanism extends far beyond the disciplines proper, far beyond the university. In Chow's words:

> unlike the white man, who does not have to worry about impairing his identity even
> when he is touched by a foreign culture, the ethnic must work hard to keep hers;
> yet the harder she works at being bona fide, the more of an inferior representation
> she will appear to be. (2002: 124)

If we follow the train of dominoes that falls down from this, what soon becomes apparent is that the notion of 'authenticity' must ultimately be construed as a hypothetical state of non-self-conscious and non-constructed essential 'being'. The fact that this is an essentialism that is essentially impossible does not mean that it does not 'happen' or is not 'assumed'; rather it means that 'ethnicity' becomes an infinitely supple rhetorical tool. It is available (to anyone and everyone) as a way to disparage both *anyone who is not being the way they are supposed to be* and anyone who is being the way they *are* supposed to be. As Chow explains, 'ethnicity can be used as a means of attacking others, of shaming, belittling, and reducing them to the condition of inauthenticity, disloyalty, and deceit' (ibid.). Ironically, such attacks are 'frequently issued by ethnics themselves against fellow ethnics, that is, the people who are closest to, who are most *like* them ethnically in this fraught trajectory of coercive mimeticism" (ibid.). What this means is that the most contempt, from all quarters, will always be reserved for he or she who does not stay in their place, play their proper ethnicity. All too often, criticism is levelled *individually*, as if it is a *personal* issue, 'despite the fact that this histori-cally charged, alienating situation is a collectively experienced one' (ibid.). Such is the disciplining, streaming, classifying force of coercive mimeticism. Such are the 'uses of ethnicity'. In the words of Etienne Balibar: 'the problem is to keep "in their place", from generation to generation, those who have no fixed place; and

for this, it is necessary that they have a genealogy' (quoted in Chow 2002:95). As such, even the work of sensitive, caring, deeply invested specialists, and expert ethnic scholars – even ethnic experts in ethnicity – themselves can function to reinforce ethnicised hierarchies, structured in dominance, simply by insisting on producing their field or object in its difference.

Ultimately, then, Chow's work on ethnicity asks us to pay attention to the micropolitics of everyday life. Ethnic subjects are always an object of discourse, constructed and construed as 'meant to be' this way or that, with accusations regularly levelled at those who choose this or that way of being. The ethnic, then, stands accused. Are you true to your history (your proper place, your proper identity)? Are you, in other words, a protestant ethnic? Or are you a sell out, turncoat, traitor?

Bruce Lee amounts to the protestant ethnic par excellence. Because he died at the height of his protestant moment, he has the dubious status of existing at the high-point, or the first stage of that two-part narrative structure, which, in the narratives of many, runs from initial energetic emergence or eruption (hope) to subsequent inexorable cultural recuperation or commodification (disappointment). Those who lived on beyond Bruce Lee do not have the same immortality, the same manner of dwelling solely in the first moment of hope, anger and energy.

THE (POST) PROTESTANT ETHOS AND THE SPIRIT OF CONSOLIDATION

In becoming a film actor, Bruce Lee's son, Brandon Lee, perhaps unsurprisingly followed in his father's footsteps. Maybe this would not have been inevitable or so visually obvious had Brandon avoided the martial arts action genre. But Brandon Lee became a martial arts action actor. In an important study of transnational China and the Chinese diaspora on global screens, Gina Marchetti observes that 'Brandon Lee created a star image that both adheres to and diverges significantly from the path taken by his father two decades before' (2006: 208). For, whilst 'Bruce Lee stood as an emblem of justified revolt and vengeance for audiences of the dispossessed globally, Brandon Lee's image promised the possibility of assimilation as he began to make inroads into a racist film industry' (ibid.). Indeed, Marchetti proposes, one of Brandon Lee's starring vehicles, *Rapid Fire*, can actually be used 'as a point of departure for understanding how Hollywood has rethought its depiction of Asian/Asian American identity as a consequence of changing patterns of immigration and in light of America's evolving relationship with the People's Republic of China' (ibid.).

Before being this, the film is certainly what Marchetti calls a 'pastiche of post-1989 Tian'anmen politics, Oedipal ambivalence, ethnic gang wars, and urban paranoia', one which 'self-consciously alludes to the connection between Brandon and his famous father within a drama that only thinly disguises its attempts to reconfigure Bruce Lee in his son's image' (ibid.). Brandon, who plays Jake Lo, is certainly constructed as a rebel figure: as Marchetti points out, Jake arrives in the film quite late, after several other key figures and intrigues have already been introduced; but when he arrives he is on a motorbike, in white t-shirt and jeans, strongly reminiscent of other such movie rebels as Marlon Brando or James Dean (2006: 210). But Jake is essentially a rebel without a cause. Flashbacks quickly allow us to see that his father was killed in the 1989 massacre at Tian'anmen Square, and Jake's refusal to join those who are still protesting in the US for democracy in China signals that all he wants to be is 'left alone' – declaring at the outset that politics is 'bullshit'. Jake wants to be free from his father's 'political' legacy (unfortunately, his father, who is apparently revered by the student activists, turns out to have been no mere protester-martyr, but in fact an American agent working undercover in Beijing, for no more compelling a reason than the apparent 'right' of the US government to monitor and spy anywhere and everywhere – a fact which perturbs neither any character in the film, nor the narrative structure of the film itself: an American spy in China is presented as something that is perfectly fine and natural); he wants to be free from the activists who hound him to represent his dead father; he wants to escape from the fact that he witnesses a Mafia/Tong murder; and he wants to be left alone by the American agents and police who want him to work for them by acting as bait to catch the criminals. Jake is ultimately a rebel *against* political rebellion. His rebellion is, as Marchetti points out, merely a rebellion at the level of style. He just wants to be the edgy, moody, free-spirited teenager. In short, Jake wants to be normal.

Indeed, Jake *could* be normal, were it not for his family history and for what he witnesses. In this specific Hollywood illustration of the workings of coercive mimeticism, almost everyone in this context puts pressure on him to (want to) play his expected role as a protestant ethnic. Even his attraction to the very epitome of the normative Euro-American heterosexual ideal – the blonde model in his life-drawing class – also works against him: the model invites him to a party, as if on a date; but it is a trap, a lure designed to get him to a Chinese pro-democracy fundraising event. As if to rub salt into the wound, she even appears to be in a relationship with the leader of the pro-democracy Chinese student activists – suggesting that the beautiful white woman *would* be attracted to Jake were he to fulfil his stereotypical cultural obligations – in other words, if he were to be a properly protestant ethnic.

Indeed, let us pause for a moment to ask: what of these *attractive* protestant ethnics – or rather, what of the *protest* that apparently *makes* them more attractive (at least to our one exemplary 'token' white girl), more attractive than the ethnic who seeks to resist the coercive mimeticism which demands that he protest? One particular irony within the film is illuminating. This centres on the status the film gives to the *object* of the protests of the protestant ethnics: namely, the pro-Chinese-democracy movement. This status is voiced by one of those present at the fundraiser – a character, Chang, who turns out to be heavily involved in international crime: when asked why he – a (sleazy, seamy) businessman – is present at a political fundraiser, he replies, saccharine-suave: 'Democracy, capitalism – it's all a good cause!' Marchetti notes, 'although it makes narrative sense' to have Jake and gangsters at the fundraising event, 'because there needs to be some explanation for Jake's involvement with gangsters to get the plot moving', nevertheless 'the ideology behind the narrative choice is startling' (2006: 211). For, 'the fact that the film seems to be saying that gangsters and pro democracy Chinese protesters share a common set of values and interests slides by in the film without comment' (ibid.). Indeed:

> No one broaches the potentially disturbing news that American and Chinese interests may not coincide and that Jake's father is a spy working for his adopted home, rather than exclusively in the interest of the Chinese demonstrators. No one in the film supports Jake's desire not to be involved with any of this. (2006: 211–12)

As Marchetti also notes, *Rapid Fire* 'voices concerns surrounding gender roles, ethnic identity, race, international politics, crime, and governmental corruption'; moreover, the film 'places these controversial issues on Brandon's shoulders in an attempt to reinvent an acceptable but nonthreatening multiethnic presence within Hollywood' (2006: 208). This is why, 'rather than defying a racist society that attempts to destroy him, Brandon's character learns to accept his role as symbol of a new America, cleansed of its racism, by putting his martial arts talents and romantic energies in the service of the police' (ibid.). Yet, Marchetti observes, 'Haunted by the ghost of Bruce Lee, this reconfigured masculinity, however, seems drained of affect, a postmodern simulation of an Asian American hero who has lost his original, justified anger' (2006: 208–9).

This draining of affect arises because the way that *Rapid Fire* negotiates the ideologically threatening problems that are clustered around ethnicity (Chinese, Thai, Sicilian) is by constructing Jake as a character who does not want to be involved in these 'controversial issues' as a *protestant ethnic*, but who merely wants to be a normal (protestant) *male* subject by playing out an apolitical Oedipal

narrative rather than a political one. His 'problem' is with his father – his father's very involvement in what is coded by the film as 'cultural politics' (but what is actually, at best, covert US reconnaissance). This 'problem' is transferred onto his relationship with the substitute father figure, the police officer, Ryan.

In fact, the resolutions of *Rapid Fire* are Oedipal through and through. Jake's relationship with his father is not 'resolved', it is simply abandoned. Jake merely has to come to terms with the fact that his father died. When Jake finds nothing new in the file about his father that Karla has acquired, Karla emphatically reaffirms: 'Your father was doing what he thought was right. He died. It happens every day. Deal with it.' Thus, the enigma that has fuelled Jake's rebellious non-accepting attitude ('I never even knew why he was over there') does not culminate in some great revelation; it simply fizzles out, fades away, has to be forgotten, moved on from.

WHEN THE BATTLE'S LOST AND WON

Marchetti notes that by structuring Jake's 'problem' in terms of the complaint 'I never even knew why he was over there', the film executes an associative sleight of hand which means that 'China and Vietnam have changed places historically' (2006: 214). America had no presence in China; there was no American conflict 'over there'. But, of course, this complaint and this sentiment is more than familiar *vis-à-vis* Vietnam. As such, any 'critique' or revelation is foreclosed at the outset by the filmic choice of the Oedipal rather than the political. One might say, the film is confused and confusing, yet it engages with its own potential complexities with a shrug of the shoulders rather than any other kind of interrogation. Or, as Marchetti puts it, even though a 'conservative reading and a critical irony inhabit the same narrative', there is 'no dialectical tension between the two; both are drained of significance' – this is chiefly because 'the film makes it appear as if the battle has been waged and lost by both sides long ago' (2006: 213–14).

Thus, she points out, 'When he critiques the government and rants against his father's politics, Jake really protests too much' (2006: 216). As symbolised by many different textual and dramatic devices, from the very first moment we see Jake in all of his 'rebel without a cause' style, to his relationship with Karla and the father figure Ryan, plus many other such features, we increasingly see his 'full commitment' to the American establishment and ultimately to the fact that 'America accepts him' (ibid.). As Marchetti observes, after the *dénouement* of the action, Jake is asked the contextually loaded question 'are you in or out?' This question is literally about whether Jake wants to ride in the ambulance with the

injured Ryan. But, symbolically, it is about whether Jake is in or out of the estab-
lishment. Marchetti's summing up of the status of Jake in *Rapid Fire* deserves to
be quoted in full:

> In *Rapid Fire*, Brandon stays squarely within his father's oeuvre, a self-conscious
> imitator, helped to achieve this duplication by some of his father's martial arts
> students. However, whereas Bruce's physical presence connoted resistance to
> racism, colonialism and class exploitation, Brandon (half Asian and half white) is
> exploited here as an image of assimilation, acceptance, and reconciliation. The
> rebel's reluctance becomes the hero's acceptance of another's battle. In *Rapid Fire*,
> Brandon does not take up his father's causes, only his father's characteristic style.
> Narrative aside, perhaps it is this imitation of Bruce's physicality, of his definition
> of Asian masculinity as a rebellion against the American mainstream, that disturbs
> the film's neoconservative flirtations with justifying US military/police interven-
> tion in Asia/Asian affairs – from Tian'anmen to the Golden Triangle heroin trade.
> Less a neoconservative icon of the new American hero, Brandon is a postmodern
> memento mori, a maudlin reminder of the struggles of the past and a fantasy that
> these battles have been concluded, a hope that the need for Bruce Lee no longer
> exists. Hollywood, through Brandon, reconstructs a Bruce Lee that never existed
> and allows Brandon to attempt to transcend him. However, as the body is drained
> of its anger, style becomes just a gesture drained of its significance, and it really
> does not matter whether Brandon is in or not. (2006: 218)

It strikes me that Marchetti's conclusion itself resounds with the postmodernism,
nostalgia and disappointment that her own work diagnoses in the text. It certainly
diagnoses the plight of the agency of the protestant ethnic (who plays out 'a
maudlin reminder of the struggles of the past and a fantasy that these battles
have been concluded'). But I also think that the orientation of Marchetti's analysis
suggests a positional mourning or melancholia of the critic's own: a disappoint-
ment that 'Brandon is a postmodern memento mori', and that, in this text, 'it
really does not matter whether Brandon is in or not'.

Certainly, I would want to propose that had the ending of the film been slightly
different – had Brandon answered the interpellative question with the answer that
he was *not* 'in', but that he was instead 'out' – the film would have been unable to
represent this in any way other than as being something negative, problematic,
unsatisfying. Recall the end of a film such as *Good Will Hunting* (1997), when Will
– who is an untrained autodidact prodigy and, specifically, a 'natural' mathematics
genius – *rejects* the option of taking a privileged place within the elite institutional
status quo of well-paid scholars. This is conveyed as a largely unintelligible and

inexplicable 'rebellious' gesture *par excellence* – as the stupid immature irrationality of someone who does not know a good thing when he sees it. Of course, Will Hunting will always have the option to return, meaning that his rejection of 'the status quo' is not necessarily a rejection but rather a deferral. Will is going off to 'live life' and to 'mature'. But my point is that, were Jake to opt out, to reject the offer of inclusion, this would constitute a certain frustrating lack of resolution or 'closure' to the film.

For rather than asking the question of whether the 'normal' rebellious teen wants to grow up or not, *Rapid Fire* asks whether the protestant ethnic wants to be in or out. The question Marchetti alerts us to is: on what grounds is continued ethnic protest justified or necessary? *Fist of Fury* depicted a situation where the Chinese in China could not walk through public parks, and where colonial powers intruded oppressively in multiple ways into everyday freedoms. Even the 'sanitized and hagiographic' biography of Bruce Lee, *Dragon: The Bruce Lee Story* (1993), depicted the experience of blatant and intrusive day to day racism. *Rapid Fire*, on the other hand, depicts a much more stabilised environment of intelligible and sedimented ethnic enclave identities: everyone can instantly recognise others according to fully intelligible stereotypes; whilst, reciprocally, characters can opt out of their stereotypical culturally (over)determined identities by claiming to be not 'Italian' or 'Chinese' but rather, as Marchetti notes, 'American'.

Despite the ambivalence at the heart of all hyphenated identities (Asian-American, Afro-American and so on), all of these options are fully available and none would disturb what Rancière often evocatively calls the distribution of the sensible, or what he calls in *Disagreement* (1999) the *geometrical* organisation of society. Society has been conceived of as geometrically arranged or structured since the time of Plato, observes Rancière; with different 'groups' assigned different positions, both theoretically and practically, both in terms of the way 'groups' are thought of and in terms of the ways they are related to, in the form of their social, legislative and institutional organisation. In this case, one can be 'ethnic-identity-x' *or* one can be 'American'. The hyphenated identity allows one to oscillate from one pole to the other. Of course, the (unhyphenated) American is the norm, or rather the ideal. The ethnic is, to borrow a phrase from Freud, the internal foreign territory. Indeed, as is well-known, the ethnic must always also be a hyphenated ethnic-American – a double status which involves both elements of mainstreaming *and* marginalising, of being both in *and* out, both normal *and* abnormal, both equal *and* unequal. The hyphenated identity is often regarded as a solution to the problem of multicultural identity politics. But it is rather more a stabilisation, taking the form of an irreducibly problematic yoking together of incompatible entities.

Despite its residual complexity, becoming this stabilised, neutralised, hybrid identity is the only real option made available to Jake, and the option he ultimately takes. Marchetti pinpoints precisely the way that the film handles the threatening dimension of ethnicity and fully 'inoculates' Jake:

> Finally, after all the efforts of the film have been spent tricking, trapping, coaxing, seducing, and generally brow-beating Jake into feeling guilty for distrusting the government that he blames for killing his father, Jake accepts America. However, despite all the plot time devoted to his forced welcome into the American main-stream, the fact of his racial/ethnic difference still disturbs the fantasy. He cannot be at peace in America until something Asian dies, so his final confrontation is with Tommy Tau. By killing Tau, Jake disposes of the alien presence within himself. Tau's Chinese ethnicity parallels Serrano's Italian exoticism. They both stand as excesses within a fiction that prizes homogeneity – for example, Jake and Karla's androgyny, Jake's ordinary, 'dull' dress and demeanor. (2006: 216)

There is, then, an enigmatic relation between several different sorts of 'differ-ence': cultural difference, ethnic difference, and sexual difference. The protestant ethnic is easily masculine or masculinised. That is, protest is easily rendered as a process of remasculinisation. But the included ethnic – what does he or she become? Does he become a she? Rey Chow has noted that even in such influ-ential (and hence exemplary) modes of thinking of ethnic agency and politics as that of Franz Fanon, political agency is gendered: the protestant ethnic is mas-culinised. Anything other than separatism is feminised. Hence, feminisation and complicity are drawn into a relation. Miscegenation is regarded as treachery (see Chow 1998: 55–73).

But what if ethnics wish not to be *protestant* ethnics – if not to *not* 'protest' at all, but rather to protest the forces of coercive mimeticism which want to force them 'to resemble and replicate the very banal preconceptions that have been appended to them' (Chow 2002: 107). As Chow clarifies, coercive mimeticism is 'a process in which [ethnics] are expected to objectify themselves in accordance with the already seen and thus to authenticate the familiar imaginings of them as ethnics' (ibid.). Now, Nitta contends that something important and distinct occurs in the martial artist as a *character vis-à-vis* the situations of coercive mimeticism. Supplementing Chow, she proposes that 'in so far as the martial artist displaces the dominant heterosexual structure of the Western action film', then, 'his sig-nificance [might] be evaluated in terms of more cutting-edge queer theory or psychoanalytical theory, rather than a theory of stereotype' (2010: 384). This is because, as we have seen, *ethnicity* is bound up with the *gendering of agency*

per se. So, where Bruce Lee is masculinised (without, nevertheless, necessarily acting as a force of or for heteronormativity), Brandon Lee is feminised. (Marchetti details at length the feminisation involved in the eroticisation of Brandon's body, even in the heterosexual love-making scene.) Moreover, the masculine body is the active body of the protestant; the feminised body is rather more passive. As Marchetti puts it: 'whereas Bruce's physical presence connoted resistance to racism, colonialism and class exploitation, Brandon (half Asian and half white) is exploited here as an image of assimilation, acceptance, and reconciliation' (2006: 218).

Yet is this destiny of the ethnic identity necessarily one of a journey from active, strident, striving 'father' to passive, castrated homogeneity? Even if the Oedipus complex were stereotypically to be regarded as resolving itself in such a way anyway (it is not: the son tends to replay the role (re)played by the father), there are other positions that remain to be considered: What about the position of the mother, for instance? Or, indeed, as one of Marchetti's subheadings phrases it, what about 'Oedipus in Diaspora'? Nitta explores this question thoroughly in her study of the interplay of masculinities in such post-Bruce Lee martial arts films as *The Karate Kid* series of the 1980s (1984, 1986, 1989). In these films she finds the martial arts subjectivity of the Okinawan-Japanese-American father-figure Miyagi to constitute the positive realisation of the masculinities produced by and in the wake of World War II. Miyagi, it must be remembered, is systematically contrasted to the ex-military martial artist 'Sensei' John Kreese of the Cobra-kai. She concludes:

> Miyagi and Daniel defeat an extremely vicious version of machismo as connected with the military culture of the Vietnam War. When the film rejects the machismo, one that misleads American teenagers, the martial arts master's gender-crossing space of training is recognized as a site where one can learn a seemingly more peaceful and less antagonistic way to dominate the Other. In this sense, Miyagi is awarded the place of man: his masculinity is certainly unconventional but he is never feminine. This might be exactly the model of hero the American martial arts film, a sub-genre of the action film, seeks to buttress as its uniqueness. Miyagi's karate as the art of self-defense, while suggesting the similarity between his cinematic role and the role of Japanese Self Defense Forces, ultimately anticipates a way of defending a 'new world order' in the post Cold-War era. (2010: 390)

Such an argument has its precedents in such founding works on globalisation as Armand Mattelart's (1993) identification and description of some key characteristics of contemporary developments in capitalism, which he approaches in

terms of the 'communications revolution'. This revolution in communication has, Mattelart argues, precipitated a 'need' for the ideological re-working of erstwhile mythologies of nationalism, and hence precipitated all sorts of crises of cultural identity and transformations in the status of alterity. Such rearticulations are necessary, according to Mattelart, in order for capitalism to realise what he calls its 'global target' (1993: 6). Thus, processes of globalisation constitute the development of a spurious universalism, an ultimately Western or Eurocentric hegemony (see Amin 1988). This amounts to a change in ideologies, away from the dialectics operative even during the very recent past, and into a state characterised not simply by nationalist ideologies but rather by 'discourses of truth' which advocate the equivalence in difference of all cultures, and, therefore, the rejection of the idea of ethnic or cultural antagonisms.[1]

Cultural antagonisms are things of the past. At least, this is the ideology of globalisation rhetoric. Traces of the impulse to represent things accordingly can be seen in the orientation of the universalist egalitarian discourse of the later Bruce Lee, of course, and also in *Game of Death*. But it can also be seen far beyond Bruce Lee. For instance, we can easily see in many other filmic texts, which can be variously regarded as iterations and reiterations of different elements of this ideology. Again, a prime example would be *The Karate Kid*, a film whose popularity could be diagnosed by ideology-critique as being a consequence of the fact that, as the poststructuralists used to say, it is an utterance (or, better, a *parole*) originating from and destined for a 'dominant hegemony' which 'speaks itself back to itself' through filmic texts like this. Semiotic analysis can reveal the ways that 'encoded messages' surround the main characters, Danny Laruso and Mr Miyagi, in particular, but also 'sensei' John Kreese of the Cobra-kai karate club. Ideology critique and semiotic analyses both seek to delineate the relevant features of the hegemonic discourses into which alterity – in this case, the Oriental alterity of the Okinawan karate expert, Miyagi – is handled. Such analyses can also reveal the extent to which Miyagi is a construction built from elements of Orientalist Western myth. But in the context of our current concerns, along with approaches which focus on discourse, ideology and hegemony, other important theoretical tools, as suggested by Nitta (2010), do still come from psychoanalysis – and, I would add (supplementarily) also from deconstruction. The connection of psychoanalysis and deconstruction within the same work can be justified in many ways. But in the context of a consideration of *The Karate Kid*, it most immediately imposes itself because of a similarity between the status and work of the *phallus* (Lacan) and the logos (Derrida) – as both being principles containing the 'constitutive contradiction' of misrecognised synthesis, coherence, plenitude and presence.

The Karate Kid conforms to the Barthesian concept of the 'readerly' text. It is designed so as to be interpretatively unproblematic. It utilises established, sanctioned techniques of encoding, that should not (*ceteris paribus* – other things remaining the same) frustrate the (Western) viewer's horizon of expectations, as it requires only that the viewer be *au fait* with dominant Hollywood 'realist' action cinema conventions. The film assumes a viewer situated within or intimately literate with what Kaja Silverman (1992) once termed the dominant fiction of the Western hegemonic intertext. The film encodes its messages in such a way as to facilitate the unselfconscious arrival at 'the' unequivocal interpretation, achieved by the use of traditional enunciative and fictional conventions, such as sequential narrative causality, strictures of continuity, verisimilitude, and effects of 'vraisemblance' derived from the familiarity of the iconic character of the televisual signs – in short, the text utilises performative codes in such a way as to create denotative effects: that is, appearances of referentiality and codes of such fixed conventionality as to have become universal in meaning among Western viewing subjects. As Stuart Hall once put it in a now canonical essay:

> Naturalism and 'realism' – the apparent fidelity of the representation to the thing or concept represented – is the result, the effect, of a certain specific articulation of language on the 'real'. It is the result of a specific discursive practice. What naturalized codes demonstrate is the degree of habituation produced when there is a fundamental alignment and reciprocity – an achieved equivalence between the encoding and decoding sides of an exchange of meanings. [...] This does not mean that the denotative or 'literal' meaning is outside ideology. Indeed, we could say that its ideological value is strongly fixed – because it has become so fully universal and 'natural'. (1980: 132)

The thematic structure of *The Karate Kid* is, again, familiar. Apart from the extra-textual or *a priori* signifying value of the title itself, the story follows a tried and tested plot formula which takes the form: upheaval – conflict – resolution. Intertwined and integral to this is the approximation to a romance, which follows a parallel pattern. Because of this, traditional methods of textual analysis would only really arrive at the conclusion that the film is not in any way a work of art: it is not innovative enough to occupy this status. But this is precisely what makes it a valuable text for cultural analysis.

The film presents the journey of Danny Laruso from the loss to the subsequent 'symbolic reappropriation of presence' (Derrida 1974: 142). The geographical upheaval of Danny from New Jersey to Los Angeles initiates a personal crisis which, though not immediately discernable, comes to prominence very early on

in the narrative. In the Lacanian terms of Kaja Silverman, on his arrival in L.A. Danny can be said to be still playing out his previously achieved and maintained 'other and fictive' fantasy of self (1992: 3). This is depicted by his pose as karate expert, and his amorous pursuit of the rich girl, Ali (who is the ex-girlfriend of a jealous boy, who also happens to be the most senior of the Cobra-Kai karate students: hence the conflict). At this stage, the '*objets a*' through which Danny has created his sense of self are intact, so to speak: he is seen by himself and others as a wielder of the power of karate, and he is seen in the same way to be obtaining the attractive Ali. So, he is, in his own ego, or '*moi*' (as Silverman notes, 'Lacan often refers to the ego as the *moi*, since for him it is that which is responsible for the production of identity or a "me"' (ibid.)), the wielder of agency, potency, completeness. Silverman notes that:

> Part of what it means to pursue the relation of fantasy to the ego is to grasp that the subject's own bodily image is the first and most important of all the objects through which it attempts to compensate for symbolic castration – to understand that the *moi* is most profoundly that through which it attempts to recover 'being'. The self, in other words, fills the void at the center of subjectivity with an illusory plenitude. (1992: 4–5)

It is the illusory plenitude of self that is shaken by Danny's physical and psychological beatings on the beach, the soccer field, and the journey home on his bicycle; as well as the trauma of seeing that his enemies are senior students at the local karate club – compounded by the fact that *they see him seeing them* in their own 'phallic' glory. Being seen in the impotent state of the desiring spectator by the senior student of karate (who is therefore the fullest bearer of the image of phallic potency) is the penultimate event in the 'upheaval' section of the film. The last straw, so to speak, comes with the beating Danny takes whilst on his bicycle (castrated state) by the motorbike gang of karateka (phallic plenitude).

Danny projects his rage about this castration onto the bicycle itself. This is, then, a metonymic condensation and displacement related to his own (ego's) position, as conveyed in the symbolic contrast of bicycle/motorbike, or rather inferiority/superiority (Silverman 1983: 177). Whilst he is taking out this anger on his bike, he tells his mother that the cause of this anger is that he does not 'know the rules here'. When asked the way in which his anger could be eradicated, he comes out with the contextual *non sequitur* of 'I gotta take karate – that's what!' This is a *non sequitur* in the sense that all the information he has given his mother so far is that he 'hates' his 'stupid bike' and that he wants to go home: 'Why can't we just go home?' It is not the bike that he hates, of course, just its

signifying function as being a vehicle for the metaphor of his own castration. And it is not necessarily 'home' he wants to return to, but rather the state of 'illusory plenitude' that he had attained and maintained before being divested of his earlier untested sense of self. Similarly, Danny does 'know the rules here'. He knows them only too well. They are the rules of masculinity and male identity condensed and displaced into the injunction, 'master karate'. When 'here' means in his own 'psyche', then his 'moi' requires the rule of 'mastery of karate: invincibility'; and when 'here' means 'within the context of the logic of this film', then the rules remain 'Danny must achieve mastery of karate'.

However, fundamentally, karate itself is not the motive force of the narrative. Karate is just conceived of by Danny and the value system of the film as an answer to all his problems. To be physically invincible is the conflation with psychic plenitude afforded by the ideal representation of his superego: and such representations, Silverman asserts, play a 'vital part' in 'defining for the subject what it lacks' (ibid.). The motive force of the narrative is the obtainment of the girl, Ali. Karate is the means to plenitude; Ali is the affirmation of that plenitude:

> Identity and desire are so complexly imbricated that neither can be explained without recourse to the other. Furthermore, although those constitutive features of subjectivity are never entirely 'fixed', neither are they in a state of absolute flux or 'free-play'; on the contrary, they are synonymous with the compulsion to repeat certain images and positionalities, which are relinquished only with difficulty. (1983: 6)

Danny will not relinquish the repetition of those representations of himself to himself, of his *moi*: karate equals phallic agency, mastery equals the reappropriation of value, signalling the point of structural narrative closure: the assertion of presence: resolution.

The means whereby Danny achieves mastery is through Mr. Miyagi. This relationship is constructed for various reasons, such as the stylistic symmetry of the film, and making the manifest themes of the 'true nature' of karate and the noticeable differences between Oriental 'wisdom' and Western insufficiency more superlatively stated, and this aspect will be considered in due course, but first it is more appropriate to continue with the examination of Danny.

What is most striking in the Danny/Miyagi relationship for the purposes of our discussion is its deployment of Oedipal structures. The absence of any other father figure in Danny's case expedites the adoption of Mr. Miyagi as a substitute. Just as the theoretical position of the father in the Oedipal triangle designates 'all those values which are opposed to lack', that is, the phallus, so Miyagi, within the parameters of the text's discursive space, should be the perfect embodiment of

that symbolic position. However, in a classic Oedipal drama, Danny should work through an ambivalence towards him, which in the psychoanalytic developmental narrative would correspond with the ambivalence felt by the child of the same sex, arising because of an ultimately rivalrous desire for that symbolic position. In this fictional situation, the desired position would be that of Miyagi as the ideal representation of phallic agency, in this case crystallised in karate, of which Miyagi is presented as the master. In the psychoanalytic narrative, the Oedipal subject experiences a 'brutalizing sense of inadequacy … because he can never be equivalent to the symbolic position with which he identifies' (ibid.).[2] However, in this text, things are slightly different.

As Nitta (2010) observes, the model of masculinity offered by Miyagi could be regarded as a potentially more significant advance on the models of masculinity proffered elsewhere. As we have seen, Nitta scrutinises Chan's (2000) contention that Bruce Lee's 'ambisexual' mode of masculinity is ineffective for hegemony and hence offers a kind of ethico-political innovation. But Nitta finds Miyagi's masculinity to be even more productive a model – for, Miyagi is nurturing, caring, soft, delicate, passive, yielding: in other words, closer to the feminine and hence occupying a position more akin to the mother. However, if this is the case, then rather than looking for a new model of masculinity in Miyagi, perhaps two possibilities need to be engaged beforehand. The first is the possibility that the film is simply Orientalist. This has all the hallmarks of Orientalist fetishisation of the good other. Miyagi represents everything feminine, enthralling, mysterious, soft and subtle.

The second is the possibility that Danny's Oedipal father figure is not something embodied in one character, whether that be Miyagi or anyone else; but rather the desire for karate insofar as it stands for complete potency and plenitude. Danny has an initial ambivalent relationship with karate: first playing at it (kicking open the entrance to the apartment complex he is moving into on arrival in L.A.), a play acting which is witnessed by another teenager who takes his performance seriously and hence offers Danny the possibility of claiming the social status and cultural capital of 'karate expert'. Then, when Danny is beaten in a fight on the beach by Ali's ex-boyfriend, he tries to recuperate his lost cultural capital by looking for a karate club in order to become the subject he fantasises himself to be. Unfortunately the club he finds is full of the very teenagers who were his opponents on the beach, and – worse – the very one who fought Danny and beat him so comprehensively is the head student. After this crushing sense of inadequacy is forced upon him, Danny tries to walk away from karate and conflict, but he is relentlessly pursued and humiliated by the Cobra-kai karatekas.

Thus, the phallic plenitude that Danny initially desires (to be) takes the form, first, of a fantasy (his play-acting the persona of being an experienced karateka). It

then becomes embodied by the version of phallic potency offered by the aggressive, hyper-masculine white American karatekas. However, excluded from this club, it is Miyagi who teaches Danny not so much an alternative interpretation of karate mastery but rather a different route to that mastery, coupled with a different ethos. Where the Cobra-kai are taught 'strike first, strike hard, no mercy', Danny is taught through a series of apparently non-training, indeed apparently nonsensical pedagogical devices ('wax on, wax off', 'sand the floor', 'paint the fence', 'paint the house') to understand karate in terms of a certain paradox – namely, that he trains to fight so that he 'won't have to fight'.

In other words, the film divides and displaces the Oedipal ingredients or coordinates throughout the film. This reminds us, in a way, not to anthropomorphise or be too subject-centric or humanist even when thinking about subject formation.

In any eventuality, the end of *The Karate Kid*, depicts the fantasy scenario of Danny resolving a kind of ideal Oedipus complex. The film ends at the moment of resolution, at the very point of Danny's emancipation from being bullied and his establishment of a coherent, complete and 'fully present' identity. In the simple universe of the Hollywood film, the culmination is this rather than the messy consolidation of multi-layered and compounded misrecognitions. Danny has mastered karate, become reconciled with his mother and won Ali; he has gained social acceptance through the affirmation of his 'value': he gets the power, the car, the girl, the trophy, and the vanquishing and approval of his former enemies. The last words of the film are spoken by the previous karate title-holder, whom Danny has now supplanted: 'You're alright, Laruso!'

LARUSO AS ROUSSEAU

Even though the direction I would like to nudge readings is not subject-centred, it is important to note the ways that, like many films, *The Karate Kid* gives a kind of insight into the way that complex problems of identity are treated ideologically, and the way that difference or alterity are brought into line, moved into place. The question is the nature of any relation this may have to the process and practices of subjective 'reality'. The story of Danny is a simple depiction of any number of standard, standardised and intelligible movie themes: justice overcoming injustice, the journey from boyhood to manhood, righteousness prevailing in the face of the odds, good overcoming and correcting bad, purity overcoming corruption, flexibility trumping rigidity, and so on. The film is easy to interpret. It is designed to be 'consumed' rather than 'wrestled with'. And, as Stuart Hall argued in his canonical work on the cultural logics of viewing and

spectatorship, any text offers a 'discourse' which:

> must then be translated – transformed – again into the social practices if the circuit is to be both completed and effective. [...] If no 'meaning' is taken, there can be no 'consumption'. If the meaning is not articulated in practice, it has no effect. [...] Before this message can have an 'effect' (however defined), satisfy a 'need' or be put to a 'use', it must first be appropriated as a meaningful discourse and be meaningfully decoded. (1980: 91–3)

In this sense, the work is an ideologically saturated utterance whose principal 'effect' is the reactivation of the very values that gave birth to its messages – the 'culturally instigated, and hence collective' desires of the 'predetermined narrative' of Western culture, within which the 'normal' 'Western subject is fully contained' (Silverman 1983: 136). As such, the film may be deemed unimportant or insignificant in and of itself. However, Gayatri Spivak draws our attention to what she calls Pierre Macheray's 'formula' for 'the interpretation of ideology'. This begins from the proposition that 'what is important in a work is what it does not say':

> This is not the same as the careless notion 'what it refuses to say', although that would in itself be interesting: a method might be built on it, with the task of measuring silences, whether acknowledged or unacknowledged. But rather this, what the work cannot say is important, because there the elaboration of the utterance is carried out, in a journey to silence... (1988: 286)

Like any 'classical' Hollywood film, what *The Karate Kid* 'refuses to say' relates to the maintenance of its enunciative status, as well as its fictionality: to the concealment of its method of production as well as the necessary but acknowledged censorships of its narrative strictures, excluding all other cinematic thematic and stylistic possibilities, so as to maintain its interpretative stability. What it *cannot* say is a different matter altogether. For what this proposition would seem to rely upon for its validity would be several qualifications, among which is the more complete notion of 'what it cannot say if it is to remain the same' – the same in status, appeal, audience, income, identification, and 'effect'. But, of course, this qualification may constitute a reversal back to the former category of 'refusals'. The question of whether a silence is a *refusal* or an *inability* to signify is perhaps largely undecidable. But for our purposes, let us merely add the minor proviso of 'staying the same': what can the film *not* 'say' if it is to remain 'the same', generically, ideologically?

Among the things that *The Karate Kid cannot* say must include the extent to which the dynamics of the situation occupied by Danny exemplify a certain elaboration of the 'working through' of what Jacques Derrida called the 'metaphysics of presence' (1974). Preferred hegemonic discourses concede to what Derrida often referred to as the metaphysical desire for resolution, for 'closure', for unitary and stable interpretations and meanings. (This is similar to the way Freudian and Lacanian psychoanalysis construe the work of the ego.) The metaphysical desire is for resolutions of certainty, the plenitude of the 'moi', the possibility for the closure of the sign.

Danny Laruso is contained in a narrative in which the attainment of full presence is presented as simultaneous with the full statement and *real*-isation of worth.[3] However, in Derrida's examination of the problems of 'presence' and 'value' as located by Rousseau, Derrida argues that in Rousseau there is no escape from a kind of inverse relationship between speech (presence) and writing (worth). Derrida quotes Rousseau: 'If I were present, no one would ever know what I was worth'. In other words, according to Rousseau, one must always sacrifice either one or the other state of 'existence'; this is because 'the operation that substitutes writing for speech also replaces presence by value: to the I am or the I am present thus sacrificed, a what I am worth is preferred' (1974: 142). If there is any philosophical or theoretical truth in this relationality, it could be said that the hegemonic operation carried out by such texts as *The Karate Kid* works to insist not on a kind of inverse proportionality of presence to value but rather on a relation of direct proportionality or co-incidence. It can therefore be 'said' that the film exemplifies the hegemonic necessity for the maintenance of the mythological fallacy that insists upon the co-incidence of presence and value, logos and phallus, that has been called 'phallogocentricity'. Laruso is 'written' so as to be known, and the existential knowledge of his worth is constructed so as to coincide with the moment of his presence, which is, of course, fictive. This makes Danny into a 'native', a 'specimen'. As Spivak puts it:

> the person who knows has all of the problems of selfhood. The person who is known, somehow seems not to have a problematic self. […] Only the dominant self can be problematic; the self of the Other is authentic without a problem… (Spivak and Gunew 1993: 202)

Posed in this way, the processes integral to the hegemonic maintenance of the dominant symbolic order (phallus/logos) – specifically, the idea of the 'unary' self, the plenitude at the centre – necessarily involve these myths of coherence and cohesion. They are the pinnacle of identitarian thinking. So there is a sense in

which such texts coax viewing and consuming subjects away from the traditional status of Western Imperial 'knowers', cultural ethnographers (replete with a 'problematic self'), and that they have rather become inculcated with the desire – as the ultimate goal – of occupying the position of the 'known' (the traditional state of the ethnographer's 'native'). The idea that 'the person who is known, somehow seems not to have a problematic self' has as if been ideologically rewritten within such texts, as: 'the person who is known obviously cannot have a problematic self (and who would want such a thing!)'. We are all known others now. We are all protestant ethnics. So what, then, is made of or done with the 'ethnic' ethnic within this text?

The acknowledged and articulated form that alterity takes within *The Karate Kid* is embodied in Mr. Miyagi. He is precisely one of those 'recurrent token figures' which Spivak concedes 'it is so much easier to have' in handling alterity when it comes to representing it (Spivak and Gunew 1993: 195). For example, the first time we see Miyagi, he is sitting, facing away from us, inexplicably clicking chop-sticks in the air. He tells Danny that he will fix his faucet 'after'. When Danny asks 'after what?', Miyagi snaps 'After after!' Later, when showing Danny how to cultivate bonsai, Miyagi's only advice is that Danny should 'close eye' and 'think only tree'. Through all of these and other similar devices, the connotations are all those of that 'alien' yet 'lisible' imagery of Japanese Zen.

This is the economy of representation employed by the text. For the purposes of the film, the figure is basically a composite derived from several strong myths about the Oriental native, combined so as to maintain the familiarity of the figure. Indeed, the very title itself establishes a specificity within the viewer's horizon of expectations. The chain of expectations activated firstly by the title, secondly by the 'kid', and thirdly by the demonstrations of the kid's ineptitude at the 'karate' promised by the title, all pave the expectant way for the rapid ascension of the otherwise incongruous and redundant Oriental character to an unequivocal genre-specific position of the 'Oriental Martial Arts Master'.

The ascension of Miyagi to his signifying status is not immediate, of course. As a necessary component of the unfolding drama the connotative sign undergoes a series of deferrals before being strongly 'fixed' – he is not, for example, presented in a freeze-frame, wearing full karate suit and black belt, looking at and saluting the American flag, as the Barthesian system might prefer. All the imagery condensed in and around him is presented intermittently and cumulatively, so as to develop the connotation of his exoticism and Zen-esque appeal. Indeed, the association with the mystery and impenetrability of 'Zen-ness' has for a long time been a prerequisite for the 'Oriental Martial Arts Master', and it is complexly intertwined with the martial arts film. The inclusion of such mysticism

within this cinematic style is a convention of the 'langue' whose primary utility comes from its propensity to signify either lofty idealism or (tautologically) just simple mysticism, or both, so as to elevate the practices advocated therein from crude violence into the ostensible realm of the 'spiritual'.

Alterity is then contrived simultaneously as being both alien and actually familiar: everyone in the film knows what it is and holds it in esteem, but the film stipulates that despite this familiarity in the West it remains Oriental and perfect only in its ethnicity, so to speak: Danny beats the seasoned karateka because his 'source' is more pure, as it comes replete with the holistic, informing 'zen-esque-ness'. Indeed, Miyagi is actually the name of one of the reputed founders of karate-do; and this lineage does stem from Okinawa and not Japan as such; a fact which complicates the commonplace belief that karate is *simply* Japanese. Karate-do has a rather more complex colonial and post-colonial history.

The fact that Miyagi is from Okinawa is emphasised throughout *The Karate Kid*. It is as if this information subtly changes the status of Miyagi, creating a category for his ethnicity more suitable to a narrative which is so susceptible to the use of superlatives. Because Miyagi is not simply Japanese yet Japanese-esque he can occupy the more perfect position of authenticated alterity combined with the USA-condoned patriotic immigrant national – who earned a medal 'for valour' in World War II by 'killing many Germans', as the inebriated Miyagi puts it. The Okinawan origin overcomes the potential signifying pitfalls inherent in either Japan or China, or any of the other 'authentic' nationalities of Martial Arts Masters, such as Korea or Thailand. For all of these Eastern possibilities carry potentially negative nationalistic connotations, and such connotations would cloud the purity of the film's messages and frustrate that strenuously motivated anti-ambiguity of the celebratory nature of the Oriental, even though that celebration belies the servitude of that Oriental to the Western subject.

The appeal made by the film to a myth of Oriental superiority regarding karate is a reflection of the hegemonically sanctioned 'understanding' of the 'reality' of Oriental otherness, and that this otherness manifests as a 'real' difference in the subjectivity of the Oriental. This subjectivity is represented in Miyagi as the warrior-poet, the fisherman-philosopher, the harmony of the yin-yang. Edward Said notes (including the tell-tale word 'known'): 'As a known and ultimately an immobilized and unproductive quality, they come to be identified with a bad sort of eternality: hence, when the Orient is being approved, such phrases as "the wisdom of the East"' (1978: 205). Of course, Said is discussing the Middle East here, but it is readily seen that the Far East contains the same myths of mysticism with immense appeal in the West. Its aphoristic philosophies of Buddhism, Zen, and Taoism are so popular as to go some way towards the explanation of the

popularity of the West's recent martial arts explosion, at least, and its hegemonic assimilation as negotiated through the generation of its own discursive idiom yet consistent with all other hegemonic utterances.

That there is such an affinity here between the West's 'utterance' about one of its others and the demythologised and demystified components of that same alterity's own formulation of itself; and that this affinity occurs at a moment of 'affiliative engagement' in a field of discourse prone to the antagonisms of nationalism and racism, is an event which implies a hegemonic tendency towards the incorporation of nationalist difference into the positive and preferred position of that discourse. Bhabha notes that:

> Terms of cultural engagement, whether antagonistic or affiliative, are produced performatively. The representation of difference must not be hastily read as the reflection of pre-given ethnic or cultural traits set in the fixed tablet of convention. (1990: 3)

The representations offered by *The Karate Kid* suggest an 'affiliative cultural engagement'. It does, of course, use as its paradigm a 'hasty' reading of the myths surrounding 'ethnic or cultural traits' as well as the premise of 'the fixed tablet of tradition' (Spivak 1988: 274), but the fact of its occurrence is ambiguous. That the alterity of Japaneseness is approximated to and celebrated as a form of difference with cultural 'worth' in the West is jarring. That this message is '*lisible*' (readable/intelligible) and therefore hegemonically sanctioned is still a further complication of the common theoretical equation and starting point of 'superstructural' ideology as being determined by the economic interests of the 'base' – for, economically, the Japanese economy was the prime mover in undermining the West's desire for monopoly, so one would expect the continued maintenance of pro-West/anti-East myth. But there are, of course, economic reasons for the eradication of constraining national ideologies: as Samir Amin argues,

> the ambiguities of the new capitalist culture developed from the Renaissance onward. On the one hand, the new culture breaks with its tributary past (a break which gives it its progressive dimension and feeds its universalist ambition). But on the other, it reconstructs itself on mythical foundations, whose function is to blur the extent of the rupture with the past through an affirmation of a non-existent historical continuity. This false continuity constitutes the core of the Eurocentric dimension of capitalist culture, the very dimension which undermines its intended universalist scope. (1988: 3)

It is evident, therefore, that the dimension of capitalism that is Eurocentrism which 'undermines its intended universalist scope' is that which is being hege-monically re-worked, so as to facilitate the realisation of capitalism's universality. This is consistent with Bhabha's contention that

> the nation-space [is] in the process of the articulation of elements: where mean-ings may be partial because they are *in medias res*; and history may be half-made because it is in the process of being made; and the image of cultural authority may be caught, uncertainly, in the act of 'composing' its powerful image. (1993: 3)

In this sense, it can be said that the 'extension' of dominant discourses from crude nationalist and ethnocentric constructions into the 'ideological emancipa-tion' of multicultural interaction and acceptance postulated by globalisation stem from the complexities of the relationship between 'interest' and 'desire' – not only in the subject-specific terms as it was presented earlier by Silverman, but also in terms of the wider theory of ideology as examined by Spivak: as being 'a theory which is necessary for an understanding of interests', the adoption of which avoids the pitfalls and shortcomings of theorisations which reject it. As Spivak argues

> Because these philosophers seem obliged to reject all arguments naming the con-cept of ideology as only schematic rather than textual, they are equally obliged to produce a mechanically schematic opposition between interest and desire. (1988: 274)

So to propose that economic interest is a determinant of ideological desire, and to acknowledge the universal aims of capitalism, is to account for the generation of the environment within which this utterance exists. The expansion of capi-talism could be said to have moved beyond the imperialist forms of its recent past, entering into a stage of globalisation no longer dependent upon the fuel of nationalist discourses and ethnocentric mythology for momentum. Processes of homogenisation to a global scale, in terms of consumptive practices and ideals, have spawned mythological discourses of putative emancipation, which could be encapsulated in the epigraph: All consumers are equal in the eyes of the commodity. Of course, this is not to say that myths incorporating national and cultural alterity are inert, for they clearly still permeate as residues echoing earlier voices of hegemony, as well as persisting as political positions and equations, and codes to be 'played-off' with each other and newer codes, but the forms of the 'homogenising hegemony' do desire the decommissioning of some of these

outmoded codes and conventions of commonsense interpretation.

Is this then to enter a discourse of postnationality? Interethnic identification and cross-cultural affiliations do seem to be increasingly possible in a world that is networked and culturally fluid on the basis of postnationalist communications technologies. These are of course ultimately and intimately intertwined with the development and functioning of capitalism. But, they are not reducible to capitalism as such. To echo T. M. Kato's Kristevan and Irigarayan point that we encountered earlier, such new materialities can and will have unintended and far-reaching effects and consequences. Indeed, as Barthes wrote in the 1970s: 'the metaphor of the Text is that of *the network*. […] Hence no vital 'respect' is due to the Text: it can be *broken*…; it can be read without the guarantee of its father, the restitution of the inter-text paradoxically abolishing any legacy' (1977: 161). Barthes' theorisation of textuality still offers us a productive way to approach Bruce Lee, martial arts, film and culture, even when erstwhile forms and forces of articulation with politics seem drained of affect.

In 'From Work to Text', Barthes clarifies the effect of structuralist studies on our understanding of, in a sense, *everything*. Barthes' post-structuralism (it is *post*-structuralist because Barthes now sees all 'structures' as *open* and *de-centred*, and therefore susceptible to being opened, fractured, broken, and hence *changed*) makes the following observations and assertions. Firstly, language is not a 'tool' that we simply 'use'. Language 'makes' us. Second, language does not magically 'divide *itself* up', into literary and non-literary language. On the contrary, the division of language into literary and non-literary forms is the work of powerful institutions – and the very distinction between 'literature' and 'non-literature' has nothing to do with '*reading*', but rather with imposed cultural values ('tastes', 'cultured-ness' and so on), which have nothing to do with reading, but work to impose order through a kind of value-driven censorship. As part and parcel of this process, literature has become sacralised, fetishised, without us ever having really noticed its social functions of instituting hierarchies of power, domination and exclusion. But, he argues, the birth of the concept of the Text changes all this. He distinguishes between 'works' and 'texts': the 'work', thought of as a 'proper' literary object, is thought to *be what it is* because of the 'genius' of a particular 'Author'. However, this, he argues, ignores language. All works are actually produced *by* language, and are therefore texts – fabrics, woven from citations. 'The Author' is something of a fantasy used to *stabilise* meanings by the dominant interpretive institutions (such as the university). Indeed, for Barthes, society is governed by institutions that control – produce, police, and regulate – meanings, and hence, practices and people, in diverse ways. But the Text is a force of political and cultural change. This is primarily because, argues Barthes, 'a certain

change has taken place (or is taking place) in our conception of language' (1977: 157). But its consequences extend beyond the concerns of the English Literature Department, and right into the realms of culture.

Nevertheless, the notion and the ramifications of textuality are a matter of reading and interpretation. Barthes contrasts the text to the earlier notion of 'the work'. As he argues, 'the work is a fragment of substance, occupying a part of the space of books (in a library for example)', whereas 'the Text is a methodological field' (ibid.). This he calls an 'opposition' – a distinction – in which 'the one is displayed' (ie, the work is a 'thing'), whilst the other, the text, is only something to be 'demonstrated' (ie, the Text is a process): 'the work can be held in the hand, the text is held in language'. Crucially, argues Barthes, '*the Text is experienced only in an activity of production*' (ibid.). In other words, you cannot simply 'see' Texts. You can see 'books' or 'works'. *Textuality* is a mode of reading – based on an acknowledgement that meaning is produced just as much, if not more, by the act of reading, than it is by the 'author's' act of writing. Indeed, 'the Text is not to be thought of as an object that can be computed' (1977: 156), insists Barthes. If texts are produced by language, then you cannot delimit what they mean or say; the 'writer' or 'producer' may have had intentions, but they cannot be 'known', nor do they have any relationship to the possible meanings that can be produced on 'reading'. The Text is infinitely polysemous. 'The Text is plural' writes Barthes, because 'the text is a tissue, a woven fabric' (1977: 159). The text is 'woven entirely of citations, references, echoes, cultural languages'. Moreover, 'the citations which go to make up a text are anonymous, untraceable, and yet *already read*: they are quotations without inverted commas' (1977: 160).

Although this influential argument is rightly familiar to those within literary, film and cultural studies, its pertinence for the study of Bruce Lee or martial arts culture *per se* has yet to be stated, let alone fully elaborated. But put bluntly, Bruce Lee has always been approached as work, as a work, as a worker with a work to do, and so on. However, says Barthes, 'the work closes on a signified. [...] The Text, on the contrary, practices the infinite deferment of the signified' (1977: 158). To approach Bruce Lee as Text is to allow for the re-opening of Bruce Lee: Bruce Lee re-opened, reloaded, recharged, precisely because no longer regarded from a position which valourises the original moment of emergence or of task, responsibility or labour. 'The reader of the Text may be compared to someone at a loose end (someone slackened off from any imaginary)' (1977: 159), writes Barthes. Such a reader of Bruce Lee must be prepared to avoid the temptations of utopianism, urgency, politicised 'realism', and so on; prepared instead to allow 'the *infinity* of the signifier' (1977: 158), prepared in other words, to let the signifiers '*play*'.

In other words, then, to study Bruce Lee, to do justice to the impact, influences and effects of Bruce Lee, one must forget Bruce Lee. Forget the protestant eth(n) ic, the intentions, the aspirations; and accept the chaotic dissemination of a truly unique intervention into myriad realms and contexts. Bruce Lee cannot simply be regarded as 'author', authority, origin and measure of the cultural legacies of Bruce Lee. Of course, as Barthes writes, 'It is not that the Author may not "come back" in the Text, in his text, but he then does so as a "guest". If he is a novelist, he is inscribed in the novel like one of his characters'. How can 'the author' be the origin of the meaning of the text? Yes, he or she may have an 'intention', but how can we 'receive' it? Historical or biographical research into their life is itself only the production of yet more texts. If you have an 'archive', you still have to interpret it, decode, translate, guess, add, infer. Your interpretation cannot be 'final' or 'decisive'. Indeed, this whole course of action is skewed from the outset by the fetishization of 'authorial intention', the fetishization of 'Man' as origin and controller of life, meaning, and destiny. The facts are, as it were, under your nose: it is language that produces us, and not the other way around:

> his life is no longer the origin of his fictions but a fiction contributing to his work....
> The word 'bio-graphy' re-acquires a strong, etymological sense, at the same time
> as the sincerity of the enunciation ... becomes a false problem: the I which writes
> the text, it too, is never more than a paper-*I*. (1977: 161)

The same may be said of the celluloid-I, and of the films we consume. But do we all always 'consume' Bruce Lee? According to Barthes, it is 'the work' that 'is normally the object of consumption'. That is to say, we 'consume' works when we read them as 'works'. They are commodities. However, in Barthes' schema, we 'produce' texts when we read things as texts. This is, in a sense, the first stage of a kind of empowerment. For, not passively consuming, but rather approaching texts as Text, argues Barthes, 'requires that one try to abolish the distance between writing and reading'. The traditional notion of 'reading' is one of passivity. The textual notion of reading is one of activity, of production. Thus, reading is itself a kind of writing – or re-writing: '*reading*, in the sense of consuming, is far from *playing* with the text. [...] the text itself *plays* (like a machine with 'play') and the reader plays twice over'. Hence, Barthes proposes 'a final approach to the Text, that of pleasure': 'As for the Text, it is bound to *jouissance*, that is to a pleasure without separation' (1977: 164). And this is doubtless the most enduring and perhaps important force in the cultural legacies of Bruce Lee: the production of a pleasure without separation.

notes

1 See Foucault: 'in any society, there are manifold relations of power which permeate, characterize and constitute the social body, and these relations of power cannot themselves be established, consolidated nor implemented without the production, accumulation, circulation and functioning of a discourse. There can be no possible exercise of power without a certain economy of discourses of truth which operates through and on the basis of this association. We are subjected to the production of truth through power and we cannot exercise power except through the production of truth' (1988: 93).

2 Silverman notes: 'When the child internalizes the image of the parent of the same sex at the end of the Oedipal crisis, it compounds mis-recognition upon mis-recognition. The result is a brutalizing sense of inadequacy both for the male and female subjects – for the former because he can never be equivalent to the symbolic position with which he identifies, and for the latter because she is denied even an identification with that position' (1983: 191).

3 *The Karate Kid*, as a fiction, utilises a process whereby the effect of closure can be affected: as the cinematic text is a process reliant upon writing, so the film is 'written', and, 'To write is indeed the only way of keeping or recapturing speech, since speech denies itself as it gives itself' (Derrida 1974: 142). Through this economy, the situation of Danny Laruso avoids the full realisation of the paradoxes integral to the desire for presence.

chapter six
SPECTRES OF BRUCE LEE

BRUCE LEE THEN AND NOW

As we have seen, in the 1970s, Bruce Lee was the very symbol of postcolonial, diasporic multicultural energy (see Miller 2000; Prashad 2001; Kato 2007); the embodiment of what Rey Chow has called 'the protestant ethnic' (see Chow 2002; Nitta 2010). However, as we have also seen, in the book *From Tiananmen to Times Square* (2006), Gina Marchetti considers the waning of the affect of the socio-political charge of the image and politics of Bruce Lee in America. That is, although in the 1970s, Bruce Lee was this symbol of postcolonial, diasporic, multicultural 'protestant ethnicity', by the 1990s, the passions and problematics associated with diasporic Asian ethnicity had somewhat changed in status, form and content.

In fact, argues Marchetti, in the 1990s Hollywood films which sought to replay and canonise Bruce Lee's energies – specifically 1992's knowingly intertextual *Rapid Fire* (starring Bruce Lee's son, Brandon), and 1993's biopic, *Dragon: The Bruce Lee Story* – the spirit of protest and radicality associated with Bruce Lee seems to have not only ossified and wizened but also to have actually atrophied and regressed: to have moved away from *politicised* protest against social injustice and to have collapsed into little more than juvenile Oedipal anger. In other

Figure 16: Donnie Yen as Chen Zhen in 2010 in Bruce Lee's 'Kato Mask' from the 1960s

words, Marchetti suggests, in America, in Hollywood, in the West, Bruce Lee (and everything for which he may once have stood) has had his day: the biopic *Dragon* situates Hollywood's racism firmly in the past, rendering it as something that Bruce Lee 'broke through' and 'overcame'; and *Rapid Fire*, which constructs Brandon as Bruce Lee's contemporary 'heir', fails to articulate a single coherent social, cultural, political or ideological 'problem' or 'issue' against which to protest. In true Hollywood style, *Rapid Fire* absorbs the potentially-political into the familiarly Oedipal. And the problem with the Oedipal is that it is such a strongly repetitive structure, one that is ultimately organised by reconciliation rather than radical transformation. So, taken as an heir to Bruce Lee's cultural legacies, *Rapid Fire* is something of a disappointment.

Perhaps this should come as no surprise. After all, *Rapid Fire* is ultimately little more than an easy-viewing, formulaic low-budget action flick. Perhaps it should not be expected to shoulder the 'non-white-man's burden', or be taken to exemplify anything more profound about culture and society than the fact that it is not really a very good film. But at the same time, we must remember: *Bruce Lee films too* are, by the same token, or by any conventional measure, not really very good films either! *And yet*, Bruce Lee films are so much more than so many other generically or formally similar films.

What is this 'so much more'? A claim of 'something more' ought not to be heard as a claim that Bruce Lee films themselves *are not* Oedipal, formulaic or simplistic. They are indeed. There is much that is irreducibly juvenile about them

and about very many – perhaps the majority of – martial arts films. And I say this in full awareness of the likelihood I might be accused of 'Orientalism' or even 'racism' – as if by pointing out the silliness and childishness of many martial arts films I am thereby reducing the Asian Other to a state of simplicity, childishness, innocence or even savagery. But, really, I am not being racist or ethnocentric. My prejudice is directed rather towards action film genres, formulas and narratives as such. It is these that are Oedipal and simplistic, and not some hypothesised (essentialised) and supposedly 'pure' and 'purely other' ethnic subject or some-how simply 'non-Western' film industry. (We ought to know enough about the international traffic in ideas, techniques, technologies and discourses to avoid this kind of thinking.) So, to clarify: it is because of the codes and formulas of action cinema that both Bruce Lee films and Brandon Lee films as well as many other martial arts and action films besides might be regarded as essen-tially 'shabby'. *But* the important point is that *despite* all of this – and *shining through* all of this – Bruce Lee films contained or encoded in condensed and displaced form several interlocking socio-political antagonisms: antagonisms of class and ethnicity, of coloniality and exploitation, of marginality and hegemony, centre and periphery, and, crucially perhaps, nation and belonging, or nation and longing. It is the destiny of some of these discourses that I want to consider in what follows.

BRUCE LEE HERE AND THERE

The story of Lee's explosion onto cinema screens all over the world, to a truly unprecedented extent, is well known (see Miller 2000; Hunt 2003). Similarly, the story of his image's role in the forging of inter-ethnic identifications, multicultural hybridisations and anti-racist and civil rights energies has been quite widely docu-mented too (see Brown 1997; Prashad 2001). But that was then, and, according to Marchetti, as the eviscerated and gestural (non-)politics of films like Brandon Lee's *Rapid Fire* demonstrate, by the 1990s, Bruce Lee was no longer quite what once he had been. This is because the cultural political landscape had moved on or settled down to such an extent that Bruce Lee no longer performed the same social and semiotic cultural functions, or fed the same fire – as the symbol of not only the outsider and underdog, but also the migrant, the worker, the exploited, the colonised, the oppressed, the victim of racism, the protesting ethnic, and of course (as everyone knows who knows anything about Bruce Lee's martial arts), the interdisciplinary postmodernist multiculturalist innovator and radicaliser of martial arts in the West. By the 1990s, Bruce Lee was well and truly a familiar

part of Western culture (an *institution*), and no longer part of Western cultural politics (as a metaphor or symbol of disruptive 'outside' force).

At the same time, the story of Bruce Lee's relation to first Hong Kong and subsequently to Chinese culture and politics, however, is something different. In saying this, I mean Chinese in the sense of the nation state rather than Chinese in the sense of ethnic Chinese. Bruce Lee as ethnic Chinese – and indeed Hong Kong culture as strongly ethnically Chinese – is one set of matters. But Bruce Lee (and, as we will see, Hong Kong) *vis-à-vis* or *within* the geopolitical entity and borders of China itself is another. And again, as very many theorists and analysts of culture have observed, Hong Kong itself has always had a complex double and also paradoxically vanishing status; functioning both as a complex node and articulator of so-called East and so-called West whilst also, to borrow the phrase of Ackbar Abbas (1997), functioning perversely and paradoxically in a mode of disappearance. For, insofar as Hong Kong has long been simultaneously constructed as 'other' of (or other than) both China and Britain (and by extension, the rest of Asia, Eurasia, Europe and America), Hong Kong has always been problematically liminal (see Chow 1998). To recall the Mafioso formula that is revealed to be spurious in the film *Old Boy* (2003) (namely, 'my enemy's enemy is my friend'), we might observe that, as other of East and other of West, the other of my other is in no way guaranteed to be my 'same'. The enemy of my enemy is not necessarily my friend; the other of my other is not necessarily my same. And this, as so many thinkers have pointed out, is the situation of Hong Kong *vis-à-vis* China and the West and the rest.

This is why, even if Bruce Lee immediately constituted a clear semiotic paradigm of 'China' and of 'Chineseness' in the West, he never (simply) did in China or Hong Kong, despite the overwhelming box office success of the films all over Asia. Furthermore, various commentators have noted that even though Bruce Lee choreographies had an immediate, dramatic and lasting effect on Western films, the immediate effects of Bruce Lee films on the Hong Kong film industry were either slight or difficult to perceive at all, for quite some time (George Tan quoted in Miller 2000: 156). Indeed, we might also observe, even today, despite the prominent and popular statue of Bruce Lee on Hong Kong's Kowloon waterfront (or his waxwork outside of the Madame Tussaud's Waxwork Museum that takes its place among the complex of restaurants and shops at the top of Hong Kong's other primary tourist destination, the viewing area at Victoria Peak), there is actually astonishingly little in the way of a Bruce Lee tourist or cultural industry in Hong Kong. It seems very much as if, in Hong Kong, Bruce Lee is regarded as something for the tourists – or even, as if Bruce Lee is regarded by Hong Kongers as being about as much a Hong Konger as Hong Kong Disneyland.

BRUCE LEE, LOCAL FOREIGNER

Nevertheless, Bruce Lee is there; and perhaps not unlike Disneyland, he is once again moving from the liminal to the centre. But this time, Lee is performing a very different kind of decentring and recentring work. For, more recently, Bruce Lee has been deliberately and unequivocally picked up and deployed ideologically by mainstream arms of the Chinese state in a number of different ways. Most notable perhaps is the way that in the run up to the Beijing Olympics, Chinese TV initiated a major and now extremely long-running TV series about the life of this uniquely Sino-American superstar.

The ideological dimension and motivation of the Chinese state appropriation and recasting of Bruce Lee (as one of China's beloved prodigal sons) perhaps goes without saying. It is a moment in a process that can be linked to the Chinese state's growing inclination to open its borders to filmmakers, on the tacit proviso that China 'itself' be depicted as visually stunning and geopolitically coherent. Such are the implications of John Eperjesi's (2004) analysis. Eperjesi has called this a new form of 'cultural diplomacy' – the rebranding and marketing of 'China itself', via the landscape, as a kind of 'other Eden'. According to Eperjesi, the 'cultural diplomacy' of the invention of a newly visualised or visualisable China was the successor to 'ping pong diplomacy'. Chinese cultural diplomacy – the re-presenting (the re-branding) of China by way of the deployment of its landscapes as visually stunning – can be marked out on a line that runs at least from *The Last Emperor* (1987) to the recent remake of *The Karate Kid* (2010) – a film which depicts China in a way that could not easily have been touched up further had it been conceived by a state apparatchik in charge of boosting tourism. (Admittedly, the film is not Orientalist through and through, but the major dose of Orientalism we are given in the protagonists' pilgrimage to a hyperreal Taoist monastery in a hyperreal version of the already hyperreal tourist and HSBC-advert destination of Guilin is second to none.)

So Bruce Lee is being redeployed in this straightforwardly ideological rebranding of the public image of China. And this is hardly surprising. But at the same time, Bruce Lee is being rather differently reworked by the Hong Kong film industry too, and on a different sort of level.

BRUCE LEE'S RETURN TO/OF HONG KONG

Much was written about Hong Kong identity in the run up to the 1997 handover of Hong Kong from British rule to Chinese rule. Much of this focused on the

understandable anxieties that arose in the face of the prospect of the ultra-capitalist 'jewel in the Orient' being handed over to the last communist superpower on Earth. If the self-writing of Hong Kong in the run up to 1997 was characterised by anxiety, then the situation of the next few years was perhaps a little like the way many felt when, filled with fear and trepidation, and holding our breath or crossing our fingers, we all tentatively turned on our computers in the morning or afternoon of the New Year's (and new millennium's) Day of January 1st 2000 AD. Was the computer going to work? Would the 'Millennium Bug' have destroyed it? Was the sky going to fall on our heads? Press the button... So far so good... It seems to be working like normal... Phew!

After a decade of Hong Kong cautiously exhaling, nervously relaxing and feeling around for signs of pain or injury, some who had left before 1997 started to return. These included a strangely familiar figure, behind a rather flimsy disguise. It was of course Bruce Lee, but not exactly. For this time, Bruce Lee was not *actually* Bruce Lee. Nor did he take the form of a character originating in Hong Kong (or even the *mainland* China of the Hong Kong peninsula) and travelling to and from America, or to and from Italy or to and from mysterious Fu Manchu-esque island fortresses. This time Bruce Lee was always not only a mainlander but a Chinese subject and a fervent patriot, travelling to and from the mainland and Hong Kong, the mainland and Europe. In this return, sometimes Bruce Lee was Ip Man – a mythologised version of Bruce Lee's real *sifu* (or *sigong*), the teacher (or, more correctly, Lee's teachers' teacher). At other times Bruce Lee was Chen Zhen – the Chinese nationalist of popular fantasy immortalised by Bruce Lee in *Fist of Fury*. Virtually every time, Bruce Lee was played by Donnie Yen. And each time, the return of the spirit of Bruce Lee saw also the rather surprising reciprocal return of Japan, playing the role of the terrible imperial enemy.

All of these films are haunted by Bruce Lee. They are *structured* by Bruce Lee, who operates as what film theorists used to call an 'absent presence' (or a 'present absence'). They are in a sense *induced* by Bruce Lee. The first *Ip Man* film came out in 2008, starring Donnie Yen. This film was reputedly both in a race with another similar film, focusing on the same subject matter, and also in a dispute about which of these films could claim the *Ip Man* title; because Wong Kar-Wei was at the same time also developing a film focusing on the character of Ip Man. However, the latter's film became mired in production problems and has not appeared yet. But there could have been both an *Ip Man* and another film about Ip Man appearing in the same year. *The Legend is Born: Ip Man* and *Ip Man 2* both appeared in 2010; the former focusing on the early life of Ip Man; the latter on his later life. In the same year, *Legend of the Fist: The Return of Chen Zhen* also came out. In this film, the Chen Zhen who was apparently shot and killed at

the end of Bruce Lee's 1972 *Fist of Fury* turns out not to have died after all, but to have gone into hiding and to have gone off to fight along with other Chinese in a subservient role in the trenches and front lines of World War I in France. This time Chen Zhen returns to Shanghai and becomes a semi-superhero crime-fighter, bizarrely wearing the Kato mask and uniform that Bruce Lee's character (Kato) wore on the US TV show *The Green Hornet*.

So, most of these 'returns' star Donnie Yen. But this is more than a good couple of years' work for Donnie Yen. What is more significant is the extent to which all of the characters and all of the films are irreducibly entangled with, indebted to, constituted by, and structured through Bruce Lee, in condensed and displaced form. The question is why, or what this might be signifying or doing?

In the first *Ip Man* film, Bruce Lee is not literally present until the end. And when I say 'literally' I mean literally in words: for it is only at the very end of the film, after Ip Man has defeated the Japanese martial arts expert General, publicly and decisively, and then been shot and had to flee, that words appear on the screen to tell us that Ip Man fled to Hong Kong whereupon he returned to martial arts teaching, training thousands of students including (drum roll, dramatic pause) Bruce Lee. End of film. Of course, this means that all of this Ip Man stuff was but a prelude or subplot to the real news, the real story: Bruce Lee – with Ip Man standing to Lee as a kind of John the Baptist to Jesus.

As such, Bruce Lee has been presiding over the film, for quite some time – from *before* the beginning. For, from the outset – from *before* the outset – as you all now know we will come to learn in the big reveal about Bruce Lee at the very end, those in the know will already have known that the single, solitary reason why *anyone* outside of Hong Kong knows *anything* at all about Ip Man is *exclusively* because of the international filmic success of Bruce Lee. This filmic success led to the popularity of the martial art that Bruce Lee studied as a teenager – wing chun. And (it is important to note) it is not the other way around: The post-Bruce Lee popularity of wing chun was regarded with no little dismay by Western martial arts scholars and historians such as Don Draeger and Robert Smith (see, for example, Smith 1999), who could not comprehend the new power of cinema and celebrity to transform the status of one minor Chinese martial arts style among many derived from Shaolin White Crane into something internationally regarded as a definitive or superior fighting art. Many Hong Kong and Chinese martial arts traditionalists do not even regard wing chun as a 'proper' martial art at all – because, for one thing, it is not old enough, and for another, again, its popularity derives from Bruce Lee movies.

Without wishing to disparage wing chun at all, it nevertheless seems fair to say that such historians as Draeger and Smith had a point, even if they vented

their spleen about Bruce Lee and wing chun rather than about the formidable power of the cinematic apparatus over cultural practices, cultural memory and the cultural writing and rewriting of history and mythology. For, as we see clearly through films like *Ip Man*, history can be dramatically reconstituted. The cart very often gets put before the horse. For what is asserted by the film, which rewrites Ip Man's life, is that Ip Man ought to be remembered as a patriotic Chinese hero, rather than a martial arts instructor, one of whose student's students happened to become immensely famous. The film also proposes that Ip Man *only* chooses to leave China for Hong Kong in order to escape *Japanese* occupation and persecution. None of this is strictly speaking the case.

Now, I do not want to undertake a process of nit-picking about the factual correctness or fictional fabulousness of any of these films. Nevertheless, one crucial historical detail deserves note. The real Ip Man left China to escape not the Japanese during the Sino-Japanese War, but rather to escape the new Communist regime of mainland China. Yet, in all of these films, it is overwhelmingly Japan that is used to play the evil empire. Communist China is thereby screened off, concealed from view, and hence from comment of any kind. Lacanians might call this foreclosure. It is certainly a different sort of structuring absence or absent presence to the traces of Bruce Lee that are perceptible within the fabric of the film texts themselves. But Bruce Lee is still its bearer. This can be seen in the recurrence of what I will call the Dojo Fight Scene.

THE ETERNAL RETURN OF THE DOJO

In 1972's *Fist of Fury*, the Chinese Jing Wu kung fu kwoon in the Japanese controlled zone of the international settlement in Shanghai in the early 1900s is targeted by a Japanese martial arts institution. As it turns out, the Chinese master, Huo Yuanjia, has been poisoned by Japanese impostors working as cooks in the Chinese school. This is evidently because the Chinese master is so skilful a martial artist that the Japanese felt threatened. As befits the basic aesthetic of celluloid treachery, the leader of the Japanese martial artists sends a delegation to Huo Yuanjia's funeral, bearing the offensive gift of a framed scroll which reads 'dōng yà bìng fū': 'Sick Man of Asia'. This is of course at least doubly offensive: for not only did the Japanese poison the Chinese man because of his superior martial skill, but also because, since the onset of European colonialism and Japanese imperialism (not to mention the British-induced introduction of large scale opium use in China), the characterisation of China itself as the sick 'man' of Asia had grown into a common stereotype – perhaps at its peak in the colonial period

of the film's setting, but no less current during the era of the film's release. So the slur works excellently on several levels, having several interlocking levels of offensiveness: national geopolitical weakness, corruption of the body politic, masculine weakness, and drug-addled weakness being the key coordinates. In this film it has the added twist of being uttered by the very people who have poisoned and weakened both the Chinese man and the Chinese nation itself. So we can see, straight away, when Bruce Lee returns the spiteful and twisted letter to its sender in the form of his visit to the Japanese dojo and his defeat of every single one of the students and teachers there, why this scene of dramatic retribution would have a very strong – overdetermined – affective charge.

The choreography here – as in all Bruce Lee fight scenes – is magnificent. Second to none, I would argue, even to this day. But the power, memorability, and intense emotional and affective charge of the scene would not have been so strong were it not that it comes in response to the 'Sick Man of Asia' provocation, which, as just mentioned, activates decades upon decades of national and diasporic ethnic Chinese hurt. (Moreover, the catharsis provided by Bruce Lee's victory for many viewers has evidently been matched, in Japan, by a kind of cultural repudiation, disavowal or repression. For, despite its immense global success, *Fist of Fury* has never been screened on terrestrial Japanese television.[1])

This overdetermination is doubtless why the scene returns so frequently in Hong Kong martial arts film. It is so good, in fact, that it returns even within *Fist of Fury* itself. In the first dojo fight scene, at the start, in response to the stinging cultural insult, Lee humiliates and hurts the Japanese martial artists. But in his subsequent return, after he has learnt the full extent of the Japanese institution's murderousness, he pulls no punches, takes no prisoners, and kills everyone who stands in his way. The scene returns again in Jet Li's *Fist of Legend*; unsurprisingly, as this is a direct remake of the Bruce Lee film. And it also returns – *as a return* – in *Legend of the Fist: The Return of Chen Zhen*, with Chen Zhen returning, after his return as if from the grave, to fight the son and heir of the Japanese master he killed the first time around.

This latter scene is not so powerful or memorable because the affective provocation is less 'condensed' or 'efficient' in *Legend of the Fist* than in *Fist of Fury*, at the same time as the choreography is not up to par either. This iteration is a shadow of its former self – an echo; more like a dream sequence. Within *Legend of the Fist*, Chen Zhen has had various 'flashbacks' to his first fights there in the dojo (actually, the flashbacks are to Jet Li's Chen Zhen in *Fist of Legend*: this is because *Legend of the Fist* was directed by the same person as the Jet Li film),[2] and in this scene we are reminded of his reasons for showing no mercy to his opponents in a flashback run-through of every one of his friends who have

been killed by the Japanese. Meanwhile the hordes of Japanese karateka bumble towards him with bokken held clumsily in the air rather than battering him down, either through skill or through the sheer weight of numbers and the extended reach that a wooden training sword would afford anyone. Moreover, it is only in this final fight scene that Donnie Yen is directed to try to imitate Bruce Lee 'fully'; and this is a pity. For despite Yen's own magnificence, his attempts to execute Bruce Lee 'catcalls' and Bruce Lee gestures and postures seem half-hearted, tagged on, and in any case unconvincing – indeed, they ultimately merely remind us that Bruce Lee is not actually here and we are being subjected to a cover version performed by a tribute act.

However, in the first *Ip Man* film (not the subsequent prequel), this spectre of Bruce Lee retains or regains something of its 1972 power. One reason for this is surely that, being ostensibly about Ip Man and putatively *not* about Bruce Lee, no actor has to try to imitate the inimitable and fail to measure up. This enables the film to combine the same 'affective' ingredients into the build-up to the dojo scene. Thus, the film gives us: an awful social situation of Japanese occupation, suspicions of Japanese iniquity, and the grotesquely unjust murder of an honourable Chinese martial artist. Thus it is with some palpable, visceral, and readily intelligible rage, that Donnie Yen's Ip Man enters another Japanese dojo, and the camera slides up and back to resume the angle and viewing position it has preferred throughout many of the earlier versions of this set-piece – offset and up and back at an angle of around 30 degrees. Close in for the close up of the clenching of the fist of fury; up and back and away for the bird's eye view of the fighting.

THE RETURN TO/OF CHINA

Thus, the connections I am making between Bruce Lee and these later films is based in the identifications produced by the viewing position constructed by the camera, first of all, as much as the formal features, tokens and traces of the scenes being viewed. The camera behaves in the same sorts of ways, producing the same sorts of views (or 'visibilities') and effects. And of course, this is not culturally specific. Many films use these angles and these set ups. But switching focus from the question of what is viewed to what enables the viewing and constructs the field of visibility and, by extension, intelligibility can be, shall we say, illuminating.

In the case of this recent wave of Hong Kong martial arts films, the legacies of Bruce Lee, in spectral and condensed and displaced forms, are again becoming

apparent. And although films are essentially only ever really 'about' films, I think that it is nevertheless clear that this wave signals a new wave in Hong Kong's self-writing. In this new chapter, Hong Kong is redrawn – less as the 'inter-zone' that it once was (an unclear space of neither/nor and/or both/and) and more the *supplement*, the graft, the transplant, the prosthesis and opening of China. The *actual* recent history of the geopolitical entity of China is ignored. Time is frozen in either the tensions and animosities of the Sino-Japanese war or of Hong Kong's pre-1997 'crown colony' status *vis-à-vis* Britain. Japan is viewed as scourge and menace; Britain with some palpable nostalgia and affection; China with love and pride…

As theorists of Hong Kong and postcoloniality have pointed out, nostalgic patriotic longing for an absent motherland is one thing: it allows one to romanti-cise. Facing the prospect of getting what one claimed to have wished for is quite another. In becoming Chinese, Hong Kong would seem to need to reconcile the capitalist and the communist ideologies it now straddles. At the same time, the stakes of criticising China become higher. This is surely why China only functions as the land, the family, the values and the folk. The evil militarised empire that drives people away from the beloved land and community is played by Japan. Driven away from home by the military tyranny, China's finest and most noble are embodied in the purity projected onto Ip Man and Chen Zhen, in a mythic rewriting of history.

Ip Man is a (or the) figure of History here. Chen Zhen is a (or the) figure of Myth. Bruce Lee is the constitutive element uniting both of these figures – absent, but implied. Were it not for Bruce Lee, neither would be gracing our screens now. Neither would be being used in Hong Kong films. Thus, in these films, we are witnessing one way that contemporary Hong Kong film is engaging-with *without* engaging-with-directly and talking-about without talking-about-explicitly, the potentially fraught cultural grafting and relation of reciprocal supplementarity that now exists between China and Hong Kong. The unspoken or unspeakable ele-ment (or 'elephant in the room') of Communist China is displaced onto Japan; and Ip Man and the return of Chen Zhen are the 're'-patriation of Bruce Lee, a 're'-patriation (for the first time) that is intimately intertwined with the repatriation (as if for the first time) of Hong Kong, rewriting itself, cinematically.

notes

1 My thanks to Keiko Nitta for this information.
2 My thanks to my student Vanessa Chan for pointing this out.

chapter seven

RE-ENTER THE DRAGON, BEYOND BRUCE LEE

ENTER THE DISCOURSE

In 1973, *Enter the Dragon* was released. In many respects, this East/West co-production was very familiar: it was, after all, just another cheesy, formulaic action flick, essentially repeating a James Bond format. However, one thing about it was different: Bruce Lee. Indeed, so different was Lee that this formulaic film changed things. Its effects were transformative. It was *an event*. And with the word 'event', as shown in earlier chapters, I mean to evoke all of the resonances and associations that both Badiou and Rancière attribute to 'events'. Of course, as a *cinematic* event, this complex technological simulacrum of a text cannot be located in or limited to merely one of the four measly regions that Badiou thinks an event has to be located in or limited to in order to be an event. Yet an event it was: aesthetic, at least; political, immanently. But, of course, as cinematic simulation, although it masqueraded as a putatively 'Eastern' graft into or onto Western popular culture and consciousness, the film was a 'simulacral event', but one that *nevertheless* founded a new discourse, a new set of discourses, a new field of discursivity. As a founder of discursivity, *Enter the Dragon* spearheaded the widespread introduction of a whole family of new terms into Western – indeed global – popular culture (martial arts, karate-do, 'black belt', kung fu, Shaolin Temple, Shaolin Monk) and a whole new set of connections and

associations (Zen and pugilism, Buddhism and battle, meditation and martial arts, fighting warrior monks). Into Western popular consciousness it punched a paradigm, a whole new aesthetic vocabulary, a whole new perceptual-aesthetic field, a reconfiguration of what Jacques Rancière has repeatedly termed the partition of the sensible/perceptible.

It completed the countercultural fascination with the 'mystical East', and it *supplemented* it – it *sublated* it – reconfiguring and superseding it. Rising out from the mush of mystical mumbo-jumbo circulating in Western discourses about the soft, feminine Eastern Other arose many things: new embodied, philosophico-haptic, kinetic, perceptual and aesthetic performative practices; new interests in the East; new asiaphilias, projections and self-Orientalisations; plus nothing short of a whole new mode of masculinity: not the hulking hero, the cowboy gunslinger, the bar-room brawler, or the cop, spy or soldier, but now the invincible martial artist monk, created through hard work, self-discipline and the means of correct training; new mindsets, new bodysets, and whole new sets of fantasies about self and other; about the very intimate and the very far; about new aims and possibilities; new fantasies about the very old and very other brought very near and very new. *Enter the Dragon* was an event. Not an isolated event, but the pinnacle of a series of interventions.

As we have seen, studies have often focused on explaining the unexpectedly intense and immense appeal of Hong Kong martial arts films among poor black and Hispanic audiences in American inner cities and elsewhere around the world. This encounter was contingent: caused by the fact that Hong Kong films were cheap to show, so the poorer cinemas in poorer areas could afford to show them. Moreover, from 1967, the Hong Kong film industry had been deliberately seeking to break the US market. But the consequences of this contingent encounter were profound. Thinkers from Charles Johnson to Bill Brown to Gina Marchetti have dealt with it at length. With much more blasé brevity, we should recall, Slavoj Žižek has also proposed that the first reason for the strong appeal of martial arts films in ghettos the world over was initially class-based. Those who have nothing, writes Žižek, have only their bodies, only their discipline, only their desire. And 'class' is of course easily transcoded into the terms and registers of ethnicity, and vice versa. Moreover, Bruce Lee exploded into popularity across Asia, India, Europe, the US, the Soviet Union – everywhere. Vijay Prashad (2001) recalls that Lee politicised consciousness in India – the small yellow man beating big whitey. T. M. Kato (2007) argues that Lee offered an anti-colonial and decolonising aesthetic, an antidote to the stifling situation in which Africans watching Tarzan would cheer *for* Tarzan and against the caricatured African tribesmen. Bill Brown (1997) argues that it was Lee's 'generic ethnicity' that sparked, fuelled and

oiled his massive popularity and enduring significance. However, over time, write both Žižek and Bill Brown, immanent class antagonism became existentialised: martial arts became about self-actualisation, about realising self-potential, about uncovering existential paradoxes (about meditative or pacifist martial arts) – or, that is, depoliticised on one level and ideologised on another.

Enter the Dragon was the exploding of all of this into the mainstream. This pinnacle was clearly in some contexts a depoliticisation. In others it was an outright affront: Hong Kong audiences reputedly hated *Enter the Dragon*, because in it Bruce Lee plays not a rural mainland Chinese working class boy, but a Western projection of a fantasy of a Shaolin Monk, an inscrutable Chinese working obediently for the British Secret Service. Moreover, the cross-ethnic identification and hybridisation associated with martial arts spectatorship is separated out and sanitised in *Enter the Dragon*: all of the cultural entities and identities that could be infected and intermixed through martial arts fantasy and practice become compartmentalised again into stock figures: the lead role of the film is split three ways, into the white ersatz Bond (John Saxon), the black inner city karateka (Jim Kelly) and the pure 'good' Chinese (Bruce Lee), all facing the entirely evil Fu Manchu character, 'Han'. So, in this highest pinnacle of the kung fu craze of the early 70s can be seen a depoliticisation, cooptation, domestication or hegemonisation. This was completed, argues Bill Brown, in the song 'Everybody was Kung Fu Fighting', which rendered twee, eccentric and comic certain counterhegemonic cultural impulses via the cultural cross-dressing of the performer and the quirkiness of the musical Chinese clichés incorporated into the disco beat.

DRAGON ENTERING

So, if the Dragon had now entered, if East Asia had arrived, right into the heart of Western – indeed, global – popular consciousness and popular culture, it had arrived as a simulacrum, a precession of simulacra, a spectacle of stereotypes. The explosion of popular cross-cultural or East-West popular cultural communication of the 1970s was initiated, initialised, orientated and organised by a kind of circuit exchange of simulacra.[1] If this is a kind of cultural communication, it has annoyed and even enraged all manner of scholars and purists. This is because it is at best a kind of 'double communication' rather than two-way communication. 'Two-way communication' implies the face-to-face co-presence of two intending consciousnesses. But what we see in cultural communication like this is a process without a subject (without, at least, a simple, single, unitary or unified subject).

According to theorists like Fredric Jameson and Rey Chow, the 'face-to-face' of cross-cultural communication always involves the play of the cross-border distribution and circulation of stereotypes and the trade in tokens; stereotypes and tokens that overdetermine in advance the structure of cross-cultural encounters.[2] Or, as Bill Brown has more generously formulated this: all of the interethnic identification and cultural mobility associated with early Western martial arts culture was premised and predicated on the collaboration of the Hong Kong and Hollywood film industries.

GO WEST

But this collaboration can hardly be said to be one of equal partners – at least not *culturally*, not *narratively*, not *discursively* (in terms of the *kinds* of texts produced), regardless of the financial figures involved. These films may easily seem, in Chow's words, to be "equally caught up in the generalized atmosphere of unequal power distribution and [to be] actively (re)producing *within themselves* the structures of domination and hierarchy that are as typical of non-European cultural histories as they are of European imperialism" (1995: 194). This is why many have argued that, cinematically, at least, the circuit of communication in which martial arts have circulated has been a one way appropriative street; or rather, a 2nd class return ticket. For, what has overwhelmingly happened is that the Western man goes or has been East, and brings back or has brought back or masters or will master something or someone from the East to the West. This is often kung fu or karate; or a woman; or both. One need only think of the cinematic legacies of Chuck Norris, Steven Seagal, or Jean Claude Van Damme, or the appropriative logic of texts like *Gold Finger* (1964), *Dr No* (1962), *Bullet Proof Monk* (2003), *The Last Samurai*, *The Matrix*, *Buffy the Vampire Slayer* or *Kill Bill* to see this. Similarly, male Asian actors all seem to share a similar narrative: massively successful in different regional film industries (especially Hong Kong) but consistently unable to play anything other than chop-socky characters in Western (especially Hollywood) productions.

The UK Jet Li film *Unleashed* (aka *Danny the Dog*) provides a good allegory of this: Li's character is removed from all culture, history, personality or personhood, kept in a dog collar and unleashed only to fight. When finally definitively unleashed from the leash, we learn that all Jet Li's Danny (the Dog) desires is *culture*.

Accordingly, a lot has been said about the racism and cultural bias of the Hollywood film industry. Of course, just as much could be said about the racism

and bias of the Hong Kong film industry. The stereotypes of Westerners in Hong Kong films are just as preposterous as their more famous Orientalist counterparts: the very recent film, *Bruce Lee, My Brother* (also known as *Young Bruce Lee*), for example, is a sentimental fabulation about Bruce Lee's Hong Kong childhood, which along the way also waxes surprisingly nostalgic about Hong Kong's British colonial past, but which, in doing so, could not seem to muster a single British actor to play any of the many British characters: at first the white actors seem to *try* to affect British accents, but by the end of the film, that brief has been entirely forgotten, and Australian and Mid-Atlantic accents abound. But this is not my interest here. One should not expect too much from Hollywood, or Hong Kong; or indeed Bollywood or Beijing. What strikes me as more significant is the question of the routes or directions of the transfers, travels and communications.

Martial arts films have long fed on the themes of diasporic displacement, of tradition and institution, of inheritance and communication, of passing on and passing over. The master dies or is assassinated; the number one son travels to a new town or a new land; the Westerner visits the East and takes away a new mastery of something very old. They feed on questions of transmission: who can be allowed to inherit the secrets – male or female, Asian or white? In which direction should things go?

As we have seen, Lee's third Hong Kong film, *Way of the Dragon*, or *Return of the Dragon*, in Chinese was called *Meng Long Guo Jiang*, which can be translated literally, as we have seen, as 'The Fierce Dragon Crosses The River', which refers to travel and migration, and to the diasporic Chinese crossing over to Europe. In this film, Lee travels from Hong Kong to Rome and defeats the mafia – who are represented in terms of perhaps the strangest, most multicultural mafia gang ever depicted on screen, consisting not of slick Italian gangsters, but rather of shabby whites and blacks, and an ultra-camp Chinese translator. This mismatching mishmash or misperception of the mafia is entirely appropriate in a film which I argued above is best regarded as precisely the kind of postcolonial ethnography that Rey Chow argues for in her chapter 'Film as Ethnography; or: Translating Between Cultures in a Postcolonial World' (1995: 176–202). Let me note that when the Europeans cannot beat Lee's Chinese local boy (aka 'native'), they call in 'America's best' – the martial artist Colt, played by Chuck Norris. Lee defeats the American karateka, restores the sovereignty of the Chinese restaurant business that he has come to save in the first place and then, when the hurly-burly's done, jets off back to Hong Kong. Thus, the film seems to say: there is nothing for the Chinese in the West other than chop-socky and chop-suey.

Lee's return trip in this film is essentially what has happened to all subsequent Asian male action leads: they go to America, beat the best of the West in action flicks, but then find nothing else for themselves, no other space, and have to return to Asia for anything like a different kind of cinematic role. Needless to say, Chuck Norris rose like a phoenix from Colt's ashes and blazed the trail which whitened and Americanised martial arts, so that, ultimately, Western martial arts films need less and less to make what was earlier their obligatory reference to an Asian origin. Many still do, but the gesture 'East' is little more than window-dressing: in *The Matrix* Neo fights Morpheus thanks to kung fu software in a vaguely Oriental room; Bruce Wayne in *Batman Begins* (2005) is trained by ninjas but kills them all (because they are devious and fiendish) – and with a martial art that was actually entirely invented by US stuntmen. Rex in *Napoleon Dynamite* (2004) invents 'Rex Kwon Do' over two seasons of fighting in the octagon. While Jason Bourne in *The Bourne Identity* (2002) doesn't even remember how or where he learned to fight.

Martial arts cinema aficionados will tell you that Bourne's fighting style is derived from Filipino kali or eskrima plus Jeet Kune Do, as taught by the film's fight choreographer, Jeff Imada, as taught to him by Bruce Lee's student Dan Inosanto. But, really – at least in one psychoanalytic register of 'really' – they have all learnt their martial arts like Bradley Cooper in *Limitless* – who learns his fighting from his memories of Bruce Lee films – or, indeed– like Brad Pitt's Tyler Durden in *Fight Club*: in the manner of a schizophrenic hallucinatory projection based on a spectator's fantasy of Bruce Lee.

Indeed, despite all reroutings, displacements, transports, transformations and deracinations, what remains clear is this: spectres of Bruce Lee structure this discourse. But is this just an Americanised discourse – a conversation or discourse entirely 'internal' to the West? I don't think so. This is because, as indicated in the previous chapter, especially following the 1997 handover of Hong Kong to China, figures, spectres, stand-ins, tokens and representatives of Bruce Lee have re-entered Hong Kong and Chinese films – and more than films – in very prominent ways.

As discussed in previous chapters, one can see that there has been a surprising upsurge of interest in Bruce Lee and Bruce Lee related themes in both Hong Kong and China. Before the Beijing Olympics, Chinese national television initiated a subsequently very long running TV series on the life and adventures of Bruce Lee. In Hong Kong over the last few years, a veritable rash of Bruce Lee related films has broken out. In most of these Bruce Lee returns at one remove, but present, in displacement: in films about his wing chun kung fu teacher, Ip Man, or about Chen Zhen, the character he played in *Fist of Fury*, as well as films about his young life in Hong Kong. All of this is fictionalised, mythologised.

The *Ip Man* films star Donnie Yen and other films about Ip Man are in production. In Yen's *Ip Man* films, Ip Man is depicted as a flawless Chinese nationalist hero, one of the folk of Southern China who had to flee to Hong Kong to escape the Japanese. Throughout these films, Ip Man is regularly conflated not only with Bruce Lee but also with the character that Lee popularised in the ultra-nationalist film *Jing Wu Men / Fist of Fury*, with his ultra-nationalist character Chen Zhen. At around the same time, Donnie Yen also played Chen Zhen in the film *Legend of the Fist: The Return of Chen Zhen*. In this, Chen Zhen is conflated not only with Bruce Lee, but also with Jet Li, and – bizarrely – also with the character 'Kato' that Bruce Lee played in the American TV show *The Green Hornet*.

Of course, as I have sought to emphasise, like Chen Zhen, the real, historical person, Ip Man, would be *entirely* unknown outside of Hong Kong, as would the martial art he taught (wing chun / yong chun). Both Ip Man and Wing Chun are now world famous *solely* because the most famous student was Bruce Lee. In other words, what shines through in this recent rash of films is the way that Bruce Lee is silently structuring more than just some films, but actually an ongoing discourse (at least a filmic discourse) about the relationship of Hong Kong to China and China to Hong Kong and on to the world. Chen Zhen returns from Europe to Shanghai to fight crime in the mask Lee wore when playing Kato in *The Green Hornet*. He returns to the famous Japanese Dojo to beat the son of the master he killed first time around in both Bruce Lee's *Fist of Fury* and Jet Li's *Fist of Legend*. Bruce Lee's and Jet Li's and Donnie Yen's Chen Zhens, plus Yen's Ip Man all beat Japanese karateka in very similar dojos viewed through very similar camera angles.

In all of these films, the key journeys and transports are between Hong Kong and Shanghai. In addition: all are organised by the idea of escaping or combatting *Japanese* aggressors. In fact, the links between Hong Kong and the mainland are prominent in them all, and closely coupled with Japanese as enemy. As such, the figure of Japan is functioning now as a 'screen memory', and accordingly therefore as a stand-in, a scapegoat. But for what? The answer becomes clear when one knows that the real historical figure, Ip Man, moved to Hong Kong not to escape from the Japanese but to escape the emergence of the Communist regime in China. Unsurprisingly, however, this entity – Communist China – is entirely absent from all of these films. In its place is the one-stop-shop bogeyman of Japan. The complex and contradictory historical relationship between Communist China and capitalist Hong Kong is the proverbial elephant in the room that these films – which are ultimately all about reinventing the relationship between Hong Kong and China – cannot look at or speak about.

BRINGING IT ALL BACK HOME

So, even though Bruce Lee has not always been regarded by Hong Kongers as a Hong Konger (as suggested earlier, he has for a long time been regarded by Hong Kongers as about as much of a Hong Konger as Hong Kong Disneyland) Bruce Lee is nevertheless structuring or suturing a renegotiated and re-grafted cultural discursive relationship between Hong Kong and China. Indeed, Bruce Lee has arguably always been the figure of the graft, the connection, the common link, the common identification, the thing shared in common. In some martial arts films – East or West – it is true that he may not always be there. But in martial arts *culture*, or the points at which martial arts connect to *culture* or connect *cultures*, he is almost always there.

Even in the recent US and Chinese co-production of the remake of the 1984 film *The Karate Kid*, Lee is *written into* a film that he was entirely absent from in its first incarnation. In the original, the focus is entirely American. It takes place in America. The martial art is Okinawan goju-ryu karatedo – karatedo being the martial art that America first experienced by virtue of its post-World War II occupation of Japan and Okinawa. And the motive for the action of the story in the first place is the fact that Danny Laruso has had to move from the East Coast of America to California, because of his mother's work. However, by the time of the 2010 remake, there are some significant changes. The eponymous 'kid', Dre Parker, now has to leave the USA itself, because of his mother's job. This is quite a new theme. More pointedly, they have to move from Detroit (America's industrial disaster area) to Beijing. Immanently significantly, Dre is black. However, interestingly, ethnicity largely vanishes in the remade film. Dre Parker may be black, but he is nevertheless immediately and unproblematically recognised and welcomed in Beijing as 'one of us' by an almost albino-blonde white boy. Whether this bespeaks the footnote to the American dream of an American identity that is colour blind, or whether it testifies to the pragmatic contingencies of all relationship-, community- and identity-formation is something that can be debated. But what the black and the white share here is place of birth, of course, and language but also reason for being there: *economic migration*.

After Dre's initial cultural disorientation and alienation, the film ditches the potentially knotty theme of cultural difference. Everyone speaks English in Beijing. Everyone is kind – except the schoolboy bullies. No one, but no one, is racist. Beijing is beautiful, welcoming. Dre and his sifu, played by Jackie Chan, go to Guilin, China's own beloved tourist destination – where they have even built some kind of bizarre open-access faux-ancient Taoist monastery at the top of some kind of crypto-Wu-tang Mountain.

In other words, if in 1973 the film title *Enter the Dragon* seemed to be the announcement of the arrival of the East in the West, and reciprocally therefore the entrance of the West into the East – the commodification and marketisation of the East by the West, the popular cultural appropriation of the Eastern in the West – by 2010 the words 'enter the dragon' seem to be more of an *encouragement* – as in, 'come on in, enter the dragon, it is great'.

This is unsurprising, perhaps, given the involvement of the China Film Group Corporation in the making of *The Karate Kid*, and the well-known concern of the Chinese state nowadays for its public image. But still, it is significant that, as if concerned for his protégé's own public image, at the end of *The Karate Kid*, whilst preparing for the final showdown at a kung fu competition, Dre Parker's sifu, Mr Han, presents him with a fine white jacket. Dre looks awed: 'just like the one Bruce Lee wore', he says. Indeed, it is obviously evocative of the white jacket Bruce Lee wears as the nationalist Chen Zhen at his master's funeral in *Fist of Fury*. But here there is no such nationalism, no such fury. Rather, the film proposes a colour blind transnational interethnic Beijing, with no racism, no ethnocentrism, and only the subjective encounters of equals.

The silliness of this new Beijing-Hollywood vision of the world (or should that be Beiwood or Hollyjing vision of the world?) perhaps goes without saying. But perhaps it has one saving grace. For, in this film, Jackie Chan has finally been allowed to act, has finally been allowed a character; finally allowed a subjecthood, a humanising back-story, a depth and complexity. If in the end, this is very little, it is certainly not nothing. For perhaps this silly little remake of a film, which achieves little more that is new other than allowing the erstwhile slapstick martial arts institution Jackie Chan to play a mature character in a Hollywood production nevertheless bespeaks or registers the shifting geopolitical relations involved in cultural hegemony, identity and production. Despite its limitations, the film is perhaps also communicating a new message: no longer a message about decentring or provincialising Europe (*Europe* is neither here nor there) but rather a message about decentring and provincialising *America*.[3]

DERACINATED NINJAS

But are things really so simple? In a chapter entitled 'An Oriental Past' in her 2010 book, *Yellow Future: Oriental Style in Hollywood Cinema*, Jane Park begins from a consideration of a film series in which Asia / the Orient / the East is both everywhere and nowhere. The films in question are *Batman Begins* (2005) and *The Dark Knight* (2008). Park uses the films as clear examples of the extent to

which clear borders between East and West are more and more blurred, less and less clear.

Asia is everywhere and nowhere in these films in a number of ways. Firstly, of course, they are not Asian films: they are Hollywood films. Yet much of the first half of *Batman Begins*, in particular, and much of the aesthetic of both is *styled* Oriental – it has an Oriental *style* or *sheen* – and nowhere more so than in the early sequences in which Christian Bale's Bruce Wayne is trained in an isolated mountaintop temple in what Park refers to as 'ninjitsu'. Park calls it ninjitsu because the masked characters who train Bruce Wayne in martial arts in the temple, and who call themselves 'the League of Shadows', are clearly marked as ninjas, are referred to once or twice as ninjas within the film, and wear the traditional/mythological black masks and black costumes, whilst training in swordplay, deception, illusion, distraction, stealth and evasion. So, we might reasonably expect our ninjas to be trained in what is referred to in Western popular culture as 'ninjitsu'.

But who and what and where are these ninjas? The location is not Japan. It is Himalayan/Tibetan. Which seems unusual or incongruous for ninjas. But of course, one might ask: would a ninja headquarters or training school really need to be in Japan in this day and age? And would ninjas need to be Japanese? Surely such an assumption would involve conflating a *practice* with an *ethnicity*. And as I want to argue here, *such a conflation is precisely the kind of thing that needs to be deliberately avoided in any study of film or culture*.

Nevertheless, it does not seem unreasonably prejudiced to note that *to be ninja* as such would seem fundamentally to require being part of a precise historical and social relation; one in which a defeated samurai clan has chosen not to surrender to a victorious samurai clan or to commit suicide but to live on, covertly, secretively, because of the existence of the other samurai clans. And this is as much as to say that one cannot be a ninja as such without being part of feudal Japanese relations; and this would strongly imply being both ethnically Japanese and being located in Japan, and, of course, living in a very precise historical period, in the past. However, if we are *not* dealing with this sense of being a ninja, and if we're just dealing with being an ultra-trained assassin with a black uniform and a predilection for swordplay, then yes, such 'ninjas' will be even better stealth assassins if they are not ethnically or linguistically marked, and if they have bases and camps all over the world. But this involves a subtle change in the meaning of the word 'ninja', one that has taken place because of what Rey Chow (following Vattimo following Nietzsche) refers to as the weakening of cultural foundations – a weakening of cultural exclusivity, borders and barriers – as a consequence of the intensification and expansion of the complexities and flows of mediated global and transnational popular culture attendant to modernity (1995: 195)

This is why, despite its technically anachronistic character, an understanding of ninjas as globalised and deracinated paid assassins with a penchant for the balletic and the bladed makes perfect sense to us today. Indeed, this is the dominant popular cultural understanding of the ninja. But we should note the Rey Chow type of point, that this is a very weakened, very fluid, deracinated and mobile conception of a ninja (1995: 195). 'To be' a ninja outside of an antagonism structuring feudal Japanese society can nowadays only mean to be a *semiotic* ninja – a trace, a remainder, a leftover, a mark, a residue, in diaspora. Nevertheless, this remains a semiotics with a *currency*, a *communicability* and a *transmissibility*: an *afterlife* and an *intelligibility* (1995: 199).

Of course, the image of the ninja as mobile and globe-trotting is surely the *dominant* image *because* it maps fluidly and fluently onto the more than century-old 'yellow peril' paradigm (see Seshagiri 2006). We should recall that one of the first 'yellow peril' fantasy constructions was that of the evil and insidious Chinese arch-villain, Fu Manchu, in the Sax Rohmer stories, written at the dawn of the twentieth century. These were inspired and structured by two diverse sources: on the one hand, Imperial worries about anti-British uprisings such as the Boxer Rebellion and, on the other hand, a desire to cash in on the successful format of the Sherlock Holmes novels. What is crucial here is that both Sax Rohmer and subsequent yellow peril fantasists have all recognised or dramatised that what is *most* perilous about the yellow peril is not when the yellow peril is a huge mass or multitude that is far, far away, over there, in a determinate other place in the East; but rather that the yellow peril is perilous because of its ability to move anonymously, individually, fluidly, fluently, silently, secretly and insidiously across the globe. Fu Manchu's headquarters were in London's East End, and he and his henchmen could and would pop up all over the world (or, more specifically, all over the British Empire), at will and unexpectedly.[4]

In other words, in 'yellow peril' semiotics, *location* is *irrelevant*. What is not deemed irrelevant in this semiotics though is ethnicity: what subtends and sustains the discourse is a belief in the permanence of a mobile and portable ethnicity which always manifests itself as anti-Western/pro-Eastern nationalist ideology (see Seshagiri 2006). Simply *being yellow*, no matter *where* and no matter how long you have been there, is taken as a sign of a necessary infidelity or non-belonging to the West; and an essential attachment – simply because of skin colour or ethnicity – to another place. Jane Park indicates the tenacity of the hold of this discourse – not just in popular fiction but also in serious public arenas – when she discusses the news media representations of *both* ethnically Asian *criminals* and ethnically Asian *victims* of crime in the US: in the language and representational structure of US news discourse, the ethnically Asian is never *simply*, *wholly* or

wholesomely American (see Park 2010). The hyphen of hyphenated US identity politics reveals itself to be a double-edged sword (see Chow 2002).

It is with this unclear nexus of ethnicity, alterity, location, place and crossing over that I will be primarily concerned here. This is because in film and in our readings of film there are often conflations and confirmation biases at play which pull our readings in certain directions, often in ways which conform to both a geographical and what Jacques Rancière calls a *geometrical* structuring of the world, along ethnic and nationalist lines. As Rancière has consistently sought to impress upon us: we fall too easily into a style of thinking in which we assume that social classes and social groups each have their *proper place* and *proper location* and *proper activities*; and, because of this aesthetic distribution of the sensible and this paradigm of viewing and apprehending, this partition of the perceptible, this shared biased commonsense, our own thought processes work like police officers: we assume that we know *where* and *what* certain groups, identities and practices *are* or should be, and we push them back into their perceived *proper places* – or, when we apprehend them or think about them or represent them or engage with them, we measure the distance between where they seem to be and where we thought and think they should be (see Rancière 1999). This is a process that Rey Chow has called 'coercive mimeticism' (2002); coercive mimeticism being a term for any of the many processes through which ethnic, class and gendered identities are assumed, imposed, enforced, insisted upon and adjudicated, in myriad contexts. My argument here will be that looking closely and thinking about the relations between ethnicity and the perhaps surprising topic of martial arts choreography offers important insights into all of this.

CHOREOGRAPHING AUTHENTICITY

In the context of the ninjas of *Batman Begins*, and of the film's 'ninjitsu', a moment's digging around or researching reveals that it is actually the case that the choreography we see in the film is derived from a martial art called Keysi Fighting Method (or KFM). This martial art was invented within the last few decades by a streetfighter from Barcelona called Justo Dieguez Serrano in conjunction with another from Hull in the north of England called Andy Norman. These two fighters met on a martial arts circuit made up of a loose network of like-minded martial artists who would travel widely around the world to train with each other at various training camps (not entirely unlike our deracinated ninjas, perhaps). Another of these like-minded fighters was a man – also from Hull – called Buster Reeves: a former sports martial arts star, freestyle sparring champion, world jujitsu champion, and

stuntman who, at a certain point in time, exactly when he was a student of Andy Norman in Hull, was lined up to be the stunt body-double for none other than Christian Bale in the up-coming film *Batman Begins* (Norman n.d.).

So, the fighting method of the Orientalised yet non-Japanese (or non-Japan-located) 'ninjas', located in an apparently ancient temple somewhere far, far away, but definitely in the East, in this Hollywood film, turns out to be a very contemporary and avowedly 'urban' martial art; one that was invented, formalised and codified – or at least baptised and commodified – by two Europeans, who met on an international training circuit but who insist in all promotional and pedagogical literature, interviews and online film materials that KFM 'comes from the street', or, at least, is *designed for* 'the street'. In any case, KFM became connected with Hollywood thanks to a certain international network of fighters, all of whom were striving for *authenticity* in their martial arts training. As Andy Norman and others say in interviews about *Batman Begins* (and elsewhere), KFM strives for authenticity and efficiency; it is not hampered by somebody else's tradition; it is not, to paraphrase Norman, an ancient residual form of someone else's truth; it is rather a truth that they themselves worked out in the here and now, through an unending process of thinking, researching, experimentation, testing and verification.

Now, to anyone familiar with martial arts rhetoric – that is, with the types of things that martial artists are going to say about their practice – it is very hard not to discern close family resemblances between KFM-style discourse and the rhetoric and discourse of Jeet Kune Do as it came out of the mouth of Bruce Lee in the late 1960s and early 1970s. For Bruce Lee, martial arts practice should not be about respecting tradition and doctrine; it should always be about experimentation and innovation and, as he was wont to say, 'honestly expressing yourself'. Thus, given the virtually identical style of rhetoric and discourse shared by Bruce Lee's JKD and today's KFM, it is clear that KFM is a contemporary manifestation of an impulse that was first defined by Bruce Lee's inventive, experimental interdisciplinary research programme that he called JKD.

Of course, Keysi Fighting Method and Bruce Lee's Jeet Kune Do (or KFM and JKD) may seem very different in appearance and execution. Where Lee's JKD would insist on the straight and the direct – the straight right lead or the direct finger jab to the eyes being its exemplary techniques – KFM is more likely to spin and roll into a different position – this is because the 'pensador' or 'thinking-man' defensive/aggressive stance is what its founders call 'the nucleus' of its approach. So Bruce Lee's JKD and today's KFM look different but they share the same experimentalist and verificationist ethos.

What is more, both were catapulted into the spotlight by a connection with the Hollywood cinematic apparatus. What is (even) more, both look and seem

Oriental – the Orient is all over them and they are marked Asian – yet neither is properly Oriental or simply Asian. KFM appears in the recent *Batman* films *as if it is ninjitsu*, but it is not; JKD appeared both in Bruce Lee's pre-Hollywood supporting role in *Longstreet* in 1967 and also in his unfinished film *Game of Death, as if it were 'kung fu'*, and it was always heavily marked as Asian, as Chinese; but it is not: *not really; not simply*. Even Bruce Lee himself at times wanted to distance himself from an ethno-nationalist interpretation of what he was doing in JKD. In *Game of Death* Lee chose to wear a bright yellow tracksuit, so that his style could not be semiotically attached to any existing formal style from any culture. And, ultimately, JKD is a Chinese name for an art born in the USA out of Lee's interdisciplinary explorations in boxing, fencing, grappling, wrestling, and kicking, from a Wing Chun basis – but a basis that became more and more translated and transformed over time, so that only certain axioms of Wing Chun remained (as expressed in sentiments about the centreline and about the immoveable elbow, and so on).

So, both JKD and KFM are heavily marked as Oriental; both are semiotically constructed as Oriental; but in the approach of Bruce Lee, to regard JKD simply as Chinese is to conflate *Lee's own ethnicity*, on the one hand, and his *deracinated interdisciplinary radicalism*, on the other; and to do so in such a way as to make the *ethnicity* trump the *activity*: in other words, it is to assume that *because Lee looked Chinese, therefore what he did was Chinese*. This sort of conflation is as legitimate as claiming that because *Batman Begins* constructs KFM as ninjitsu, therefore KFM is Japanese. In other words, this all points to a problem of culture; one that raises its obscure – or obscured, or black-masked – head, whenever there is a crossover. This is especially visible when the crossover involves or is enabled by cinematic mediation or mediatisation.

IN AUTHENTIC CROSSING

Jane Park argues that in many manifestations of Hollywood's cinematic imaginary – in its semiotic vernacular – 'the Orient' stands simultaneously for the ancient past *and* the technological or technologised future. She argues that in the recent *Batman* films, East and West are blurred. I want to emphasise the ways that the Orient is played and erased here and elsewhere, in order to show the deconstruction of location – and of certain conceptions of 'culture' – through the problematisation of space and location attendant to international film. The Orient is everywhere and nowhere here. It has both crossed over and been crossed out. It has also been underlined.

According to the interviews and short films that make up the extras of the DVD release of *Batman Begins*, Keysi Fighting Method became appropriated by Hollywood and was incorporated into the film largely because of its visual novelty: as one of the interviewees – the fight and stunt coordinator David Forman – puts it: we had seen kung fu, taekwondo, jujitsu; but we hadn't seen *this* before. So, KFM offered a novel visual spectacle boiling down to a new and flowing style of movement, one that they decided suited the character and personality they were giving to Batman in the film: brutal, animalistic, pugilistic, almost crude in appearance, yet at the same time highly viewable and ultra-slick. According to Andy Norman, the co-founder of KFM, what the filmmakers liked about the look of KFM was that it showed a new way of moving, a way of moving never seen in fight choreography before (Norman n/d).

Because of this, in the wake of *Batman Begins*, Keysi Fighting Method started to become global. (It is also seen in *Mission Impossible 3* (2006)). This take-off itself is a new version of the same mediatised route that first made all nominally Oriental martial arts global: David Carradine and Bruce Lee introduced nominally Chinese martial arts quite decisively to the West and off the back of this media-tion, untold numbers of people all over the world started practicing nominally or actually Chinese, Japanese and Korean arts, first of all, and more and more diverse nationalities of arts subsequently – Brazilian jujitsu and capoeira, in particular.

In relation to the exemplary case that is Bruce Lee, it is fair to say that it was only because of his celebrity that Jeet Kune Do became known. Then, as people looked backwards in time, so to speak, ever-desirous to return to the source or the mythic origin of Lee's art, more and more people discovered Wing Chun. So it was only because of Bruce Lee that the art he studied as a teenager, wing chun, became popular outside of Hong Kong. By the same token, it was only because of Bruce Lee that his teacher, Ip Man, became so well known that he has since been reclaimed and reconstructed as a legendary Chinese patriot within some recent Hong Kong produced films.

To put it bluntly: virtually no one would have heard about kung fu were it not for Bruce Lee; no one would be doing Jeet Kune Do; Wing Chun would be insig-nificant outside (and possibly within) Hong Kong, and Ip Man would be equally unheard of. I say this without any disrespect intended to any of these people or styles. I just want to emphasise the crucial role of the filmic apparatus in pro-ducing visibilities, mythologies, beliefs and practices. In fact, there is a sense in which almost every martial art or martial artist today could be said to have a debt to cinema (no matter how unwanted), and could also be said to be mediatised (no matter how anti-spectacular the martial art is). This is the case *even* with Bruce Lee's JKD and with KFM (not to mention MMA and the UFC), and even in the

face of their shared and avowed commitment to *authenticity* and *reality*.

For, with both, it is the case that an art that was inspired and guided by the desire for the real and the authentic has been mediatised, and in that mediatisation glamourised, and in that glamourisation further commodified. So, now, even if you cannot find an actual human instructor in KFM, you can sign up and download the syllabus – white belt, yellow belt, and so on, through to black. And these training videos are themselves pretty slick textual productions: finely crafted and beautifully edited films which emphasise the different ways to train in order to practice, to simulate and emulate and generate authenticity – or the effects and features of authenticity – in training for real and authentic combat. So, pretty soon there should be plenty of virtually-produced KFM certified instructors to set up physically-located schools.

In itself, this is no big deal. There have long been correspondence courses. And far be it from me to fetishise the value of the face-to-face co-presence of teacher and student. (Derrida deconstructed this decisively decades ago.) Rather, the point I would like to make is to caution the conflation of text with geographical location, or geographical location with ethnicity and/or 'culture'.

NATIONAL GEOGRAPHETHNICITY

Rey Chow nails one problem of this tendency in her 1993 book, *Writing Diaspora*. In this book, Chow points out the ways that, in American universities in particular, the academic world is all too easily divided up *geographically*. That is to say, academic departments and approaches are divided up along nation-state lines, in a way that actually mirrors – and yet obscures – the geopolitical organisation of the world. It mirrors it in that a school or department can be, for example, a school of Chinese studies. In this school or department, there will be experts in so many areas of this geographical entity's social and cultural landscape: for example, Chinese literature, Chinese language, Chinese history, Chinese philosophy, and so on. In the next building or somewhere across the campus, there will be the Japanese counterpart of this; elsewhere the Russian and Slavic and elsewhere the Indian and so on and so forth – in a way in which the geopolitical identity of nation states is mirrored in the academic division of labour.

(There may also be – as there is in my own university, for instance – schools of European Studies. But such schools and departments are less likely to teach European Philosophy than they are to teach the unmodified and putatively universal discipline of capital p Philosophy – in other words, the supposedly *universal* category or version of a subject; a universal or transcendent version of a subject,

whose 'universality' is of course merely the simultaneous acknowledgement and disavowal of its Eurocentrism.)

The reiteration of geographical or geopolitical (or, in other words, national) boundaries as a way to organise universities, their departments and schools, their disciplinary landscapes, and ultimately therefore the knowledge they produce, has many consequences. For instance, Chow draws attention to the likelihood that translated Chinese texts dealing with, for example, women or the family or the state will all too often be given a modifier in translation, so that, in their English language versions they become, all of a sudden, texts dealing not with 'woman' or the family or the state but now with *Chinese* women, the *Chinese* family and the *Chinese* state – and in a precisely diametrically opposite way to the way in which European texts about the same subjects would be translated. Chow proposes that a French language text called, say, *la femme*, *la famille*, *l'état*, would almost certainly be translated as something much closer to *woman*, *the family*, *the state* than *French women, the French family and the French state* (1993: 6). Of film itself, Chow says: let's contrast titles of studies of 'first-world' film with titles of studies of non-'first-world' film. While the former typically adopt generic theoretical markers such as 'the imaginary signifier', 'the cinematic apparatus', 'feminism', 'gender', 'desire', 'psychoanalysis', 'semiotics', 'narrative', 'discourse', 'text', 'subjectivity', and 'film theory', the latter usually must identify their topics by the names of ethnic groups or nation-states, such as 'black cinema', 'Latin-American cinema', 'Israeli cinema', 'Brazilian cinema', 'Japanese cinema', 'Indian cinema', 'Spanish cinema', 'Chinese cinema', 'Hong Kong cinema', and so forth. To the same extent, it has been possible for Western film critics to produce studies of films from cultures whose languages they do not know, whereas it is inconceivable for non-Western critics to study the French, German, Italian, and Anglo-American cinemas without knowing their respective languages (1995: 27).

So, Chow points to the hierarchies of value involved in organising knowledge *geographically*. The problem is both that this can too easily take place against the backdrop of an assumed universality – capital p Philosophy (as universal) versus 'Eastern Thought' (as regional), for example – and also that this type of thinking follows an implicit Cold War, Orientalist, imperialist or colonialist logic, in which the *other* culture is there to be known in the form of a data-mine or, ultimately, *a target*.

Anthropology is a residue of British imperialism, it is often said: the natives are objects and curios, relics from the past, specimens from nature, to be studied by the modern Western investigator. Area Studies, it is also said, is a disciplinary field that is a direct product of the post-World War II and Cold War US mindset,

elaborated in accordance with the injunction to 'know your enemy'. Such a geographical imaginary – when it organises academic work – is both politically consequential in one way and also depoliticising in another. Edward Said names it 'Orientalism', of course; and I feel confident that I do not at this point need to digress into a lesson on Orientalism. But one consequence of the regionalisation of knowledge according to national borders is its essentialism. And essentialism – as much as it can be shown to be politically consequential – is also depoliticising; in that it works to reinforce the idea that national cultures, with their histories and their languages, organised by borders, are expressions of a cultural essence, with culture regarded as a treasure trove of history to be revered. In this framework, only the past is authentic. The past is superior. The present is corrupt. And specific cultural studies of specific cultures become inclined to evaluate contemporary cultural productions in terms of how well they fare against the values imputed to the past. And this transforms the very definition of, say, literature, or music or art – precluding it from being assessed as a critical or political discourse, and demanding that it be an expression of an authentic culture – an authentic culture that it will inevitably be doomed to fail to live up to, because of the fact that it is contemporary and alive and therefore corrupted by the present complexity of the interconnected, ever-crossing-over world.

REGIONALITY

But, the retort may come: ok, so maybe we *can* deconstruct the idea of regional cultures and regional practices and regional texts, like film, because everything is increasingly transnational – for instance, in film financing, film distribution, film production teams, film values, film talent, and so on. But on the other hand, there are *obviously* regional film industries and histories and institutions and realities. So, how are we to engage with the ongoing reality of this self-evident regionality? If we ignore it on the basis of its complicity with either Orientalist or imperialist or otherwise nationalist processes, are we not ignoring a significant political fact about regional film? After all, does not even a cultural theorist like Rey Chow, who prominently problematises regionalising perspectives, herself write entire books about Chinese film, even as she points to pitfalls and problems of nationalising film studies and essentialising cultures along nationalistic lines and within Eurocentric and colonial conceptual universes? So, if we want to listen to Chow and learn a lesson from Chow, how then do we negotiate the paradox opened by two of her key cautions – first, the caution against falling into the 'area studies trap', of nationalising, homogenising and essentialising culture along national and

ethnic lines (1993; 1998); while, second, treating film as ethnography, as she also proposes (1995)?

Chow herself resolves the paradox of her twin yet apparently contradictory injunctions – on the one hand, *do not ethnographise film*; but on the other hand, *approach film as ethnography* – by elaborating what we now too easily call a deconstruction of the notion of both ethnography and – ultimately – of translation, and specifically of what she calls cultural translation.

This is not *simply* a deconstruction because although she certainly deconstructs ethnography and anthropology, she does not really 'deconstruct' translation or cultural translation. In actual fact, she turns Jacques Derrida and Paul de Man's own deconstructions of translation against them in order to show the limitations of their approach, or rather, the points at which they stop. She does this to show that what she calls the negative impulse – the rigorous but negative critical energy of deconstruction – cannot really engage with the specificity of the film medium itself. And this is the important task, she argues: because this is where the action is.

To say that Chow does not deconstruct is not quite right, however. She definitely advocates the need to deconstruct nativism, primitivism, regionalism, ethno-nationalism, and so on. She certainly wants to deconstruct the tacit idea that there is an original text, for instance or, more than that an original *before* any particular text; *an original that the text is trying to represent, communicate, or indeed 'translate'*. This is why she regularly points to the criticisms levelled against globally successful filmmakers such as Chen Kaige and Zhang Yimou – in order to show the ways that most of the criticisms made against these directors are based on the idea that their textual productions are unfaithful representations of some true depth and essence of China. Ultimately, she suggests, such criticisms are based on a self-essentialising which follows from a belief that there is an essence or an underlying truth to China that needs to be (yet cannot fully be) translated with accuracy and fidelity into filmic form.

But every text is a construct, Chow reminds us. *Every* text. And this includes the pre-text of a nation, such as China. So Chow certainly deconstructs the idea and relation of original to copy. But she takes her leave from deconstruction when she notices that the readings of the deconstructionists are so much orientated towards the past (at least the etymological past) and hence towards some sense of the prior and original – even if deconstruction also shows that the original text is a failed or incomplete or unsutured text. The point, for Chow, lies in the orientation towards the past as such. For such an orientation means that, even though the deconstructionists deconstruct the original text, they still believe in it, and look to the past to find it.

This is a problem for Chow, for lots of reasons, but mainly because if one orientates one's reading towards the past then the present is always going to look like an inferior, corrupt and bad copy: a bad translation. So, instead of going down this line, Chow insists, one needs always to remember that even the putative original is always and already an unoriginal construction, a *fragment* made up of fragments. So, one should orientate one's reading or valuation of it in terms of its effects on and within the present. In going down this line, Chow foregrounds the work of Walter Benjamin.

CULTURAL TRANSLATION

The key moment in Chow's elaboration of a theory of cultural translation comes when she quotes a long passage of Walter Benjamin quoting Rudolph Pannwitz. Pannwitz writes, as Benjamin and Chow both point out:

> Our translations, even the best ones, proceed into German instead of turning German into Hindi, Greek, English. Our translators have a far greater reverence for the usage of their own language than for the spirit of the foreign works. . . . The basic error of the translator is that he preserves the state in which his own language happens to be instead of allowing his language to be powerfully affected by the foreign tongue. Particularly when translating from a language very remote from his own he must go back to the primal elements of language itself and penetrate to the point where work, image, and tone converge. He must expand and deepen his language by means of the foreign language. (Quoted in Chow 1995: 188–9)

I think it may be harder to see or imagine what this might mean in written language or literary culture than it is to see what it might mean in film language and visual culture. Indeed, I think that it is *easy* to see the ways that not only the supposed 'best' but also even the (arguable) 'worst' films deftly, happily, joyously and fluidly translate from one film language to another, from one genre to another, from one regional semiotic or technical vernacular to another. In other words, what I am arguing here is that you see this sort of cultural translation all the time, in which an importation (a copy from or of an 'origin') intervenes into and modifies a milieu (a 'destination', a context, a present). Such interventions or translations or crossovers are inevitably in one sense unfaithful betrayals of a former state, but equally – as Chow concludes – in another sense respectful reiterations and animating breaths of new life, even if that life is a transformation, an afterlife.

EAST WINDS

So, I am suggesting that a film like *Batman Begins* is best approached not in terms of a paradigm of *simple appropriation* but in terms of a thinking of *cultural translation*. The film is certainly an index of the effects that the translation of Oriental style into Hollywood continues to have in film. But if we think of it as an appropriation or an implicitly unjust expropriation of something quintessentially Oriental, I think that we are sentencing ourselves to operate according to problematic assumptions about culture as *property* or *underlying essence* rather than *process* or *productive event*.

Of course, features of this process do also indicate the extent to which Western discourses often seek to appropriate and to claim ownership and mastery of practices that might more organically be connected with other cultures. Gary Krug, for instance, has written a fascinating study of the American appropriation of Okinawan karate – a long discursive process, he lays out, which culminates in events like the peculiar case of an America-based martial arts association expressing outrage and refusing to recognise the authority of Okinawan and Japanese martial artists in the same style to award the highest dan-grades without the consent of the US association. In other words, the US-based association bearing the name of a formerly and concurrently Okinawan martial art now regards itself as holding the ultimate authority and being the sole institution with the power to award the grade of tenth dan to anyone. The Okinawan practitioners are regarded by the American association as no longer able to legislate on their own activities (see Krug 2001).

So crossovers do often entail crossings-out and discursive controversy. There was always controversy at the heart of Bruce Lee's crossings-over, from Hong Kong to Hollywood and from Wing Chun to Jun Fan to Jeet Kune Do. And, of course, at the pinnacle – the explosion – the crossroads – of Lee's crossover, he died. In the wake of his untimely demise, Hollywood hungered for more Oriental or Oriental-esque martial choreography. More importantly, it hungered not just for exotic choreography, but also for more of the Bruce Lee style of authenticity in choreography. The fast, the ferocious, and the beautiful; not the robotic rhythms of kata but the *believable spectacle* (the *unbelievable-believable*).

There were always a range of styles of martial choreographies on offer. But one style rose to dominance, trampolining to prominence especially but not solely after the entrance into film of Bruce Lee's son, Brandon. For, Brandon had studied Jeet Kune Do under Bruce Lee's friend and student, Dan Inosanto. Moreover, Brandon studied JKD along with his own friend and contemporary Jeff Imada. And Jeff Imada, who was working in the film industry, helped out prominently

with Brandon Lee's own films and then went on to become the stunt and fight choreographer for an extremely long list of Hollywood films.

What this means is that it is possible to trace a strong connection between – and a largely untold story of – Hollywood fight choreography *per se* (or *tout court*) and *Dan Inosanto's* school of Jeet Kune Do. And one thing that is particularly under-acknowledged in this regard is the fact that, whilst Bruce Lee preached interdisciplinarity and innovation in martial arts research, he also always insisted that Dan Inosanto himself should respect and champion the martial arts of his parent culture – the Philippines (a place that Inosanto himself is not actually from). Accordingly, Inosanto has always studied and championed a wide range of martial arts of the Philippines.

Now, what is perhaps even less widely acknowledged is the extent to which it is these Filipino arts – specifically Filipino Kali and Eskrima – that we see depicted in film after film after film from Hollywood. A multitude of Hollywood films with the most memorable martial arts choreography have involved Imada in choreographing role. So we might want to rush to a conclusion about the presence of the Filipino arts in Hollywood. But there is more. For what is perhaps most peculiar about many of the films that could be said to be full of Filipino martial arts is the extent to which the choreography within them is represented *as if it is non-Eastern, as if it is entirely deracinated*, connected with either 'the US military', 'Special Forces' or 'the street' – specifically, of course, the US street. There is little if any mention or acknowledgement of the Filipino connection – of the fact that these putatively deracinated, universal, logical, rational, Western martial arts – as best seen in *The Bourne Identity* trilogy, for instance, is not simply universal or US, but rather Filipino.

But what about *Batman Begins*? The founders of KFM are adamant that their art comes 'from the street', and that it is 'for the street'. What they neglect to mention nowadays is that these selfsame founders of KFM, who choreographed *Batman Begins*, are also – or were formerly – qualified instructors of Dan Inosanto's school of Jeet Kune Do. This is a branch of JKD which is heavily informed by Filipino Kali. And a quick look at the current appearance of Filipino Kali shows it to be, in many respects, very much like that of KFM.

There is a lot that could be said about this. One thing would be the observation that the 'east winds' that are blowing here are not following the same course between Hong Kong and Hollywood and back again that they once were, in what was once a very visible interaction of regional styles and practices. Now there appears to be some kind of movement between Hollywood and the Philippines, but via two American-born, American-living, American-working but ethnically-Asian martial artist choreographers (Dan Inosanto and Jeff Imada). This

movement now proceeds according to what we might call a less straightforward, less visible and less regionally-specifiable crossover.

Another thing of note is the problematic double-status of the martial arts formerly known as Filipino: on the one hand, they are clearly a dominant force, one that is arguably hegemonic within Hollywood action choreography; but on the other hand, as this 'ethnicity' is largely unknown or unrepresented, and because what aficionados might recognise as Filipino is not *marked* as Filipino and is depicted instead as if it is the height of rational US military or street efficiency, then Filipino martial arts might be regarded as simply the most exploited work force in town. In either case, whether 'hegemonisation' or 'exploitation', this new formation has clearly involved a crossing out or erasing of an earlier ethnic or cultural identity.

But does it matter? Am I an ambassador for Filipino martial arts, wanting to right the wrong of under-acknowledgement, or wanting to right the historical record by publicising the cultural lineage of the martial arts choreography? I am not, and the point of all of this is not just nit-picking or being pedantic for the sake of it or for the sake of raising consciousness or awareness. The point is rather to draw attention to the *processuality* of culture and to the *constitutive* character not just of the textual productions – the cultural translations – but also the often unpredictable, often overdetermined nature of the networks that are constructed before, around and in the wake of them. As Fredric Jameson (1991) once said of the postmodern condition: in facing it, we must resist the temptation to judge it good or bad, because to judge it is a category mistake. It's just the way it is. Traditions, networks and relations are constitutively mediated and mediatised. Cultures no longer have self-evident and self-identical layers, depths, surfaces and properties. Instead of *properties* cultures are constructed, deconstructed and reconstructed through *proper-ties* and *improper-ties*: connections, linkages, articulations and reticulations. As Ernesto Laclau once put it, writing in the context of political theory:

> [We] gain very little, once identities are conceived as complexly articulated collective wills, by referring to them through simple designations such as classes, ethnic groups and so on, which are at best names for transient points of stabilization. The really important task, is to understand the logics of their constitution and dissolution, as well as the formal determinations of the spaces in which they interrelate. (2000: 53)

In the face of the globality of the 'space' of the cinematic apparatus, Jane Park is absolutely right to focus on the blurring and crossing over of Oriental and Western

styles. The 'east winds' are still blowing strongly, so much so that the 'East Asian' of 'East Asian Cinema' is no longer in its supposed 'proper place' or existing within its supposed 'proper ties', but is now at the heart of cultural crossovers of such complexity that region, space, location, ethnicity and identity should now all be approached as cross-cut, cross-hatched, crossed-over, cross-fertilised, crossed out and underlined, in ways that should oblige the study of film culture to blow the cover of any conflation of culture, identity, value or significance with nation, location, language, ethnicity and other essences.

notes

1 The phrase 'Enter the Dragon' suggests *active arrival*: the active entrance of an actor or agent onto a certain stage: It is the Dragon that enters somewhere else, something else, or someone else. But the phrase also has its other equally possible reading: as an injunction or imperative: a command: 'Enter the Dragon!' As in 'See that Dragon there? Enter it!' And, as has been argued throughout this book, there certainly is a two-way movement, a double-communication, between East and West, West and East.

2 Using Lacan's terms, Laclau and Mouffe spoke of *points de capiton*, which they translated as 'quilting points', and theorised as those nodal points of discourse which enable predication and signification, no matter how false or constructed they may turn out to be. Hence I am saying 'double communication' rather than two-way communication; for this is a communication which may or may not be two-way but in which there is always a doubleness or even duplicity.

3 As simple, facile, saccharine and utopian as it may often seem, I agree entirely with Rey Chow, who has argued that 'There are multiple reasons why a consideration of mass culture is crucial to cultural translation'. To her mind, 'the predominant one' is to examine 'that asymmetry of power relations between the "first" and the "third" worlds'. However, that is not all: as she continues, 'Critiquing the great disparity between Europe and the rest of the world means not simply a deconstruction of Europe as origin or simply a restitution of the origin that is Europe's others but a thorough dismantling of *both* the notion of origin and the notion of alterity as we know them today' (193-4). To my mind, the entrance and the re-entrance of the dragon has long been active in this complex communication and translation process.

4 The most recent iteration of the Fu Manchu figure was, of course, the media representation of Osama bin Laden after 9/11: Bin Laden was cast as a Fu Manchu character who seemed to be able to be everywhere and nowhere, apparently at will, and to be able to command hordes of minions and henchmen.

BIBLIOGRAPHY

Abbas, Ackbar (1997) *Hong Kong: Culture and the Politics of Disappearance*. Minneapolis: University of Minnesota Press.

Adorno, Theodor (1984), *Minima Moralia*, London: Verso.

____ and Horkheimer, Max, (1972), *Dialectic of Enlightenment*, London: Herder & Herder. Online at http://sfs.scnu.edu.cn/blogs/linghh/uploadfiles/2007314215657614.pdf

Althusser, Louis (1971), *Lenin and Philosophy*, New York: Monthly Review Press.

Amin, Samir (1988) *Eurocentrism*. London: Zed Books.

Anon. (1971) *Secrets of Shaolin Boxing*. Taipei: Zhonghuawushu Press.

Arditi, Benjamin (2007) *Politics on the Edges of Liberalism: Difference, Populism, Revolution, Agitation*. Edinburgh: Edinburgh University Press.

Badiou, Alain (1997) *Saint Paul: The Foundation of Universalism*. Stanford, CA: Stanford University Press.

____ (2001) *Ethics: An Essay on the Understanding of Evil*. Trans. Peter Hallward. London: Verso.

____ (2009) 'Cinema as a Democratic Emblem', *Parrhesia*, 6. Trans. Alex Ling and Aurélien Mondon. www.parrhesiajournal.org.

Barthes, Roland (1972), *Mythologies*, Paladin: London.

____ (1977) *Image – Music – Text*. Fontana: London.

____ (1989), *The Rustle of Language*, Berkeley: University of California Press.

Benjamin, Walter (1999), *Illuminations*, London, Pimlico.

Bewes, Timothy (2001) 'Vulgar Marxism: The Spectre Haunting Spectres of Marx', *parallax*

20, July-September 2001, pp. 83-95.

Bhabha, Homi (1990) *Nation and Narration*. London: Routledge.

Bishop, James (2004) *Bruce Lee: Dynamic Becoming*. Frisco: Promethean Press.

Bolelli, Daniele (2003) *On the Warrior's Path: Philosophy, Fighting, and Martial Arts Mythology*, Berkeley, CA: Blue Snake Books.

Bourdieu, Pierre (1990), *The Logic of Practice*. Translated by Richard Nice. Stanford: Stanford University Press.

Bowman, Paul (2006), 'Cultural Studies and Slavoj Žižek', Gary Hall and Claire Birchall, eds., *New Cultural Studies: Adventures in Theory*. Edinburgh: Edinburgh University Press.

____ (2006a), 'Enter the Žižekian: Bruce Lee, Martial Arts and the Problem of Knowledge', *Entertext*, Volume 6, Number 1, Autumn. (http://arts.brunel.ac.uk/gate/entertext/issue_6_1.htm)

____ (2007), *Post-Marxism Versus Cultural Studies: Theory, Politics and Intervention*. Edinburgh: Edinburgh University Press.

____ (2007a), 'The Tao of Žižek', Paul Bowman and Richard Stamp, eds., *The Truth of Žižek*, Edinburgh: Edinburgh University Press.

____ (2008), *Deconstructing Popular Culture*, London: Palgrave.

____ (2010) *Theorizing Bruce Lee: Film – Fantasy – Fighting – Philosophy*. Amsterdam: Rodopi.

Brown, Bill (1997) 'Global Bodies/Postnationalities: Charles Johnson's Consumer Culture', *Representations*, 58, Spring, 24–48.

Brown, Terry (1997) *English Martial Arts*. Frithgarth: Anglo-Saxon Books.

Butler, Judith (2000), 'Competing Universalities', in Judith Butler, Ernesto Laclau and Slavoj Žižek (eds) *Contingency, Hegemony, Universality: Contemporary Dialogues on the Left*. London: Verso, 137–76.

Castells, Manuel (2000) *The Rise of the Network Society*. London: Blackwell.

Chambers, Sam and Michael O'Rourke (2009) 'Jacques Rancière on the Shores of Queer Theory', *Borderlands*, 8, 2, 1–19.

Chan, Stephen (2000) 'The Construction and Export of Culture as Artefact: The Case of Japanese Martial Arts', *Body & Society*, 6, 1, 69–74.

Chan, Jachinson W. (2000) 'Bruce Lee's Fictional Models of Masculinity', *Men and Masculinities*, 2, 4, 371–87.

Chow, Rey (1991), *Woman and Chinese Modernity*, Minnesota and London: University of Minnesota Press.

____ (1993) *Writing Diaspora: Tactics of Intervention in Contemporary Cultural Studies*. Bloomington, IN: Indiana University Press.

____ (1995) *Primitive Passions*. New York: Columbia University Press.

____ (1998), *Ethics After Idealism*, Bloomington, Indiana: Indiana University Press.

____ (2002) *The Protestant Ethnic and the Spirit of Capitalism*. New York: Columbia University Press.

____ (2006) *The Age of the World Target*. Durham, NC: Duke University Press.

____ (2007) *Sentimental Fabulations: Contemporary Chinese Films*. New York: Columbia University Press.

_____ (2010) 'An Interview with Rey Chow', *Social Semiotics*, 20, 4, 455–65.

Clarke, J. J. (1997), *Oriental Enlightenment: the Encounter Between Asian and Western Thought*, London: Routledge.

De Man, Paul (1978), 'The Epistemology of Metaphor', Sheldon Sacks, ed., *On Metaphor*, Chicago: Chicago University Press.

Debord, Guy (1967/1992), *The Society of the Spectacle*, London: Verso.

_____ (1988), *Comments on the Society of the Spectacle* (http://www.notbored.org/commentaires.html).

Deleuze, Gilles (1988) *Foucault*. Trans. Sean Hand, Minneapolis: University of Minnesota Press.

Derrida, Jacques (1962/1978) *Edmund Husserl's Origin of Geometry: An Introduction*, New York and Brighton: Harvester.

_____ (1974) *Of Grammatology*. Baltimore: Johns Hopkins University Press.

_____ (1978), *Writing and Difference*, London, Routledge & Kegan Paul.

_____ (1981), *Dissemination*, trans. B. Johnson, Chicago and London: University of Chicago Press.

_____ (1982) *Margins of Philosophy*. London: Harvester Wheatsheaf.

_____ (1987), *The Truth in Painting*, Chicago: University of Chicago Press.

_____ (1992), 'Mochlos; or, The Conflict of the Faculties', *Logomachia: The Conflict of the Faculties*, in Richard Rand (ed.), Lincoln and London: University of Nebraska Press.

_____ (1992a), 'Canons and Metonymies: An Interview with Jacques Derrida', *Logomachia: The Conflict of the Faculties*, Rand, R. (ed.), Lincoln and London, University of Nebraska Press.

_____ (1994), *Specters of Marx: The State of the Debt, the Work of Mourning, & the New International*, London: Routledge.

_____ (1995), *The Gift of Death*, Chicago and London: University of Chicago Press.

_____ (1995a), *Points... : Interviews, 1974-1994*, Stanford, California: Stanford University Press.

_____ (1996), 'Remarks on Deconstruction and Pragmatism', Chantal Mouffe (ed.) *Deconstruction and Pragmatism*, London: Routledge.

_____ (1997), *Politics of Friendship*, London: Verso.

_____ (1998a) *Monolingualism of the Other; or, the Prosthesis of Origin*. Stanford, CA: Stanford University Press.

_____ (1998b), *Resistances of Psychoanalysis*, Stanford, Ca.: Stanford University Press.

_____ (2002), *Who's Afraid of Philosophy?: Right to Philosophy 1*, Stanford, Calif., Stanford University Press.

Dickinson, John (1976), *A Behavioural Analysis of Sport*, London: Lepus.

Downey, Greg (2002) 'Domesticating an Urban Menace: Reforming Capoeira as a Brazilian National Sport', *International Journal of the History of Sport*, 4, December, 1–32.

_____ (2006), '"Practice without Theory": The Imitation Bottleneck and the Nature of Embodied Knowledge', unpublished manuscript.

Eperjesi, John R. (2004) '*Crouching Tiger, Hidden Dragon*: Kung Fu Diplomacy and the

Dream of Cultural China', *Asian Studies Review*, 28, 25–39.

Ferraris, Maurizio (2001), 'What is there?', in Jacques Derrida and Ferraris, *A Taste for the Secret*, Polity: Cambridge.

Feyerabend, Paul (1993), *Against Method: Outline of an Anarchistic Theory of Method* (3rd Edition), London: Verso.

Foucault, Michel (1970) *The Order of Things: An Archaeology of the Human Sciences*. London: Tavistock.

____ (1978), *The History of Sexuality: Vol. 1*, London: Penguin.

____ (1988) *Power/Knowledge: Selected Interviews and Other Writings, 1972–1977*. London: Harvester Press.

____ (1995), *Discipline & Punish: The Birth of the Prison*, New York: Vintage Books.

Freud, Sigmund (1899), 'Screen Memories', *The Standard Edition of the Complete Psychological Works of Sigmund Freud, Volume III (1893-1899): Early Psycho-Analytic Publications*, 299-322.

Froment-Meurice, Marc (2001) 'Specters of M', *Parallax 20*, 7, 3, 51–62.

Funakoshi, Gichin (1975) *Karate-Dō: My Way of Life*. Tokyo: Kodansha International.

Gilbert, Jeremy and Ewan Pearson (1999) *Discographies: Dance Music, Culture and the Politics of Sound*. Routledge: London.

Giroux, Henry A. (2000), *Impure Acts: The Practical Politics of Cultural Studies*, London: Routledge.

____ (2002) *Breaking into the Movies*. London: Blackwell.

Godzich, Wlad (1987), 'Afterword: Religion, the State and Post(Al) Modernism', in Sam Weber, *Institution and Interpretation*, Minneapolis: University of Minnesota Press.

Hables Gray, Chris (1997) *Postmodern War: The New Politics of Conflict*. London and New York: Routledge.

Hall, Stuart (1980) 'Encoding/Decoding', in Stuart Hall, Dorothy Hobson, Andrew Lowe and Paul Willis (eds) *Culture, Media, Language: Working Papers in Cultural Studies, 1972-79*. London: Routledge, 117–26.

____ (1992), 'Cultural Studies and Its Theoretical Legacies', in Lawrence Grossberg, Cary Nelson, Paula Treichler (eds.), *Cultural Studies*, New York and London: Routledge.

____ (1996), 'On postmodernism and articulation: an interview with Stuart Hall', David Morley and Kuan-Hsing Chen, eds., *Stuart Hall: Critical Dialogues in Cultural Studies*, London: Routledge.

____ (1996a) 'New Ethnicities', in *Stuart Hall: Critical Dialogues in Cultural Studies*, ed. David Morley and Kuan-Hsing Chen, London: Routledge.

____ (1997), 'Minimal Selves', *Studying Culture*, ed. Jim McGuigan, London: Arnold.

Hardt, Michael and Antonio Negri (2000) *Empire*. Cambridge, MA: Harvard University Press.

Harland, Richard (1987) *Superstructuralism*, Methuen: London.

Heath, Joseph and Andrew Potter (2005) *The Rebel Sell: Why the Culture Can't Be Jammed*. Capstone: Chichester.

Hegel, G. W. F. (1977 [1807]) *Phenomenology of Spirit*. Oxford: Oxford University Press.

Heidegger, Martin (1971), 'A Dialogue on Language: Between a Japanese and an Inquirer', *On The Way To Language*, New York: Harper Collins.

Heiskanen, Benita (2006) 'On the ground and off: The theoretical practice of professional boxing', *European Journal of Cultural Studies*, 9, 4, 481–96.

Humphreys, Christmas (1947/1972), *Walk On*, London: The Buddhist Society.

Hunt, Leon (2003) *Kung Fu Cult Masters: From Bruce Lee to Crouching Tiger*. London: Wallflower Press.

Inosanto, Dan (1980) *Jeet Kune Do: The Art and Philosophy of Bruce Lee*. Los Angeles: Know How Publishing.

Jameson, Fredric (1991) *Postmodernism: Or, The Cultural Logic of Late Capitalism*. Durham, NC: Duke University Press.

Johnson, Spencer (1998) *Who Moved My Cheese?: An Amazing Way To Deal With Change In Your Work and in Your Life*. New York: G. P. Putnam's Sons.

Kato, M. T. (2007) *From Kung Fu to Hip Hop: Revolution, Globalization and Popular Culture*. New York: State University of New York Press.

Kennedy, Brian and Guo, Elizabeth (2005) *Chinese Martial Arts Training Manuals: A Historical Survey*. Berkeley, CA: North Atlantic Books.

Krug, Gary J. (2001) 'At the Feet of the Master: Three Stages in the Appropriation of Okinawan Karate into Anglo-American Culture', *Cultural Studies: Critical Methodologies*, 1 4, 395–410.

Lacan, Jacques (1989), *Ecrits: A Selection*. London: Routledge.

Laclau, Ernesto, and Mouffe, Chantal, (1985), *Hegemony and Socialist Strategy: Towards A Radical Democratic Politics*. London: Verso.

Laclau, Ernesto (1989) 'Preface', in Slavoj Žižek, *The Sublime Object of Ideology*, London: Verso.

_____ (2005) *On Populist Reason*, London: Verso.

Landon, Brooks (1992) *The Aesthetics of Ambivalence: Rethinking Science Fiction Flm in the Age of Electronic (Re)Production*. Westport, CO: Greenwood Press.

Laplanche, Jean, and Pontalis, J.-B. (1988), *The Language of Psychoanalysis*, London: Karnac.

Lee, Bruce (1963/1987), *Chinese Gung-fu: The Philosophical Art of Self-Defense*, Santa Clarita, California: Ohara Publications.

_____ (1971) 'Liberate Yourself from Classical Karate', *Black Belt Magazine*, September, 24–8.

_____ (1975) *The Tao of Jeet Kune Do*. Santa Clarita, CA: Ohara Publications.

_____ (2001), *Bruce Lee, Artist of Life: The Essential Writings*, compiled and edited by John Little, Boston: Tuttle.

_____ (2002) *Striking Thoughts: Bruce Lee's Wisdom For Daily Living*, Ed. John Little. Boston: Tuttle.

_____ (n/d), http://www.fightingmaster.com/masters/brucelee/quotes.htm

Lee, Bruce and John Little (1997) *Bruce Lee: Words of the Dragon: Interviews, 1958–1973*. Boston: Tuttle.

Little, John (1996) *Bruce Lee: A Warrior's Journey*. McGraw Hill Contemporary.

Lo, Kwai-Cheung (2005) *Chinese Face/Off: The Transnational Popular Culture of Hong Kong*. Chicago: University of Illinois Press.

Longxi, Zhang (1992), *The Tao and the Logos: Literary Hermeneutics*, East and West, Duke: Durham and London.

Lui, Elizabeth (2005) *The Travels of Lao Ts'an*. Yi Lin Chu Ban She.

Lyotard, Jean-François (1984), *The Postmodern Condition: A Report on Knowledge*, Minneapolis: University of Minnesota Press.

____ (1988), *The Differend: Phrases in Dispute*, Manchester: Manchester University Press.

Mao Zedong (1957), *On the Correct Handling of Contradictions among the People*, available at: http://eprints.cddc.vt.edu/marxists/reference/archive/mao/selected-works/volume-5/mswv5_58.htm

Marchetti, Gina (2001), 'Jackie Chan and the Black Connection', in Matthew Tinkcom and Amy Villarejo, eds., *Keyframes: popular cinema and cultural studies*, London: Routledge.

____ (2006) *From Tian'anmen to Times Square: Transnational China and the Chinese Diaspora on Global Screens, 1989–1997*. Philadelphia: Temple University Press.

Mao, Zedong (1957) *On the Correct Handling of Contradictions among the People*, February 27; http://www.marxists.org/reference/archive/mao/selected-works/volume-5/mswv5_58.htm

Mattelart, Armand (1993) 'Globalisation', *Vertigo*, Summer/Autumn, 5–8.

May, Reinhard (1996), *Heidegger's Hidden Sources: East-Asian Influences on His Work*, London: Routledge.

Miller, Davis (2000) *The Tao of Bruce Lee*. Vintage: London.

Montague, Erle, (1993), *Dim Mak: Death Point Striking*, New York: Paladin.

Morris, Meaghan (2001) 'Learning from Bruce Lee', in Matthew Tinkcom and Amy Villarejo (eds) *Keyframes: Popular Cinema and Cultural Studies*. London: Routledge, 171–84.

____ (2005) 'Introduction: Hong Kong Connections', in Meaghan Morris, Siu Leung Li and Stephen Chan Ching-kiu (eds) *Hong Kong Connections: Transnational Imagination in Action Cinema*. Durham, NC: Duke University Press, 1–18.

Mowitt, John (1992), *Text: The Genealogy of an Antidisciplinary Object*, Durham and London: Duke.

____ (2002) *Percussion: Drumming, Beating, Striking*. Durham, NC: Duke University Press.

____ (2003), 'Cultural Studies, in Theory', in Paul Bowman, ed., *Interrogating Cultural Studies: Theory, Politics and Practice*, London: Pluto.

Musashi, Mayamoto (1994), *The Book of Five Rings*, trans. Thomas Cleary, Boston and London: Shambala.

Nitta, Keiko (2010) 'An equivocal space for the protestant ethnic: US popular culture and martial arts fantasia', *Social Semiotics*, 20, 4, 377–92.

Norman, Andy (no date), Interview, Martial Edge Website, http://www.martialedge.com/articles/interviews-question-and-answers/andy-norman-of-keysi-fighing-method-kfm/

Park, Jane Chi Hyun (2010) *Yellow Future: Oriental Style in Hollywood Cinema*. Minneapolis: University of Minnesota Press.

Peters, Michael A. (2001), *Poststructuralism, Marxism and Neoliberalism: Between Theory and Politics*. London: Rowman and Littlefield.

Prashad, Vijay (2001) *Everybody Was Kung Fu Fighting: Afro-Asian Connections and the Myth of Cultural Purity*. Boston: Beacon Press.

Preston, Brian (2007) *Bruce Lee and Me: A Martial Arts Adventure*. London: Penguin.

Protevi, John (2001), *Political Physics: Deleuze, Derrida and the Body Politic*, London: Athlone.

Rancière, Jacques (1974) *La Leçon d'Althusser*. Paris: Gallimard.

____ (1987) *The Ignorant Schoolmaster: Five Lessons in Intellectual Emancipation*. Stanford: Stanford University Press.

____ (1992) 'Politics, Identification, and Subjectivization', *October*, 61, Summer, 58–64.

____ (1999) *Disagreement: Politics and Philosophy*. Minneapolis: University of Minnesota Press.

____ (2000) 'Jacques Rancière: Literature, Politics, Aesthetics: Approaches to Democratic Disagreement: Interviewed by Solange Guénoun and James H. Kavanagh', *Substance*, 92, 3–24.

____ (2006a) *Film Fables*. Oxford and New York: Berg.

____ (2006), 'Thinking Between Disciplines: An Aesthetics of Knowledge', *Parrhesia*, Vol. 1, No. 1, 1-12.

____ (2006), *The Politics of Aesthetics*, London: Continuum.

Rayns, Tony (1984), 'Bruce Lee and Other Stories', in Lau Shing-hon (ed.), *A Study of Hong Kong Cinema in the Seventies*, Hong Kong: Hong Kong International Film Festival/ Urban Council, 26-9.

Rojek, Chris (2003), *Stuart Hall*, London: Polity.

Ronell, Avital (2004) 'Koan Practice or Taking Down the Test', *parallax*, 10, 1, 58–71.

Ross, Kristin (1987) 'Translator's Introduction', in Jacques Rancière, *The Ignorant Schoolmaster: Five Lessons in Intellectual Emancipation*. Stanford: Stanford University Press, vii-xviii.

Royle, Nicholas (2000), 'What is Deconstruction?', *Deconstructions: A User's Guide*, Basingstoke and New York: Palgrave.

Said, Edward (1978) *Orientalism*. London: Vintage.

Sedgwick, Eve Kosofsky (2003) *Touching Feeling: Affect, Pedagogy, Performativity*. Durham, NC: Duke University Press.

Seshagiri, Urmila (2006) 'Modernity's (Yellow) Perils: Dr Fu-Manchu and English Race Paranoia', *Cultural Critique*, 62, Winter, 162–94.

Sandford, Stella (2003), 'Going Back: Heidegger, East Asia and 'The West'', *Radical Philosophy*, 120, 11-22, July/August.

Silverman, Kaja (1983) *The Subject of Semiotics*. Oxford: Oxford University Press:

____ (1992) *Male Subjectivity at the Margins*. London: Routledge.

Skinner, Frank (2002) *Frank Skinner*. Arrow Books: London.

Smith, Damon (2006), 'Tai Chi Ch'üan', Yongquan Martial Arts Association (http://www.xingyi.org.uk/html/tai_chi_chuan.html).

Smith, Robert W. (1999) *Martial Musings: A Portrayal of Martial Arts in the 20ᵗʰ Century*. Erie, PN: Via Media.

Smith, Huston and Novak, P. (2003), *Buddhism*, London: Harper Collins.

Spivak, Gayatri Chakravorty (1976), 'Translator's Preface', in Jacques Derrida, *Of Grammatology*, Baltimore: Johns Hopkins University Press.

____ (1988) 'Can the Subaltern Speak?', in *Marxism and the Interpretation of Culture*. Chicago: University of Illinois Press, 271–314.

____ (1999), *A Critique of Postcolonial Reason: Toward a History of the Vanishing Present*, Cambridge Ma., and London: Harvard University Press.

Spivak, Gayatri Chakravorty and Sneja Gunew (1993) 'Questions of Multiculturalism', in Simon During (ed.) *The Cultural Studies Reader*. London: Routledge, 193–202.

Telegraph, The (2009) 'David Carradine Obituary', 4th June: http://www.telegraph.co.uk/news/obituaries/culture-obituaries/tv-radio-obituaries/5446396/David-Carradine.html

Teo, Stephen (2008) *Hong Kong Cinema: The Extra Dimension*. London: British Film Institute.

____ (2009) *Chinese Martial Arts Cinema: The Wuxia Tradition*. Edinburgh: Edinburgh University Press.

Thomas, Bruce (1994) *Bruce Lee: Fighting Spirit*. Basingstoke: Sidgwick & Jackson.

Thompson, Geoff (1993a) *Real Self Defence*. Chichester: Summersdale.

____ (1993b), *The Pavement Arena: Adapting Combat Martial Arts to the Street*. Chichester: Summersdale.

Tierney, Sean M. (2006), 'Themes of Whiteness in *Bulletproof Monk*, *Kill Bill*, and *The Last Samurai*', *Journal of Communication*, 607-624.

Toch, Hans (1972), *Violent Men: an inquiry into the psychology of violence*, Harmondsworth: Penguin.

Wacquant, Loic (1995) 'The pugilistic point of view: how boxers think and feel about their trade', *Theory and Society*, 24, 4, 489–535.

Watts, Alan (1957) *The Way of Zen*. London: Penguin.

Weber, Sam (1982), *The Legend of Freud*, Minneapolis: University of Minnesota Press.

____ (1987) *Institution and Interpretation*. Minneapolis: University of Minnesota Press.

Wile, Douglas (1996) *Lost T'ai-chi Classics from the Late Ch'ing Dynasty*. New York: State University of New York Press.

Williams, Raymond (1977) *Marxism and Literature*. Oxford: Oxford University Press.

Yu, Cheng (1984), 'Anatomy of a Legend' in Li Cheuk-to (ed.) *A Study of the Hong Kong Martial Arts Film*, Hong Kong: HKIFF/Urban Council, 149-50.

Xu, Jian (1999) 'Body, Discourse, and the Cultural Politics of Contemporary Chinese Qigong', *Journal of Asian Studies*, 58, 4, 961–91.

Yamamoto, Tsunetomo (1979), *Hagakure: The Book of the Samurai*, Translated by William Scott Wilson, Kodansha International.

Žižek, Slavoj (1998), 'A Leftist Plea for "Eurocentrism"', *Critical Inquiry* 24 (2), pp. 988-1,009.

____ (2001a) *On Belief*. London: Routledge.

____ (2001b), *Did Somebody Say Totalitarianism? Five Interventions in the (Mis)use of a Notion*. London: Verso.

____ (2002), *Revolution at the Gates: Selected Writings of Lenin from February to October 1917*, London, Verso.

____ (2004) 'The Lesson of Rancière', afterword to Jacques Rancière's *The Politics of Aesthetics*. London: Continuum, 69–79.

____ (2005), *Interrogating the Real*, ed. Rex Butler and Scott Stephens, London and New York: Continuum.

INDEX

207